Conceptual Art Tony Godfrey

Kaelyn Garcia

ART&IDEAS

Φ

LIVE AND DIE	LIVE AND LIVE	SING AND DIE
DIE AND DIE	DIE AND LIVE	SCREAM AND DIE
SHIT AND DIE	SHIT AND LIVE	YOUNG AND DIE
PISS AND DIE	PISS AND LIVE	OLD AND DIE
EAT AND DIE	EAT AND LIVE	CUT AND DIE
SLEEP AND DIE	SLEEP AND LIVE	RUN AND DIE
LOVE AND DIE	LOVE AND LIVE	STAY AND DIE
HATE AND DIE	HATE AND LIVE	PLAY AND DIE
FUCK AND DIE	FUCK AND LIVE	KILL AND DIE
SPEAK AND DIE	SPEAK AND LIVE	SUCK AND DIE
LIE AND DIE	LIE AND LIVE	COME AND DIE
HEAR AND DIE	HEAR AND LIVE	GO AND DIE
CRY AND DIE	CRY AND LIVE	KNOW AND DIE
KISS AND DIE	KISS AND LIVE	TELL AND DIE
RAGE AND DIE	RAGE AND LIVE	SMELL AND DIE
LAUGH AND DIE	LAUGH AND LIVE	FALL AND DIE
TOUCH AND DIE	TOUCH AND LIVE	RISE AND DIE
FEEL AND DIE	FEEL AND LIVE	STAND AND DIE
FEAR AND DIE	FEAR AND LIVE	SIT AND DIE
SICK AND DIE	SICK AND LIVE	SHIT AND DIE
WELL AND DIE	WELL AND LIVE	TRY AND DIE
BLACK AND DIE	BLACK AND LIVE	FAIL AND DIE
WHITE AND DIE	WHITE AND LIVE	SMILE AND DIE
RED AND DIE	RED AND LIVE	THINK AND DIE
YELLOW AND DIE	YELLOW AND LIVE	PAY AND DIE

**Opposite
Bruce Nauman**,
*One Hundred
Live and Die*
(detail of 6),
1984.
Neon and glass
tubing;
300 × 335·9 ×
53·3 cm,
118 × 132⅛ × 21 in.
Naoshima
Contemporary
Art Museum

I don't believe in Jesus
I don't believe in Kennedy
I don't believe in Buddha
... I don't believe in Elvis
I don't believe in Zimmerman
I don't believe in Beatles
I just believe in me
John Lennon, 'God' from the *Plastic Ono Band* album, 1970

Imagine someone saying: 'But I know how tall I am!'
and laying his hand on top of his head to prove it.
Imagine people who could only think aloud.
(As there are people who can only read aloud.)
Ludwig Wittgenstein, *Philosophical Investigations*, 1953

Conceptual art is not about forms or materials, but about ideas and meanings. It cannot be defined in terms of any medium or style, but rather by the way it questions what art is. In particular, Conceptual art challenges the traditional status of the art object as unique, collectable or saleable. Because the work does not take a traditional form it demands a more active response from the viewer, indeed it could be argued that the Conceptual work of art only truly exists in the viewer's mental participation. This art can take a variety of forms: everyday objects, photographs, maps, videos, charts and especially language itself. Often there will be a combination of such forms. By offering a thorough critique of art, representation and the way that they are used, Conceptual art has had a determining effect on the thinking of most artists.

Art in the twentieth century has been awarded the highest accolade as something that we should admire and respect. To question it, as Conceptual art has done, is therefore to question the inherent values of our culture and society. In recent years the art museum has taken

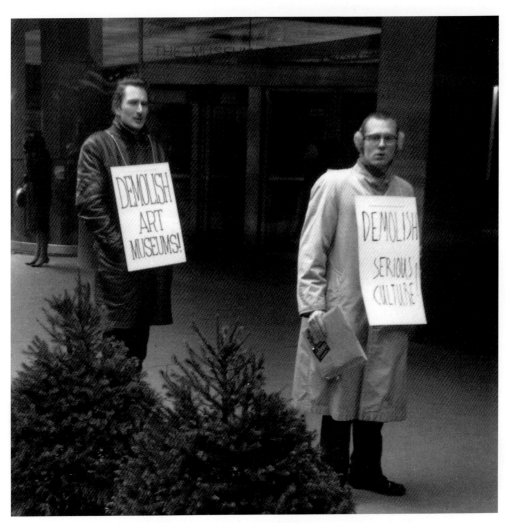

1
Jack Smith and
Henry Flynt
protesting
outside the
Museum of
Modern Art,
New York,
1963

on many of the aspects of the church or temple: the reverential hush, the fetishism with which it preserves and guards its sacred objects. This is something that Conceptual artists have seized on with glee, whether it be an outright denouncement of the institution as with Henry Flynt's anti-museum campaign of 1963 (1), or in the more meticulous recent deconstructions of museum practices by such artists as Joseph Kosuth (see 242) and Fred Wilson (see 243).

Conceptual art can be said to have reached both its apogee and its crisis in the years 1966–72. The term first came into general use around 1967, but it can be argued that some form of Conceptual art has existed throughout the twentieth century. The earliest manifestations are often seen to be the so-called 'readymades' of the French artist Marcel Duchamp. The most notorious of these was *Fountain* (2), a urinal placed on its back on a plinth and signed R Mutt, which Duchamp offered as a work of art to the 1917 exhibition of the Society of Independent artists in New York (see Chapter 1). Before *Fountain* people had rarely been made to think what art actually was, or how it could be manifested; they had just assumed that art would be either a painting or a sculpture. But very few could see *Fountain* as a sculpture.

A work of art normally behaves as if it is a statement: 'This is a sculpture of the Old Testament hero David by Michelangelo'; or 'This is a portrait of the Mona Lisa'. We may, of course, ask questions such as 'Why has Michelangelo made David double life size?' or 'Who was this Mona Lisa?', but these questions follow on from an acceptance of the initial statement that the artwork proposes. We accept it both as a representation and as being *ipso facto* art. In contrast the readymade is presented not as a statement, 'This is a urinal', but as a question or challenge: 'Could this urinal be an artwork? Imagine it as art!' Or, of Duchamp's *LHOOQ* (3): 'try and imagine this reproduction of the Mona Lisa with a beard as an artwork, not just a defaced reproduction of an artwork, but an artwork in its own right.'

Some of the questions raised by the Conceptual artists in the late 1960s had, therefore, been anticipated by Duchamp fifty years earlier, and to some extent they were also anticipated from 1916 onwards in

the anti-art gestures of Dada (see Chapter 1). They would be brought up again and extended by a whole range of artists, including the neo-Dadaists and the Minimalists, in the twenty years after World War II (see chapters 2 and 3). As we shall see in chapters 4 to 8, the issues were most fully developed and theorized by a generation of artists that emerged in the late 1960s, whose work must lie at the heart of any study of Conceptual art. Subsequently, many of them have continued to develop their work, while a new generation has adopted Conceptual strategies to elucidate their experience of the world (see chapters 9, 10 and 11). Whether we should see such work as late Conceptual, post-Conceptual or neo-Conceptual is as yet unresolved.

Conceptual art was, and is, a truly international phenomenon. In the 1960s you were as likely to find it being made in San Diego, Prague and Buenos Aires as New York. As New York has been the centre of art distribution and promotion in this period, the work made there has been the most heavily discussed. I would like, to some extent, to redress that balance.

If it is not defined by medium or style, how can you recognize a piece of Conceptual art when you encounter it? Generally speaking, it may be in one of four forms: a *readymade*, a term invented by Duchamp for an object from the outside world which is claimed or proposed as art, thus denying both the uniqueness of the art object and the necessity for the artist's hand; an *intervention*, in which some image, text or thing is placed in an unexpected context, thus drawing attention to that context: *eg* the museum or the street; *documentation*, where the actual work, concept or action, can only be presented by the evidence of notes, maps, charts or, most frequently, photographs; or *words*, where the concept, proposition or investigation is presented in the form of language.

Duchamp's *Fountain* is the most famous, or notorious, example of a readymade, but the strategy has been adopted and adapted by many artists. An example of intervention is the billboard project by the American artist Felix Gonzalez-Torres, where a photograph of an empty double bed with crumpled bedclothes was displayed on

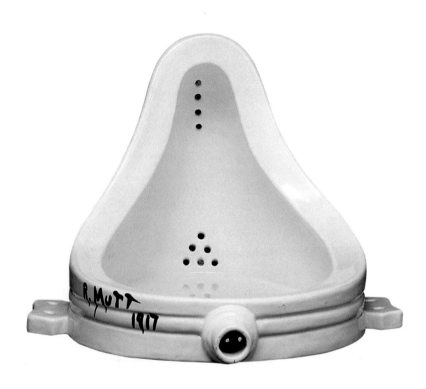

2
**Marcel
Duchamp**,
Fountain,
1950 replica of
1917 original
(now lost).
Porcelain;
h.33·5 cm, 14 in.
Indiana
University Art
Museum,
Bloomington

3
**Marcel
Duchamp**,
LHOOQ,
1941–2.
Rectified
readymade
(pencil on
postcard);
19·4 × 12·2 cm,
$7^5_8 × 4^3_4$ in.
Philadelphia
Museum of Art

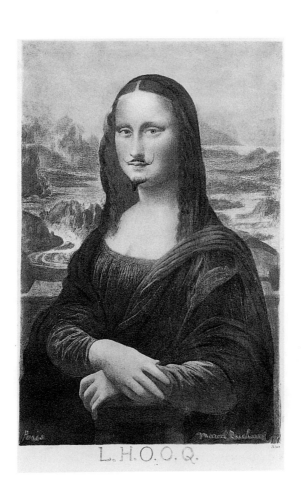

L.H.O.O.Q.

twenty-four billboards at various sites throughout New York (4). What did this mean? It had no words or legend attached. To the passer-by it could mean many things, depending on his or her own circumstances. It spoke of love and absence: double beds are normally for lovers to share. It is what many of us see before we leave for work in the morning. This was an unusually intimate image to display where all could see it and, of course, the setting or context in which it was seen became an intrinsic and crucial part of its meaning. Perhaps a few passers-by recognized that it was a work by Gonzalez-Torres and guessed that, for him, such an image would be of the bed he had shared with his lover Ross, who had recently died of AIDS. But that specific personal meaning is not prescriptive: the meaning is what we each discover in it.

Joseph Kosuth's *One and Three Chairs* (5) is an example of documentation, where the 'real' work is the concept – 'What is a chair?' 'How do we represent a chair?' And hence 'What is art?' and 'What is representation?' It seems a tautology: a chair is a chair is a chair, much as he claimed that 'art is art is art' was tautologous. The three elements that we can actually see (a photograph of a chair, an actual chair and the definition of a chair) are ancillary to it. They are of no account in themselves: it is a very ordinary chair, the definition is photostatted from a dictionary and the photograph was not even taken by Kosuth – it was untouched by the hand of the artist.

The Californian artist Bruce Nauman's *One Hundred Live and Die* is a clear example of art presented as words (6). The viewer, like a child learning to read, is asked to rehearse a set of paired terms, but these pairings become increasingly jarring and unsettling. It is constructed in neon, a medium that we associate with shop signs and which, used on this scale, fills the gallery with a disturbing hum.

We must, however, be wary of typologies, something which Conceptual artists have regarded as anathema. It is the possible meanings of the four works above, which we will return to, that matter. Many Conceptual works will not fit any clear typology, just as many Conceptual artists resist any restrictive definition of what they do. One reason for their frequent opposition to the

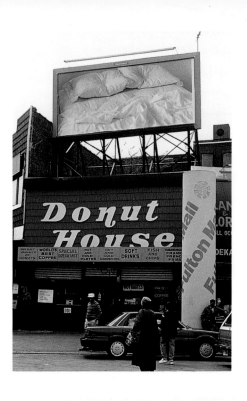

chair, n hence v; chaise (longue) and chay;
(ex) cathedra, cathedral (adj and n), cathedratic;
element -hedral, -hedron, q.v. sep.

1. Gr hedra, a seat (cf Gr hezesthai, to sit, and,
ult, E sit), combines with kata, down (cf the prefix
cata-), to form kathedra, a backed, four-legged,
often two-armed seat, whence L cathedra, LL
bishop's chair, ML professor's chair, hence dignity,
as in 'to speak ex cathedra', as from—or as if
from—a professor's chair, hence with authority.
L cathedra has LL-ML adj cathedrālis—see sep
CATHEDRAL; and the secondary ML adj cathe-
drāticus, whence E legal cathedratic.

museum is its insistence on such categories: often with absurd consequences. When removing Kosuth's *One and Three Chairs* from exhibition, the major museum that owned the piece was reputedly uncertain as to where it should be stored, there being no department of 'Conceptual art', and hence no specific storage area. Eventually it was stored according to the logic of the museum: the chair was stored in the design department, the photograph of the chair in the photography department and the photocopy of the dictionary definition stored in the library! So in effect they could only store the piece by destroying it.

If a work of Conceptual art begins with the question 'What is art?', rather than a particular style or medium, one could argue that it is completed by the proposition 'This could be art': 'this' being presented as object, image, performance or idea revealed in some other way. Conceptual art is therefore 'reflexive': the object refers back to the subject, as in the phrase 'I am thinking about how I think.' It represents a state of continual self-critique.

The quotation that began this chapter comes from John Lennon's song 'God', on his 1970 album, *Plastic Ono Band*, which was made just after he had broken from the Beatles and his guru the Maharishi Mahesh Yogi. His negative credo, intoned against a simple piano accompaniment, begins with the enigmatic statement, 'God is a concept by which we measure our pain' and after a long list of things that he no longer believes in (Magic, I Ching, Bible, Tarot, Hitler, Jesus, Kennedy, Buddha, Mantra, Gita, Yoga, Kings, Elvis, Zimmerman, Beatles) ends 'I just believe in Me / Yoko and me / and that's reality ...' Conceptual art begins with a similar negativity or doubt, but then moves beyond it by imagining, or making a proposition, much as Ludwig Wittgenstein does in the second quotation. This two-fold operation of doubting and imagining underlies Conceptual art.

Symptomatically, there has never been a generally accepted definition of Conceptual art, though many have been proposed. The first widely acknowledged use of the term came in the artist Sol LeWitt's 'Paragraphs on Conceptual Art', published in the magazine *Artforum* in 1967: 'In conceptual art the idea or concept is the most

important aspect of the work. When an artist uses a conceptual form of art, it means that all the planning and decisions are made beforehand and the execution is a perfunctory affair. The idea becomes a machine that makes the art.' However this definition applies best to a way of working such as LeWitt's (see Chapter 5). Soon he was having to make a distinction between conceptual art, which was what he did, and Conceptual art (with a capital C), which was what others did.

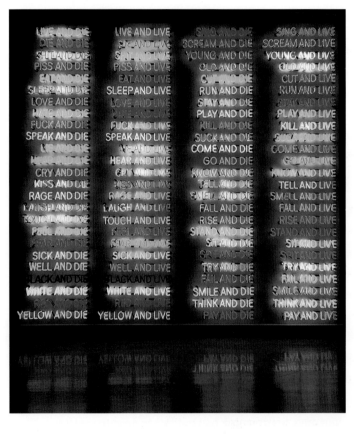

6
Bruce Nauman,
*One Hundred
Live and Die*,
1984.
Neon and glass
tubing;
300 × 335.9 ×
53.3 cm,
118 × 132¹⁸ × 21 in.
Naoshima
Contemporary
Art Museum

Another early definition was given by Joseph Kosuth in his 1969 article 'Art after Philosophy', published in the magazine *Studio International*: 'The "purest" definition of conceptual art would be that it is inquiry into the foundations of the concept "art", as it has come to mean.' Again, this is a definition of Kosuth's own practice as an artist; as critic Lucy Lippard wryly remarked years later, there seemed to be as many definitions of Conceptual art as there were

Conceptual artists. The spectre is raised of a 'pure' and, presumably therefore, an 'impure' Conceptual art, anticipating later disputes over 'correct' and 'incorrect' ways of working. Other Conceptual artists characterized what Kosuth made as 'Theoretical art', which they saw as tedious and self-indulgent.

Lucy Lippard, a critic especially associated with Conceptual art in the late 1960s, emphasized the 'dematerialization' of the art object as a defining factor, but others rejected this as a chimera. By 1995, however, Lippard was offering a far more circumspect definition, in the catalogue to the retrospective exhibition *Reconsidering the Object of Art: 1965–1975*: 'Conceptual art, for me, means work in which the idea is paramount and the material is secondary, lightweight, ephemeral, cheap, unpretentious, and/or dematerialized.' Kosuth too was, by 1996, offering a far less prescriptive definition: 'Conceptual art, simply put, had as its basic tenet an understanding that artists work with meaning, not with shapes, colors, or materials.'

Art & Language, one of the most important collaborative groups of artists in the late 1960s, characterized Conceptual art as Modernism's nervous breakdown. A nervous breakdown happens when we can no longer believe in all we have based our lives on: friends, family, job, beliefs. Conceptual artists could no longer believe in what art, or Modernist art, claimed to be, nor in the social institution it had become. Modernism as it developed from the mid-nineteenth century had sought to represent the new world of industrialization and mass media in new and more appropriate forms and styles. But by the 1960s the dominant strand of Modernism had become Formalism where attention was focused solely on these forms and styles. Progress in Formalism had nothing to do with explaining life in a rapidly changing world but everything to do with refining and purifying the medium as an end in itself. Conceptual art was a violent reaction against such Modernist notions of progress in the arts and against the art object's status as a special kind of commodity. The purely retinal or visual nature of art, especially painting, was extolled by theorists and promoters of Modernism. This was anathema to Conceptual artists who emphasized instead

the crucial role of language in all visual experience and understanding. Modernist art had become a refined and hermetic discourse: Conceptual art opened it up to philosophy, linguistics, the social sciences and popular culture.

Conceptual art was made, it seems, in times of crisis, when authority – both political and artistic – came into question. Was Conceptual art, though, a symptom of a time of crisis or an attempted cure? Were the artists of the late 1960s political or apolitical? Did they have Utopian aspirations, or were they careerists? Why, if they were so politically motivated, is there so little direct reference in their work to the Vietnam War or the student riots in Paris in 1968? All this will be examined further in the following chapters.

Much of the literature on Conceptual art in the 1960s has been partisan: there has been a depressing amount of squabbling over precedence, over who did what first. For example, Art & Language dispute the dates that Kosuth gives to his early work, arguing that they were not exhibited that early. Kosuth, in reply, claims that Art & Language have constructed a purely fictional history of Conceptual art, with themselves as heroes. Those who supported the most theoretical tendencies in Conceptual art have remained the most vocal, with the result that much that was poetic, witty or humorous has been, in comparison, underrated or neglected. Because of its high intellectual component the subject has seemed the natural province of academia. This book seeks to give a wider picture of what Conceptual art was and is – not a narrow and elitist academic concern.

One reason for opening each chapter, as I have, with a quote from rock music and from philosophy is to give the reader springboards for thought, as well as to emphasize the way that Conceptual art is concerned both with intellectual speculation and with the everyday. Conceptual art asks questions not only of the art object: 'Why is this art? Who is the artist? What is the context?' – but also of the person who looks at it or reads about it: 'Who are you? What do you represent?' It draws viewers' attention to themselves, making them self-conscious, as is illustrated by Annette Lemieux's work *Where am I* (7).

Conceptual art is not a style, nor can it be limited to a narrow period in time. It is, arguably, a tradition based on the critical spirit, although the use of the word 'tradition' is paradoxical given the opposition of much Conceptual art to the very notion of tradition. Although I seek in the following pages to give a clear, lively and honest introduction to the continuing history of Conceptual art, I cannot and would not want to be prescriptive. In the last resort you will have to decide what you believe, just as in engaging with any example of Conceptual art it is the response of you, the viewer, that defines the work.

7
Annette Lemieux,
Where am I,
1988.
Latex on canvas;
304.8 × 86.4 × 10.2 cm,
120 × 34 × 4 in.
Private collection

```
Where  am     I
Where  are  you
Where  is    she
Where  is     he
Where  are  they
Where  are   we
Who    am      I
Who    are   you
Who    is    she
Who    is     he
Who    are  they
Who    are   we
What   am      I
What   are   you
What   is    she
What   is     he
What   are  they
What   are   we
Why    am      I
Why    are   you
Why    is    she
Why    is     he
Why    are  they
Why    are   we
```

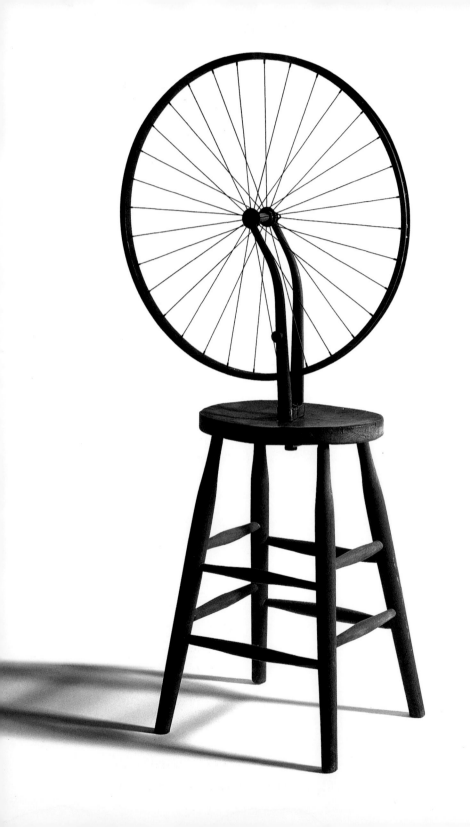

Moses, Moses, king of the Jews,

Wiped his arse in the *Daily News*.

Popular song quoted in *Ulysses* by James Joyce, 1922

The German word 'unheimlich' is obviously the opposite of 'heimlich'
['homely'], 'heimisch' ['native'] – the opposite of what is familiar; and
we are tempted to conclude that what is 'uncanny' is frightening
precisely because it is *not* known and familiar.

Sigmund Freud, 'The Uncanny', 1919

**Art is a concept: it does not exist as a precisely definable physical type
of thing, as elephants or chairs do. Since it became self-conscious,**

8
Marcel Duchamp,
Bicycle Wheel,
1964 replica of
1913 original.
Bicycle wheel
and stool;
h.126.5 cm,
49¾ in.
Private collection

**aware that it was a special category, art has often played with this
'conceptual' status. The Classical writer Pliny tells of a competition
between the artists Zeuxis and Parrhasios, in the fourth century BC,
to paint the most lifelike painting: Zeuxis painted a bunch of
grapes with such mimetic skill that the birds tried to eat them, but
Parrhasios won because he painted a curtain so realistic that Zeuxis
himself tried to pull it back to see the painting behind it. Art and that
which was not art were confused. Zeuxis and Parrhasios were playing
games with epistemology (how do we know what we know?) and
with ontology (what is a thing or category, such as art?). When
Rembrandt painted the *Holy Family with Curtain* in 1646 (9), and
included as part of the painting both the frame and the cloth that
would cover it, or rather an illusion of that frame and cloth, he was
not only wittily demonstrating his technical skill, but making us
uncomfortably aware that we are looking at a painted picture.**

**Is this, however, Conceptual art? It may be self-aware, but it is not
self-critical. It is not fully reflexive. In neither of these instances is the
language of painting criticized. It is with the advent of Modernism in
the nineteenth century that self-consciousness begins to turn to self-
criticism. A work such as Édouard Manet's *A Bar at the Folies-Bergère***

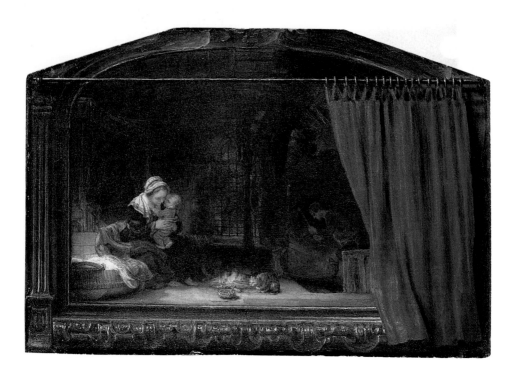

(10) of 1882, is a trap: we find ourselves in the gaze of the barmaid, who may also moonlight as a prostitute, while, because of the curved mirror behind her, the customer is displaced to the right: as a result, we feel in a strange position, unsure of ourselves. Where do we stand – physically and ideologically? Our sense of unease is, crucially, accentuated by the oddities of the painting: the label on the bottle that is flat when perspective should make it curved, the cut-off legs of the trapeze artist, the passages of paint that stay resolutely blobby. What are we actually looking at? A picture or a painting? Are the two no longer compatible?

Manet's contemporary, the poet Stéphane Mallarmé, used the page and the shape of his text in a deliberately radical and problematic way, making his poetry self-evidently visual, and hence as strange as Manet had made his painting. In the poem *A Throw of Dice* (*Un Coup de dés*; 11), the whole page is used as a field across which the text spreads – lines are dispersed like elements in a picture, words are

9
Rembrandt van Rijn,
Holy Family with Curtain, 1646.
Oil on panel;
46·5 × 68·8 cm,
18³⁄₈ × 27⁷⁄₈ in.
Staatliche Museen, Kassel

10
Édouard Manet,
A Bar at the Folies-Bergère, 1882.
Oil on canvas;
96 × 130 cm,
37⁷⁄₈ × 51¼ in.
Courtauld Institute Galleries, London

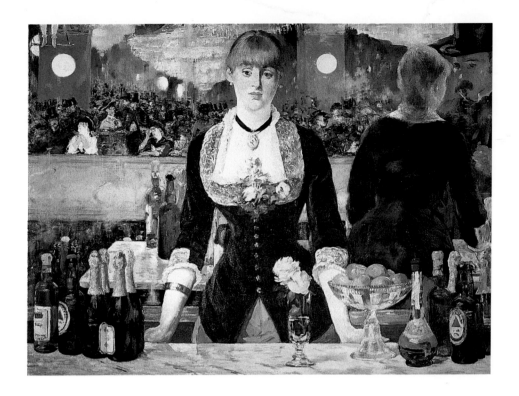

given different sizes and typefaces. Moreover, the poem seeks to embody what Mallarmé called 'subjects of pure and complex imagination or intellect', rather than passions and dreams, which he saw as the traditional subject of verse. The poet Paul Valéry remarked that 'it seemed to me that I was looking at the form and pattern of a thought, placed for the first time in finite space'. 'Imaging' thought or consciousness was, as we shall see, a primary aim of later Conceptual art.

It is only with Duchamp and his readymades that we arrive at an art that consistently put itself forward as art while at the same time questioning exactly what 'art' was. Were these readymades unique and isolated examples, at this time, of what we may call retrospectively Conceptual art? How were they received? What did Duchamp exactly mean by them? What was the situation in art and culture that led to these strange objects appearing? First, however, we should consider Cubism, for that was the starting point of Duchamp's great adventure.

SOIT
que

l'Abîme

blanchi
 étale
 furieux

 sous une inclinaison
 plane désespérément

 d'aile

 la sienne

 par

THOUGH IT BE
 that

 the Abyss

blanched
 spread
 furious
 beneath an incline
 desperately plane

 on a wing

 its own
 fallen
 back in advance from being unable to dress its flight
 and covering the spurtings
 cutting off the surges

 most inwardly sums up

 the shadow buried in the deeps by this alternate sail

 to the point of adapting
 to the wingspan

 its gaping maw like the shell

 of a ship

 listing to starboard or larboard

avance retombée d'un mal à dresser le vol
 et couvrant les jaillissements
 coupant au ras les bonds

11
Stéphane
Mallarmé,
Verse from *A
Throw of Dice*
(*Un Coup de dés*),
1897

très à l'intérieur résume

l'ombre enfouie dans la profondeur par cette voile alternative

jusqu'adapter
 à l'envergure

sa béante profondeur en tant que la coque

d'un bâtiment

penché de l'un ou l'autre bord

Cubism is the high point of that crisis in painting which attempted to resolve what is represented (things in the world, the illusion, depth, textures, plus perhaps emotions) with what is presented (pigments on woven fabric) – the fictive reality of what the picture purports to show, and the actual reality of what it is. In early 1912 Picasso made a small painting, *Still Life with Chair Caning* (12). Perhaps 'painting' is no longer an accurate word, because a considerable part of the picture was not painted, but rather glued on: namely the piece of chair caning, which was actually printed oilcloth, filling the bottom half of the picture. The function of this fake caning is paradoxical: on the one hand, it is a slice of pure realism (what could be more real than the actual thing – an old scrap of oilcloth?), but on the other hand, it destroys any last vestige of pictorial illusionism – any sense that we are looking through an imaginary window at a scene from the real world. We are looking at both an illusion and a 'real' thing. We should also note in Picasso's painting the eccentric frame made of rope and the letters 'J O U', which presumably we should read as part of 'journal' (newspaper). The words, like the chair caning, are a clear link to reality, though they are not themselves material reality. At the same time as we see the image, we read the incomplete word.

Although Cubism never abjured painting and stuck to remarkably traditional subject matter (still lifes and portraits) it is important in the genesis of Conceptual art for four main reasons: (1) the intro-duction of everyday images and objects prefigures the use of the readymade; (2) it is avowedly about epistemology, an inquiry into representation and how we know what we know; (3) it foils or disrupts the expectation of the viewer; (4) it is about fusing the life of the street with the hermetic life of the studio. We can find other parallels to the Cubist use of everyday images and objects in litera-ture of the period. Just as the poet Guillaume Apollinaire later claimed that his inkwell was a 'readymade' work of art, so he took chunks of overheard conversation and plopped them into his poems.

By 1912 Duchamp, whose two elder brothers were themselves well-known Cubist artists, was beginning to establish himself as a Cubist painter. However, to his great surprise and chagrin, he was forced to

12
Pablo Picasso,
Still Life with Chair Caning,
1912.
Oil and oilcloth mounted on canvas in a rope frame;
29 × 37 cm,
11·4 × 14·6 in.
Musée Picasso, Paris

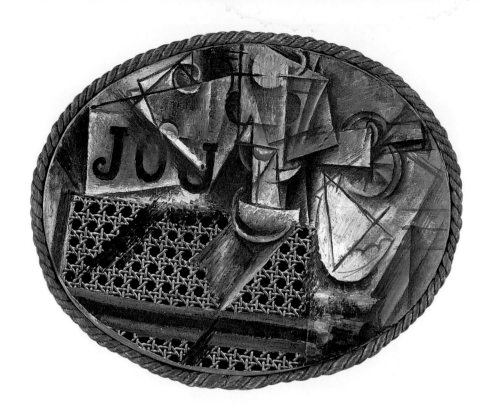

withdraw his painting *Nude Descending a Staircase (No. 2)* (13) from the Salon des Indépendents. His two brothers arrived at his house on the day of the opening to tell him that Albert Gleizes and Jean Metzinger (members of the hanging committee and dogmatic Cubists) did not like the painting. Firstly they felt that, in its depiction of movement, the work too closely resembled Futurism, a movement they did not want to be associated with. Secondly they decided that the painting had 'too much of a literal title, in the bad sense – in a caricatural way'. Moreover the painting had its title actually written on the lower part of the canvas. This was not what they believed a Cubist painting should be. 'A nude never descends the stairs,' the hanging committee had pronounced, 'a nude reclines.' This was an outrageous piece of academic codswallop: perhaps in the unreal, pallid world of the academy, a nude did just recline, but in the real world people when nude do more than that. 'The Cubists think it's a little off beam. Couldn't you at least change the title?' pleaded Duchamp's siblings, who were, without doubt, embarrassed

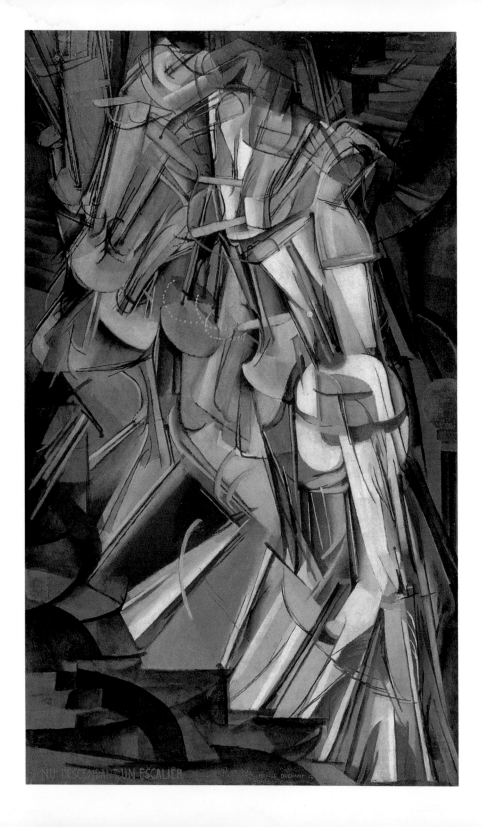

NU DESCENDANT UN ESCALIER　　　　　　　　　MARCEL DUCHAMP

by the whole affair. Thus Duchamp realized that the avant-garde Modernists could be as doctrinaire, exclusive and tyrannical as their supposed enemies, the academicians. He reacted decisively: he did not change his picture, but withdrew it from the exhibition; moreover, soon after, he gave up painting.

What were Duchamp's objections to painting, other than resentment at the way the Cubists had treated him? 'I wanted,' he said later, 'to get away from the physical aspect of painting. I was much more interested in recreating ideas in painting. For me the title was very important. I wanted to put painting once again at the service of the mind. And my painting was, of course, at once regarded as "intellectual", "literary" painting.' It is interesting – considering how painting has been so often seen as the butt of Conceptual art's mockery – that Duchamp rejected not painting *per se*, but stupid painting. Duchamp believed making and thinking were separate things: we think in words and images, not in paint. He stood firmly against the doctrine of painting for painting's sake. This tyranny of pure painting was, he believed, as much a tyranny as any the academy had set up. 'There was no thought', Duchamp claimed, 'of anything beyond the physical side of painting. No notion of freedom was taught.'

13
Marcel
Duchamp,
*Nude
Descending a
Staircase (No. 2)*,
1912.
Oil on canvas;
146 × 89 cm,
57½ × 35 in.
Philadelphia
Museum of Art

The idea of the readymade took shape after Duchamp had moved to New York in 1915. As early as 1913, he had fixed a bicycle wheel onto a stool (see 8) – he liked to spin the wheel round – and in 1916 he had a replica made for his new studio. By then, he had decided that it was a 'Readymade work of art'. He described the gestation of the form in 1961:

In New York in 1915, I bought at a hardware store a snow shovel on which I wrote 'In advance of the broken arm'. It was around that time that the word 'Readymade' came to mind to designate this form of manifestation. A point which I want very much to establish is that the choice of these 'Readymades' was never dictated by an aesthetic delectation. This choice was based on a reaction of *visual* indifference with at the same time a total absence of good or bad taste ... In fact a complete anaesthesia. One important characteristic was the short sentence which I occasionally inscribed on the 'readymade'. That

sentence instead of describing the object like a title was meant to carry the mind of the spectator towards other regions more verbal.

Let us examine in greater detail *Fountain* (see 2), that most notorious of readymades, whose history is well documented. In 1916 a group of New York artists and sympathetic collectors had set up the Society of Independent Artists to organize an annual exhibition. In a true democratic spirit they decided that there would be no jury and no censorship: that any artist who paid the fee of six dollars could exhibit. This was an attempt to circumvent the conservatism of such institutions as the National Academy of Design. The president of the society was William Glackens, a Realist painter; other directors included Marcel Duchamp, Man Ray and the collector William Arensberg.

Just before the opening of the first exhibition on 10 April 1917, Marcel Duchamp bought a urinal from the showroom of the J L Mott Ironworks. He placed it on its back, signed it 'R Mutt' and dated it. (Duchamp later said that the R stood for Richard, French slang for 'moneybags', while Mutt referred to Mutt and Jeff the cartoon characters, plus J L Mott himself.) He then submitted it to the Society to be exhibited with the two thousand or so other works. Instantly the arguments started: Glackens, who of course did not know that R Mutt was a pseudonym of Duchamp, was horrified; he believed that it was indecent and could not possibly be shown. Arensberg, a supporter of Duchamp who had encouraged him in this venture, retorted that R Mutt had paid his six dollars and that therefore the piece must be shown; anyway, he claimed, 'a lovely form has been revealed, freed from its functional purpose, therefore a man clearly has made an aesthetic contribution. Mr Mutt has taken an ordinary object, placed it so that its useful significance disappears, and thus has created a new approach to the subject.'

A meeting of the directors was hurriedly called and a vote was taken not to exhibit the work. One intention of Duchamp had been to see whether the organizers would stick to their principles: they had not. The directors, by way of justification, told the press that it was 'by no definition a work of art'. The day after the opening Duchamp wrote to his sister: 'One of my female friends under a masculine pseudo-

nym, Richard Mutt, sent in a porcelain urinal as a sculpture; it was not at all indecent – no reason for refusing it. The committee has decided to refuse to show the thing. I have handed in my resignation and it will be a bit of gossip of some value in New York.' Although this reference to the 'female friend' was probably a Duchampian joke, the faint possibility still remains that the true 'author' of *Fountain* was not in fact Duchamp, but his friend Louise Norton.

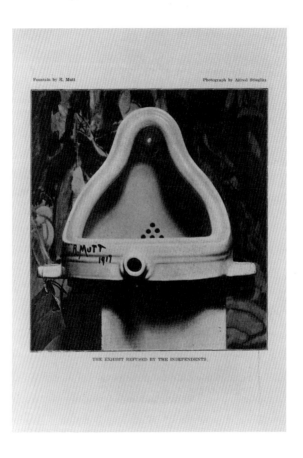

Fountain by R. Mutt Photograph by Alfred Stieglitz

THE EXHIBIT REFUSED BY THE INDEPENDENTS.

14
Marcel
Duchamp.
Fountain,
1917.
Photograph by
Alfred Stieglitz,
reproduced in
The Blind Man,
no.2, May 1917;
71·1 × 50·8 cm,
28 × 20 in.
Philadelphia
Museum of Art

Duchamp retrieved the rejected object and took it to the gallery of Alfred Stieglitz, the famous photographer and supporter of Modernist art. Stieglitz photographed it in front of Marsden Hartley's painting *The Warriors* (14), the two flags seen behind the urinal making perhaps an oblique reference to World War I and contemporary flag waving. The photograph was reproduced in the magazine *The Blind Man* with an editorial alongside, written by Duchamp's friend and fellow artist Beatrice Wood:

They say any artist paying six dollars may exhibit.

Mr Richard Mutt sent in a fountain. Without discussion this article disappeared and never was exhibited.

What were the grounds for refusing Mr Mutt's fountain:–

1. Some contended it was immoral, vulgar.

2. Others, it was plagiarism, a plain piece of plumbing.

Now Mr Mutt's fountain is not immoral, that is absurd, no more than a bathtub is immoral. It is a fixture that you see every day in plumbers' shop windows.

Whether Mr Mutt with his own hands made the fountain or not has no importance. He CHOSE it. He took an ordinary article of life, placed it so that its useful significance disappeared under the new title and point of view – created a new thought for that object.

As for plumbing, that is absurd. The only works of art America has given are her plumbing and her bridges.

An article by Louise Norton in the same magazine likewise emphasized how beautiful the object was – how its lines recalled classical Buddhas or the legs of Cézanne's nudes. As *Fountain* has generally been seen subsequently only as a deliberate outrage, it is worth bearing in mind this contemporary defence. But scandal was what Duchamp expected, indeed sought. We can detect a note of glee and satisfaction in the words to his sister: 'a bit of gossip of some value in New York'. The purpose of the work was to test standards and the behaviour of the Society's directors. It was meant to initiate a debate. Ultimately the debate (which is still going on) is of far more importance than the actual object – which in fact disappeared soon after it was photographed!

We must ask who *Fountain* was meant to shock, how it was meant to shock and why it was meant to shock. World War I, which America had just entered, was supposedly being fought to defend culture and higher values. For this reason the Germans had been vilified in the popular press as barbarians: 'Huns' who vandalized the artistic monuments and raped the women of Belgium. In fact such propaganda, with its lies and self-righteousness, served, in the final

instance, only to discredit the very 'culture' it supposedly supported. The young men who had marched off to war in a spirit of gaiety were now slaughtered like cattle in the trenches, demoralized, doubting that there was any higher justification for their torment and death. The French army, fed up with the unending, futile carnage, was about to mutiny. The best art of this moment and the truest, we would argue now, was one of anger, or of doubt. The expatriate American poet Ezra Pound put it sourly in 'Hugh Selwyn Mauberly':

There died a myriad,
And of the best, among them,
For an old bitch gone in the teeth,
For a botched civilization ...

For two gross of broken statues,
For a few thousand battered books.

If Pound was questioning the value and efficacy of this culture, then Duchamp was questioning the very nature of art and culture. At this time there was a crisis of authority.

Authority was not just a political matter: it was also religious, sexual (patriarchal) and cultural. Academies and groups such as the Society of Independent Artists represented authority just as much as any parliament or king. Art, even Modernist art, it was believed, stood for certain things: culture, decency and high aspiration – hence Glackens's refusal to see something indecent as art. It was indecent to him not only in breaking the decorum of the academy, but in raising issues of sexuality and the unidealized body. It was a low-life object. Above all it was an anti-authoritarian object, because it questioned the definition of art. By what authority could the directors of the Society say it could not be defined as art? And, contrariwise, if they could not define what art was, what authority did they have?

There are, of course, precedents for *Fountain* and Duchamp's other readymades. We could think of the way in which the Catholic Church has treated relics of the saints. A bone or a fingernail or a scrap of hair, if it is believed to be from the body of some saint or revered person, is treated as something especial. Perhaps the talismanic

predecessor for the readymade is that little wafer of bread which is lifted up by a priest in the Roman Catholic Church and transformed into the body of Christ. This is a miracle – at least for a believer – in which a banal object is turned into one of transcendental significance. What could be more special than the body and blood of the Redeemer? Is this not the ultimate claim of authority? No wonder that James Joyce parodies it obsessively in his novel *Ulysses*, or that blasphemy became such a common strategy of early Modernism.

Fountain had been put up not only for exhibition, but also for sale, and hence also raised questions about objects as commodities, and why we collect. In a secular society collecting has absorbed some of the function that religion once had. As the German critic and cultural theorist Walter Benjamin said, 'the collector always retains some traces of the fetishist, and, by owning the work of art, shares in its ritual power'. Collecting – and perhaps the drive to collect is inherent in all people living in culture – is about giving special significance to certain objects: 'This is my very best Barbie doll!' 'This is the ring my grandmother wore at her wedding!' 'This is my most beautiful piece of Minton china!' 'This is mine!'

15
Marcel
Duchamp,
Bottle Rack,
1961 replica of
1914 original.
Galvanized iron;
h.59.1 cm,
23¼ in.
Private
collection

The differing interpretations of fetishism are important here. Karl Marx describes in *Das Kapital* (1867–94) how a man-made object, a commodity, may appear 'a very trivial thing and easily understood'. But 'it is, in reality, a very queer thing, abounding in metaphysical subtleties and theological niceties'. Because of the labour invested in it, it becomes a social thing, and assumes a transcendental nature far greater than its mere use-value. It is enwrapped by a totally false mystique: 'In the mist-enveloped regions of the religious world the productions of the human brain appear as independent beings endowed with life, and entering into relation both with one another and the human race. So it is in the world of commodities with the products of men's hands. This I call the Fetishism which attaches itself to the products of labour, so soon as they are produced as commodities, and which is therefore inseparable from the production of commodities.' Objects cannot just be objects in our society: we overload them instinctively with meanings and significance. In Marx's

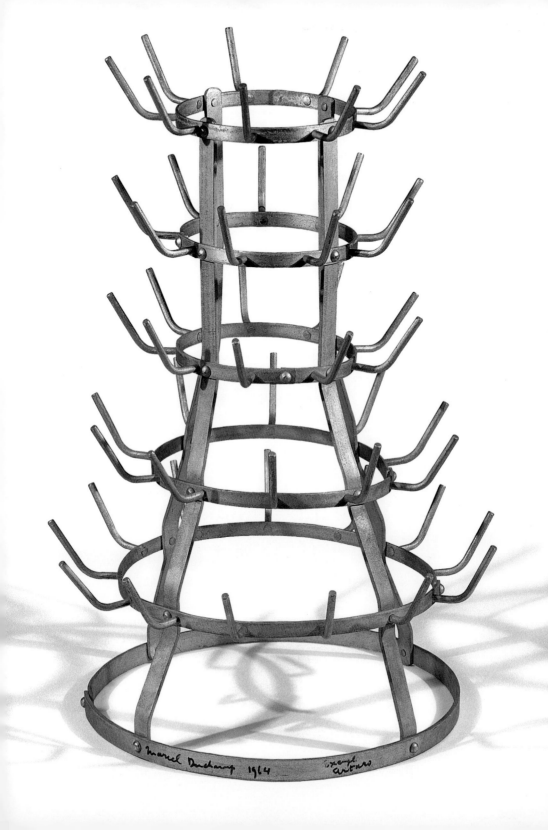

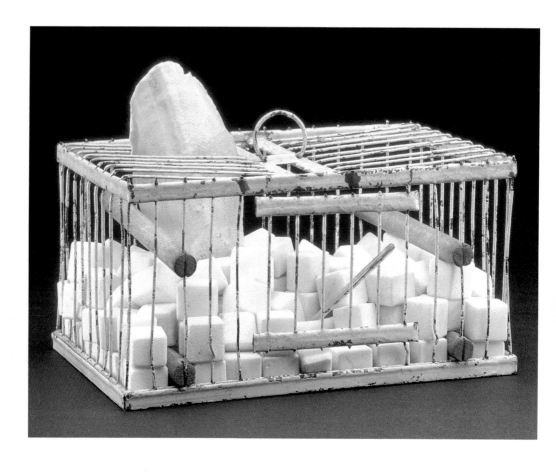

analysis this false perception of commodities is one reason for our estrangement or alienation from the world.

Fetishism was also a key term for Sigmund Freud: for him it occurred when one part of the body came to represent its entirety ('I am obsessed with your knee') or else something associated with a body became a substitute for it, and sexual desire would be misdirected at it ('May I fondle your high heels?'). Fetishism may, he suggested, be based on a primal misapprehension ('Could that high heel be a stand-in for your Mother's missing penis?'); it certainly suggests a world perceived as incomplete or unbalanced. The various analyses of fetishism in Freud, Marx and their commentators show us how objects in this world can be uncanny, or symptomatic of how we understand the world at large.

16
Marcel
Duchamp,
*Why Not Sneeze
Rose Sélavy?*,
1921.
Marble blocks
in the shape of
sugar lumps,
thermometer,
wood and
cuttlebone in
a birdcage;
11·4 × 21·9 ×
16·2 cm,
4¹₂ × 8⁵₈ × 6³₈ in.
Philadelphia
Museum of Art

By 1921 Duchamp had made (or chosen) fifteen readymades, including *Bicycle Wheel* (see 8), *Bottle Rack* (15), *Why Not Sneeze Rose Sélavy?* (16) – the most complex of what he termed 'assisted readymades', where the object was in some way changed – and *LHOOQ* (see 3). This work (the initials, if spoken aloud, sound like the French for 'She has a hot ass') not only cocked a snook at the cult of the artist as genius and the 'masterpiece' but the rigid cultural demarcation of the sexes. Sexual ambiguity was to become a leitmotif in his work. Each of these works presented a different approach to the problem he had set himself. He did not want to repeat himself, to make fetishes, or to create a 'style'. Another variation that he suggested, but did not pursue, was the 'reciprocal readymade': the example he gave was using a Rembrandt painting as an ironing board – art becoming an everyday object rather than an everyday object becoming art.

The readymades of Duchamp's American associate Man Ray show how easily the object could become merely illustrative, literary or fetishistic. One of his first – made in 1920 – a plaster cast of a child's hand painted green and planted in a flowerpot, was the result of a dream. He even called it a dream object – something Duchamp would never have done. After the publication of Freud's *The Interpretation of Dreams* (1900), how could something chosen in a dream be seen as indifferent? Like Duchamp, however, Man Ray had no reservations

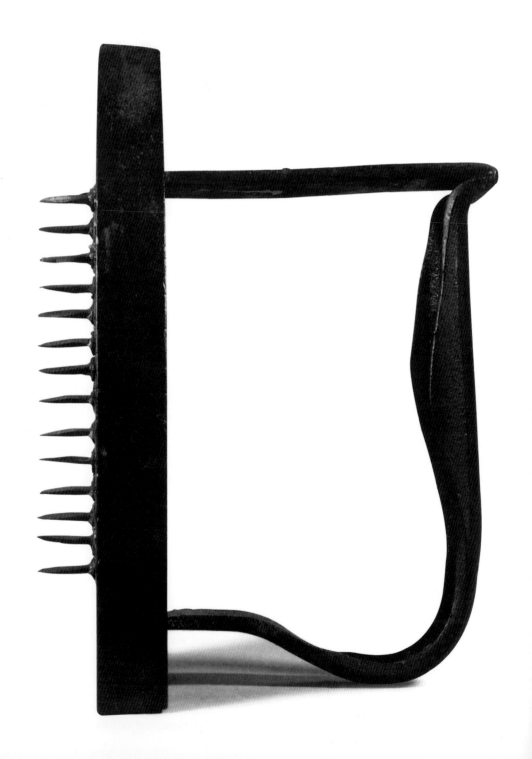

about manufacturing duplicates, often as multiples, for, as he noted, it was the concept that mattered not the making. When he arrived in Paris in 1921 Man Ray made his *Cadeau* or *Gift* (17): an iron on which he had glued tacks. As with Duchamp's *Bicycle Wheel* it was a union of two banal objects that rendered both useless: the iron would rip shirts to shreds and the tacks could no longer be hammered into anything. The violent and erotic implications are overt: 'You can tear a dress to ribbons with it,' Man Ray pointed out. 'I did it once, and asked a beautiful eighteen-year-old coloured girl to wear it as she danced. Her body showed through as she moved around, it was like a bronze in movement. It was really beautiful.'

Dada, to which both Man Ray and Duchamp were affiliated before Surrealism, was short-lived. It was initiated in Zurich in 1916 at the Cabaret Voltaire, very much as a protest against World War I: 'We had found,' said the German Dadaist Richard Huelsenbeck, 'in the war that Goethe and Schiller and Beauty added up to killing and blood-shed and murder. It was a terrific shock to us.' But by 1921 it was over: its participants had ceased their raucous demands for freedom and dispersed, to become career artists (Hans Arp), religious converts (Hugo Ball) and psychoanalysts (Richard Huelsenbeck). How influen-tial was Dada? Can we agree with the philosopher Henri Lefebvre, writing in 1975, that 'to the degree that modernity has a meaning, it is this: it carries within itself, from the beginning, a radical negation – Dada, this event which took place in a Zurich café'? If Dada can be seen as a first wave of Conceptual art, Surrealism, which followed it, had different interests and its investigation into the nature of art (begun by Dada) was less radical.

Certainly it would be wrong to see the 'conceptuality' of Duchamp and Dada, or the period generally, as residing solely in the ready-made. The critique of art is extended and certain 'conceptual' strat-egies are established in the advent of the monochrome painting and the 'anti-painting' of Francis Picabia; in the deployment of outrage; in the desire to fuse media; in the analysis of the relationship, or lack of it, between word and image; and in the exploration of the exhibi-tion as a spectacle.

17
Man Ray,
Gift,
1921.
Flat iron with
tacks;
h.15 cm, 6 in.
Private
collection

L'ŒIL CACODYLATE

Paul "Z" final DERMÉE

Tout le monde ont signé je signe Y. Moreau

Je m'appelle DADA depuis 1892 Milhau

Écrire quelque chose c'est bien!... Se taire: c'est mieux

J'arrive de la campagne Metzinger

MON ŒIL en DEUIL de verre

MARGUERITE BUFFET au tien

Picabia 3 Dda tel

je prête sur moi-même

G. Ribemont Dessaignes

Comprendre? S. Antoine Salvira

Couronne de mélancolie

VOUS REGARDE FATTY J. Crotti GOOD LUCK

moi, j'aime FRANCIS et germaine

Marcelle Evrard

IL FAUT MAIS JE NE PEUX PAS

VOILÀ JEAN HUGO

Parlez pour moi. I. Rigaut.

MOI = Je suis bête

Quand on me prend au dépourvu

Bonjour...

Suzanne Duchamp

C'est difficile

Se on mire

à Francis Picabia qui raconte des histoires

Gabrielle Buffet de nègre

peintre Roman-Schwatz

H. Jourdan-Morhange

non je ne signerai pas!

Dumoncel Sergent

MON COEUR BAT VALENTINE J. HUGO

René Blysée

VIVE AGAGA PANSAERS

PICABIA Te souviens tu de PHARAMOUSSE!

Le petit de Massot sourit AU GRAND PICABIA!

André Hazia

SOLEIL RUSSE

EXCELSZ

S. CHARCHOUNE

J. Povolozky

J'aime la salade

réveillez me toujours!

GERMAINE EVERLING

J'admire Léo Clarétuz

J'aime sans françoise sans

RENATA BORGATTI

"Études Picabia" par Maria de La Hire

LES CROISSANTS SONT BONS

je n'ai rien fait et je signe FRANÇOIS HUGO

JE ME TROUVE TRÈS

MICHEL CORLIN LE CUCULIN

ALICE HALARCON LA FLEUR

J'AIME PICABIA de tout son

J'aime Francis

J'aime...

FRANCIS PICABIA 1921

Hania Routchine

TRISTAN TZARA

Poulenc

The crisis in the picture reached a logical conclusion or climax in Russia in 1914 when Kasimir Malevich painted a black square. This was for him an absolute statement of pure painting, a springboard to the spiritual. In 1921, Alexander Rodchenko painted three mono-chromes in the primary colours: he saw them as demonstrations of pure paint. For him they represented a full stop to painting's history. Obviously, in both cases, knowledge of the artist's (verbal) intentions was and remains a prerequisite for understanding the work. For Rodchenko and other radical artists, this act of demystification left them free to explore new media and a new socially useful role for art and the artist.

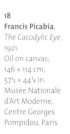

18
Francis Picabia,
The Cacodylic Eye,
1921.
Oil on canvas;
146 × 114 cm,
57½ × 44⅞ in.
Musée Nationale
d'Art Moderne,
Centre Georges
Pompidou, Paris

19
Benjamin Peret
insulting a priest.
Photograph in *La Révolution Surréaliste*, no.8,
1 December, 1926

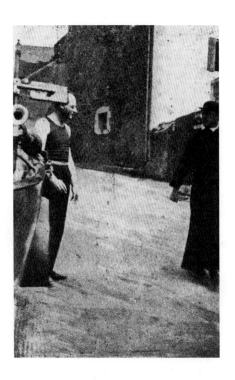

If Duchamp's *Fountain* is at once a deconstruction of sculpture and a sculpture, Picabia's *The Cacodylic Eye* (*L'Oeil cacodylate*; 18) is at once a deconstruction of painting and a painting. Picabia had a large canvas placed in his salon, with some pots of paint beside it. Everyone who visited him was asked to sign it or add something; so it was eventually covered with over fifty signatures, puns, doodles, aphorisms and an eye to look back at the bemused viewer. (The title

refers to a foul-smelling ointment that he was using for an eye complaint.) Shown at the 1921 Salon d'Automne it inevitably caused a scandal, one critic describing it as the 'wall of a public urinal' – what could be less like high art than graffiti? Picabia defended the painting on the grounds that art was all about choice: so he had a right to sign anything. 'Art is everywhere,' he protested, 'except with the dealers of Art, in the temples of Art, like God is everywhere, except in the churches.' That the work was a direct attack on painting and its pretensions to represent the unique, coherent vision and identity of the artist is shown by his disclaimer: 'Whereas I – as I have often said – am nothing, just Francis Picabia who put his signature to *L'Oeil cacodylate*, along with lots of other people who even extended their kindness so far as to put down a thought on the canvas!' The painting was not an expression of one personality, but rather a site where many people could meet.

The outrages initiated by Dadaists were deliberately extreme – they were meant primarily to shock. Tristan Tzara regularly appalled the dowagers of Zurich by asking them the way to the brothel. The Surrealist Benjamin Peret maintained this 'tradition' by publicly insulting Catholic priests in the street; a photograph of one such action appeared in the periodical *La Révolution Surréaliste* (19). This echoes the 'propaganda of the deed' – the random bombings and assassinations of authority figures by the more violent anarchists, whereby they sought both to show the rottenness of the system and to shock that system into crisis.

Outrage was a dismissal of the norm. Revolution was being called for in private and political life as well as in art. The Dadaist Hugo Ball, who had been initially an anarchist, flirted with various methods of transgression: drugs, sexuality. He tells in his diary how he kept the skull of a girl who had died a hundred years before and on which forget-me-knots had been painted, and how he wanted to have sex with her as much as with his girlfriend Emmy Hennings, or the Virgin Mary. Such a concatenation of blasphemy and necrophilia recalls the 1909 anarchist rising in Barcelona, when the convents were burned down and at least one male anarchist danced with the skeleton of a

long dead nun in the streets. This was carnival at its most grotesque and extreme: all the decorum and taste that maintains polite society was overturned. It was such a carnival, when the world is stood on its head, that the Dadaists wanted to initiate.

Some outrages were, at least superficially, polite. Picabia's *Portrait of a Young American Girl in the State of Nudity* (20), printed in his magazine *291*, was a sort of illustrative readymade. The drawing was similar to that one would find in a technical manual and the metaphor of the spark-plug as a woman was scandalous: she was hard, sharp, mechanical, but eternal. Her purpose in life was to 'spark', an obvious

20
Francis Picabia,
Portrait of a Young American Girl in the State of Nudity,
1915.
291, nos 5/6

synonym for either desire or orgasm. Like Duchamp or Ball, Picabia saw sexuality as pervasive, transgressive and contagious. The machine was a recurrent metaphor for the person in the work of Duchamp, Man Ray and Picabia, and a key element in their attack on the humanist view of art and culture, with its assumption that man and woman are inherently pure and 'spiritual'.

Both in rebellion against the domination of easel paintings and traditional poetry as separate art forms, and in rebellion against the bourgeois denial of the physical body, the Dadaists turned to perfor-

UNE NUIT D'ÉCHECS GRAS

PagE composée par Tristan TZara *

HIHIHIHIHIHIHIHIHI

Réclame pour la

VENTE DE PUBLICAtIONS dada

du 10 au 25 Décembre 1920

chez PovoLoZKY, 13, rue Bonaparte, Paris

• •

DA DA DADALINE DA DA DAASTE DADAPHONE DA DA DA DA CHOSE DADA

JÉSUS-CHRIST RASTAQUÈRE PAR FRANCIS PICABIA PARAIT AUJOURD'HUI

391 N° 6
2 Frs
New-York

mettez le Brodway à Besançon
et un petit parfum dans New-York
Saluez le timbre poste

391 N° 8
2 Frs
ZURICH
rose

feu économique
rose

l'art est mort

Picabia, Gabrielle Buffet Arp.
Tzara. Alice Bailly, Pharamousse
et le
VAGIN MYSTIQUE
de Zurich

Ne vous pressez pas
les 25 poèmes
de Tristan Tzara
sont
épuisés
Il ne reste que quelques
exemplaires sur hollande.
(tirage de 7 exemplaires)
A 150 Fr.

Vient de paraître : **HÉLAS**

Francis PICABIA

UNIQUE EUNUQUE

Préface par Tr. TZARA

COLLECTION DADA

Au Sans-Pareil, Paris : 3 fr. 50

La pierre s'exprime par la forme, et parfois la luminosité des
facettes, - vibration de l'air parcouru. Je hais la nature Picabia
n'aime pas le métier. Ses poèmes n'ont pas de fin, ses proses ne
commencent jamais il écrit sans travailler! présente sa person-
nalité, ne contrôle pas ses sensations. Pousse dans la chair des
organismes

FRANCIS PICABIA :
La Fille née sans Mère
4 Fr.

Pensées sans langage
3 Fr. 50

La parole fertilise le métal : bolide ou
urubu ouragan ourlé et
ouvert — il laisse dormir ses senti-
ments dans un garage. 3 Fr. 50.

IL Y A DADA ET DADA.

Un livre de GEORGES RIBEMONT-DESSAIGNES
est sous presse. — Lequel ? Ah !

Max Ernst, vous voilà célèbre.
Max Ernst, vous voilà célèbre
Max Ernst, vous voilà célèbre
et la horde des arrangés par

MAX ERNST

DIE SCHAMADE

Serner :

DERNIER DÉRANGEMENT
(Steegmann, Hannovre)
3 Fr.
manifeste Dada

L'AMOUR dans le Cœur

Parlez-lui de moi * *

Jne homme dessin. cub. ou tr. bureau
très bon. réf.
Tout le monde
collabore. Toute le
monde lit Tout
le monde mange.
Personne ne
vous met l'a-
mour dans le
cœur parlez-lui de moi. Lisez Canni-
bale. Le secret de Rachilde de Foch
de la Mercer les origines secrètes de
Dada-band. La tête sur le chapeau
Exempl. de luxe à 10 frs. Garantis.

N° 1 N° 2
1 Fr. 1 Fr.
Directeur : Francis
PICABIA

CANNIBALE

La Revue

BLEU

de Mantoue, courag-usement dirigée par
Cantarelli et Fiozzi va devenir l'organe dada italien
M™ Renée Dunan la célèbre philosophe, écrit que Dada
n'est pas une métaphysique mais une ypopsychie. Bleu
ouvre un concours pour la meilleure explication de
L'YPOPSYCHIE

! Je ne vous ! ELLE est LES
conseille pas épuisée exempl. de luxe
d'ACHET R coûtent 25 fr.
l'anthologie Dada

DIVORCE RAPIDE
90 à l'heure

Vient de paraître :
ALMANACH DADA
chez Erich Reiss, Berlin, coll.
Dermée Citroën, Picabia Mehring, Arp.
Huelsenbeck, Tzara. Heartfield.
Ribemont-Dessaignes Lacroix
d'Arezo Dermonières Hausemann
etc.

par Francis
PICABIA

JÉSUS-CHRIST RASTAQUÈRE

Chez POVOLOZKY 5 FR. 1000 exemplaires de luxe et un
seul sur papier ordinaire il y a un tirage spécial sur papier doux et
transparent pour décalquer la Sainte VieRge.

PROVERBE
Dir. c'œur : PAUL ÉLUARD
Tout le sel est dans tout. Partout caisse-on

MATCH

391
13
Achetez-le
dans votre
intérêt

II III III II III II III IX X XI XII XIII
I
II
III
IV
V
VI
VII
VIII
IX
X
XI
XII
XIII
XIV
XIV XIII XII XI X X IX VIII VII VI V IV III II I

CINÉMA CALENDRIER DU CŒUR ABSTRAIT

par TRISTAN TZARA
19 Bois par ARP
Collection Dada
tirage limité

10 exempl. sur Japon 150 Frs.
200 exempl. sur papier à la forme 25 Frs.

Adresser les commandes au " Sans Pareil"
37, Av. Kléber, Paris

Paul Bourget écrit sur ce livre :
Il faut absolument lire ce livre merveilleux

Henri Lavedan écrit sur ce livre :
Il faut lire ce livre. Tzara est un sinistre farceur

Henri Bo deaux écrit :
Il faut lire ce livre sur un champ de violettes

Picasso écrit :
Arp est le plus grand graveur sur bois

Anatole France écrit :
Tzara est un idiot, son livre un attentat aux mœurs

FRENCH CANCAN
RIO TINTO

MERCI
I LOVE YOU

Réclame
pour

moi
Tristan
Tzara

La solution de tous les mystères de
l'univers

Des recettes contre :
la famine,
la blennoragie
les indispositions de l'estomac cérébral,
le dadaisme de l'Académie Française,
les bordeis mai exploités,
la peste de Constantinople et les exposi-
tions de peinture de Paris.

Un écrivain pur n'a
pas de machine à écrire
il n'écrit pas un écrivain
mais un parfum

DADA 3
Fr. 1.50
Edition de Luxe
20 Fr.
Occasion, Situation, Expropriation

BRAVO ! DADA !

ARP :
La Pompe à nuages
(Steegmann Hannovre
3 Frs
voici le célèbre Arp
le voici venir
voici le célèbre Arp
le voici venir venir venir

DADAPHONE
Prix 1 fr 50

messieurs mesdames achetez entrez achetez et
ne lisez pas vous verrez celui qui a dans ses
mains la clef du magere l'homme qui boite
dans une boite les hemisphères dans une va-
lise la mer mélodrame dans un lampion chinois
vous verrez vous verrez vous verrez la danse
du ventre dans la seringue de massachussets
vous verrez de près et le peau se dégonfle
les bas de soie de mademoiselle attendue la
malle qui fait 6 fois le tour du monde pour
trouver le destinataire monsieur et sa fiancée
son frère et sa belle-sœur vous trouverez l'a-
dresse du monsieur la montre à crapauds le
nerf en voyge papier vous aurez l'adresse de
celui qui fournit les photos obsédan au roi sinon
que l'adresse de l'action française

J. EVOLA
ARTA ASSTRATTA
Collection DADA. ROME. 2 Frs.
Théorie Poésen, dessins.

Bulletin Dada
2 Frs 2 Frs

2 Frs 2 Frs 2 FR 2 fr 2 FR 2 FR
2 Frs 2 Frs 2 frs 2 FR. 2 FR. 2 fr
2 fr. 2 Fr. 2 FR. 2 Fr. 2 Fr. 2 fr.
collaborateurs collaborateurs col-
laborateurs Ribemont Ribemont
Ribemont Picabia. Eluard Elu-
ard Eluard, Picabia Serner Serner
Bre'on Breton Serner Breton Tzara
Dermée Dermée Aragon Soupault
Aragon Jacques Edwards Aragon
Aragon Arp Picabia Schad Arp Arp

An object is not so attached to its name that one cannot find another for it which suits it better:

An image can take the place of a word in a statement:

Any shape whatsoever may replace the image of an object:

There are objects which do without a name:

An object can make one think that there are other objects behind it:

An object never performs the same function as its name or its image:

A word sometimes only serves to designate itself:

Everything tends to make one think that there is little relation between an object and that which represents it:

The visible contours of objects in reality touch each other as if forming a mosaic:

21
Tristan Tzara,
A Night of Fat Chess,
391, no.14,
November 1920

22
René Magritte,
Words and Images (detail),
1929.
La Révolution Surréaliste,
vol. 5 no.12,
December 1929
(translated from the original French)

An object meets its image, an object meets its name. It happens that the image and the name of that object meet each other:

Words which serve to designate two different objects do not show what may distinguish those objects from one another:

Vague figures have a meaning as necessary and as perfect as precise ones:

Sometimes the name of an object takes the place of an image:

In a painting words are of the same substance as images:

Sometimes, names written in a painting designate precise things, and images designate vague things:

A word can take the place of an object in reality:

One sees images and words differently in a painting:

Or, indeed, the contrary:

mance and cabaret where such art forms were combined. Only to see or hear was to be alienated from the whole body and the multiplicity of pleasures it offered. They demanded simultaneity and ecstasy rather than the refinement of one sense in isolation. 'On the stage of a gaudy, motley, overcrowded tavern are several weird and peculiar figures representing Tzara, Janco, Ball, Huelsenbeck, Hennings, and your humble servant,' wrote Hans Arp of an evening at the Cabaret Voltaire in 1916. 'Total pandemonium. The people around us are shouting, laughing, and gesticulating. Our replies are sighs of love, volleys of hiccups, poems, moos, and the miaowing of medieval *Bruitists*. Tzara is wriggling his bottom like the belly of an Oriental dancer. Janco is playing an invisible violin and bowing and scraping. Madame Hennings, with a Madonna face, is doing the splits. Huelsenbeck is banging away nonstop at the great drum, with Ball accompanying him on the piano, pale as a chalky ghost.'

A fusing of media, both literary and visual, was also to be found in the magazines of Dada. In these, the typography became more and more dislocated, ruptured and outlandish (21). They were an attempt to make a visual/verbal equivalent of the simultaneous perfor- mances at the Cabaret Voltaire, as well as overturning the authority of traditional typography and layout. At the heart of Dada was an implicit critique of language as supposedly transparent. This contin- ued in Surrealism, though often in a less urgent and contrary way. What was once angry has now become style. The Belgian René Magritte's *Words and Images* (22), printed in *La Révolution Surréaliste* in 1929, is a more subtle deconstruction of the relationship between language and representation, typical of the more ironic attitude of Belgian Surrealism.

23
Marcel
Duchamp,
*First Papers of
Surrealism*
exhibition,
1942. Whitelaw
Reid Mansion,
New York

Dada was notable also for its attacks on the nature of the exhibition. When, in 1919, the German artists Max Ernst and Johannes Baargeld were invited to show at the Cologne Kunstverein, they were con- signed, once the director saw the nature of their recent work, to a separate room. They therefore included not only their own work but also that of Sunday painters and children – not to mention such '*objets d'art*' as an umbrella, a piano hammer and African sculptures.

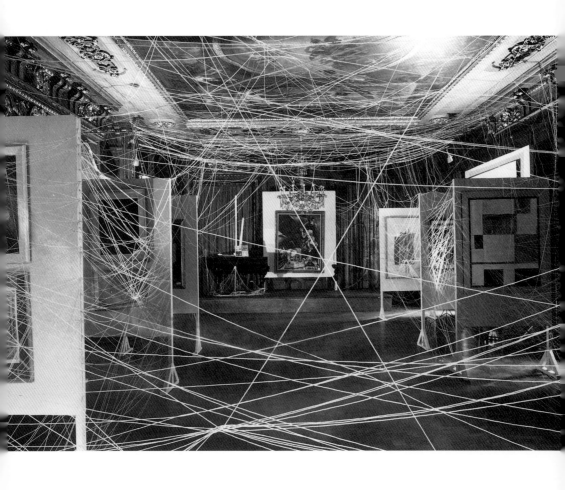

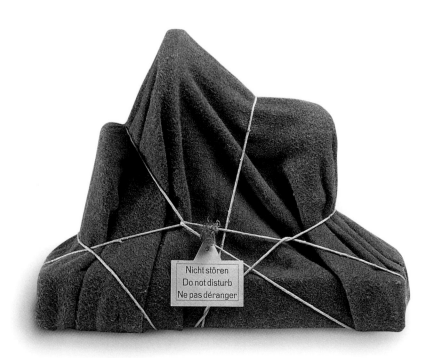

24
Man Ray,
*The Enigma of
Isidore Ducasse,*
1971
reconstruction of
1920 original
(now destroyed).
Sewing machine
wrapped in
blanket with rope;
h.45 cm, 17³⁄₄ in.
Museum
Boymans-van
Beuningen,
Rotterdam

25
**Meret
Oppenheim**,
*Fur Covered Tea
Cup, Saucer and
Spoon,*
1936.
h.7·3 cm, 3 in.
Museum of
Modern Art,
New York

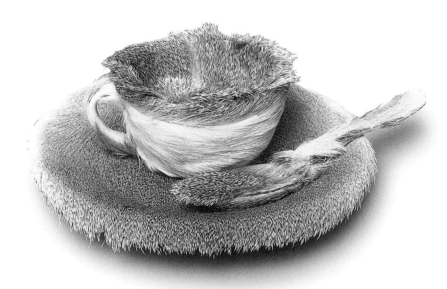

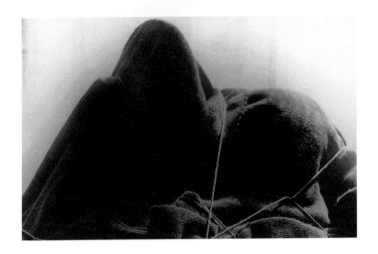

The staging of the exhibition, rather than any of the individual elements, had become the artwork. Similarly, in 1920, Ernst and Baargeld, having had their work removed from a supposedly open exhibition, rented a courtyard partly covered by a glass roof at the Brasserie Winter in Cologne. It could be reached only via the men's toilet. Those who ventured in were invited to destroy anything they didn't like. This was an inversion of the bourgeois exhibition. It demanded the active involvement, rather than passive meditation, of the viewer, and it mocked the authority of the artist. Fellow Dadaists John Heartfield and George Grosz had announced in 1919 that, 'The name of "artist" is an insult. The denomination "art" demolishes equality between men.'

The Surrealists extended this deconstruction of the bourgeois exhibition, making a burlesque of it with outrageous spectacles, prefiguring the attention that later Conceptual artists would pay to the way art was exhibited and experienced. The most elegant of these exhibitions was probably the *First Papers of Surrealism* in 1942 (23), when Duchamp unravelled a mile of string between all the works on show, obstructing the viewer's passage and view, literally tying the exhibition together and making the exhibition itself the artwork.

The readymade became the 'Surrealist object'. In Surrealism the poetic allusion or the sexually fetishistic was generally emphasized. Symptomatically, André Breton, the 'Pope of Surrealism', cited Man

Ray's photograph of his readymade *The Enigma of Isidore Ducasse* of 1920 (26), as an instance of pure Surrealism. Based on an image by the Symbolist poet Lautréamont (whose pseudonym was Isidore Ducasse), 'lovely as the fortuitous encounter on a dissection table of a sewing machine and an umbrella', this wrapped and bound sewing machine (24) had an air of mystery very different from Duchamp's ontological paradoxes. Meret Oppenheim's *Fur Covered Tea Cup, Saucer and Spoon* (25), with its suggestion of cunnilingus, its simultaneous play on the familiar, the sensual and perhaps the shocking, is another classic example of this more illustrative type of readymade.

The Surrealists knew Freud's writings well. In his essay 'The Uncanny' he suggested why objects can hold strange and disturbing meanings. Objects and places seem to have their own 'language' and history. This was, as Breton put it, 'the crisis of the object', sexualized, made strange, taking us back to our past and our fantasies. However, the Surrealist understanding of the uncanny was, we may argue, a crude one: their objects illustrated the uncanny, rather than being, by an act of displacement, *ipso facto* strange. In making their context – which had seemed so comfortable and familiar – unfamiliar, it is Duchamp's readymades that truly enact the uncanny. As Freud himself said, in seeking to develop and challenge the definition of the uncanny with which this chapter is prefaced, the uncanny is in fact rooted in the displacement and repression of what was once familiar. The *unheimlich* (unhomely) is paradoxically disturbing because it is *heimlich*, homely. The uncanny was not to be found in the exotic, but in the everyday.

Duchamp expressed both the necessity for Dada and its inability to develop when he remarked in 1946 that 'Dada was an extreme protest against the physical side of painting. It was a metaphysical attitude. It was intimately and consciously connected with "literature". It was a sort of nihilism to which I am still very sympathetic. It was a way to get out of a state of mind – to avoid being influenced by one's immediate environment, or by the past: to get away from clichés – to get free. The blank force of Dada was very salutary. Dada was very serviceable as a purgative. And I think I was thor-

oughly conscious of this at the time and of a desire to effect a purgation in myself.'

Attitude was perhaps as important in the moment of Dada as the various strategies that it helped to initiate. When Breton organized a Dada trial of the writer Maurice Barres (a one time socialist turned patriot) in 1921, Picabia left the 'movement'. In a statement to the press, he said, 'Dada had been about a spirit of freedom and liveliness, but now it was a success, it was just a movement like Cubism. Now Dada has a court, lawyers, soon probably police ... I do not like

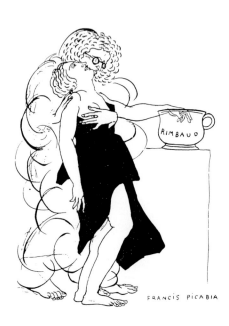

FRANCIS PICABIA

27
Francis Picabia,
Breton and Initiate at the Cup of Rimbaud,
1924.
391, no.16

28
Marcel Duchamp,
The Bride Stripped Bare by her Bachelors, Even (Large Glass),
1915–23.
Oil and lead wire on glass;
277·5 × 175·6 cm,
109¼ × 69⅛ in.
Philadelphia Museum of Art

illustriousness, and the directors of *Littérature* are nothing but illustrious men. I prefer to walk at random, the name of the streets matters little, each day resembles the other if we do not create subjectively the illusion of something new, and Dada is no longer new.' Picabia carried on a campaign of abuse against Breton, especially after he founded the Surrealist group. To Picabia, Surrealism was a misappropriation of Dada by a bunch of pedantic bores. 'André Breton is not a revolutionary,' fulminated Picabia, 'he is an *arriviste*!' In one caricature from his magazine *391* (which succeeded *291*) Picabia showed Breton wearing a judge's wig, leading a devotee to a cup

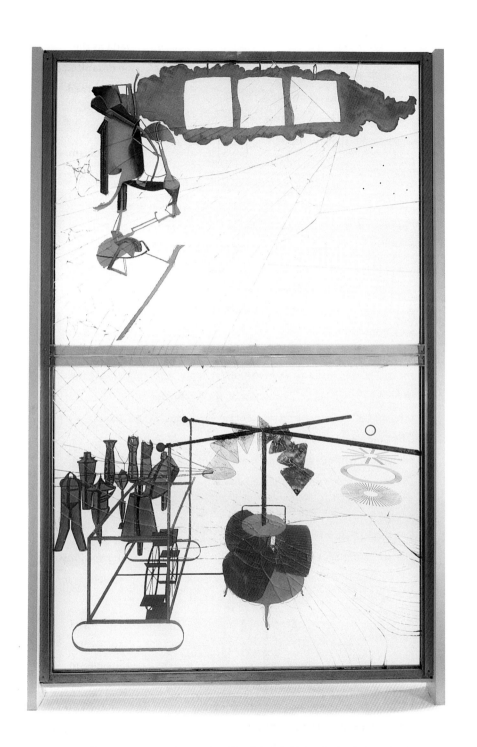

(actually a chamberpot) entitled 'Rimbaud', groping her as he does so (27). The implication is clear: Surrealism is just a return to the left-overs of nineteenth-century poetry, its leader a hypocritical lecher. It is impossible here to summarize Duchamp's career after *Fountain*, but in all his activities, whether as chess theorist, art dealer, wit or curator of his own work (especially in the *Boîte-en-valise – Box-in-a-Suitcase*, which contained reproductions or miniatures of sixty-nine of his works, the whole opening out to create an entire Marcel Duchamp museum in miniature), it is his laconic questioning attitude that is key. From 1915 to 1923 a good deal of his time was taken up with one single piece of work, *The Bride Stripped Bare by her Bachelors, Even*, normally referred to as the *Large Glass* (28). In so far as this sought to be a total and self-enclosed artwork it is arguably not really a piece of 'Conceptual art'. But the notes Duchamp made for it were to be more fruitfully provocative. Sixteen of these short, elusive hand-written notes were photographed and published in an edition of three in 1914 (*The White Box*). Importantly, they were published as an artwork, a limited edition, each note on a separate sheet of paper, in a box, rather than as a book. Arguably, words are being published here as visual art. In 1934, a further ninety-four of these notes, drawings and photographs were published in facsimile (*The Green Box*). His thoughts about the *Large Glass* were thus presented, without embarrassment, as art in their own right. These notes vary from the philosophical paradox:

[see]
One can look at seeing;
one can't hear hearing.

to the instructional:

hook

falling from the top of the bachelor apparatus take a hook – considerably enlarged. and functioning in the basement – which it enters through 2 holes. placed between the glider and the grinder

Presciently, the concepts that will lead to the manufacture of the work are displayed as art in their own right.

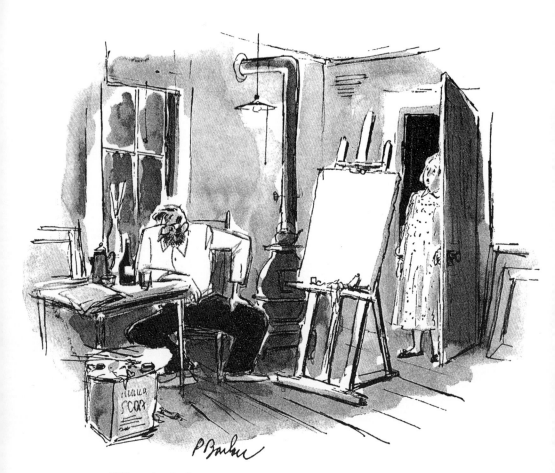

"Time for bed, Anton. You've suffered enough for one day."

Well I'm writ'n a lil' letter, goin' to mail it to my local DJ,

Yes, it's a jumpin' lil' record I want my jockey to play,

Roll over Beethoven! I got to hear it today.

Chuck Berry, 'Roll over Beethoven', 1956

Man must be everyday, or he will not be at all.

Henri Lefebvre, *The Critique of Everyday Life*, 1947

After World War II, there was little appetite for a radical art that
questioned or mocked traditional assumptions, especially in Europe.
Rather, there was an audience eager for what were believed to be the
healing and civilizing powers of the visual arts, particularly the long
accepted genres of painting and sculpture. Because of this, because
of the postwar hunger for material culture and because the logic
of Modernist painting had still to be played out, the art world was
dominated by painting for the fifteen years after the war. Whether it
was the figurative work of Francis Bacon or the Abstract Expression-
ism of Americans like Willem de Kooning, Jackson Pollock and Mark
Rothko, this was a painting confident in its ability to convey candidly
the tragic, sublime or spiritual. Characteristic of the paintings and
painters of this period, on both sides of the Atlantic, was earnestness,
the exact opposite of the playful spirit of Duchamp or Picabia. A
cartoon from the *New Yorker* magazine (29) represents the mood
precisely: an artist, inevitably male and bearded, sits in his studio,
down at mouth; his wife has opened the door, cheerily calling to him,
'Time for bed, Anton. You've suffered enough for one day.'

René Magritte's *Vache* or 'cow' paintings, so-called because a friend
of the artist likened them to cowpats, were a wonderful exception to
this earnestness (31). Having secured a one-man show in Paris in
1948, he set out to offend good taste as much as possible: the
paintings were filled with parodies of Modernist art, cartoon-book
jokes and apparently incompetent handling. Colours seemed

29
Perry Barlow,
Cartoon in the
New Yorker,
March 1955

arbitrarily applied: noses and skies were painted in tartan patterns; pipes sprouted from men's heads like carbuncles, there was an earthy sexuality. Breton had referred to Magritte's work, the year before, as being like that of a backward child who wanted always to be cheerful; so this was also a case of winding up 'the Pope of Surrealism'. The exhibition was a great success: the Parisians hated it and nothing sold.

Such ironic or conceptual painting was rare. Nevertheless we shall look at a number of groups of artists in this chapter, which, in their various ways, both opposed the tyranny of painting at its most po-faced and pompous, and bore witness to the possibility of a self-critical art: Gutai, Cobra, the Lettristes, the Nouveaux Réalistes, the Situationists and individuals such as John Cage, Robert Rauschenberg, Ad Reinhardt, Yves Klein and Piero Manzoni. Some sought to revive the ideas of Duchamp and Dada, taking a radical approach to form and questioning the status of the object – though all too often this would slide back into a more conformist and gallery-friendly art than its model. Some sought to redefine the role of art, as one not of making objects, but of giving experiences, and asserted the everyday as the subject of art, rather than the aesthetically rarefied. We see the first attempts to 'dematerialize' the art object and witness a continuing investigation of the exhibition as a phenomenon in itself. On occasion, too, we see a desire by artists to make art respond directly to this most politically confrontational of periods.

The Cobra group (the letters stand for Copenhagen, Brussels and Amsterdam) was founded in 1948 by, among others, Constant (Constant Anton Nieuwenhuys), Christian Dotremont and Asger Jorn, and is best known today for paintings in vibrant colours (30), with imagery from the art of children or the insane. But there were other equally important aspects to their work: the attempt to fuse text and image, the use of the readymade and the attempt to create a new social function for art. Their first exhibition at the Stedelijk Museum in Amsterdam included not just sculptures and paintings, themselves often placed on the floor or very high on the wall, but also

30
Asger Jorn,
Mati,
1950–1.
Oil on canvas;
91.4 × 73.3 cm,
36 × 28⅞ in.
Gemeente-
museum,
The Hague

31
René Magritte,
The Cripple,
1947.
Oil on canvas
mounted on
panel;
60 × 50 cm,
23⅝ × 19⅝ in.
Galerie
Christine et
Isy Brachot,
Brussels

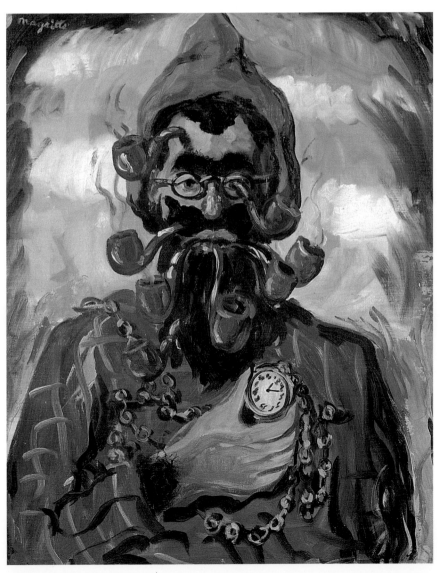

books and objects. At an exhibition, *The Object through the Ages*, which they organized in Brussels in 1949, nothing was displayed but writings and everyday objects. Dotremont exhibited potatoes in a glass case. He pointed out that whereas Duchamp's readymades were 'just as exhibitable as when exhibited for the first time, potatoes are perishable and need replacing and anyone has the right to replace me as *author* in order to exhibit *them* today.'

Such a concern with everyday objects and life shows the influence of a book by the Marxist philosopher Henri Lefebvre, *The Critique of Everyday Life*, which was published in 1947. In this, Lefebvre attempted to extend Marxist theory by showing that it was not just economics but everyday life that revealed alienation. Society had developed from a primitive state, in which man lived at one with nature and his community, to one where, because of master–slave relations and the commodity status that capitalism puts on objects, he is alienated from nature, society, work, everyday life and, above all, himself and his body. Lefebvre believed that we could overcome alienation only if we made a critique not only of economic and power structures, but also of everyday life and things: where, as with Dotremont, even potatoes could become revolutionary. The goal of Marxism for Lefebvre was 'the transformation of life in its smallest, most everyday detail'. 'The end, the aim,' he wrote, 'is to make thought – the power of man, the participation of man, the partici-pation in and the consciousness of that power – intervene in life in its humblest detail … the aim is to change life, lucidly to recreate everyday life.' It is not surprising that these ideas were viewed with suspicion by the Stalinist French Communist party (who were to prevent the publication of Lefebvre's next book), but were extremely appealing to artists, anarchists and others who were primarily interested in a transformation of the self.

The Lettriste group also avoided traditional forms, wanting, like the Dadaists, to fuse the media. Their original intention to unify poetry and music by emphasizing sounds, soon changed to that of unifying poetry and visual art by the painting of letters or visual units. In fact, Lettriste paintings from the 1950s tend to be a stew of calligraphy,

ideograms and gestural marks. Their work even extended to printing textiles and clothing with Lettriste motifs (32). Of much greater interest are their films, in which they attacked or exposed the conventions of the cinema. Isidore Isou's 1951 movie *The Drivel on the Eternity Treatise* included footage that was scratched and torn, while the soundtrack was out of sync. It was painfully obvious that one was watching a film. In other films chairs were hung over the screen, letters were written on the actual filmstock, or the soundtrack included spectators' conversations. The most infamous of all Lettriste films was Guy Debord's 1952 *Howls in Favour of Sade*, where monochrome black alone was projected onto the screen with no accompanying sound track; periodically this blackness would be interrupted by a short burst of white light, accompanied by desultory dialogue. For the last twenty-four minutes nothing was seen but uninterrupted blackness, nothing was heard save the clicking of the projector. Debord's film and those he made subsequently were less about privileging the word over the image, as Isou's were, than about forcing the viewer to become an active participant, not just a passive consumer.

Lettrisme had begun with a violent demonstration in 1946, when Isou and others had interrupted the performance of Tristan Tzara's play *Flight* to declaim their own wordless poems. It is appropriate, therefore, that the Lettriste movement was split by another such manifestation. In 1952, Guy Debord and several radical Lettristes invaded a press conference given by Charlie Chaplin (darling of the Surrealists) to denounce him as a hypocrite, who feigned empathy with the poor but did nothing for them, and to force inflammatory leaflets on the assembled bemused journalists. Isou promptly denounced them. They then denounced him in turn, as a mere aesthete, and went off to found their own movement, the 'Ultra-Lettristes'. These recurrent 'outrages' reveal both a disbelief in cultural icons and a desire to turn the demonstration into a perverse art form. Two years earlier a young man, Michel Mourre, dressed as a Dominican friar and accompanied by two more Lettristes, had inveigled his way into the cathedral of Notre Dame in Paris during the Easter mass and read out a blasphemous sermon, denouncing

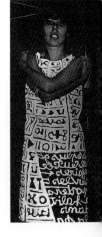

32
Michèle
Hachette
wearing
Lettriste dress,
1966

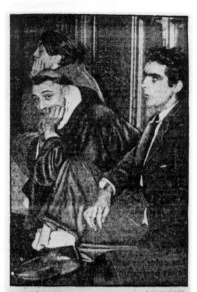

Trois malades?
Trois goujats?
Trois héros?

Cette page est faite pour vous permettre de fixer votre opinion sur le geste de Michel Mourre, 21 ans (faux dominicain), Serge Bernard et Ghislain Desnoyers de Marbais, que l'on voit ici réunis après le « scandale » sur le banc du commissariat du quartier Saint-Gervais.

the Catholic Church, to the outrage of the congregation (33).

Such confrontation was not the way of the American John Cage, who had already become known as an experimental composer by the end of the 1930s. After discovering Zen Buddhism, he began to use chance and the *I Ching*, the ancient Chinese book of divination, in his music. Just as the Minimalist sculptor Donald Judd would, much later, attack the European tradition for its supposed obsession with composition, so Cage rejected its apparent obsession with hierarchy, both in form and achievement. He denied that certain composers were sacrosanct. Like Chuck Berry, in the quotation that opens this chapter, he took special exception to the deification of Beethoven. In 1952 at Black Mountain College, an experimental liberal arts college in North Carolina, he initiated, with the help of painter Robert Rauschenberg, dancer Merce Cunningham, poet Charles Olson and pianist David Tudor, the first of what were subsequently described as 'Happenings'. In the same year Tudor premiered Cage's *4' 33"*, ostensibly a piano sonata in three movements, in which the pianist, having sat down at the concert piano, lifted his hands as if to begin, then twice more lifted his hands during the duration of four minutes and thirty-three seconds, as if beginning subsequent movements – but never a note he played. This was not a joke or insult, though many of the audience took it as such: after the first embarrassed shuffling of feet, the audience, if they were prepared to, could detect far-off bird songs or cars travelling or wood creaking – silence was surprisingly noisy. Cage was asking people to listen to the sounds that were all around them, at all times. Nothing could be everything, if only one's attitude was right. 'Let sounds be themselves,' he said – all noises were potentially music. Likewise, Merce Cunningham treated all movements of the body as potential dance movements. From 1951 on, he also used chance to determine his choreography: his dancers would move all across the stage, like molecules in flux (34), not concentrating on centre stage, as in traditional ballet. Cunningham saw such a concentration as having an unpleasant association of class and hierarchy, as in the distinction between principal dancers and the corps de ballet.

33
'Three mental cases? Three boors? Three heroes?' Michel Mourre (centre) with Lettriste poets Ghislain de Marbaix (left) and Serge Berna (right) in police custody following the Notre Dame demonstration, *Combat*, 12 April 1950

34
Walkaround Time, 1968. Choreographed by Merce Cunningham with set design by Jasper Johns after Marcel Duchamp's *Large Glass*

ERASED de KOONING DRAWING
ROBERT RAUSCHENBERG
1953

Cage described music as 'purposeless play', but 'this play is however an affirmation of life – not an attempt to bring order out of chaos, nor to suggest improvements in creation, but simply to wake up to the very life we're living, which is so excellent once one gets one's mind and desires out of its way and lets it act of its own accord.' At the root of his attitude was a Utopian belief that people could be free, could 'have their own lives rather than lives that society has given them second hand'. This may sound similar to Lefebvre, but Cage was a quietist: he saw no need for political change, whereas it was crucial to Lefebvre's argument. Cage was opposed to quality or value judgements, more than once angrily rebutting an interviewer, 'Why do you waste your time and mine by trying to get value judgements? Don't you see that when you get a value judgement, that's all you have? They are destructive to our proper business, which is curiosity and awareness.'

Robert Rauschenberg's early work had been heavily influenced by Abstract Expressionism, but by 1953 he was making unmodulated white paintings. Aware that these would get dirty, Rauschenberg arranged in later years for a studio assistant to repaint them. Whereas the touch of the artist was crucial to Abstract Expressionism, what was important here was not how they were painted, but what they revealed: as Rauschenberg observed, 'they had to do with shadows and projections of things onto the blank whiteness.' John Cage referred to these white paintings as 'airports for the lights, shadows and particles'.

In the same year Rauschenberg approached Willem de Kooning, an artist whom he especially admired, and told him that he would like to make an artwork in reverse, that is, by rubbing it out. De Kooning agreed, but gave him a very heavily worked drawing, so that he too would have to labour hard. What are we left with after the six weeks that it allegedly took Rauschenberg to rub it out (35)? Was this a satire of gestural painting and its earnestness? Is it just a joke that we now see enclosed in a gold frame? The symbolic erasure of the artistic father figure? Is it a ghost of a De Kooning drawing or a completed Rauschenberg drawing? Could an act of apparent

destruction be creative too? The answers can only be ambivalent. When in 1957 the critic Leo Steinberg telephoned Rauschenberg to discuss the *Erased De Kooning Drawing*, of which he had heard rumours, he asked if he would appreciate it more if he actually saw it. Rauschenberg thought not. 'This was,' Steinberg wrote, 'my first realization that art could take on this new modality, spinning like a satellite through consciousness, rather than being physical fact.' Nevertheless, Rauschenberg thought enough of the drawing to put it in a gold frame.

The most trenchant critic of gestural painting and its pretensions was himself a painter – one often mistakenly referred to as an Abstract Expressionist – Ad Reinhardt. In a series of essays from 1952 onwards he emphasized the tautological nature of art: 'The one thing to say about art is that it is one thing. Art is art-as-art and everything else is everything else. Art-as-art is nothing but art. Art is not what is not art.' As a painter, his work, which was always geometric rather than gestural, became increasingly monochrome. By 1960 he had embarked on what he saw as the ultimate paintings (36): 152 × 152 cm (60 × 60 in) canvases, which seemed uniformly black, but which – were one to look sufficiently long – revealed a cruciform composition. Each painting was in fact composed of nine squares of near black. He was paradoxically both rehearsing the end of painting and purifying it by getting rid of all illustrational elements. This then was a fully reflexive art, as were the earliest monochrome paintings, made by Kasimir Malevich and Alexander Rodchenko in Russia.

There was another important side to Reinhardt. He made cartoons for socialist magazines and cartoons about the art world. In one (37), a little man wearing a trilby points at an abstract painting and jeers, 'What does this represent?' Below, the painting sprouts legs and a pointing finger and shouts at the surprised man, 'What do you represent?' The play here is on two meanings of the word 'represent'; it is implied that the man must represent a political and ethical position. For Reinhardt true art necessitated moral integrity. Aesthetic detachment and political engagement were not incompatible.

36
Ad Reinhardt,
Abstract Painting No.5,
1962.
Oil on canvas;
152·4 × 152·4 cm,
60 × 60 in.
Tate Gallery,
London

37
Ad Reinhardt,
'What do you represent?',
1945.
Detail from
How to Look at a Cubist Painting,
P.M.,
27 January 1946

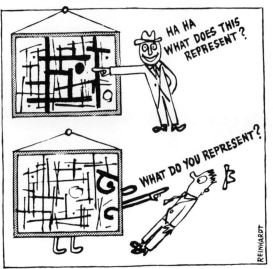

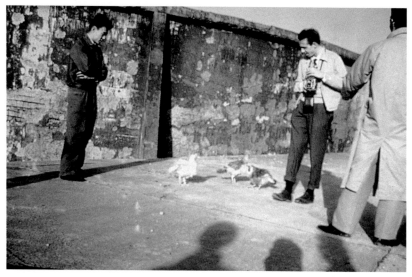

In contrast, the Gutai group in Japan sought aesthetic engagement and political detachment. Gutai was founded in 1954 in Osaka by Jirō Yoshihara, who was already well known as an abstract painter. Yoshihara's main intent was to create a new, vital and radical art, in opposition to the second-hand academic abstraction or social realism being made elsewhere in Japan, especially in Tokyo. The works exhibited at the Gutai open-air exhibitions of 1955 and 1956 in Osaka were certainly provocative. Yoshihara, however, all too aware that Japanese Dada had been banned in the 1920s because of its left-wing affiliations, avoided any overt political reference. In one exhibition Atsuko Tanaka fixed a 10 m square (over 30 ft) of pink rayon just above the ground so that it rippled in the breeze. Sadamasa Motonaga hung transparent containers filled with coloured water from the trees (38) – he said that he wanted to make art with rain. Akira Kanayama's 1,500 m (almost 5,000 ft) line of white vinyl marked with footsteps wended through the exhibition finally ending at a tree: should one follow the footmarks and climb the tree? When, in 1956, journalists from *Life* magazine came to see the group, they obligingly mounted a one-day exhibition, which included a work by Yoshihara consisting of three hens painted red, green and yellow (39) – a truly living work of art. The editors had of course been looking for an amusing story, but this was too outrageous and they refused to publish it.

The Gutai artists were not only inviting the viewer to be a participant in art and nature, but also inviting nature to make the work itself. Yoshihara commented that 'what we are trying to do is forge direct links with the earth and to yield to natural conditions, such as the sun, the wind and rain'. Such ecological intentions were to be symptomatic of much later art in the West: Kanayama's walk prefigures those of Stanley Brouwn and Richard Long (see chapters 3 and 4).

Why, however briefly, had such a radical movement happened in Japan, where art had been aping Western models with such slavish reverence? We might relate it to a collapse of belief in received wisdom and traditional authority after the humiliations of World War II. Equally, in questioning the nature of art, these artists were

38
Sadamasa
Motonaga,
Water,
1956.
As reconstructed
for the 1987
Venice Biennale
(Akira
Kanayama's
Footprints is
also visible)

39
Jirō Yoshihara,
Painting Cocks,
9 April 1956.
Performance at
Amagasaki, near
Ashiya

playing on the fact that before the mid-nineteenth century, when Japan was first forced to open up to trade with the West, there was no Japanese word for art as a separate and autonomous concept. Gutai promised an art that was not autonomous, but more integrated with nature and lifestyle than was possible in Western Modernism. In the halcyon, early days before its members returned to making gestural paintings in the Western style, Gutai was an art of the 'everyday', as much as a new 'high' art.

No one was less concerned with the political or the everyday than the Frenchman Yves Klein. He was a charismatic figure, a strange mix of the mystic and the charlatan. His schoolfriend, the artist Arman, reports Klein as saying, 'the blue sky is my first artwork', and signing it in 1948. (Quite where or how he actually signed it remains unclear.) The major element of his artistic production was monochrome paintings, especially in blue (40). He was to patent the particular pigment he used for the blue monochromes as International Klein Blue in 1960. Yet in a sense these were anti-paintings: his parents had been painters and he detested the mystique of the medium. To avoid the 'artist's touch', he sprayed the pigment on to the canvas or on to sponges which he attached to paintings or exhibited as sculptures.

Blue was the colour of the sky, or of the spirit, as he had learned from the mystical cult of Rosicrucianism. It offered liberation: 'Through colour, I experience a feeling of complete identification with space, I am truly free.' The goal of his work was the immaterial, 'I want to create work which will be spirit and mind.'

Klein had been present at the première of the film *Howls in Favour of Sade* and Debord, who viewed Klein's mysticism with scorn, claimed that his film, with its continual monochrome, had given Klein the idea for his paintings. But Klein's intention was radically different to that of Debord.

For his exhibition *Le Vide* (*The Void*) at the Iris Clert Gallery in Paris in 1958, Klein created a 'void' – or 'zone of invisible pictorial sensibility' – by removing all the furniture and painting the walls white.

40
Yves Klein, Untitled blue sponge sculptures and blue monochrome bas-reliefs, 1957–61. As exhibited at the *Leap into the Void* exhibition, Hayward Gallery, London, 1995

Before they entered, visitors to the private view were given a blue cocktail (made from gin, Cointreau and methylene blue), as a result of which they would urinate blue for days afterwards. In dematerializing the art object he was, unlike Duchamp, not seeking to demystify it, but rather to re-mystify it. His ambitions continued: in 1960 he claimed to have leapt or flown, that is, literally to have entered the void. To prove this, he performed the leap again for the benefit of a photographer (42). The photograph is, unsurprisingly, doctored: a dozen judo students had stood below holding a tarpaulin for him to land in.

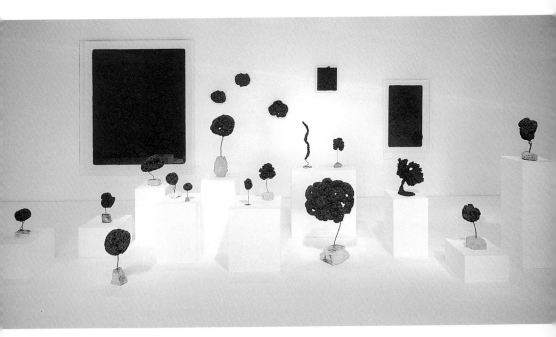

Both because of his zeal for publicity (witness the newspaper that he produced, albeit only for one day, devoted solely to his own exploits; 41) and his charisma, the message of Klein was dispersed widely. He exhibited or performed on both coasts of the United States, as well as throughout Europe. One particularly famous exhibition was held in Milan in 1957, when he exhibited eleven identical blue monochrome paintings, each held away from the wall on a rod, so as to emphasize its materiality, and each priced differently according to its specific 'pictorial sensibility'.

Conceptual Art

41–42
Yves Klein,
*Dimanche – Le
journal d'un
seul jour*,
27 November,
1960, featuring
the photograph
of his leap into
the void

Klein has often been associated with the Nouveau Réaliste group. On 27 October 1960 the critic Pierre Restany met Arman, Daniel Spoerri and other artists who worked with urban junk or torn-up posters, at Yves Klein's flat, and the Nouveaux Réalistes were officially founded. Their work, together with the early work of Robert Rauschenberg and Jasper Johns, has been characterized as neo-Dada. The installations and Happenings of Allan Kaprow, and the objects made by the Fluxus group (see Chapter 3), have also been enlisted under this banner. Restany had written what was to serve as the Nouveaux Réalistes' manifesto earlier in the year: in defiance of belief in the 'eternal immanence of certain noble genres and of painting in particular', they turned to what they described as a sociology of the world that was being created around them, whether it be 'the tearing up of posters, of the allure of the object, of the household rubbish or the scraps of the dining room'. This was 'the passionate adventure of the real perceived in itself and not through the prism of conceptual or imaginative transcription'.

Behind Restany's purple prose, this sounds remarkably like another attempt, like that of Lefebvre, to overcome our alienation and reconnect with the physical world, but the manifesto lacks the demand for political and social change. In fact, it consciously rejects 'aggressivity'. It is far closer to John Cage's apolitical, Zen-influenced philosophy of acceptance. The subsequent activities of these artists

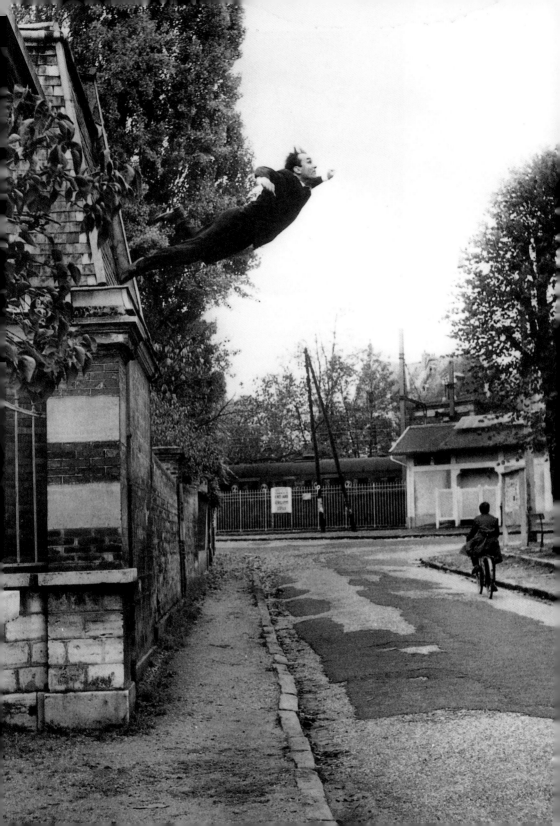

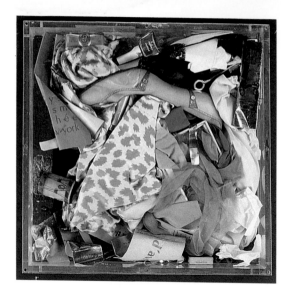

43
Arman,
*Identikit Portrait
of Iris Clert*,
1960.
Personal effects
and objects under
plexiglas;
41 × 42 × 8·5 cm,
16¹⁄₈ × 16¹⁄₂ × 3³⁄₈ in.
Galerie
Beaubourg, Vence

certainly show them as being in love with their world: pranksters,
rather than critics of the commodity system. Klein was included in
the group (what interest did he have in urban detritus?) partly
because he was a close friend, but partly because the aura of
charming, but utterly fake spirituality that he cast upon the world
was akin to what they sought.

Perhaps the quintessential Nouveau Réaliste exhibition had opened
four days before the founding of the group: *Le Plein* (*Full Up*) by
Arman at the Iris Clert Gallery. This consisted of as much junk, found
by the artist in the street, as could be crammed into the gallery. It was
the perfect counterpoint to Klein's exhibition *Le Vide*. When Iris Clert
asked forty-one artists to do a portrait of her for an exhibition in
1960, Arman's was a collection of things that she had worn: a shoe,
underwear and cosmetics (43). This smacks of fetishism, both
Freudian and Marxist (the shoe is appropriately high-heeled).
We may also note that Arman presents the artist as collector, and a
compulsive collector at that. Their approach is inevitably uncritical –
everything was becoming a readymade.

Duchamp, in 1963, pointed out (incorrectly) that whereas he had only
made ten to twelve readymades in his whole life, neo-Dada was
based on unwarranted repetition. 'I had realized very soon,' he said

44
Daniel Spoerri,
Lunch,
1972.
Collage on
panel;
70 × 71 × 34 cm,
27⁵⁄₈ × 28 × 13³⁄₈ in.
Private
collection

two years earlier, 'the danger of repeating indiscriminately
this form of expression and decided to limit the production of
"Readymades" to a small number yearly. I was aware at that time,
that for the spectator even more than for the artist, *art is a habit-
forming drug* and I wanted to protect my "Readymades" against
such contamination.' Further corroboration that neo-Dada was an
exuberant but slightly facile adaptation of Duchamp is given by
Rauschenberg's contribution to the exhibition, a telegram saying,
'This is a portrait of Iris Clert if I say so'.

As Duchamp noted, neo-Dada did not introduce objects from the
real world to challenge art, but to make them into art. There was
a lack of critical spirit here: if one habitually presents collected
objects, they eventually become as much a trademark as a painter's
signature. We recognize Arman's accumulations in much the same
way that we recognize Jackson Pollock's drips. Indeed the commercial
success of an artist such as Arman was predicated precisely on the
repetitive and recognizable nature of his accumulations. Ultimately
the Nouveaux Réalistes, for all their formal novelty, accepted material
culture as it was. They performed a sociology or archaeology of con-
temporary life: they did not seek to change it, merely to document it.

Perhaps the most provocative neo-Dada works were those by Daniel

Spoerri. For his table-pictures (44), the plates, bottles and glasses would be left on the table at the end of a meal and fixed. Turned through ninety degrees and hung on the wall, they invited one to see a certain aesthetic value in the way that people unconsciously arranged these items. His work suggests a rather more quizzical approach to consumption than Arman and a greater concern with the passing of time. Spoerri's best known and most influential work was, in fact, his book *Anecdoted Topography of Chance*, first published in 1962, in which he analysed, partly as an explorer would, partly as a collector of memorabilia would, the hundred and one objects that happened to be on his table on 21 February 1962 at 8·07 pm.

Underpinning all such neo-Dada activities was the rediscovery of Dada itself, and Duchamp in particular. In 1951 Robert Motherwell had published a compilation of Dada texts. However this significantly omitted the more politically motivated texts associated with Berlin Dada, and gave undue space to Paris, where Dada had degenerated into an 'ism', just another art movement. Nevertheless, Motherwell's book gave access to a forgotten tradition – or 'anti-tradition' – of Modernism. Artists like Allan Kaprow treasured the book. Many years later he noted that:

Dada seemed really very far-out, although we didn't necessarily understand its socio-political programs. We did not think, as the Dadaists did in 1916, that the world had gone crazy and there was no redemption in sight – its current of cynicism. Rather we felt that here was freedom to put the real world together in weird ways. It was a discovery, a heady kind of appetite for debris, for cheap throwaways, for a new kind of involvement in everyday life without the judgements about it, either social or political.

Arman had known of Duchamp since 1948, when Yves Klein gave him a copy of the 1947 Surrealist exhibition catalogue (bearing a false breast on the cover, chosen by Duchamp, with the invitation, 'Please Touch'). Spoerri had discovered Duchamp in 1952, but he had mistakenly thought that he was dead and that it had been a toilet, rather than a urinal, that he had placed on a plinth. Such a misunderstanding is characteristic of the mythical status that

Duchamp had acquired by this time. It was not until 1959 that the first book on Duchamp, by Robert Lebel, was published; the same year in which Johns and Rauschenberg finally met him. But they all took what they wanted from Duchamp. Rauschenberg said that he didn't 'think that Duchamp meant any of his things to be just gestures, any more than I meant the *Erased De Kooning* to be a gesture. His *Bicycle Wheel* is one of the most beautiful sculptures I've ever seen.' Duchamp was, of course, very much alive, though not making much work – supposedly he was 'silent', having long since stopped making art in favour of playing chess. But if he was not especially active as an artist *per se*, his profile and reputation were about to expand enormously: no fewer than fifty interviews were broadcast or published in the last ten years of his life. Presumably much to his amusement, he had become an oracle.

The political backdrop to Nouveau Réalisme was the collapse of French colonialism: the élite of the French army had been surrounded and unexpectedly forced to surrender in 1954 by the Vietnamese army at Dien Bien Phu. French rule in Algeria was deteriorating. Despite the claims of the French media that their empire was united, it was collapsing. How could French culture claim to be a uniquely civilizing force when it was associated with savage reprisals against the Arabs in Algeria, with the torture and summary execution of suspects there and in Asia? The Nouveaux Réalistes had little to say about this.

However, the artists and theorists of the Situationist International did, and they sought change. To them, neo-Dada and its later derivative Pop Art was 'materially and "ideologically" characterized by *indifference* and dull complacency'. The group was set up in 1957, a year after a conference at Alba between members of the Lettriste International (a splinter group of the Ultra-Lettristes!) and the Movement for the Imaginist Bauhaus. This latter group had been founded in 1953 by Asger Jorn in opposition to Max Bill's attempt to restore the Bauhaus, with its clinical ethic of functionalism. Jorn called for education through experimental activity, rather than pedagogy, through self-discovery, rather than dogmatic instruction.

He believed that artists must heal society's wounds, not merely design band-aids.

The main protagonists of Situationism were Guy Debord, Constant, Asger Jorn and Giuseppe Pinot-Gallizio. Taking heart from the rebellions against Communist rule in Poland and Hungary (alas, short-lived), strikes in Fascist Spain and the success of the Algerian insurrection, they saw the possibility of a new society and the end of traditional art in favour of a 'unitary urbanism', in which art and life co-existed.

As with the Dadaists and the Lettristes before them, the Situationists believed in provocations. At the 1958 conference of the Association of International Critics of Art in Brussels, they showered the assembled functionaries with abusive leaflets. The major artistic manifestations of the Situationists were the 'industrial paintings' by Pinot-Gallizio, exhibited in 1958 and 1959 in strips of over a hundred metres (about 330 feet) long. As these were paintings for all and to be used by all, one metre (about three feet) would be cut for any prospective buyer. By way of showing one possible use, fashion models paraded wearing samples at the 1958 opening in Milan. Constant had ceased making paintings, and in his *New Babylon* project exhibited models of visionary cities, in which people could roam at will. Much influenced by Lefebvre and his critique of the alienating aspects of the modern city, the Situationists were trying to create a new urbanism where people could be free, not ideological slaves. An individual's passage would not be a rush from home to work and back, but a meander, or adventure, through the city, open to all its possibilities – in the Situationist term, a *dérive*.

If art was going to disappear in this new and better world, then the need for artists themselves was questionable. As Asger Jorn wrote nine years later, 'The anti-art of the late 1950s and early sixties stated that visual art was a useless medium for creativity and thinking. It was the radiation of art into pure existence, into social life, into urbanism, into action and into thinking which was regarded as the important thing.' Given their implicit views on the status of art – 'our participation in experimental art is a critique of art' – it is no

surprise to find that the theorists gradually expelled the artists from the Situationist movement: Pinot-Gallizio was expelled in 1960; Constant resigned in disgust soon after. By 1963 Debord counted up the expulsions and noted that twenty-three of the twenty-eight members who had been expelled were artists. 'Art,' it was claimed, 'can be realized *only by being suppressed*.'

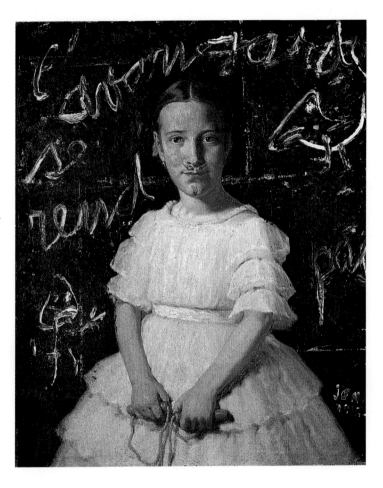

45
Asger Jorn,
The avant-garde doesn't give up
1962.
Oil on canvas;
73 × 60 cm,
28³⁄₄ × 23⁵⁄₈ in.
Private collection

Another key concept of Situationism was *détournement*, which can be roughly translated as 'diversion' or 're-routing'. It was an attempt to extend the notions of parody, plagiarism and collage. 'Since,' as Debord and Gil Wolman (another theorist) had written in 1956, 'the negation of the bourgeois conception of art and artistic genius has become pretty much old hat, [Duchamp's] drawing of a moustache on the Mona Lisa is no more interesting than the original version of

that painting. We must now push this process to the point of negating the negation.' In the Situationist magazines we find several examples of maps that have been *détourné*: in one, all the major cities in France have had their names replaced by those of Algerian towns. The old meanings are lost and supplanted by new and subversive ones.

Asger Jorn's *détournements* were made by taking amateur paintings that he had bought in flea markets, and overpainting them with childlike figures, monsters, blotches and slogans. It was a kind of

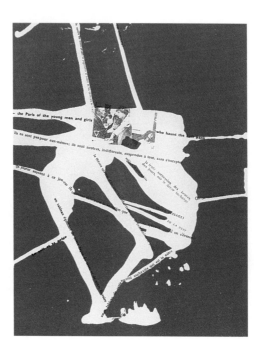

46
**Guy Debord
and Asger Jorn**,
Page from
Mémoires,
1959

47
Piero Manzoni,
Achrome,
1958.
Kaolin on
canvas;
100 × 80 cm,
39³⁄₈ × 31¹⁄₂ in.
Private
collection

euthanasia for their old tired meanings: but new unexpected meanings could be born from these collisions of visual language. Over one, a portrait of a bourgeois woman, he added a moustache and the slogan 'The avant-garde doesn't give up' (45). Similarly, in a collaborative book *Mémoires* (46), Guy Debord spread out cartoons, maps, photographs, snippets of text from newspapers, novels and adverts, while Jorn overlaid them with squiggles, splodges and lines. The eye is forced into a *dérive* around this 'urban' space. The onus is on this 'eye', the reader, to get a sense of the 'story' from these

channels and areas of text and image. The 'story' in fact relates to the history of Debord and the Situationists. The book is probably the most successful attempt to confuse the visual and the verbal, something originally sought by the Lettristes.

To a greater or lesser extent, all the work discussed above helped to create a space – however peripheral it may have seemed – in which an art that was both critical and self-critical could emerge. The work of Yves Klein and the Italian Piero Manzoni more clearly embodies the Conceptual project. Both of their *oeuvres* were framed as an

inquiry. Manzoni was much affected by Klein's 1957 monochrome exhibition in Milan. By the end of the year he had begun making what he called 'achromes'. Initially these were made from raw plaster on canvas, but later Manzoni soaked cloth in kaolin (white china clay) and applied it to the canvas (47). His intentions seemed similar to Klein's: 'Why not,' he wrote in 1960, 'empty this receptacle, free this surface, try to discover the unlimited meaning of a total space, a pure and absolute art?' He believed that pure matter could be transformed into pure energy: 'expression, illusion, and abstraction

48
Piero Manzoni
signing the arm
of a woman,
1961

49
Piero Manzoni
with *Artist's
Shit*,
1961

are empty fictions. there is nothing to be said. there is only to be, there is only to live.'

In 1959 Manzoni had begun to draw lines on sheets of paper, roll them up and seal them in boxes. On the boxes would be written the length of the line, its date and, of course, his signature. Here was a truly immaterial and invisible work: if the seal was broken it ceased to be art. As with Rauschenberg's *Erased De Kooning Drawing*, only the ensemble could constitute the work of art. The viewer had to take it on trust that there really was a line inside. He or she had to make an act of faith. If they could make another act of faith, they could purchase the artist's breath (in fact a box containing a balloon, and a tripod on which to place it). Manzoni was tough about prices: the box sold at 30,000 lire (about $30), but he was also prepared to inflate the balloon at a further cost of 200 lire (20¢) per litre of air. Soon the balloons that he inflated (and sealed with a lead stamp) would become deflated, shrivelled blobs on their wooden bases, like the relics of a saint.

In the same year Klein took the Conceptual logic of *Le Vide* to its conclusion: he began to exchange 'Zones of Immaterial Pictorial Sensibility' (literally nothing) for a set amount of gold. In 1962, having been paid in gold leaf, Klein dispersed half the gold on the waters of the Seine. Then, as previously agreed, the buyer burned Klein's *Receipt for the Immaterial*. So there was no proof that they had ever owned the invisible work. The making, purchase and ownership of the work of art had become a mystery, or ritual.

Manzoni's play on the artist's role as magician or prankster continued. At an exhibition in Copenhagen he boiled eggs, stamping them with his thumbprint. He invited the audience to eat them, so that within seventy minutes the entire exhibition was consumed. He began to sign people (part or complete, a leg or an arm, or the whole body, for a period of time or for perpetuity) as authentic works of art (48). The Belgian artist Marcel Broodthaers and the Italian novelist and semiotician Umberto Eco were just two of the people that he signed. He also had himself photographed emerging from the toilet, smiling broadly, holding in his right hand a little tin (49). Like each of the ninety tins he filled, it bore the legend 'Artist's Shit, contents, 30 GR net, freshly preserved, produced and tinned in May 1961'. They were to be sold, literally, for their weight in gold.

Although the concept may seem to destroy the status of the actual object, it in fact only changes it. It is certainly difficult to see the tins of the artist's shit in aesthetic terms, but they retain a certain perverse fascination. (Manzoni always had a more robust sense of humour and a greater sense of the ironic than Klein.) In part, this is because of the inversion of value. There is an emphasis here on making and doing that continues in much European Conceptual art (see Chapter 5). In this emphasis on the body (or its products) and on the subversive, as much as in the rigour with which he fulfilled his concepts, Manzoni established an important prototype.

Both Klein and Manzoni were to die young: Klein in 1962, his heart condition worsened by his amphetamine habit and the solvents he used to spray his own blue paint; Manzoni in 1963, his health also undermined by the chemicals he had used. It is possible to see Klein's body of work as complete – by the end of his life he seemed to be repeating himself – but not Manzoni's. There were many projects he had planned but never fulfilled, such as letting twenty white chickens loose in a museum (a living, squawking achrome); or boarding up his allocated space in an exhibition and attaching the note 'Here is the spirit of the artist'.

Nobody ever taught you how to live out on the street

And now you're going to have to get used to it ...

How does it feel to be on your own

With no direction home,

A complete unknown,

Like a rolling stone?

Bob Dylan, 'Like a Rolling Stone', 1965

A man *may* have a sense of his presence in the world as a real, alive, whole, and, in a temporal sense, a continuous person. As such, he can live out in the world and meet others: a world and others experienced as equally real, alive, whole and continuous. Such a basically *ontologically* secure person will encounter all the hazards of life, social, ethical, spiritual, biological, from a centrally firm sense of his own and other people's reality and identity.

R D Laing, *The Divided Self*, 1960

The early 1960s was a time, for the Western world, of apparent peace and wealth. But behind an outward complacency there were many signs of both underlying tension and social malaise. In his popular and influential book on schizophrenia *The Divided Self*, cited above, the psychiatrist R D Laing talks about people in terms of ontological security or insecurity: whether they were capable of relating to themselves, other people and the world. Was mental illness, then, potentially implicit to all rather than occasionally aberrational? In 1960, at the University of California at Berkeley, militant students were attacked by armed police. In 1963 200,000 people marched on Washington demanding equal rights for black and white. Bob Dylan's protest songs became the anthem of the disaffected young. And surreptitiously the American government was sending increasing numbers of military 'advisors' to South Vietnam in a bid to counter Communist infiltrators from the North.

50
Robert Morris,
Card File,
1962.
Metal and file
cards mounted
on wood;
68·5 × 27 × 4 cm,
27 × 10⅝ × 1⅝ in.
Musée National
d'Art Moderne,
Centre Georges
Pompidou, Paris

The Cold War continued: the Berlin Wall was built in 1961, freezing the divided status of Europe. In 1964 the head of the much-loved statue of the Little Mermaid in Copenhagen was cut off (51), reputedly by members of the Second Situationist International (whose members included Jørgen Nash), presumably as a protest against institutionalized sentimentality.

It is in this atmosphere of apparent contentment, but incipient resentment, that 1960s Conceptual art emerges. The discrepancy between appearance and reality was another contemporary leitmotif

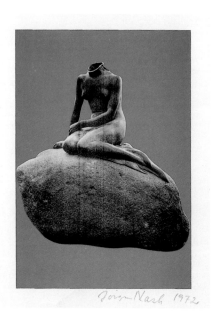

51
Jørgen Nash,
Decapitated Little Mermaid,
1972.
Serigraph;
70 × 50 cm,
27½ × 19¾ in

52
Kenneth Noland,
Gift,
1961–2.
Acrylic on canvas;
182·9 × 182·9 cm,
72 × 72 in.
Tate Gallery,
London

and would be an abiding concern of Conceptual art. In general, the arts mirrored society's apparent contentment: the brightly coloured abstract paintings (52) and sculptures of the time epitomized the age of consumption, with its interest in ever-increasing scale and new materials. However, just as one could sense a malaise in politics, so one could in art. There was a growing discontent with its institutions – the public museums and commercial galleries – and a growing disaffection with traditional forms: artists increasingly presented themselves not just as experimental but as 'alternative'. It was not a matter of

improving art, but of making another type of art altogether.

This was in part a resistance to the critical status quo, as expressed by the American critic Clement Greenberg. In such articles as 'Modernist Painting' of 1961, he claimed that Modernism was a self-critical activity, in which the artists working in each medium must concentrate on critiquing that particular medium alone. 'The task of self-criticism became to eliminate from the effects of each art any and every effect that might conceivably be borrowed from or by the medium of any other art. Thereby each art would be rendered

"pure", and in its "purity" find the guarantee of its standard of quality as well as of its independence. "Purity" meant self-definition, and the enterprise of self-criticism in the arts became one of self-definition with a vengeance.' This excruciatingly limited form of self-critique seemed a perfect doctrine for the age of late capitalism, when each and every job was becoming more specialized. For such artists as Robert Rauschenberg, who wanted their work to exist in the gap between art and life, crossing boundaries, and others who wanted art to retain a social role, such rigid compartmentalization of function and career was anathema.

Happenings – a term coined by Allan Kaprow in 1959 for his exhibition *18 Happenings in 6 parts* at the Reuben Gallery in New York – were one way in which artists sought both to escape from the role of commanding genius and to empower the viewer, or rather the participant. They were also a way of escaping the gallery and museum. 'The romance of the studio, like that of the gallery and museum, will probably disappear in time. But meanwhile the rest of the world has become endlessly available,' remarked Allan Kaprow. Although these performances were avowedly about freedom, about breaking down repression, they were often in fact run in a very dictatorial way. In one of his Happenings Claes Oldenburg shouted at the audience. 'Don't sit down, stand!' John Cage and Marcel Duchamp, who were both present, made a point of sitting down.

George Brecht's Happenings were less demonstrative: he might leave a pack of cards for viewers to play with, or objects for them to unwrap. The viewer became a player. From 1960 he wrote instructions for events on cards and sent them to friends, who, as Kaprow noted, could 'perform them at their discretion and without ceremony'.

DIRECTION

Arrange to observe a sign
indicating direction of travel

. travel in the indicated direction

. travel in another direction

For the group exhibition *Environments, Situations, Spaces* held in New York in 1961 Brecht placed an ordinary chair in the gallery under a spotlight, another in the toilet and one outside the front door (53). The artwork was a modest intervention: sitting on the chair too could become a modest and undemonstrative work of art.

Marcel Duchamp continued to intrigue a new generation of artists. In 1963, at the age of seventy-six, he was finally given a major retrospective exhibition, not however in Paris or New York, but in

53
George Brecht,
Chair Events,
1961.
Chair placed
outside the
Martha Jackson
Gallery, New
York for the
exhibition
*Environments,
Situations,
Spaces*

54
Ed Kienholz,
The Art Show,
1963.
Brass title
plaque, 23·5 ×
29·8 cm, 9¼ ×
11⅝ in, with
framed
instructions,
34 × 23·5 cm,
13⅜ × 9¼ in.
Private
collection

THE ART SHOW

KIENHOLZ 1963 — 197?

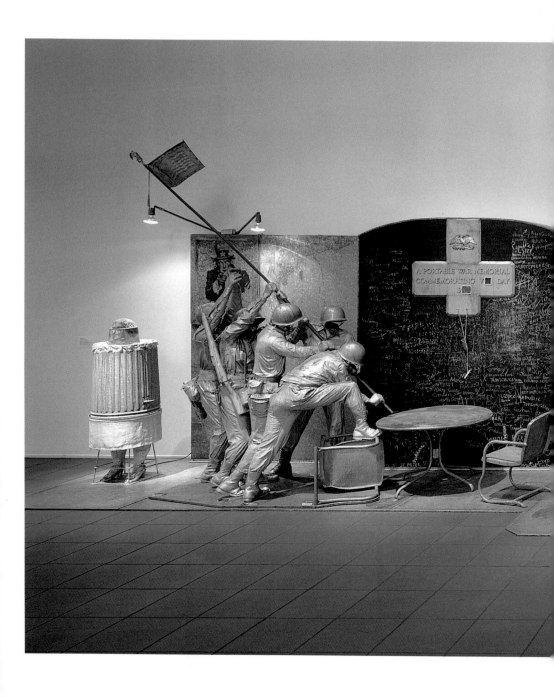

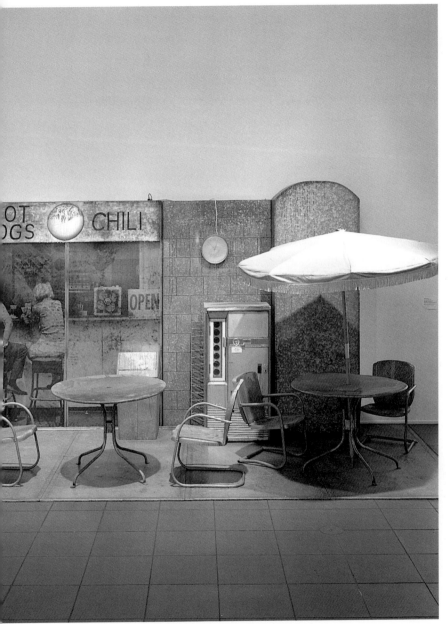

55
Ed Kienholz,
*The Portable
War Memorial*,
1968.
Plaster casts,
tombstone,
blackboard,
flag, poster,
restaurant
furniture,
photographs,
working Coca-
Cola machine,
stuffed dog,
wood, metal
and fibreglass;
h.289·6 cm,
114 in.
Museum
Ludwig,
Cologne

Pasadena, California. Despite having supposedly given up art thirty-nine years earlier, there was a substantial and complex body of work and documentation (if one can make such a distinction with Duchamp). To the many Los Angeles artists who attended the private view, Duchamp appeared a welcome alternative to the Pollockian model of the suffering artist or, as Ed Ruscha put it, 'not a monster, not a genius. He was completely open and friendly; not an artist with bizarre tendencies.' This was a new role model: the intelligent, polite, witty and ironic Duchamp, in contrast to the heavy-drinking, angst-ridden, self-mythologizing painters of the New York School.

The Los Angeles artist Ed Kienholz had given up painting in the late 1950s and had begun working with real objects instead. These got more and more complex until they became full-scale environments; however they were expensive and time consuming to make. To circumvent this problem, from 1963 onwards Kienholz produced what he called 'concept tableaux' (54), which gave instructions for a piece of work that an owner could then commission, should they wish. The purchaser could buy the concept (with a title plaque), then commission a drawing of the work, then with a third, larger payment, have the work made. Four of these concept tableaux, including the *State Hospital* and *The Portable War Memorial* (55) were eventually constructed, but most remained only 'concepts'. Although occasionally referred to as the first Conceptual art works, his concept tableaux were in fact more of a necessary expedient.

In New York, the Pop artists had evolved generally from a neo-Dadaist position of playing with objects from the real world in a rather deferential way, to a much more radical (or banal) presentation. Claes Oldenburg's early work had, like Rauschenberg's, targeted the gap between art and life, collaging together junk elements from the street in a funky and fantastical way. By 1961, having moved from his studio to an old shop, he created *The Store* (56), an environment which simulated the way that consumer culture presents objects for sale. This was a witty parody of basic commercial activity – and of art commerce in particular. Over a hundred different objects were presented – including doughnuts, cakes, corsets and

56
Claes
Oldenburg,
Interior view of
The Store, 107
East 2nd Street,
New York,
1961–2

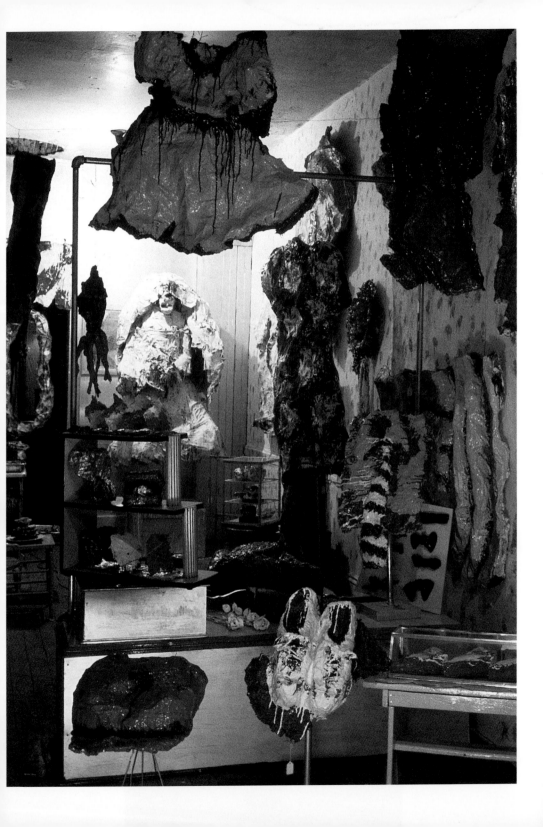

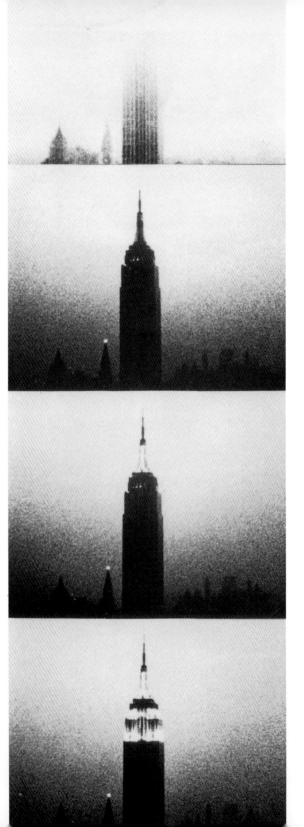

Conceptual Art

57
Andy Warhol,
Empire,
1964.
Film stills

58
Andy Warhol,
*Brillo Boxes
(Soap Pads) and
Campbell's Boxes
(Tomato Juice)*,
1964.
Each Brillo box:
44 × 43 × 35.5 cm,
17^{3}_{8} × 17 × 14 in.
Museum Ludwig,
Cologne

trousers – all of which could be bought at low prices. The objects were not the 'real' thing, however, but sloppily painted plaster replicas. Crucially these were objects that had not been used: they had no history or sociological association. In their newness these objects were, though made by the artist, closer to Duchamp's objects than those of the neo-Dadaists. They were born, not borrowed, and as things newborn their name and identity was uncertain. (Neo-Dada was invariably about the aesthetic redistribution of used objects.)

It was Andy Warhol who presented the images and objects of his society in the most clinical and naked manner. A one-time commercial illustrator, his work bore fewer and fewer signs of the hand of the artist, eschewing traditional authorship in favour of the detached approach, employing assistants. Images of Campbell's Soup cans, Coca-Cola bottles, the Mona Lisa, Elvis Presley, Jackie Kennedy or Marilyn Monroe were photographed and silkscreened directly on to the canvas, often in great numbers – *A hundred Marilyns are better than one*. Images of people, like the objects on the supermarket shelf, were not just readymades but available in endless profusion. In 1963

he began to call his studio The Factory for, after all, that was where he got workers to come and make his paintings.

Less glossy but formally more radical were the films he began to make in the same year. In *Blowjob* we watch for thirty-five minutes a poor quality, grainy black-and-white film of a man's head. Apart from the glimpse of another man's leather-coated shoulder, this is all we see. The action, the narrative, literally happens off frame: because of the length of the film, and its hypnotic and repetitive character, we become very conscious of watching a film, which is enhanced by its grainy, scratchy quality. We are made especially aware of ourselves as watchers, because the film's subject matter puts us in the role of voyeurs. In other films there is a similar lack of action, a similar emphasis on repetition and duration: in *Empire* (57) we watch the Empire State Building for eight hours, in *Sleep* we watch a sleeping man for six hours. As the film critic Stephen Koch said, they were films to hear about rather than to see.

If Warhol's paintings lacked the aura of the artist and his films make one painfully conscious of the nature of the medium, the mounting of his early exhibitions was equally pointed. The exhibition of *Campbell's Soup Cans*, at the Ferus Gallery in Los Angeles in 1962, included thirty-two paintings, the same number as there were types of soup then available; they were not hung, but displayed on shelves as in a supermarket. His 1964 exhibition of boxes at the Stable Gallery in New York showed them – *Brillo Boxes (Soap Pads), Campbell's Boxes (Tomato Juice), del Monte Boxes (Peach Halves) and Heinz Boxes (Tomato Ketchup)* – arrayed in mass profusion, stacked chaotically or in neat lines on the floor, as if the lorry from the factory had just made its delivery (58). In a 1965 retrospective at the Philadelphia Museum of Art, all the work was removed for the opening; so many guests were expected that this became an exhibition not of art, but of an exhibition. The only thing on show was Andy Warhol being famous. Was this all that art and exhibiting were ultimately about – the fifteen minutes of fame that he had anticipated for everyone in the future?

The philosopher Arthur C Danto became fascinated by Warhol's *Brillo*

Boxes and the problems they set. What made this art when a real Brillo box was not? How did the way that we look at it differ when we believed it to be art? The theory he propounded in an article published in 1964 proposed simply that art became art by being seen as art, by being placed in an art context. 'To see something as art requires something the eye cannot decry – an atmosphere of artistic theory, a knowledge of the history of art: an artworld.' In other writings Danto applied the same reasoning to Duchamp's *Fountain*.

Twenty years later Danto argued:

Without theory, who could see a blank canvas, a square lead plate, a tilted beam, some dropped rope, as works of art? ... Perhaps the same question was being raised all across the face of the art world but for me it became conspicuous at last in that show of Andy Warhol at the Stable Gallery in 1964, when the Brillo box asked, in effect, why it was art when something just like it was not. And with this, it seemed to me, the history of art attained the point where it had to turn into its own philosophy. It had gone, as art, as far as it could go. In turning into philosophy, art had come to an end. From now on progress could only be enacted on a level of abstract self-consciousness of the kind which philosophy alone must consist in. If artists wished to participate in this progress, they would have to undertake a study very different from what the art schools could prepare them for. They would have to become philosophers.

Although it was arguably a little later that art truly began consciously to act like philosophy, with artists such as Joseph Kosuth, Bruce Nauman or the group Art & Language, the comment was prescient. Philosophy is, of course, that discourse which is inevitably reflexive, where to think is also to think about thinking.

As dispassionate as anything by Warhol were the books being produced by Ed Ruscha. The first of these, *Twenty-Six Gasoline Stations*, showed twenty-six photographs of service stations between Los Angeles (where he lived) and Oklahoma City (where he had been brought up). The photographs were artless, seeming neither clever nor eloquent. What was important was their indifferent and

everyday quality. The image was allowed to be itself and to speak for itself. It was not important whether he had taken them himself; indeed sometimes he got others to take the photographs for him. In the books they were ordered so as to evoke neither narrative nor mood. There is no text, as he wanted the material to remain neutral. 'My pictures,' he said, 'are not that interesting, nor the subject matter. They are simply a collection of "facts"; my book is more like a collection of "readymades".' So *Various Small Fires and Milk* (59) is quite literally that: photographs of various small fires and a glass of milk. The books were well made and printed, but they were not like traditional artist's books: apart from the first one, they were not

Realities in the Early 1960s

59
Ed Ruscha,
Cover and pages
from *Various
Small Fires and
Milk*, 1964

60
**Marcel
Broodthaers**,
Pense-Bête,
1964.
Books, paper,
plaster, plastic
sphere and wood;
30 × 84 × 43 cm,
11⁷⁸ × 33¹⁸ × 17 in.
base 98 × 84,
× 43 cm, 38⁵⁸
× 33¹⁸ × 17 in.
Estate of
the artist

individually numbered as a limited edition would normally be. They were just books. Why are they so intriguing? They present, and are implicitly about, the act of seeing, the act of selecting and the very act of presenting. They are banal, yet complicated, once one starts to think about them – and thinking about them includes thinking about one's reactions to them. In all this they were a photographic equivalent to what would soon be known as Minimalist sculpture, such as that by Robert Morris and Donald Judd.

In a very different way, the Belgian poet and artist Marcel Broodthaers

also began making books as visual objects. In 1964 he had an exhibition in which he placed the unsold copies of his book *Pense-Bête*, along with a rubber ball, into a mound of plaster (60). A paradox was set up: if you took the book out to read it – that is if you practised 'literature' – you destroyed the sculpture, or art. Broodthaers began to write on Pop Art, emphasizing how it was dependent on his fellow-Belgian René Magritte. He noted how financially successful artists could be if lucky: 'I, too, wondered if I couldn't sell something and succeed in life. For quite a while I had been good for nothing ... the idea of inventing something insincere finally crossed my mind, and I set to work at once. At the end of three months I showed what I had produced to Philippe Edouard Toussaint, the owner of Galerie Saint-Laurent. "But it is Art," he said, "and I shall willingly exhibit all of it." ... What is it? In fact it's objects.'

These works were strange mixtures of things and words: *The black problem in Belgium* consisted of eggshells stuck to a newspaper and covered with black paint; *Oval of eggs 1234567* was an oval board on which white painted eggs were stuck, with the numbers 1, 2, 3, 4, 5, 6 and 7 written on them. When Pierre Restany gleefully asked him whether he had found the eggs in rubbish bins, hoping to enlist him as a Nouveau Réaliste, Broodthaers denied it. In fact they were obtained from the cook at the restaurant *La Boue*, who knew just how Broodthaers wanted them broken.

Whether or not the various works above can properly be considered as Conceptual art, they all contributed to a concerted attack on tradition, Modernist or otherwise. Indeed, as Danto surmised, that tradition or history had effectively ended. As in Bob Dylan's song, quoted at the start of this chapter, artists now were going to have to live out on the street and find their own direction.

The two movements of the early 1960s from which Conceptual art of the late 1960s most clearly derives are Fluxus and Minimalism. This is paradoxical, for they were almost diametrically opposed, the first being concerned with the ephemeral and the second with obdurate reality (as it was often called at the time); the one silly, the other po-faced. They both have a notional beginning in the same event. In 1958

a professor in the Music Department at Berkeley University, Seymour Shifrin, was so perturbed by a composition handed in by a graduate student, La Monte Young, that he arranged a performance of it to show him how patently stupid it was. In Young's *Trio for Strings*, the viola began playing a single C-sharp note, after fifty-one seconds of this monotone the violin joined in with a single sustained E-flat for seventy-seven seconds, then a cello joined in with a monotone D-natural for 102 seconds. Then the cello stopped, forty seconds later the violin stopped and forty-eight seconds later the viola. This whole first section of the trio, then, had only three notes occupying over five minutes. In its structure it broke with the serialism promoted by Arnold Schoenberg that was then *de rigueur* in academic circles; secondly, it was by its simplicity, despite the use of traditional instruments, questioning what music was; thirdly, in its duration it drew attention to the very nature of time. Young was, of course, unrepentant: this was not a jape or freakish novelty, but an outcome of his growing belief that it was time to reject the inherited traditions of Western music. Music should be about sound vibration, not narrative sequence; time was to be experienced, not denied.

Composition 1960 #7

to be held for a long time

La Monte Young
July 1960

Subsequent work by La Monte Young, after he had discovered the work of John Cage, included 'non-musical' sounds: *Poem for Tables, Chairs, Benches, etc.* of 1960 used the sounds made by scraping or dragging furniture around the stage. Like Cage he began to mix the audience with the performers, seeking to break down the barrier between performer and listener. His *Compositions* of 1960 were, if not necessarily unhearable or unimaginable, arguably unplayable (61). *Composition #5* was the instruction, 'Turn a butterfly (or any number of butterflies) loose in the performance area. When the composition is over, be sure to allow the butterfly to fly away outside. The composition may be any length, but if an unlimited amount of time is available, the doors and windows may be opened before the butterfly is turned loose and the composition may be considered finished when the butterfly flies away.' *Composition #10 to Bob Morris* simply had the instruction 'Draw a straight line and follow it'.

Young has claimed, on the grounds of these works, to be the first

Conceptual artist, and his work was certainly influential. One artist who saw its possibility was Henry Flynt, who began making paradoxical word pieces. A work from 1961 states

Concept Art: Work such that no-one knows what is going on. (One just has to guess whether this work exists and if it does what it is like.)

Young was also the crucial inspiration for a whole group of composers including Philip Glass, Steve Reich and Terry Riley, who broke from serialism in favour of an emphasis on repetition and reduction of means. It was to be the work of these three composers above all that established Minimalism as a movement within music.

At this time La Monte Young also began to edit a book entitled *An Anthology* which was to include various artworks that took their particular medium to a *reductio ad absurdum*. The dancer Simone Forti submitted the instructions 'One man is told that he must lie on the floor during the entire piece. The other man is told that during the piece he must tie the first man to the wall.' Henry Flynt's contribution was an article entitled 'Concept Art' in which he wrote, '*Concept art* is first of all an art of which the material is *concepts*, as the material of *eg* music is sound. Since *concepts* are closely bound up with language, concept art is a kind of art of which the material is language.'

When *An Anthology* finally appeared in 1963, George Maciunas was listed as the designer. It was Maciunas who organized many of these assorted people – La Monte Young's associates, students of John Cage such as George Brecht, and such Japanese performers as Yoko Ono – into a group that was to be known as Fluxus. The membership was fluid, many people having only a passing involvement in it. In a way it was more like an itinerant social club. The nearest thing to a clear definition of Fluxus was given in Maciunas's 1963 manifesto (62). But generally he and other participants avoided any rigid definition. Despite the supposedly libertarian or anarchist philosophy of Fluxus, Maciunas acted much like André Breton had in his role as the 'Pope' of Surrealism: excommunicating members, telling them what to do and where to perform (not that they always listened).

In addition to acting as editor and impresario, Maciunas composed

62
George Maciunas, Fluxus Manifesto, 1963

63
Performance of George Maciunas's *In Memoriam to Adriano Olivetti* at Festum Fluxorum, Düsseldorf, 1961. l to r: Tomas Schmidt, Nam June Paik, Arthur Køpche, Wolf Vostell, Daniel Spoerri, Emmett Williams, Frank Trowbridge, unknown

64
Shigeko Kubota, *Vagina Painting*, 1965. As performed at Perpetual Fluxfest, New York

ART	FLUXUS ART-AMUSEMENT
To justify artist's professional, parasitic and elite status in society, he must demonstrate artist's indispensability and exclusiveness, he must demonstrate the dependability of audience upon him, he must demonstrate that no one but the artist can do art.	To establish artist's nonprofessional status in society, he must demonstrate artist's dispensability and inclusiveness, he must demonstrate the selfsufficiency of the audience, he must demonstrate that anything can be art and anyone can do it.
Therefore, art must appear to be complex, pretentious, profound, serious, intellectual, inspired, skillfull, significant, theatrical, It must appear to be valuable as commodity so as to provide the artist with an income. To raise its value (artist's income and patrons profit), art is made to appear rare, limited in quantity and therefore obtainable and accessible only to the social elite and institutions.	Therefore, art-amusement must be simple, amusing, unpretentious, concerned with insignificances, require no skill or countless rehearsals, have no commodity or institutional value. The value of art-amusement must be lowered by making it unlimited, massproduced, obtainable by all and eventually produced by all. Fluxus art-amusement is the rear-guard without any pretention or urge to participate in the competition of "one-upmanship" with the avant-garde. It strives for the monostructural and nontheatrical qualities of simple natural event, a game or a gag. It is the fusion of Spikes Jones, Vaudeville, gag, children's games and Duchamp.

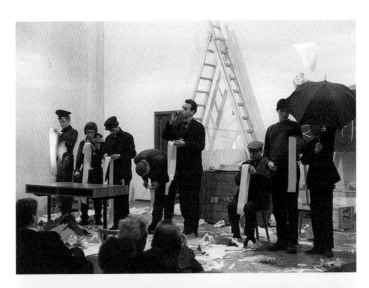

a few events himself, including the piece *In Memoriam to Adriano Olivetti* (63). Each of the ten participants took a used roll of paper from an Olivetti adding machine, and had to lift their hat then open an umbrella then bend over etc., depending on the numbers on the particular roll they held. This was typical of the arbitrary, whimsical and absurdist Fluxus performance: generally they were shorter and more enigmatic than the increasingly chaotic Happenings. In a 1962 piece, *One for Violin Solo*, Nam June Paik, a student of John Cage, took a violin and smashed it on a table. He insisted that it should always be 'played' with a high quality violin so that a good sound could be obtained. Shigeko Kubota's performance *Vagina Painting* of 1965 (64) was unusual for its outright rejection of the feminine as muse in favour of woman as creator: she moved over a canvas on the floor with a brush (dripping red paint) fixed to her underwear. Not only was this an inversion of Jackson Pollock's masculine 'action painting', it was an assertion of her womanhood – the red paint being a clear reference to menstruation. A more typical performance was that made by Joseph Beuys in 1963 during his brief dalliance with Fluxus: he came on stage, wound up a clockwork toy of two musicians and watched it until it stopped.

Generally, compared to the early Dada events, there was not much innovation in Fluxus performance art, but a lot of play. We have to conclude that, despite the claims made for them by Maciunas (he compared Fluxus to Russian revolutionary art and identified himself, with typical inconsistency, as anarchist, communist, socialist and apolitical), few Fluxus events had more revolutionary potential than a stamp-collecting convention. When, in 1963, Fluxus held a demonstration in Amsterdam the Provos, a group of anarchists who believed – like the Situationists – that art should be subsumed into political activism, disrupted the event. The Provos no doubt saw it as mere dilettantism, whereas what they did – providing free bicycles throughout Amsterdam or, more nihilistically, smoke bombing the wedding of Princess Beatrix – was considered to be a genuinely social version of Dadaistic ideas.

Away from the comfy milieu of Western avant-garde gallery-goers,

65
Fluxus Collective,
Flux Year Box 2
('A' Copy),
c.1968.
Mixed media
in wooden box;
20·3 × 20·3 ×
8·6 cm,
8 × 8 × 3⅜ in.
Gilbert and Lila
Silverman Fluxus
Collection,
New York

however, Fluxus or Fluxus-type events could have some genuine resonance. The Czechoslovakian artist Milan Knizak's demonstrations in Prague in the early 1960s, where he created environments on the street and got people involved in walks or strange rituals, are a case in point. These had a real function in opening people's eyes to the life around them. Given the oppressive nature of the Communist regime after the Russian occupation of 1968, it is not surprising that Knizak spent a good deal of the next decade in prison.

From 1962 on, under the banner of Fluxus, Maciunas editioned assorted objects, ephemera and publications. These were delibe- rately cheap: filmstrips, a manifesto in the shape of a suppository, games, jokes and, above all else, boxes (65). The Danish artist Per Kirkeby mocked Maciunas's obsession with boxes as being no different from the 'petit bourgeois mania for small, curious, tasteful gadgets which could be placed on useless shelves in the living room', but he also saw Fluxus as crucial in being a short, sharp squall, an 'expulsion from the temple', an explosive break with the past. In this purgative effect it acted not unlike Dada, as Duchamp claimed, but arguably, like any emetic, it could not and should not be repeated.

Other artists who had been briefly involved with Fluxus bailed out: Robert Morris withdrew his contribution to La Monte Young's *An Anthology*, and publicly disaffiliated himself from the movement in 1964 saying that 'the Fluxus performances under the direction of Maciunas were nothing more than vaudeville, shallow revivals of the Dadaist performances of Hugo Ball and Tristan Tzara.' Young himself had left the year before, unhappy with the destructive tendencies shown in performances by Paik, Ono and others.

Yet Fluxus did open up the question 'What could be art?' and helped to create the atmosphere out of which the Conceptual art of the late 1960s emerged. It was also genuinely international: Fluxus artists could be found all around the world, from Japan to Lithuania. The Lithuanian musician Yvautas Landbergis, who was a member, was to be the first president when that country gained independence.

Robert Morris is perhaps unique in being involved in both Fluxus and

Minimalism. In 1962 he staged a performance: the curtain rose to reveal a grey painted wooden column, 2·4 m (8 ft) high by 0·6 m (2 ft) wide. After three and a half minutes it fell down (the artist was supposed to be hidden inside the column to precipitate the fall, but having injured himself in rehearsal he used a string to pull it down instead). Three and a half minutes later the curtain fell.

Why should this not be regarded as just another Fluxus event? Firstly because it was not funny: it was no jape but a highly structured and serious – even boring – event. The stage was left blank for the specta-tor's eye to fill. Morris was proposing a very different role for the

audience: he was not titillating them with a display of whimsical eccentricity. He was using the stage just as he would later use the gallery space: as a convention or language within which to work, and within which viewers, in their turn, had to work. Above all, unlike Fluxus, there was an emphasis on the materiality of the object. Like Warhol's *Brillo Boxes* (as discussed by Danto), this was a most philosophical piece of wood. Morris was to entitle it *Column* and exhibit it the next year in a gallery, unadorned, as art.

Later in the same year, in his first one-man show, Morris was to present two different types of work. Firstly, Duchampian pieces such as *Box with the Sound of its Own Making*, a 23 cm (9 in) square box containing a tape recorder playing a tape of the hammering and sawing as the box was made (his instructions on making this piece were to have been his contribution to *An Anthology*) and *Card File* (50 and 66), a library card file that lists on each of the plastic index tabs the abstract operations involved in its construction. These were self-referential pieces; indeed because of its tautological, reflexive nature the *Card File* has often been cited as the first true Conceptual work (by the critic and art historian Benjamin Buchloh among others). Another piece, *Litanies*, had twenty-seven keys hanging from a small lead-covered box with a keyhole. Each key was engraved with a word from the section of Duchamp's notes for the *Large Glass* entitled 'Litanies of the Chariot'. When the purchaser, the architect Philip Johnson, failed to pay, Morris made another work reproducing *Litanies*, with a certificate stating that all aesthetic content had been withdrawn from the original.

The second type of work was represented by a large horizontal slab of grey-painted plywood like *Column*, entitled *Slab*. This was an early example of what was to be called Minimal art. Sol LeWitt showed his equally 'minimal' wooden sculptures at the Daniels Gallery in New York for the first time in 1965. He told the gallery director Dan Graham to use them afterwards as firewood. Nothing was expected to sell. Other New York artists making Minimal work included Carl Andre and Donald Judd. By 1965 the Minimal artists, along with many who were soon to be termed 'Conceptualists', were often to be

found at Max's Kansas City Bar in New York. This was, it has been argued, the first generation of New York artists who had been to university. Because of that, and because they saw the need to dismantle the type of formalism that was championed by Greenberg, their discussions were more theoretical than those of the painters who had so far dominated American art. The literature that soon surrounded their work was more difficult and arcane than any encountered before in art criticism – at times it seemed hermetic, as if intended only for a small group of the initiated. Many of them had been writing for some time about art: Donald Judd had been doing so since 1959, while Mel Bochner and Dan Graham were first known as writers rather than artists.

Art in the 1960s was not only fashionable, but, like fashion, prone to sudden change. New movements or 'isms' appeared with increasing regularity: the 'New Sculpture', 'Hyperrealism', 'Op'. All these were foisted on a willing audience who had grown hungry for the next art fad. No wonder that in 1966 *Arts Magazine* had a cartoon with a hopeful artist exhibiting 'P Art' – the logical successor to Pop and Op (67). Perhaps Minimalism was the real 'P Art', especially as it was presented in the 1966 exhibition *Primary Structures* at the Jewish Museum. This exhibition was expected by many to be the apogee of sculptors such as Anthony Caro, with their bright version of formalist abstraction. In fact it was the more austere Minimal works such as Carl Andre's *Lever* (68) that drew attention: Barbara Rose remarked in her review that works by Judd and Morris looked like illustrations to

Wittgenstein; another critic noted that many exhibits seemed to be 'visual presentations of ideas, the activity more conceptual than aesthetic'. Ignoring all the other thirty-six artists in the show, the artist and writer Mel Bochner, in an exceptionally partisan review, characterized the Minimalists as the real core of this exhibition:

When Robert Smithson writes about his piece *The Cryosphere* for the catalogue, he lists the number of elements, their modular sequence and the chemical composition of his spray-can paint. He strips away the romance about making a work of art. 'Art-mystics' find this particularly offensive. Carl Andre's *Lever* is a 360 inch row of firebricks laid side to side on the floor. He ordered them and placed them. He de-mythologizes the artist's function. Don Judd's two Untitled 40 x 190 x 40 inch galvanized iron and aluminium pieces are exactly alike. One hangs on the wall. The aluminium bar across the top front edge is sprayed blue. The second piece sits on the floor directly in front of the first. The aluminium bar across the front edge is not sprayed. Their only enigma is their existence. 'Art-existentialists' find this particularly distressing ... It will do no good to call this work anti-art. Don Judd says in his catalogue statement: 'If someone says his work is art, it's art.' The definitions are phenomenological. Even the definitions are phenomena ... What these artists [Andre, Flavin, Judd, LeWitt, Morris, Smithson] hold in common is the attitude that Art – from the root artificial – is unreal, constructed, invented, predetermined, intellectual, make-believe, objective, contrived, useless. Their work is dumb in the sense that it does not 'Speak to you', yet subversive in that it points to the probable end of all Renaissance values. It is against comfortable aesthetic experience. It is a provocative art as distant from the humanistic stammering of Abstract Expressionism, Happenings and Pop Art as it is from the decorative subterfuges of the Louis-Noland school.

Bochner was keen to establish that this work was radically different, that these artists constituted not just a group or movement, but what the American philosopher and historian of science Thomas Kuhn described as a 'paradigm shift', when all the values and presumptions of a discipline have to change at once. It was, he hoped and believed,

68
Carl Andre,
Lever,
1966.
Firebricks;
11·4 × 22·5 ×
883·9 cm,
4½ × 8⅞ × 348¼ in.
National Gallery
of Canada,
Ottawa

69
Anthony Caro,
Shaftesbury,
1965.
Steel painted
purple;
68·5 × 323 ×
274·5 cm, 27 ×
127¼ × 108⅛ in.
Private collection

not just another phase in Modernist art history. The way in which he noted that 'definitions too are phenomena' was prescient.

The *bête noire* for Bochner and those who felt the same way, was the work of Anthony Caro (69). Nowadays, Caro's sculptures of this time may seem witty, elegant, and less remorseless than Minimalist work, so that it is hard to understand the fervent acclaim and hatred they once evoked. It was the inherent specialness, or 'presence' claimed for them by Greenberg or his confrères, such as William Reuben, curator at the Museum of Modern Art in New York, that offended – a presence that was synonymous with the 'human essence', 'civilization', 'quality', 'genius' – all terms associated with a conservative and mystificatory ideology. What you saw was not what you saw, but a whole lot more: the ideology of the culture then parading itself in Vietnam.

It was the 'compositional structures' of 'European art' that Judd most forcefully abjured, for he believed they carried 'with them all the structures, values, feelings of the whole European tradition. It suits me fine if that's all down the drain.' He objected to their tendency to reduce everything to a balance, to a sense of harmony. His friend the painter Frank Stella had, for similar reasons, dismissed European culture and those, such as the Abstract Expressionists, who wanted to see painting idealistically. 'I always,' he said, 'get into arguments with people who want to retain the old values in painting – the humanistic values that they always find on the canvas. If you pin them down, they always end up by asserting that there is something there besides the paint on the canvas. My painting is based on the fact that only what can be seen there is there. It really is an object ... What you see is what you see.'

'Minimal' such artists may have been, but they were still making art objects. In this sense they were less radical than Duchamp and his readymades. Nevertheless, the works were so 'ordinary' that the viewer was made to think about the uncertain distinction between things in art and things in the world. These works made viewers first consider their immediate environment, as much as the object *per se*, and then consider themselves. They represent an experience that

70
Blinky Palermo,
Softspeaker,
1965.
Wall object
in two parts.
Part one:
Dyed raw cotton;
47 × 176.5 cm,
18$\frac{1}{2}$ × 69$\frac{1}{2}$ in.
Part two:
Dyed raw cotton
on wooden frame;
41.5 × 93.8 × 4.5 cm,
16$\frac{3}{8}$ × 37 × 1$\frac{3}{4}$ in.
Museum für
Moderne Kunst,
Frankfurt am Main

begins as a concept in the artist's head, and culminates inside the viewer's head as self-reflection. 'Is', the artist or critic began to ask, 'the object really necessary for this transaction?'

We have been looking almost exclusively in this chapter at art made in New York. Was there equivalent work, Minimal or proto-Conceptual, being made in Europe at the same time? The situation is even more disparate than in America. There is no real sense of large groups of artists working in unison. Generally, there is also a greater sense of the poetic, a greater reluctance to be rid of the art object. But, although it is not so ruthless as Minimalism, there is work that deals with similar concerns.

One of Joseph Beuys's students in Düsseldorf, Blinky Palermo, was beginning at this time a whole series of paintings and objects which embody a complex response to the notions of objects and environments. A typical example from 1965 consisted of a piece of yellow fabric wrapped around a wooden stretcher (something that looked like a painting in other words), while positioned above it was a similar piece of yellow fabric attached directly to the wall (70). If the top part was not a painting, what was it? As always with Palermo, this was not just an ontological paradox, but an aesthetically curious and plaintive object. Another piece by him, entitled *Grey Disc*, featured grey-painted canvas stretched across a smooth

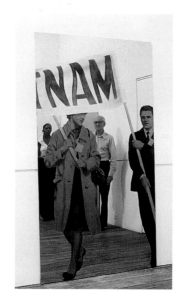

71
**Michelangelo
Pistoletto**,
Vietnam,
1962–5.
Painted tissue
paper on
polished
stainless steel;
220 × 120 cm,
86⅝ × 47¼ in.
Menil
Collection,
Houston

but irregular piece of wood, resembling perhaps a cloud or a stone. Again, was this a painting or an object? As an object it was more strange and allusive than anything then being made in New York.

In Italy, where Piero Manzoni's work was still much discussed, Michelangelo Pistoletto had been making mirror paintings since 1962. In these a painted piece of tissue paper bearing the image of people or objects was stuck to a reflective metal sheet. Reflected in the mirrored surface, the viewer would literally seem to be in the painting, themselves standing by a nude woman or participating in a political demonstration (71). These were elegant works, but ones which problematized the position of the viewer: as Ad Reinhardt would have said, the question was not what the painting represented, but what you represented. This new attitude towards the viewer and where the viewer stands in relation to the work is a crucial characteristic of Conceptual art.

It has been argued commonly that Conceptual art comes directly out of Minimalism, especially in the United States. Minimalism was certainly a highly conceptualized way of making and experiencing art; it was highly theorized by the main practitioners, and its emphasis on the object rather than on the signifier was radical: you

were seeing a thing, not an 'expression' or 'symbol'. What you saw was what you saw. Secondly, Minimalism, if we see it as an attitude rather than a style, was a way of thinking and making which implied that all things could be seen potentially as art or as language. Why then did one have to make any sculpture, even a Minimal one?

Around 1966, Victor Burgin, then a post-graduate student at Yale making Minimal-type work, asked a visiting tutor – none other than Robert Morris – a telling question. Burgin remembered that in a series of articles on sculpture Morris had claimed 'that he wanted his work to be merely one of the "terms" in the room, neither more nor less important than the other terms in the room (by "terms in the room" I assumed he meant architectural details like mouldings, floorboards, windows and so on) … I brought this up and asked him, "If the work is a term no more important than any other term, why bother making it?", and he said something like, "I never said that". I knew damn well he'd *written* it because I'd got the article in front of me. I thought, "Well, this is it; I've hit it; here's *the* historical problem. How do you have something that's here and not here?"' Burgin then gave up making objects completely.

By 1966, Mel Bochner was close to doing the same: penniless, living in a small flat, he spent his time reading and drawing in notebooks. The activity of drawing was for Bochner, as for others, the most immediate connection between thinking and making. Drawing here was also closest to writing. As he began planning geometric models or sculptures, his drawings became more like diagrams, often executed on graph paper. Eventually he began to see that, as the simple mathematical forms he was using could be conceived easily in the head, the act of drawing or diagramming was itself the fabrication. Therefore was it really necessary to make the objects?

Bochner had been asked in 1966 to organize a Christmas show of drawings at the gallery of the New York School of Visual Arts where he then taught – not as an artist, but in the art history department. He asked several of his friends to lend him drawings, telling them that they did not necessarily have to be 'art'. The gallery director, on being shown the works that Bochner had gathered together, was so

unimpressed that she refused to get them framed. When he asked if she would take photographs of them and show those instead, she refused again, as she considered that an equal waste of college money. Undeterred, Bochner xeroxed his hundred drawings, reducing them each to a standard page size. Having copied them each four times, he put them into four loose-leaf notebooks and placed those on four sculpture plinths (72). In the guise of 'the definition is a phenomenon', he had presented the copy of the diagram of an idea as an art object. Moreover, through multiplication he had removed any pretensions that these grainy and already fading copies had to be unique and mystical works of art. The display looked 'minimal-istic' in its blankness and its seriality, but the viewer quickly became a reader. Among the drawings were working sketches by Sol LeWitt (73) and Dan Flavin (more numbers than lines), an invoice from one of Donald Judd's suppliers detailing the elements and prices of one of his sculptures, a mathematician's calculations, a page from the magazine *Scientific American*, a musical 'score' by John Cage. The first drawing in the sequence was a plan of the gallery and the last was the assembly diagram for a xerox machine.

This exhibition, which Bochner called *Working Drawings and Other Visible Things on Paper Not Necessarily Meant To Be Viewed as Art*, has often, with good reason, been cited as the first exhibition specifically of Conceptual art. The viewer became a reader, an active participant: as there was no immediately obvious art on show, the readers had to make or deduce the art experience for themselves. There was also some doubt about authorship: was this all Bochner's work? The distinction between artist and curator was blurred. The exhibition was uncomfortable for the visitor, both physically and mentally: the drawings took a long time to decipher, leaving them with an aching back and an uncertainty as to whether they had in fact been given an 'art' thing to contemplate. Perhaps only in retrospect would they realize that it had been not the pictures or objects, but the exhibition itself, or their experience of it, that constituted the 'art'.

The exhibition is a convenient landmark for the advent of a truly Conceptual art. In fact, Conceptual-type work had been realized

72–73
Mel Bochner, *Working Drawings and Other Visible Things on Paper Not Necessarily Meant To Be Viewed as Art*, 1966
Above
4 identical looseleaf notebooks, each with 100 xerox copies of studio notes, working drawings and diagrams collected and xeroxed by the artist, displayed on 4 sculpture stands. As installed at the School of Visual Arts Gallery, New York
Below
Xerox of drawing by Sol LeWitt, 1966. Photocopy on paper; 27·9 × 21·6 cm, 11 × 8½ in

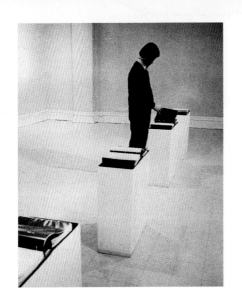

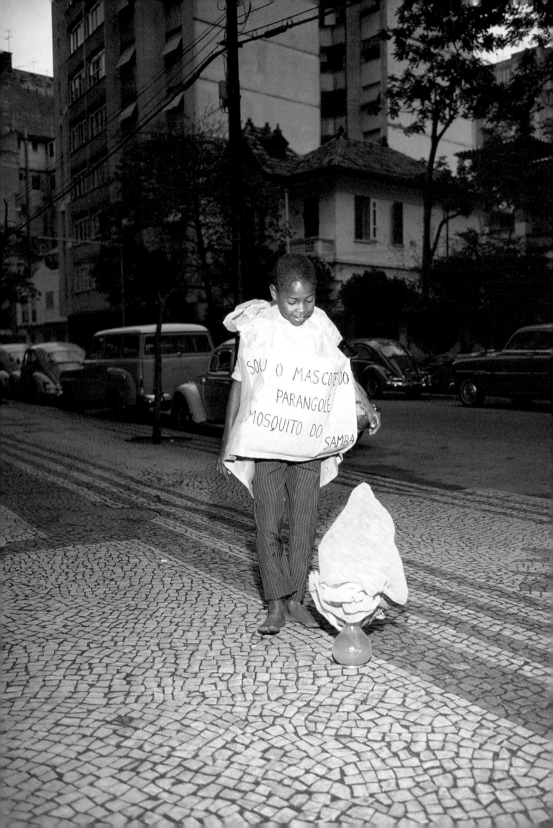

74
Hélio Oiticica,
Mosquito of
Mangueira
dancing with
Parangolé P10
Cape 6 and
Glass Bólide 5
Homage to
Mondrian,
1965.
Projeto Hélio
Oiticica,
Rio de Janeiro.
Sign reads:
I am the mascot
of Parangolé,
Mosquito of
the Samba

75
Hélio Oiticica,
Glass Bólide 10,
B-331 (Homage
to Malevich),
1965

76
Hélio Oiticica
and Lygia Clark,
Dialogue of
Hands,
1966

quite independently by artists outside New York. For example, in Holland, Stanley Brouwn had for some time been making work where the art object was fully dematerialized: one of his pieces was 'all the shoe shops in Amsterdam', another was 'a walk through a grass field'. A 1960 piece ran:

a sheet with note stamped this way brouwn

this way brouwn. pedestrians on their way from a
to b are asked at point c by stanley brouwn to
explain on paper how to walk from c to d. some
passers by make notes, others not. every sheet
is later provided with the stamp this way brouwn.

This was an art seemingly without objects, just a sheet of paper (or was the thought or the act the 'work' of art?), but it was also about being in the everyday world. In what ways was his work different from Fluxus, to whom he was briefly associated? In its rigour, in its ordinariness (this was everyday life), in its use of paradox.

The Brazilian artist Hélio Oiticica was at the end of the 1950s making monochrome panels that referred back to Malevich, but by the 1960s he was making an art more overtly based in the social life of São Paulo. He designed *parangolé* (74), a word which was slang for an animated situation or a sudden agitation between people but which Oiticica brought his own meanings to. The works were made of fabric and functioned both as banners and costumes. Often with words sewn on them, they were meant to be both seen and worn: the viewer could quite literally become a participant. It was not, Oiticica remarked, just using the body as 'support for the work. On the contrary it was a total incorporation. It is an incorporation of the body in the work and the work in the body.' This concern with enfranchising the viewer, of breaking the barrier between art and the body, can be seen in his later work, which was increasingly in the form of environments. His desire to work between the gallery and the street can be seen also in such a work as the *Glass Bólide 10: Homage to Malevich* (75), where the primary colours and geometric shapes of an earlier Utopian Modernism are reconnected with the materials and life of the street.

Whereas Brouwn proposed an art which was lived in the head, Oiticica's was more obviously social. Where they are similar is in emphasizing the body as the site for both experience itself and the validation of that experience. In moving away from the object to the experience, individual and communal, dance seemed the ideal model. His collaborative projects with Lygia Clark such as *Dialogue of Hands* (76) can be seen as either sculpture or dance, a statement at once personal and shared, an act, an object and a metaphor.

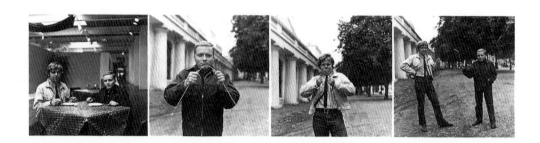

DIE ENERGIE EINES ENGLISCHEN FRÜHSTÜCKS UMGESETZT IN DAS
BRECHEN EINES STAHLDRAHTES DURCH DIE KÜNSTLER DIBBETS
UND RUTHENBECK

LONDON, AUGUST 1969

THE ENERGY OF A REAL ENGLISH BREAKFAST TRANSFORMED INTO
BREAKING A REAL STEEL BAR BY THE ARTISTS DIBBETS AND
RUTHENBECK

LONDON, AUGUST 1969

Imagine all the people

living for the day

Imagine there's no country

it isn't hard to do

Nothing to kill or die for

and no religion too.

John Lennon, 'Imagine', 1971

Most of the propositions and questions to be found in philosophical works are not false but nonsensical. Consequently we cannot give any answer to questions of this kind, but can only point out that they are nonsensical. Most of the propositions and questions of philosophers arise from our failure to understand the logic of our language.

Ludwig Wittgenstein, *Tractatus Logico-Philosophicus*, 1921

By the end of December 1966 Bochner's exhibition *Working Drawings and Other Visible Things on Paper Not Necessarily Meant To Be Viewed as Art* had been dismantled. On the other side of the world, by this time, there were over 400,000 US soldiers in Vietnam. The first officially to arrive had been deployed around Da Nang airfield on 8 March 1965 and, since then, the number had escalated rapidly. Vietnam, the great trauma of the 'American century', was getting into full swing. The moment of Conceptual art, 'the nervous break-down of Modernism', had also come. As we have seen, the art world had been exposed to an increasing number of works that had no traditional form, in which the roles of artist and viewer were left uncertain. In addition, and this is crucial, a good deal of criticism and theory had been published, especially around the subject of Minimalism, which remorselessly attacked traditional assumptions of what art was, and how we receive it.

The heyday of Conceptual art has normally been seen as the period between or around the years 1966 and 1972 (often loosely referred to

as the 'late Sixties'). This chapter and the following four are dedicated to that time. A chronological survey of the varied manifestations of Conceptual art – or things that look like Conceptual art – would be too long; there was such a plethora of exhibitions and artists exhibiting. Any straightforward narrative would be both partial and partisan and must inevitably give a false picture. Therefore, we shall begin by looking at particular works, rather than imposing any single viewpoint or theory on the period. This chapter focuses on eight works that test the various definitions of Conceptual art. The next chapter will identify various approaches to making Conceptual art, giving an overview of the range of work that was produced. Chapter 6 will look more specifically at the crisis of authority in and around the year 1968, at the major Conceptual exhibitions of 1969 and 1970, and at the ways in which the exhibition and dissemination of work were revolutionized. Chapter 7 looks at the early 1970s and considers whether Conceptual art ended at this point. Chapter 8 considers the situation of women artists with regard to Conceptual art. As the Vietnam War was the key political and cultural event of this period, underpinning everything, a discussion of events there introduces each chapter.

The first of these eight examples (77) consists of four photographs taken in 1969 with a caption that reads 'The energy of a real English breakfast transformed into breaking a real steel bar by the artists Dibbets and Ruthenbeck'. The first picture shows the Dutchman Jan Dibbets and the German Reiner Ruthenbeck eating breakfast together; the second shows Ruthenbeck bending a steel bar outside the Institute of Contemporary Arts in London; in the third, Dibbets bends it still further, while in the fourth the two stand together, each holding part of the broken bar. The photographs are unpretentious, technically no better than the average holiday snapshot. Witty though it might be, this is not just a Fluxus-style jape, but a proposition conducted and presented in high seriousness. Symptomatically, neither of the men is smirking, as any true Flux-artist would have been.

When we consider the words in the caption – 'real', 'transformed'

and 'artist' – we realize that several questions are being asked implicitly: not just 'What is a "real" English breakfast?' or 'Did this "really" happen?', but 'What does "real" mean?' The photographs suggest that it is all for real – in the banal, dead-pan style of documentary photography that we associate with a school textbook – but there is, in fact, no proof that the men in the picture actually broke the steel bar. What does 'transformed' mean? Are these men 'artists'? What makes this act art? Is it the supposed transformation of the breakfast into a broken steel bar, or rather the questions that the text and image generate? These questions also draw attention to the seemingly transparent, but in fact problematic, relationship between text and image. We must remember that the dominant and pervasive form of visual communication in this period was advertising, in which text and image were paired in a supposedly natural, but in fact highly manipulated and manipulative, relationship (see 183). Finally, what happened to the actual object, the steel bar? As if to underline that the object is not the issue, there is no record of it being kept.

Bruce Nauman gives us an object, and a strange one at that: a lead plaque, attached to a tree, bearing the statement 'A rose has no teeth' (78). The words are not his but Wittgenstein's, from his *Philosophical Investigations*:

'A new-born child has no teeth.' – 'A goose has no teeth.' – 'A rose has no teeth.' – This last at any rate – one would like to say – is obviously true! It is even surer than that a goose has none. – And yet it is none so clear. For where should a rose's teeth have been? The goose has none in its jaw. And neither, of course, has it any in its wings; but no one means that when he says it has no teeth. – Why, suppose one were to say: the cow chews its food and then dungs the rose with it, so the rose has teeth in the mouth of a beast. This would not be absurd, because one has no notion in advance where to look for teeth in a rose. ((Connection with 'pain in someone else's body'.))

While Wittgenstein tests out his apparently absurd premise verbally, Nauman does it differently – by imprinting the words on a lead plaque and nailing it to a tree in a garden, where one might expect

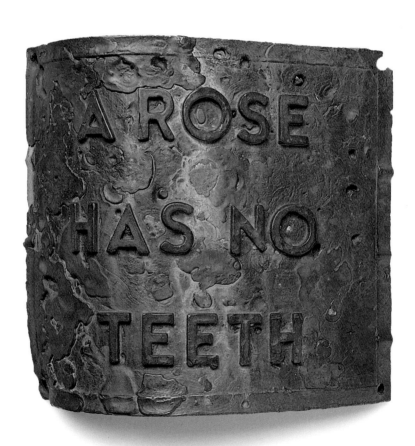

to see a horticultural label or a commemorative plaque. The presentation and the context become part of the meaning of the work. Like Dibbets and Ruthenbeck, Nauman is putting centre stage the whole problematic nature of truth-telling by asking such questions as 'What does this mean?' 'Is it true?' 'How do we know that it is true?' 'Could it be metaphorically true?'

With this work Nauman was also taking a stand against the intrusive nature of most outdoor sculpture. He didn't want his work to assert itself over nature and pointed out that 'after a few years the tree would grow over it and it would be gone.' Another element to his statement against monumental sculpture was his making of multiple casts of the plaque in polyester and sending them to friends.

78
Bruce Nauman,
A Rose Has
No Teeth,
1966.
Lead plaque;
19 × 20·4 × 5·6 cm,
7½ × 8 × 2¼ in.
Private collection

79
Bruce Nauman,
Coffee Thrown
Away Because It
Was Too Cold
from *Eleven*
Colour
Photographs,
1966–70.
Leo Castelli
Gallery,
New York

In such a work Nauman raises another question: 'What does an artist do?' Having decided to give up painting in 1965, at the end of his student years, Nauman was still resolved to be an artist. Believing that an artist must have a studio, just as a doctor has a surgery or a gardener has a garden, he found a studio. His work began to evolve from that starting point: 'If you see yourself as an artist and you function in a studio ... you sit in a chair or pace around. And then the question goes back to what is art? And art is what an artist does, just sitting around the studio.' Asked about his photographs of *Coffee Thrown Away Because It Was Too Cold* (79), he remarked, 'I didn't know what to do with all that time. There was nothing in the studio because I didn't have much money for materials. So I was forced to

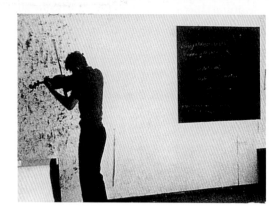

examine myself and what I was doing there. I was drinking a lot of coffee, that's what I was doing.' This existential flavour distinguishes Nauman's version of Conceptual art from other people's. But like many of his contemporaries his work was often about failure. Traditional art is, almost by definition, about quality and success – about 'perfection'. But it is part of a commitment to the everyday in Conceptual art to look at, and live with, failure.

Nauman's studio had become the space of a do-it-yourself philosopher: the only materials he used, other than his mind, were paper, junk and his own body. The body and its experience were central to his approach: 'In a way I was using my body as a piece of material and manipulating it. I think of it as going into the studio and being involved in some activity. Sometimes it works out that the activity involves making something, and sometimes the activity itself is the piece.' Thinking, moving and making were all activities. From 1965, he was making films about these activities: *Bouncing Two Balls between the Floor and Ceiling*, *Playing a Note on the Violin While I Walk around the Studio* (80). If Dibbets and Ruthenbeck introduce one key theme of Conceptual art – the connection, or disconnection, between text and image – Nauman introduces another, the connection, or disconnection, between thought and body. Given that Conceptual art is often assumed to be disembodied and rational, this may be surprising, but the withdrawal from the traditional art object often led to an examination of bodily experience.

80
Bruce Nauman,
Playing a Note on the Violin While I Walk around the Studio,
1968.
Still from a
9-minute film

81
Richard Long,
A Line Made by Walking, England,
1967.
Anthony d'Offay Gallery, London

This is also true, if less obviously, of the apparently artless photograph taken by the English artist Richard Long in 1967. *A Line Made by Walking, England* (81) documents a walk back and forth across a park, which was repeated until eventually the grass along his route was trampled down. The work can be interpreted in many ways. First, it should be emphasized that it was the act of walking which constituted the work of art, although the photograph has been exhibited and could be sold. The work is democratic (anyone could do it); it exists outside the circuit of the commercial gallery (at least until the gallery acquires the photograph); it is based on an idea – 'walk back and forth until the grass is trodden into an evident line' – and it makes one think about one's relationship to the world. It is, of course, ecologically sound, since no lasting damage was done to the environment. If an artist normally draws a line, is walking a line a kind of drawing? Are we, then, all artists when we walk? In so far as Long was positing the possibility of being in nature, not just seeing it, but *being* in it, he is also making a political statement. We can escape from alienation and false consciousness: by a wilful act we can be wholly in the world – reconnected.

This political level of interpretation is significant. In 1988 Dan Graham was to say, of the changing mood of the 1960s, that 'minimal was closer to disillusioned existentialist intellectual, say from Antonioni to Beckett, which is a disillusioned left position. As it veered to Conceptual – Conceptual would be moral, utopian puritanical and personal. Personal in the sense of the personal ethos; it would be closer to the New Left ... a very moral puritan kind of vision.' What makes Long's work so much more than mere Fluxus whimsy is this potential moral/political meaning. There is also a complete absence of pathos and sentimentality. The work is presented as a proposition – what you see is what you make of it.

A scarcely more substantial intervention is presented by Robert Smithson's *Mirror Displacement (Portland Isle, England)* (82), a sequence of photographs of mirrors placed in a stone quarry, which was, together with a map, printed in a catalogue of the Düsseldorf exhibition *Prospect 69*. Travelling through England, he placed mirrors

**82
Robert
Smithson**,
*Mirror
Displacement
(Portland Isle,
England)*,
September
1969.
Estate of the
artist

ū·ni·vẽr'săl, *a.* [ME. and OFr. *universel*; L. *universalis*, universal, from *universus*, universal, lit., turned into one; *unus*, one, and *versum*, pp. of *vertere*, to turn.]
1. of or relating to the universe; extending to or comprehending the whole number, quantity, or space; pertaining to or pervading all or the whole; all-embracing; all-reaching; as, *universal* ruin; *universal* good; *universal* benevolence.

The *universal* cause,
Acts not by partial, but by general laws.
—Pope.

In this mental concept
one may distinguish between
the negative meanings
and its positive meanings
and also between its use
in connection with what is quantitative,
and its use
in connection with what is non quantitative,
but only qualitative.
The negative meanings of the term
may be expressed variously
by indeterminate or endless in quantity or extent, etc.,
and indefinite or indeterminate in quality.
The positive meanings
may be expressed by the expressions
self-determined, self-dependent,
complete or perfect.
The negative use of the term
is no doubt the older.

in the landscape and photographed them. 'I'm using a mirror because the mirror in a sense is both the physical mirror and the reflection: the mirror as a concept and abstraction; then the mirror as a fact within the mirror of the concept … the mirror is a displacement.' Underlining this convoluted statement is the idea that the mirror is like human consciousness: to know something, to become aware of it, is to be aware of one's separation (alienation, displacement) from it. Smithson was interested in the notion of the site and the non-site: the site being the 'real' place, the non-site being the representation of it. A non-site could, for example, be a pile of rocks, relocated in the gallery space. But the site was always, he was aware, in a process of change and entropy. Another underlying concern was therefore with the passage of time: the transition from one to seven mirrors in this work both relates to this and to a more general interest during this period in simple structures and counting. Counting was, as the Minimalists realized, a way of making arrangements rather than compositions (see Chapter 3).

Smithson's *Mirror Displacement* also raises the whole question of the canonical form for a Conceptual work of art. While for *Prospect 69* the work was shown as a sequence of seven black-and-white images, it would subsequently be shown in other formats. Images from this project are sometimes exhibited separately, while the catalogue of his photographic work now lists the piece as being a sequence of 128 slides. If the concept or action was paramount, the exact nature of the documentation will be contingent on the context that it appears in. Perhaps the best way to regard the photographs is as evidence of a research project.

If we look now at two works by Joseph Kosuth and Giulio Paolini, we see that they combine words and their visual presentation, but in both cases precedence is given to the text. Kosuth presents a negative photostat of the dictionary definition of the word 'universal' (83). Paolini has taken the definition of the word 'infinity' from the *Encyclopaedia Britannica* and, putting it in a typographically more elegant form (84), issued it as a lithograph.

As Kosuth pointed out in 1969, his piece is 'purely conceptual art'. It

was at this time that he claimed that 'The "purest" definition of conceptual art would be that it is inquiry into the foundation of the concept "art", as it has come to mean.' His position was based on a reading of art history, in which 'the value of particular artists after Duchamp could be weighed according to how much they questioned the nature of art; which is another way of saying "what they *added* to the conception of art".' He quoted on more than one occasion Malevich's dictum, 'The artist who wants to develop art beyond its painting possibilities is forced to theory and logic.' This is apposite, for many of the artists of this period were much affected by their reading of *The Great Experiment* by Camilla Gray, the first book to explore and make public the Utopian project of Russian avant-garde artists like Malevich and Rodchenko. Kosuth discriminated clearly between the work of art and its 'documentation'. 'I never wanted anyone to think that I was presenting a photostat as a work of art.' This is one of the reasons why he subtitled such pieces *Art as Idea as Idea*, 'The idea with the photostat was that it could be thrown away and then re-made – if need be – as part of an irrelevant procedure connected with the form of the presentation, but not with the "art".' As soon as people began to see the photostats as placebo paintings, he stopped making them. On the other hand, these black photostats unmistakably echo in colour, shape and size Ad Reinhardt's black paintings. Indeed, one could argue that his work is so rooted in previous American art that it should be seen not as anti-Modernist or post-Modernist, but (like Minimalism) as late Modernist. In the formalist game of self-reflexivity and reduction, could a square black photostat not be the next logical move after Reinhardt and Minimalism?

Another reason for Kosuth's subtitle was that he saw art as a tautology. As he said in a key article of 1969, 'Art after Philosophy', 'What art has in common with logic and mathematics is that it is a tautology; *ie* the "art idea" (or "work") and art are the same and can be appreciated as art without going outside the context of art for verification.' To Kosuth, Duchamp's readymades were tautologies: they announced themselves, as it were, by saying 'I am art because I am art', rather as Reinhardt said 'Art is art-as-art' (see Chapter 2). By

contrast, a formalist painting announces itself, 'I am art because I look like other paintings.' In essence, it was not therefore tautological ('I am who I am'), but typological ('I am because I am like others'). For this reason, Kosuth believed, a painting could never question the nature of art, because the medium had an in-built assumption about what art was.

If Kosuth's work is rooted firmly in Minimalism and in the theories of American abstraction, Paolini's is rooted elsewhere: in European art, especially that of Manzoni, and in literature. On the surface, Paolini's *Infinity* covers the same territory as Kosuth's piece: extracting a definition of an abstract idea from a dictionary to make us try to conceive of it. But unlike Kosuth's throwaway photostat this is a lithograph that can be purchased from a gallery. In keeping with the subject, the lithograph is in an unlimited edition: it may be printed and numbered up to infinity. Whereas Kosuth is unambiguously anonymous, we are aware of Paolini as author, if only in his role as typesetter. Here we have one of the recurrent differences between European and American Conceptual art: the artist never really pretends to be dead in Europe, nor is there any concerted attempt to dematerialize the object. The typographic arrangement is a distancing or aestheticizing device: recurrently, Paolini evokes or alludes to objects, whereas Kosuth defines or pictures them.

Since 1960, well before Kosuth, Paolini had been pondering the idea of art as art, exhibiting paintings turned to the wall, making plain white canvases, starkly empty in comparison to Manzoni's highly textured achromes, or showing stretchers with no 'painting' stretched on them, just a pot of paint placed inside. If, for Kosuth, painting has been abandoned as an archaism, for Paolini it still exists, either as a ghost or a dream. If Kosuth was interested in puzzles, Paolini was interested in mysteries. Kosuth states while Paolini suggests.

Painting was normally a medium despised by Conceptual artists, but on occasion they used it, although again to document art rather than as art itself. This is demonstrated in a series of canvases by the Californian artist John Baldessari. If Duchamp had reacted against

A PAINTING BY DANTE GUIDO

A PAINTING BY PATRICK X. NIDORF O.S.A.

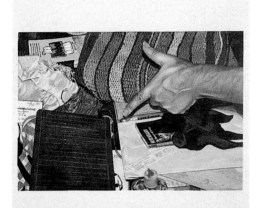

A PAINTING BY NANCY CONGER

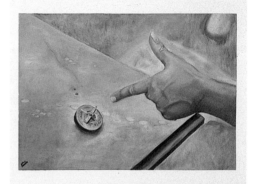

A PAINTING BY PAT PERDUE

85
John Baldessari,
Four of *The*
Commissioned
Paintings,
1969–70.
Acrylic or oil
on canvas;
150·5 × 115·6 cm,
59¼ × 45½ in.
Private collection

the implicit conservatism of supposed Modernists, such as Glackens (see Chapter 1), Baldessari's generation was reacting against the conservatism of late Modernism, in particular such critics as Clement Greenberg and his disciples. Greenberg, who was influential on both artists and writers, rejected art that had ostensible subject matter and which introduced elements from the real world, believing that it polluted the creative process. This he characterized as kitsch or 'novelty art'. In the late 1960s Al Held, an abstract painter associated with formalist writers such as Greenberg, said, 'all Conceptual art is just pointing at things'. Even Duchamp, it could be argued, had not made anything, but simply pointed at a urinal.

Baldessari took Held at his word and made a series of works based on pointing. Among these were *The Commissioned Paintings* of 1969–70 (85). He took photographs of a friend pointing at the things that they found interesting during a walk through town. He then sent these to fourteen Sunday painters whose work he had seen at country fairs and asked them each to make a painting of the photograph of their choice. This set of canvases, each with the name of the painter stencilled on it, was then exhibited. So who was the artist? John Baldessari as the conceiver, or Nancy Conger, Dante Guido, Patrick Nidorf, Pat Perdue and others as the painters? Traditionally, the person who paints the painting is the artist, even when they are copying some other image: we refer to Vincent van Gogh's copies of prints by the nineteenth-century illustrator Gustave Doré as 'Van Goghs'. Yet this group of work is always discussed as a 'Baldessari'. He was, we could argue – and this is how he saw himself – the impresario or composer, who provided a script or score for others to perform. Authorship therefore depends here more on the concept than on the performance. Just as importantly, which element does the art reside in? In the painting? In the complete ensemble of fourteen paintings? Or is it in the underlying concept? If it lies in the concept – and we are inclined to say that it does – should we not see the actual paintings as documentation of the art, rather than the art itself?

The whole notion of authorship was becoming problematic at this time. An influential essay by the French semiotician Roland Barthes,

'The Death of the Author', which emphasized the role of the reader rather than the author in making meaning out of texts, had been published for the first time in English translation in 1967, in the avant-garde magazine *Aspen*. A similar denial of the sanctity of the author or performer could sometimes be seen in music of the period: on one occasion in 1967, when the rock band the Mothers of Invention were playing at the Garrick Theatre in New York, only ten people turned up; these privileged few were given the instruments to play while the band sat in the auditorium.

The eighth and final piece in this chapter is probably the one that succeeds in appearing most radically unlike a traditional work of art. This is the introduction to the first issue of *Art–Language*, the magazine started in 1969 by the four members of Art & Language (Terry Atkinson, David Bainbridge, Michael Baldwin and Harold Hurrell) as a journal of Conceptual art (see 101). As this amounts to eleven pages of closely argued reasoning, we can quote it here in part only. Having announced his intention to discuss the differences between American and British Conceptual art, Atkinson makes his claim outright:

Suppose the following hypothesis is advanced: that this editorial, in itself an attempt to evince some outlines as to what 'conceptual art' is, is held out as a 'conceptual art' work. At first glance this seems to be a parallel case to many past situations within the determined limits of visual art, for example the first Cubist painting might be said to have attempted to evince some outlines as to what visual art is, whilst, obviously, being held out as work of visual art. But the difference here is one of what shall be called 'the form of the work.' Initially what conceptual art seems to be doing is questioning the condition that seems to rigidly govern the form of visual art – that visual art remains visual.

After discussing whether Conceptual art classifies as art theory, he points out that 'Inside the framework of "conceptual" art the making of art and the making of a certain kind of art theory are often the same procedure.' It is noticeable here, as elsewhere, that Atkinson is paying more attention to the work of art than to the object of art: it is the activity that matters, rather than the thing, which is a key shift

away from the priorities of neo-Dada. Would the essay be seen as art if it were exhibited on the gallery wall?, Atkinson asks. (In fact, this is just what happened: dealers pasted up pages from *Art–Language* as a way of 'exhibiting' them.) Is the recognition of art dependent upon seeing? There are, he suggests, four methods by which the artist has sought to make sure his work is recognized as art: (1) making an object with all the morphological characteristics traditionally associated with a work of art, as an oil painting, for example; (2) adding something new or alien to this, as when the Cubists added collage; (3) putting an alien object in an 'art' context, as Duchamp did; (4) declaring that something is art, as when Atkinson and Baldwin asserted that a column of air comprising a base of one square mile was art or that Oxfordshire was an artwork. Unlike the others, this fourth method does not use a 'concrete existential object', but a theoretical one.

'The British conceptual artists,' Atkinson writes, 'found at a certain point that the nature of their involvements exceeded the language limits of the concrete object.' In other words, the concrete object could no longer say all that was required of it. 'Soon after they found the same thing with regard to theoretical objects, both put precise limits on what kinds of concepts can be used.' This is a more intellectual approach than Manzoni's signing of things and people as artworks because it was the basis for extended theoretical discussion. 'These theses,' Atkinson concludes, 'have tended to use the language form of the support languages, namely word language, and not for any arbitrary reason, but for the reason that this form seems to offer the most penetrating and flexible tool with regard to some prime problems in art today.' He quotes the philosopher Richard Wollheim's observation that it is impossible to imagine art outside a society of language users. 'I would suggest', he had said, 'it is not beyond the bounds of sense to maintain that an art form can evolve by taking as a point of initial inquiry the language-use of the art society.' The material of art was to be found in the discussion of art. The way in which this editorial is written indirectly brings out another theme of Conceptual art, that of the nature of consciousness, or, as Atkinson himself later described it, 'the issue of self-consciousness of self, a

86
Giulio Paolini
working on the
installation of
At last alone at
the Museum of
Modern Art,
Oxford, 1980

87
Joseph Kosuth,
*Information
Room (The Third
Investigation)*,
New York
Cultural Center,
1970

problematic of self, with its proliferating reflexive dances.'

We have been thinking of the art, but what of the artists? As we have seen, their role was as much in question as the status of the art object itself. How did they present themselves? Dibbets and Ruthenbeck (see 77) look like ordinary men, a bit untidy maybe, but not exceptionally so. Do they not stand like a pair of fishermen showing off the day's catch? Importantly, like Nauman, they present themselves as the objects of their work, not the masters. Paolini and Kosuth seem to offer new models: the artist as everyday man, or as intellectual. Paolini is typically shown here in workman's clothes, drawing, his head modestly averted from the camera's gaze (86). But Kosuth sits at the table, his head buried in books, reading, cogitating (87).

What do the eight works that we have considered have in common? Perhaps the most obvious common feature is the lack of colour. This Puritan element is in direct contrast to the gleeful polychrome of advertising and other art in the period. Black and white was also preferred for its anonymity, and for its connotations of truthfulness and emotional detachment. It was also cheap.

How do these works fit the differing definitions of Conceptual art quoted in the Introduction: LeWitt's notion (as stated in his 'Paragraphs on Conceptual Art') that the concept behind the work actually constitutes the art; Kosuth's description of an inquiry 'into the foundations of the concept "art"' (which narrows the field of definition to analytical and linguistic work); and Lippard's notion of the dematerialization of the art object (though some artists have preferred the word 'demystification' to 'dematerialization')? No one definition covers these works adequately, but all apply to varying degrees. All the works share certain characteristics: that the object or image is not given a unique aura, that the role of the artist is blurred, that there is an awareness of the context in which the work will be seen, and that the work is potentially critical of received opinions and beliefs. The works also refer implicitly, or explicitly in the cases of Smithson and Atkinson, to the nature of self-consciousness. We are being made to think of ourselves thinking.

How do we place these works in regard to the four modes we established in the Introduction? The readymade is singularly absent, apart perhaps from the missing bar of steel in Dibbets and Ruthenbeck's work. To a greater or lesser extent, they all come under the category of documentation. It is symptomatic of the period that the thrust had moved from the sample object, as in Duchamp and neo-Dada, to things present only in trace and reflection. 'Words' and 'Intervention', the other two modes, though evident here, would be developed more fully later and will be explored in chapters 5 and 6.

The position of the viewer is a recurring theme. Writing of his installations and Happenings, Allan Kaprow observed that in becoming a participant the viewer was in effect the object, or the painting, while the stuff and instructions were like the canvas. Active engagement was also demanded on a mental level. The viewer had to become a thinker. This was a very different role from that required by formalist paintings of the time, such as Jules Olitski's, which Lucy Lippard characterized as 'visual muzak'. There one could relax as though in a comfy armchair, wallowing in the luxurious colours. With Conceptual art the viewer stands in intellectual discomfort.

Roland Barthes had used the term 'writerly' for texts by which the reader is first irritated and then activated. So, in reading the poems of Stéphane Mallarmé such as *A Throw of Dice* (see 11), the eyes dart back and forth across the page, as though following the steps of a complex dance. The reader must follow the words actively, much as a dancer re-enacts the steps laid out by a choreographer, or much as a pianist must recreate Beethoven's score as music. The act of reading becomes not passive, but active. It is an operation of immediate enactment and interpretation. This was to become a crucial aspect of late Modernism, and what has come to be called post-Modernism: it is the reader's experience that matters, not the writer's. This has repercussions for the status of the author, as was touched upon earlier. In 'The Death of the Author', Barthes argued that we read language, rather than an author. Mallarmé, he says, was the first to see 'the necessity to substitute language itself for the person who until then had been supposed to be its owner.' Mallarmé's entire

poetics consists in suppressing the author in the interest of writing (which is, as will be seen, to restore the place of the reader). Before we ever speak through language, language speaks through us: the notion of the author's originality and of his ability to control the text he produces are, for Barthes, romantic illusions. Once we realize this, we can understand that it is the reader who owns the text that they are reading. These eight works are similarly open, incomplete and writerly.

As we said in the Introduction, a work of Conceptual art begins in doubt, by questioning, as in Wittgenstein (quoted at the beginning of this chapter), the language of supposed truth propositions. Only after such an analysis is it possible to put forward a feasible proposition, or to begin imagining. One can see Lennon's 1971 album *Imagine*, the title song of which opens this chapter, as either a return to sentimental optimism or a different approach to the same problem as his album *Plastic Ono Band*, from which we quoted in the Introduction. He himself said that the earlier album 'was too real for people, so nobody bought it. It was banned on the radio. But the song "Imagine" which says: "Imagine that there was no more religion, no more country, no more politics" is virtually the communist manifesto ... exactly the same message, but sugar-coated. Now "Imagine" is a big hit almost everywhere.' If the imagination could grasp something, perhaps mind, body, even one's society, could follow.

What will you do if we
Let you go home,
And the plastic's all melted
And so is the chrome –
WHO ARE THE BRAIN POLICE?
Mothers of Invention, 'Who are the Brain Police?', 1966

As the great words of freedom and fulfilment are pronounced by campaigning leaders and politicians, on the screens and radios and stages, they turn into meaningless sounds which obtain meaning only in the context of propaganda, business, discipline, and relaxation.
Herbert Marcuse, *One Dimensional Man*, 1964

88
Album cover for
We're Only In It
For The Money,
1968 by Frank
Zappa and the
Mothers of
Invention

By the end of 1967 there were 500,000 US soldiers in Vietnam. What had begun as a secretive act of foreign policy had become a national crusade, deploying resources on a scale not seen since World War II. Unlike that conflict, however, there was no clear enemy, no clear end, no clear moral purpose. Nevertheless, the prestige of the United States as technological and moral world leader was at stake. The country was led by Lyndon Baines Johnson, a man described by Hubert Humphrey, his vice-president, as 'an All-American president. He was really the history of this country, with all its turmoil, the bombast, the sentiments, the passions. It was all there. All in one man.' As in Greek tragedy, this whole gung-ho, Utopian enterprise was soon to turn sour.

It is a truism that truth is the first victim of war, but this was especially the case in Vietnam, where a whole language of deceit began to appear. 'Redebriefing': soldiers being told to lie about what had actually happened in the field; 'proof-package': a lot of statements that looked like truths; 'incident': shooting; 'air operations': bombing; 'sustained pressure': more bombing; 'irregularities': black market sales of United States equipment; 'body-counts': mounds of

dead soldiers and peasants counted inaccurately. The language of the state was, as the philosopher and political theorist Herbert Marcuse observed in *One Dimensional Man*, 'operational': what mattered was not 'truth', but getting the intended result. (This book was an attack on the dehumanizing aspects of capitalism, but it privileged personal liberation rather than economics as Marxist theory would. Such an emphasis was to be typical of what was to become known as the 'New Left'.) 'One does not,' noted Marcuse, '"believe" the statement of an operational concept but it justifies itself in action – in getting the job done, in selling and buying, in refusal to listen to others, etc.' The language of politics had become indistinguishable from that of advertising.

The late 1960s seemed, on the domestic front, the moment of the adman and the public relations man, an age of conspicuous consumption, when capitalism was in its full glistening glory. Technological progress promised a life that would become ever easier and better. Society too could share this delirious contentment. In this new world, the old Marxist analysis that man was alienated under capitalism had become unsustainable, for, as Marcuse noted, 'the extent this civilization transforms the object world into an extension of man's mind and body makes the very notion of

89
Country Joe and the Fish performing at the Woodstock Festival, New York, 1969

alienation questionable. The people recognize themselves in their automobile, hi-fi set, split-level home, kitchen equipment. The very mechanism which ties the individual to his society has changed, and social control is anchored in the new needs which it has produced.' In art objects, this rage for the new as a value in itself was exemplified and fulfilled by new materials (acrylic, liquitex, polyester, fibreglass) and by new techniques (spray-painting, vacuum-forming).

The musicians of the new wave of rock bands often reacted violently against the shallowness of the society that had spawned and supported them, none more hilariously than Frank Zappa, founder of the Mothers of Invention:

You rise each day the same old way,
And join your friends out on the street,
Spray your hair
And think you're neat,
I think your life is incomplete.
But maybe that's not for me to say –
They only pay me here to play.

When the Mothers of Invention were asked by Detroit television to mime to their single 'Who are the Brain Police' from the album *Freak Out*, quoted at the beginning of this chapter, each member took one physical action and repeated it while the camera focussed on them – as Zappa said, it was 'Detroit's first whiff of home-made prime-time Dada'. Nor were their fellow bands safe from parody: the famous cover by the British Pop artist Peter Blake of the Beatles' *Sergeant Pepper's Lonely Hearts Club Band* was ruthlessly spoofed in the Mothers of Invention's *We're Only In It For the Money* (88).

At the Woodstock Festival in 1969 (89), Country Joe and the Fish raised the fish cheer 'Give me an F, give me a U, give me C, give me K. What's that spell? FUCK.' This could be seen as an act of personal rebellion against repressive authority – the 'Brain Police' – a call for revolution from within, as though personal liberation would lead to a more general liberation. Or it could be seen as little more than an excuse for self-indulgence. Beneath all the rhetoric, the popular

mood was perhaps closer to the sentimental egotism of hippyism than the more puritanical programme of the New Left.

Conceptual art can be seen as a reaction against the misuse of language and also as a critique of consumer society. As we saw in Chapter 4, the status of the object or event and its documentation, and indeed the status of the artist, was increasingly questioned by Conceptual artists. In this chapter, the wider range of their work is explored. Despite the general denial of traditional categories, provisionally at least, we can see Conceptual art as working in seven areas, all unapproved by authoritarianism and its deceitful, alienating rhetoric: serial works, anti-form sculptures, language-based and theoretical work, monochrome paintings, interventions and the poetic approach to the readymade associated with Arte Povera.

Mel Bochner observed that 'serial or systematic thinking has generally been considered the antithesis of artistic thinking'. If the masterpiece was that single painting or sculpture into which the supreme artistic achievement of a career is compressed, then the serial work offered instead a set of alternatives, none of which took precedence. By implication, the concept underlying the series or the process was therefore more important than the final object. 'With serial imagery the masterpiece concept is abandoned,' wrote critic John Coplans in a 1968 essay.

90
Peter Roehr,
Untitled (FO-29),
1965.
Paper mounted
on card;
22.5 × 23.4 cm,
8⁷⁄₈ × 9¼ in.
Museum für
Moderne Kunst,
Frankfurt am
Main

Serialism did not necessarily mean an attack on the mystic or aura-laden, but it was certainly a rejection of hierarchical composition. In Germany Peter Roehr had begun making serial compositions in 1962 (90), after an involvement in Zen Buddhism. We could see his and other serial works as being like mantras in their hypnotic effect, rather as we experience much Minimal music. But the focus for meaning was dissipated. 'The picture has no focal point, it happens everywhere,' Roehr remarked in 1965. His earliest serial works had been made with calculating machines that merely repeated the numbers remaining from a previous calculation until the paper ran out. Words, everyday objects, images from advertising or abstract elements would be set in grids. By 1965 he was also re-editing film clips into short repetitive movies. Bereft of the precise relationship

that composition gave it, the object or fragment was left hanging. Its conceptual intent became uncertain, but of central importance. As Duchamp remarked of Warhol, 'when someone takes fifty Campbell's soup cans and puts them on canvas, it is not the retinal image which concerns us. What does interest us is the concept which wants to transfer fifty Campbell's soup cans to canvas.'

For some, repetition emptied the object or sign of meaning and significance. A central text in this debate was Walter Benjamin's essay 'The Work of Art in the Age of Mechanical Reproduction' (first published in 1936, but only widely known in the 1960s) with its analysis of the loss of aura. It is usually asserted that, repeated fifty times, Warhol's Marilyn Monroes become ciphers, empty of presence. But we should note that Roehr saw his work as giving back aura or immanence to the reproduction; and we may ask whether the five-fold repetition, 'never, never, never, never, never', in Shakespeare's *King Lear*, empties the word of meaning or allows the actor, or reader, to fill the words with variety and intensity.

Sol LeWitt was especially associated with serial work. As mentioned in the Introduction, in 1967 he published his 'Paragraphs on Conceptual Art', with its memorable phrase: 'The idea becomes a machine that makes the art.' As he had said in an earlier statement, 'the serial artist does not attempt to produce a beautiful or mysterious object but functions merely as a clerk cataloguing the results of the premise.' If we look at his drawings of this period, we see a simple mathematical idea worked out. In *Four Color Drawing (Composite)* of 1970 (91), four colours (yellow, black, red and blue), and four types of line (horizontal, vertical and both diagonals), are combined together. But process interested him as much as thinking: hence his belief that the working drawings with their scribbles and calculations were often the most interesting 'works'. LeWitt 'never thought that if the thing existed only as an idea that it was a complete idea.' He claimed that 'I had the idea that the cycle had to be complete to be a work of art.'

From 1968 onwards, LeWitt began also to make his drawings on the wall, but he did not normally execute them himself. A draughtsman

would be given instructions: 'Ten thousand random straight lines drawn by one draughtsman, 1,000 lines a day, for ten days, within a 120″ square.' 'Lines, not short, not straight, crossing and touching, drawn at random, using four colours (yellow, black, red and blue), uniformly dispersed with maximum density covering the entire surface of the wall.' By drawing directly on the wall, he was getting away from the illusionism of painting; moreover by being made on the wall the work could not, in theory, be bought (although in practice one could buy the concept, or commission a new one). It was a temporary art, wiped out or painted over at the end of the exhibition. In one wall drawing, the draughtsman was even ordered to wipe his handiwork out himself.

LeWitt was not comfortable with the 'more advanced' Conceptualists, with their emphasis on words and verbal long-windedness. Some of his works, in which lengthy propositions would result in very simple drawings, were intended in part as a satire on such artists. He disclaimed logic: 'Conceptual art is not necessarily logical … Ideas are discovered by intuition.' So was LeWitt making Conceptual art at all? 'I wasn't really involved in conceptualism as a movement as such but I was more interested in using abstract or geometric form to generate other kinds of ideas, but not to get into the backwaters of philosophy,' he remarked. When we consider that he had a passion for music, and the way that he referred to his concepts or instruc-tions as being like scores for performers, we can see his work as using music, rather than language, as its paradigm. Robert Rosenblum wrote of Sol LeWitt's drawings and Philip Glass's music (both made up of many small repetitive notes or marks) that 'the experience becomes rather a kind of slow immersion in a sonic sea, where the structural anchors of the score, discernible by the intellect's intervention, tend to be washed away by the mounting sensuous force of the cumulative sound.' He was close to describing the mystical experience itself with its joyous loss of self.

However, if there is 'at the heart of conceptual art', as critic Bernice Rose claims, 'the ambition to return to the roots of experience, to recreate the primary experience of symbolization uncontaminated

Four Color Drawing
for MW
Sol LeWitt March 15
1970

by the attitudes attached to traditional visual modes, whether representational or abstract', then LeWitt's work can be seen at the centre (or one of the centres) of Conceptual art.

Other artists turned to the basic act of counting in their work. Since 1965 the Polish painter Roman Opalka has done nothing but paint in white on a grey background the series of numbers from one towards infinity (93, 94). As he does so, he speaks out the numbers into a tape recorder. Staying faithful to his original premise, he has changed little in his working method, save that he makes each painting marginally whiter by adding one per cent extra white pigment to the background, so that they move closer to becoming white on white paintings. To emblematize the passage of time further, Opalka (who has now reached the four millions) has also photographed himself each day.

Equally obsessed with the passage of time is On Kawara, who in 1971 produced a ten-volume book which enumerated, one by one, the past one million years. On 4 January 1966 he began his 'date paintings', each consisting of the date on which the work is made, painted against a monochrome background. Up to three works may be done in one day, but if the painting is not completed by midnight of the day it commemorates, it is destroyed. They are made meticulously, with four or five layers of paint to ensure a perfect surface, and no sign of individual expression. By 1991 he had made nearly two thousand of these paintings. They are sold in boxes, each containing a page from a local newspaper of that day (92). The paintings therefore reveal where Kawara was on any one day, yet he always remains anonymous: he is never photographed or interviewed, and he does not even attend his own exhibitions. In 1969 he sent a friend a telegram which read 'I am not going to commit suicide don't worry'. Since then, he has periodically sent telegrams to friends with the enigmatic message 'I am still alive'. Often exhibited with these works are his books: *I read* (a collection of newspaper clippings), *I met* (a list of people he has met), *I went* (an equally deadpan list of where he has gone). Like Roehr's pieces, it can be argued that the date paintings are a form of meditation.

92
On Kawara,
*4 March 1973,
Dakar,*
1973.
Acrylic on
canvas;
20.5 × 25.5 cm,
8 × 10 in.
Museum
Boymans-van
Beuningen,
Rotterdam

Much sculpture at this time, with its emphasis on materials and process, can be described as the translation of Cage's injunction 'let sounds be themselves' into 'let stuff be itself'. Various terms have been used to describe such work: process, anti-form, post-Minimalism. Because of the emphasis on material, it is at once the opposite of, and the necessary corollary to, an art which approached the state of existing only in concepts or words. 'I am certainly no kind of conceptual artist because the physical existence of my work cannot be separated from the idea of it,' remarked Carl Andre. 'I have no art ideas, I only have art desires.' He was interested not in abstract ideas, but in consciousness, an experience of being in the world.

Like LeWitt, Andre wanted to distance himself from hardcore linguistic Conceptualism: 'I have a great anger against so-called conceptual art because the great beauty of art, of the physical arts now, and even many kinds of poetry, is the simple fact that art is close to nature, and the trouble with conceptual art is that it is not close to nature. If abstract art is art as its own content, then conceptual art is pure content without art. Following Reinhardt, I desire art-as-art, not art-as-idea.' Andre was speaking at a 1970 symposium in New York where not only he, but also Dan Graham,

93–94
Roman Opalka
Left
OPALKA 1965 /
1-00 Detail
1815786–1837737,
1965.
Acrylic on
canvas;
195·6 × 134·6 cm,
77 × 53 in
Right
OPALKA 1965 /
1-00 Detail
1896176–1916613,
1965.
Acrylic on
canvas,
195·6 × 134·6 cm,
77 × 53 in.
Collection of the
artist

Douglas Huebler and Jan Dibbets, all commonly seen as 'Conceptual', likewise tried to avoid being pigeonholed as such.

Anti-form, or an emphasis on process rather than an achieved final and definite result, is as much a reaction to formalism as any linguistic art. At this time, many artists began to leave in galleries piles of earth, unravelled wire, bales of hay, rough and fragmented stone: materials that would deteriorate or change before one's eyes. Richard Long created simple lines or circles on the floors of galleries, made from mud, pine needles or twigs. By 1968, Rafael Ferrer was making works from ice or leaves so that the inevitable decay of the

95
Robert
Smithson,
*Asphalt
Rundown*,
1969.
As executed in
a quarry near
Rome

sculpture put the emphasis on the process of the materials rather than the process of the maker. This was not, we should note, totally novel: Allan Kaprow had earlier made a Happening called *Fluids*, where people were invited to watch a wall of ice melt; in 1964, Iain Baxter in Canada made a two-ton ice sculpture as a way of presenting the concepts of disappearance, impermanence, change and destruction.

Robert Smithson also made sculptures, or interventions in nature, with viscous and unstable materials: in 1969 he had a lorry-load of asphalt tipped down the side of a quarry near Rome (95). The asphalt was left to do its own thing, to be itself, 'just following the slope, running down, and dissipating itself'. There were many other

pouring, dropping or falling pieces: Iain Baxter poured glue into holes in the ground; several of Lawrence Weiner's pieces asked for pouring (for example, *An amount of bleach poured upon a rug and allowed to bleach*); Bas Jan Ader fell from chairs, bicycles and roofs. These were works in which things happen to things – in Ader's case with the added undertone of both physical and psychological failure.

What of an art as concept and nothing but concept? This was the object of language-based work, but how should one present those words? Should presentation be an issue? With typical irony, in 1967 and 1968 John Baldessari made a series of works, in which anecdotes

or epigrams about painting were painted onto canvas by a professional sign writer (96). Baldessari no longer 'painted' himself but presentation was always part of his art and if painting was necessary to it, or contributed to its meaning, as we have seen with his *Commissioned Paintings* (see 85), there was no reason not to use it. Others, notably Joseph Kosuth, saw painting as a kind of pollution that a Conceptual artist must avoid. Presentation was not his concern, as he made clear in 1969:

My current work, which consists of categories from the thesaurus, deals with the multiple aspects of an idea of something. I changed the form of presentation from the mounted photostat, to the purchasing of spaces in newspapers and periodicals (with one 'work' sometimes

WHAT THIS PAINTING AIMS TO DO.

IT IS ONLY WHEN YOU HAVE BEEN PAINTING FOR
QUITE SOME TIME THAT YOU WILL BEGIN TO RE-
ALIZE THAT YOUR COMPOSITIONS SEEM TO LACK
IMPACT-- THAT THEY ARE TOO ORDINARY.
THAT IS WHEN YOU WILL START TO BREAK ALL THE
SO-CALLED RULES OF COMPOSITION AND TO
THINK IN TERMS OF DESIGN.
THEN YOU CAN DISTORT SHAPES, INVENT FORMS,
AND BE ON YOUR WAY TOWARD BEING A CRE-
ATIVE ARTIST.

taking up as many as five or six spaces in that many publications – depending on how many divisions exist in the category). This way the immateriality of the work is stressed and any possible connections to painting are severed. The new work is not connected with a precious object – it is as accessible to as many people as are interested, it is non-decorative – having nothing to do with architecture; it can be brought into the home or museum, but was not made with either in mind; it can be dealt with by being torn out of its publication and inserted into a notebook or stapled to the wall – or not torn out at all – but such decision is unrelated to the art. My role as an artist ends with the work's publication.

Of Baldessari, Kosuth remarked that 'although the amusing pop paintings of John Baldessari allude to this sort of work by being "conceptual" cartoons of actual conceptual art they are not really relevant to this discussion.'

96
John Baldessari,
What this
painting aims
to do,
1967.
Acrylic and oil
on canvas;
172·1 × 143·5 cm,
67¾ × 56½ in.
Sonnabend
Collection,
New York

At this point it might be useful to consider why so many artists were using words primarily or exclusively by the end of the 1960s. First, there was the ongoing project to dematerialize the art object. Secondly, there was an ambition to communicate to a wider audience. Thirdly, there was a desire to 'be in your head' as Harald Szeeman put it (see Chapter 6). As Robert Barry remarked in 1983, by which time his work had become almost exclusively word-based, 'I use words because they speak out to the viewer. Words come from us. We can relate to them. They bridge the gap between the viewer and the piece. When I read words, when I read a book, it is almost as if the author is speaking to me. The page seems to read itself to me. It seems to be speaking to me.' Fourthly, some argued that all works of art were essentially linguistic or, as Joseph Kosuth wrote in his 'Introductory note to *Art–Language* by the American Editor of 1970', 'Fundamental to this idea of art is the understanding of the linguistic nature of all art propositions, be they past or present, and regardless of the elements used in their construction.' Fifthly, there was a need to theorize about the meaning of art. Finally, another major reason for the tendency to dematerialize was disgust at the art market. As the sculptor and writer Ursula Meyer said in 1972, 'the shift from

object to concept denotes disdain for the notion of commodities – the sacred cow of this society. Conceptual artists propose a professional commitment that restores art to artists, rather than "money vendors".' By eliminating the art object artists could escape being assessed either in terms of 'style' or 'quality'.

In their 1968 article, 'The Dematerialization of Art', John Chandler and Lucy Lippard claimed that the emotional and intuitive way of making art which had dominated the market since 1945 had given way to 'an ultra-conceptual art that emphasizes the thinking process almost exclusively'. Because work was being made outside the studio, 'the studio is again becoming a study. Such a trend appears to be provoking a profound dematerialization of art, especially of art as object, and if it continues to prevail, it may result in the object's becoming wholly obsolete.' Many artists saw the obsession with dematerialization as foolish, however. Mel Bochner, for example, pointed out in a 1970 article that 'outside the spoken word, no thought can exist without a sustaining support.' Even a piece of typing needed paper.

Total dematerialization of the art object was sought by several artists, the Americans Ian Wilson and Christine Kozlov being among the most extreme. Wilson wanted to make purely verbal artworks and, to escape any vestigial materialization, spoke them aloud in a gallery rather than putting pen to paper. Kozlov likewise worked with sound, although the presence of a tape recorder, it could be argued, was very much an object in her exhibitions. For one of these, *Information, No Theory* (1970), the machine recorded all the noises in the room: as it contained only a two-minute continuous loop of tape, what was recorded was constantly being erased. The tape recorder was in a glass box, so the visitor to the gallery had to take it on trust that this pointless task was actually being performed.

The most famous of all 'dematerialized' exhibitions was Robert Barry's 1969 show at the Art & Project Gallery in Amsterdam (97). He pinned to the front door a sign that read, 'during the exhibition the gallery will be closed'. There was no work on view, not even a room where work could be seen: all that the artist presented was the fact

97
Robert Barry,
Bulletin issued for the 'Closed Gallery' piece at the Art & Project Gallery, Amsterdam, 1969

or assertion that an exhibition was going on – albeit invisibly. Inadvertently, no doubt, this echoed both Klein's *Le Vide*, and Manzoni's unfulfilled project to board up his studio, with a sign outside saying that the spirit of the artist lived there. Unlike Manzoni, however, Barry did not emphasize the artist as a personality – his concern was with the experience of the viewer. One wonders how the unsuspecting visitor felt when they arrived at the gallery door. Perhaps, amused or irritated, they reflected that Barry had in fact needed words to make his point. Were those eight words on the gallery door art, or a part of the art?

art & project

adriaan van ravesteijn
geert van beijeren bergen en henegouwen

amsterdam 9
richard wagnerstraat 8
(020) 720426

bulletin 17

drukwerk/
printed matter

aan/to

during the exhibition the gallery will be closed.

17.12 – 31.12.1969
exhibition:

robert barry

tuesday 2-5 p.m.
wednesday 2-5 p.m.
thursday 2-5 p.m.
friday 2-5 p.m.
saturday 2-5 p.m.

Lawrence Weiner had been seeking to make a dematerialized art for some time. As early as 1960, he had made a series of craters in Mill Valley, California by using explosions: they could be seen as a sculptural equivalent of Rauschenberg's *Erased De Kooning Drawing* (see 35): a work made by removing, rather than adding. By 1967, having given up painting a couple of years earlier, he was using language exclusively: 'I realized', he said, 'I wanted to spend the rest of my existence dealing with the general idea of materials rather than the specific.'

Weiner's 1968 exhibition at the New York gallery run by Seth
Siegelaub consisted of twenty-eight phrases, which were published,
one per page, as a book entitled *Statements*. These included the
following five:

A field cratered by structural simul
taneous TNT explosions

A removal to the lathing or support
wall of plaster or wallboard from a
wall

One standard dye marker thrown into
the sea

A series of stakes set in the ground
at regular intervals to form a rect
angle
Twine strung from stake to stake to
demark a grid

One quart exterior green enamel thro
wn on a brick wall

The fifth of these phrases was designated as a specific statement,
one that could be 'bought' rather than remaining, in perpetuity, in
the public freehold. The fourth had been 'realized' in the grounds of
Windham College, Vermont, the previous year, as part of a sculpture
show. The twine had got in the way of the fraternity boys who
wanted to play touch football, so they cut it. Weiner realized that it
ultimately did not matter: the words or instructions were sufficient.
Art was for him not the making of objects as an end in itself, but
was about 'the relationship of human beings to objects and objects
to objects in relation to human beings'. Nor was the display of the
words a problem: he was happy for them to be just handwritten on
loose sheets of paper or printed in catalogues. It was not Weiner, but
an early collector, Count Panza de Biumo, who first had his pieces
written up on the wall.

A language-based art allowed communication via the postal service

or even the telex system. It obviated the need for unnecessary production. When Victor Burgin called for 'an art of pure information' it was firstly out of revulsion at 'all those bent bits of metal and acres of canvas clogging up the basements of museums. A form of ecological pollution.' Secondly, Burgin was calling for an art that could communicate directly. Whereas Donald Judd might use the telex to send instructions for a sculpture's fabrication, other artists were using it to convey artworks themselves. This was a period when communication was being seen as an inherently good thing. The notion of an international community of artists, in constant communication with one another, was a highly attractive one in this period of anti-nationalist sentiments.

98
Dan Graham,
*Untitled
(Figurative).*
As printed in
Harper's Bazaar,
March 1968

The desire not just to communicate, but to reach a wider audience, and one outside the art world, partly explains why Dan Graham published artworks in such magazines as *Harper's Bazaar* and *The New York Review of Sex*, in the guise of advertisements. In the first (98), accompanied by the words 'Figurative by Dan Graham', he published an ill-printed receipt from a supermarket, in the second he requested a medical description of post-coital detumescence. In both cases, what he presents is at once banal and strange. They are out of place: *Figurative* appeared between an advert for tampons and one for bras; *Detumescence* was surrounded by adverts for pornographic books and sex aids. This was a strategy of intervention, an attempt to make the everyday strange.

```
1,000,000,000,000,000,000,000,000.00000000 miles to edge of known universe
  100,000,000,000,000,000,000.00000000 miles to edge of galaxy (Milky Way)
            3,573,000,000.00000000 miles to edge of solar system (Pluto)
                     205.00000000 miles to Washington, D.C.
                       2.85000000 miles to Times Square, New York City
                        .38600000 miles to Union Square subway stop
                        .11820000 miles to corner 14th St. and First Ave.
                        .00367000 miles to front door, Apart. 1D, 153 1st Ave.
                        .00021600 miles to typewriter paper page
                        .00000700 miles to lens of glasses
                        .00000098 miles to cornea from retinal wall
```

99
Dan Graham,
March 31, 1966,
1970

100
Victor Burgin,
Any Moment,
1970

0
ANY MOMENT PREVIOUS TO
THE PRESENT MOMENT

1
THE PRESENT MOMENT AND
ONLY THE PRESENT MOMENT

2
ALL APPARENTLY INDIVIDUAL
OBJECTS DIRECTLY EXPERIENCED
BY YOU AT 1

3
ALL OF YOUR RECOLLECTION AT 1
OF APPARENTLY INDIVIDUAL OBJECTS
DIRECTLY EXPERIENCED BY YOU AT
0 AND KNOWN TO BE IDENTICAL
WITH 2

4
ALL CRITERIA BY WHICH YOU MIGHT
DISTINGUISH BETWEEN MEMBERS OF 3
AND 2

5
ALL OF YOUR EXTRAPOLATION FROM
2 AND 3 CONCERNING THE DISPOSITION
OF 2 AT 0

6
ALL ASPECTS OF THE DISPOSITION
OF YOUR OWN BODY AT 1 WHICH
YOU CONSIDER IN WHOLE OR IN
PART STRUCTURALLY ANALOGOUS
WITH THE DISPOSITION OF 2

7
ALL OF YOUR INTENTIONAL BODILY
ACTS PERFORMED UPON ANY MEMBER
OF 2

8
ALL OF YOUR BODILY SENSATIONS
WHICH YOU CONSIDER CONTINGENT
UPON YOUR BODILY CONTACT WITH
ANY MEMBER OF 2

9
ALL EMOTIONS DIRECTLY EXPERIENCED
BY YOU AT 1

10
ALL OF YOUR BODILY SENSATIONS
WHICH YOU CONSIDER CONTINGENT
UPON ANY MEMBER OF 9

11
ALL CRITERIA BY WHICH YOU MIGHT
DISTINGUISH BETWEEN MEMBERS OF
10 AND OF 8

12
ALL OF YOUR RECOLLECTION AT 1
OTHER THAN 3

13
ALL ASPECTS OF 12 UPON WHICH
YOU CONSIDER ANY MEMBER OF 9
TO BE CONTINGENT

A word-based art could also make the act of thinking strange. If you got rid of the object with the exception of a few scraps of paper or writing on the wall, you were left with nothing but the words inside your head. This is illustrated dramatically by Dan Graham's *March 31, 1966* (99).

One begins with scarcely imaginable distances and ends up inside one's own eye. Macrocosm to microcosm. As one tries to imagine or comprehend these things, one is pushed back into one's mind, or quite literally into one's own physical body – into the infinitesimal gap between cornea and retinal wall. The necessity is to imagine, or to expand one's consciousness. It is in this experience that the object is truly dematerialized, that there is nothing but concept.

These artists wanted a language that was accessible. There was a sense that the 'language' of formalist art was an elitist one. Only a connoisseur could understand Caro's witty syntax of form (see 69). Only someone initiated in the mysteries of formalist art history could appreciate the philosophical rationale for Noland staining his canvases rather than painting on them (see 52). But anyone could understand the language of Lawrence Weiner or Dan Graham's works. Likewise, cold though the language may seem, and difficult though the mental gymnastics needed to conceive it may initially appear, a piece like *Any Moment* by Victor Burgin from 1970 (100) is comprehensible to any reasonably literate person.

Although this is an exercise in categories, the phrase 'bodily sensations' and the word 'emotions' indicate that this should be as much a sensory and emotional experience as watching a movie or examining a sculpture.

Other language-based work was quite deliberately difficult. When, in 1968, Terry Atkinson, David Bainbridge, Michael Baldwin and Harold Hurrel officially named themselves Art & Language, they formalized the discussion group as a producer of art. As we saw in Chapter 4, *Art–Language* (101) was the magazine that they produced sporadically from 1969. The first issue described itself as a journal of Conceptual art, but after that became almost entirely the mouth-

piece of the group. By using bureaucratic and academic language, the journal made strange the aesthetic, and discarded completely any trace of artistic emotive self-expression or the refined and wordy insight of the connoisseur. The following extract from a 1970 text by Michael Baldwin is not untypical of their somewhat acerbic tone and impersonal vocabulary:

Before anyone proceeds to chatter uncircumspectly about causally efficacious procedures and processes, he has to sort out whether or not these concepts are contextually intelligible. And a lot of this would appear to be functionally related to his interest in an ontological commitment to 'art objects', 'works of art' or what you like. This may well be a commitment mooted in terms of operational significance. If anyone wants that in short-term language, he might well be concerned with sorting out what sorts of entity are art; and that is largely taxonomic.

As we have seen, such discussion was not just about art, it was arguably art itself; not language about art, but language as art.

VOLUME 1 NUMBER 3 JUNE 1970

Art-Language

Edited by Terry Atkinson, David Bainbridge
Michael Baldwin, Harold Hurrell
American Editor Joseph Kosuth

CONTENTS

Art-Language is published three times a year by
Art & Language Press, 26 West End, Chipping Norton, Oxon.,
England, to which address all mss and letters should be sent.

Price 12s.6d. UK, $2.50 USA All rights reserved

Willis & Company (Printers) Limited, Industrial Estate, Platts Common, Barnsley, Yorkshire.

101
Art &
Language,
Cover of
Art-Language,
vol.1, no.3,
June 1970

Indeed, crucially, they were claiming not just language as art, but theorizing about art as art. Their journal acted as a continuing, roller-coaster critique of Modernism and of how the making, promoting and understanding of art was always, inevitably, ideologically preconditioned. It was theory rather than practice – if such a distinction can be drawn – that established one's stance in opposition to the complacency of established modes. Conceptualism was, however, rapidly becoming an accepted mode itself and the journal acted as a forum for both self-criticism and an invigorating satire of art institutions.

Keith Arnatt
TROUSER – WORD PIECE

'It is usually thought, and I dare say usually rightly thought, that what one might call the affirmative use of a term is basic - that, to understand 'x', we need to know what it is to be x, or to be an x, and that knowing this apprises us of what it is **not** to be x, not to be an x. But with 'real' it is the **negative** use that wears the trousers. That is, a definite sense attaches to the assertion that something is real, a real such-and-such, only in the light of a specific way in which it might be, or might have been, **not** real. 'A real duck' differs from the simple 'a duck' only in that it is used to exclude various ways of being not a real duck - but a dummy, a toy, a decoy, &c.; and moreover I don't know **just** how to take the assertion that it's a real duck unless I know **just** what, on that particular occasion, the speaker had it in mind to exclude (The) function of 'real' is not to contribute positively to the characteri- sation of anything, but to exclude possible ways of being **not** real - and these ways are both numerous for particular kinds of things, and liable to be quite different for things of different kinds. It is this identity of general function combined with immense diversity in specific applica- tions which gives to the word 'real' the, at first sight, baffling feature of having neither one single 'meaning,' nor yet ambiguity, a number of different meanings.'
John Austin, 'Sense and Sensibilia.'

102
Keith Arnatt,
Trouser-Word Piece,
1972.
Photograph and text

Another example of theory-based work is Keith Arnatt's *Trouser-Word Piece* (102), in which a large quotation from a philosophical text is seen beside the photograph of Arnatt holding his droll slogan, 'I'm a real artist'. It is uncertain whether the photograph acted as·a critique of the philosophy or was merely the pretext for quoting it. It is a problem with this, as with much other similar work, that most people remember the photograph, or at least the placard that Arnatt held, but few recall the 'serious' textual material he appended. Was it really necessary? In setting up an enquiry into the word 'real', yes. As a critique of the simple irony, yes. But it does not function well as an integral part of the work, serving ultimately only to underline what is implicit.

Alongside this plethora of language-based works was the monochrome painting – the most wordless or 'silent' of art. As early as 1965, both Mel Ramsden and Victor Burgin had begun making grey monochromes. This echoed both Rodchenko's and Reinhardt's endgame art. The monochrome was language *in absentia* – something made plain by Ramsden's sardonic claim that one of his paintings had an invisible content. The literature surrounding the subject was substantial, and the terms applied to it were many and various: 'silent painting', 'essential painting', 'opaque painting', 'fundamental painting'. Common to them all is the notion that by

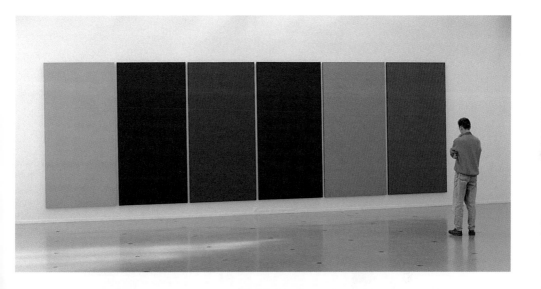

103
Alan Charlton,
Monochrome
paintings as
installed at the
Musée d'Art
Moderne de la
Ville de Paris,
1989

returning to the very basis of paint, the question 'What is painting?' could be clarified. For an artist such as Alan Charlton, this was an end in itself: from 1972 his entire *oeuvre* consisted of grey monochromes (103). But for most, including Burgin and Ramsden, it acted as a *reductio ad absurdum* after which they could leave painting behind completely.

The intention simultaneously to distil and negate the essence of painting is found again in work made by Daniel Buren and Niele Toroni, but the way that their work acted as intervention was the pre-eminent factor. By the end of 1966 these two Paris-based artists had arrived at uniform formats: Buren painted vertical stripes 8·7 cm

(3½ in) wide, Toroni made marks 'with a no. 50 brush pressed on the given carrier at regular intervals of 30 cm'. Two other painters, Oliver Mosset and Michel Parmentier, had also reduced their work to basic formats: Mosset to a single circle on a plain background, Parmentier to horizontal stripes.

In a demonstration at the opening of the Salon de la jeune peinture, an annual exhibition given over to old-fashioned figurative and abstract gestural paintings, these four artists each made a painting in their chosen signature format (104). All the while a loudspeaker intoned the words 'Buren, Mosset, Parmentier and Toroni advise you to become intelligent.' The next day they removed their paintings, leaving on the wall the slogan 'Buren, Mosset, Parmentier and Toroni do not show'. A pamphlet accompanying their demonstration listed all the things that they found wrong with painting, culminating with the comment 'to paint is to give aesthetic value to flowers, women, eroticism, the daily environment, art, dadaism, psychoanalysis and the war in Vietnam, *We are not painters*.' Such collaborations were typical of the time, although they were mostly temporary (Buren, Mosset, Parmentier and Toroni went their separate ways within a year). Collaboration was one means of breaking away from the notion of the solitary genius making 'masterpieces'.

104
Buren, Mosset,
Parmentier,
Toroni,
Manifestation
at the Salon de
la jeune
peinture, Paris,
January 1967

In another manifestation in June, they hung their paintings above the stage in the lecture theatre of the Musée des Arts Décoratifs in Paris (105). After an hour in which nothing happened, they passed out a paper to the bemused and fidgeting audience, telling them that 'obviously this is only a matter of looking at the paintings of Buren, Mosset, Parmentier and Toroni.' Marcel Duchamp, who was present, remarked, 'What a frustrating happening: one couldn't have done it better!' The word he should have used, rather than 'happening', was 'intervention'. Stella's dictum of 'what you see is what you see' had been taken to its logical conclusion: the paintings lacked any mystical message or aesthetic kick: they just were. But, crucially, by being placed where they were, they drew attention to their context, institutional and cultural. For all their seeming dumbness they had a political significance.

Toroni, like Buren, has maintained his signature format throughout his career. When reproached for consistently doing the same thing he retorts, 'Would you waste your time on someone who said, "I'm not interested in making love; it's always the same"? That's *his* business.' In short, the marks of the brush are always the same, but they are also always different, because they are made in a different context, in a different place, at a different time. His precise format, he has always insisted, is not arbitrary but arrived at by experiment, so that painted and not-painted are in equilibrium – earlier paintings where he had the marks at differing distances shimmered like Op Art, an association that he deplored. If the monochrome was the epitome of the wordless painting, then Toroni's brushmarks act not like words, but rather like punctuation: giving a momentary structure to the place and time where they manifest themselves.

For the opening of his first one-man exhibition at Yvon Lambert's gallery in Paris in 1970, Toroni left his name off the invitation: he wanted his work to appear as anonymous as the rain or the snow – an association also made explicit by Buren in his article 'It rains, it snows, it paints', published in *Arts Magazine* in 1970. In that text Buren quoted the French literary theorist Maurice Blanchot who argued that 'art is an inquiry, precise and rigorous, that can be carried out only within a work, a work of which nothing can be said, except that it is.' Buren calls for an anonymous 'rather impersonal "work" that offers the viewer neither answer nor consolation nor certainty nor enlightenment about himself or the work which simply exists. One might say that the impersonal nature of the statement cuts off everything we habitually call communication between the work and the viewer. Since no information is offered, the viewer is forced to confront the fundamental truth of the questioning process itself.' This impersonal work had no reference to a metaphysical scheme. Buren claimed that 'now we can say for the first time, that "it is painting", as we say, "it is raining". When it snows we are in the presence of a natural phenomena, so when "it paints" we are in the presence of an historical fact.' Painting was an undifferentiated, unending activity. Quite literally so, for, like Pinot-Gallizio and Manzoni, he often painted on rolls of canvas so large that it was unlikely they could ever be fully exhibited.

Arte Povera, the final manifestation of Conceptual art that we shall look at, means literally 'poor' or 'impoverished' art, a reference to the commonplace materials used in its making. All the various approaches explored above have at their heart a desire to demystify the work of art, but the Italian artists associated with Arte Povera sought rather the opposite. Its appeal to the poetic associations that cling to objects and materials, rather than to clean, abstracted mental processes, puts Arte Povera in a problematic relationship to Conceptual art. If we accept Kosuth's purist definition – an 'inquiry into the foundations of the concept "art"' – then we can only conclude that Arte Povera is most happily and grossly impure!

The term was coined by the Milanese art critic and impresario

105
Daniel Buren, Oliver Mosset, Michel Parmentier, Niele Toroni, Manifestation at the Musée des Arts Décoratifs, Paris, June 1967. Clockwise from top left: Buren, Mosset, Toroni, Parmentier

Germano Celant, and was used as the title for a number of exhibitions that he initiated from 1967 onwards, which included such artists as Giovanni Anselmo, Alighiero Boetti, Pier Paolo Calzolari, Luciano Fabro, Jannis Kounellis, Mario Merz, Giulio Paolini and Michelangelo Pistoletto. 'What has happened,' wrote Celant in 1967, 'is that the commonplace has entered the sphere of art ... Physical presence and behaviour have become art. The instrumental sources of language have been subjected to a new philological analysis. They have been reborn and with them a new humanism has arisen.' In fact, the airy rhetoric of both Celant and the artists themselves has obscured the genuine kinship of their work to other Conceptual art.

Celant's appeal to a golden age of understanding seems far distant from the cool acerbity of Burgin or Kosuth: 'Arte Povera', he remarked in 1969, 'is a refreshing phenomenon that tends towards "deculturation", toward the regression of the image to the pre-iconographic stage. It is a hymn to commonplace, primary elements – to nature understood in terms of Democritean unities, and to man as a "physiological and mental fragment".' At least initially, the political dimension of Arte Povera was very specific, as Swiss curator Jean-Christophe Amman remarked in 1970, 'Ars Povera means art that aspires to a poetic message in opposition to the technological world, and expresses that message by the simplest means. This return to the simplest and most natural laws and processes, with materials deriving from the power of the imagination, is equivalent to a re-evaluation of one's behaviour in industrialized society.'

Invited to exhibit in a gallery in Rome in 1969, Jannis Kounellis brought in twelve live horses and stabled them there (106). This and other Arte Povera works can be seen as a redirection of the ready-made. It was also a riposte to the antiseptic nature of the white space of the modern art gallery, its anonymity and neutrality. This was a far more theatrical gesture than any of Duchamp's. Why twelve horses? Would not one have made the point? But of course, Kounellis has more than one point to make: twelve is a number with mystical associations: twelve disciples, twelve months of the year. This was by all accounts an extraordinary sensory experience: the smell of horse

sweat, urine and dung, the noise as they shifted their iron-shod hooves, the sense of claustrophobia, the manifold associations of the horse – the stable, the heroic statue, the nightmare. Like other Arte Povera artists, Kounellis was interested not in industrial objects, as Duchamp had been, but with natural objects and materials as Richard Long and Robert Smithson were. He was concerned to re-establish a balance between sensibility and structure. So here the horses represent sensibility and the gallery represents structure, much as in painting the paint functions as 'sensibility' and the frame as 'structure'. The live animals also represent real life and the emphasis on real objects, as equivalent to language, underpins Arte Povera.

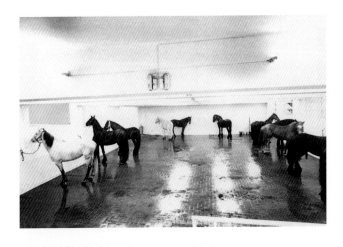

106
Jannis Kounellis, *Untitled*, 1969. As installed at the Galerie de l'Attico, Rome

While many artists were turning from object-making to words, Kounellis chose to go the other way. His work before 1967 had been dominated by paintings of words and numbers, often accompanied by performances. As Celant wrote, he:

moved from a written language on canvas to a daily physical operation to concrete and natural encounters, from the 'spoken' to the 'unspoken' and felt. His intention was to establish a contact and a confrontation involving the whole being, from the instincts to the unconscious. The implication of that experience became the only way of escaping from the dictatorship of the written word, which ran the risk of becoming a puritanical and aseptic language: a superior,

107
Jannis Kounellis,
Untitled,
1969.
Twelve hanging
shelves with
coffee; each shelf
23·5 cm, 9¼ in.
Kaiser Wilhelm
Museum, Krefeld.

108
Joseph Beuys,
Fat Chair I,
1963.
Wooden chair,
fat, thermometer
83·5 × 43·5 × 47 cm
32⅞ × 17⅛ × 18½ in.
Private collection

official language, like a computer's, against which Kounellis set the 'slang' of natural and organic matter. The use of organic and natural materials also implies ideological and social values: to a form of elitist language, that of philosophy, he opposes a popular language, that of the senses.

Alternatively, one might say that he emphasizes what Celant called the 'critical presence of materials', by contrast with the rather abstract phenomenology we associate with Minimalism. In a 1969 catalogue Kounellis presented the following text:

9 May 1969
I'll paint a tree black

15 May 1969
I'll bring a sailboat from the sea to a mountain lake,
and I'll paint it black

20 May 1969
I'll paint a farmhouse in the Roman countryside bright blue
(inside and out).

Comparing these utterances with those of Laurence Weiner, Kounellis differs above all in the use of the pronoun 'I'. Where Weiner seems to have no specific hearer or speaker – anyone can throw the dye marker in the sea – it is Kounellis himself who must paint the tree black. His work is about the adventure of his own life, his acts are loaded with potentially symbolic meaning. If Weiner's work is secular, that of Kounellis often seems to document some hermetic religious rite.

In another work from 1969 Kounellis placed fresh coffee on a series of scales, suspended one on top of the other (107). Again there is the appeal to the senses: the smell lingers in the museum, or it does if the curators follow his instructions and add freshly ground coffee regularly. The smell awakens not only the body's senses, but also its memories. There are personal memories for Kounellis in this piece: he was born in Piraeus, the main port of Greece, and the weighing of coffee can be seen as a symbol of trade and exchange. But we should

resist such narrow biographical interpretations. Our reading of the work should derive from a first-hand experience, which must involve our own personal memories: it is not an illustration of something else. The elements are floating signifiers. We may designate these and other Arte Povera works as poetic derivations of the assisted readymade. But whereas Duchamp is always cool, Kounellis leaves the objects and materials 'hot', mobile, uncertain.

This poetic reworking of the Duchampian readymade is not just an Italian phenomenon: Joseph Beuys and Reiner Ruthenbeck in Germany and Marcel Broodthaers in Belgium all worked with basic materials and forms, making them strange. The next chapter will look at the exhibitions in which such works appeared and will clarify how they can be considered an inherent part of an art that included supposedly dematerialized concepts and actions known only through documentation.

If Arte Povera can be considered a variety of Conceptual art, can the work of the Messianic German artist Joseph Beuys be so considered? He can certainly be described as reworking the Duchampian readymade – if not inverting it. Beuys had an enormous ego: his work was about himself, his myth and his teachings. In this sense he is very different from much of what we assume Conceptual art to be: rational, anti-autographic, wary of the creation of objects. Again, his drawings, wonderful though they may be, are very much about the gestural, autographic mark. It is when Beuys is at his most 'conceptual' (as for example in 1964 when he said that the Berlin Wall should be heightened by 5 cm or 2 in for aesthetic reasons) that he is least interesting and merely whimsical. His use of the readymade was always dominated by his signature: it is true that the readymade cannot exist without the signing or naming of it, but Beuys took it to greater extremes so that the readymade seemed no more than a support for the signature, as the canvas is for a painting. In 1974, when giving a lecture in New York, Beuys discovered that the blackboard eraser was labelled 'noiseless blackboard eraser': he signed all the 550 examples that he could find, so that they could become 'inexpensive multiples that would symbolize his first visit to

the United States'. Obviously it is the act of signing and the way that it links the object to Beuys (or the Beuys legend) that is crucial. If we compare his *Fat Chair* of 1963 (108) with the chairs of either George Brecht (see 53) or Joseph Kosuth (see 5), it is apparent that it is what he, Beuys, has done to the chair – covering the seat with fat and manipulating it like a sculptor models clay – that matters. It is more a sculpture than a readymade. His multiples are not so much readymades as relics: their purpose is to remind us of Beuys and his teachings, much as a fragment of the true cross reminds the devotee of the death and teachings of Christ. The Beuysian readymade functions much like any piece of traditional art: it comes ready-coded as the illustration to a narrative, the narrative of his life and teaching. Unlike most Conceptual art, it totally lacks irony.

Having now got a sense of the range of work made under the banner of 'Conceptual' art, and having introduced most of the more important or representative artists of this moment, in the next chapter we shall go back to 1968 and see how that troubled year parallels their work, and how the crisis of truth in representation and the crisis of authorship, which Conceptual art effectively revolves around, was part of a more general crisis of authority.

One pill makes you larger, and one pill makes you small,

And the ones that mother gives you don't do anything at all.

Go ask Alice when she's ten feet tall.

Remember what the Dormouse said,

'Feed your head'.

Jefferson Airplane, 'White Rabbit', 1968

The spectator's alienation from and submission to the contemplated object (which is the outcome of his unthinking activity) works like this: the more he contemplates, the less he lives; the more readily he recognizes his own needs in the images of need proposed by the dominant system, the less he understands his own existence and his own desires. The spectacle's externality with respect to the acting subject is demonstrated by the fact that the individual's own gestures are no longer his own, but rather those of someone who represents them to him. The spectator feels at home nowhere, for the spectacle is everywhere.

Guy Debord, *The Society of the Spectacle*, 1967

Conceptual art was always dialectical, being made in response to both its institutional and its political context, attempting often to make these contexts evident and sometimes actually to change them. In this chapter we look first at the political crisis which underlies this period, and second at the institutional context of museums, galleries and magazines in which Conceptual art appeared. The year 1968 represents the climax of that crisis of authority for which Conceptual art is both symptom and diagnosis. The institutional context, the 'art world', was a singularly naked example of capitalist machination and mystification. Artists were acutely aware of the context in which they showed their work and, indeed, one of the long-term effects of Conceptual art has been to revolutionize the way that art is exhibited. These two contexts, political and institutional, were not unconnected, for, as we saw in

109
Soldiers with
writing on their
helmets,
Vietnam, 1967

Chapter 1, the authority that declares a war is intimately related to the authority that declares what is art and what is not. Both had power invested in their language.

By the end of the 1960s, the 'Language Wars' of Vietnam had grown still more complex: the euphemisms had multiplied. 'Acute environmental reaction': shell-shock; 'credibility disaster': being found out; 'terminate with extreme prejudice': kill; 'fragging': murdering unpopular officers. According to news broadcasts, it seemed that the war was being waged by acronyms (NVA, DMZ, ARVN, MACV, PX – mystificatory names by which the North Vietnamese Army, Demilitarized Zone and such like were invariably referred to), but in reality it was being fought, on the American side, by teenagers (the average soldier was aged nineteen), uncertain why they were there and, in many cases, high on drugs.

At the start of 1968, President Johnson's advisors assured him that the Vietcong were incapable of resisting much longer. 'We have reached an important point when the end begins to come into view,' said General Westmoreland. Then, at the end of January, during the Tet holiday, the Communist forces unexpectedly launched attacks of unequalled ferocity. Briefly, they even occupied the United States Embassy in Saigon. Images of the battles flashed across the television screens and newspapers of America. Within a month the Vietcong had been driven out of Saigon, Hue and the other towns, suffering terrible losses, but the credibility of the American army and its publicity machine had been irrevocably damaged. 'We had to destroy the town to save it,' said one officer after the recapture of Hue. The American nation still, on the whole, supported the military adventure in Vietnam, but with a sense of foreboding, and a growing distrust of all that the politicians were telling them.

The infantry (or grunts), as journalist Michael Herr relates in his book *Dispatches*, whether in humour, desperation or mere confused bravado, had written on their helmets (109) and flak jackets, 'names of old operations, of girlfriends, their war names (Far From Fearless, Mickey's Monk, Avenger V, Short Time Safety Moe), their fantasies (Born to Lose, Born to Raise Hell, Born to Kill, Born to Die) their

ongoing information (Hell Sucks, Time is on My Side, Just You and Me God – Right? Why Me?).' It became an art form. The helmet of Tim Page, the photographer whose images best capture the confusion of Vietnam, quoted Frank Zappa: 'Help, I'm a Rock'. In unwitting parody of the art of Opalka, many marked up the calendar on their helmets and then crossed out each day they served and survived.

The trauma of Vietnam is the watershed of the late twentieth century. Too much was too preposterously pledged there. An advisor to President Nixon (110) told him in 1969, when he came into office, that 'the future of western civilization is at stake in the way you handle yourself in Vietnam.' It has been argued that Conceptual exhibitions such as the 'January Show' and *When Attitudes Become Form*, held that same year, were the death knell of a particular kind of Modernism in art, just as the Tet Offensive was the death knell of a particular kind of political, economic and technological modernism. The most technologically advanced nation in the world, the self-proclaimed standard-bearer of democracy, was gradually being defeated and humiliated by Asian peasants, the so-called 'gooks'. 'The American century,' as the theorist Daniel Bell said in 1975, 'foundered on the shoals of Vietnam.'

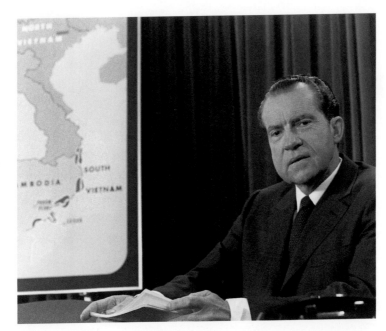

110
Richard Nixon announcing on television that he is sending US troops into Cambodia, April 1970

Given the political furore of the time, it is surprising how little art addressed the political situation directly. 'The American way of life is a myth,' wrote Sol LeWitt in 1968. 'Even middle class people do not follow it and only give lip service to it. American life is rapidly breaking down – it has not existed for a long time. There is no reason that the artist should feel he is part of something that is so decadent and without any purpose. He cannot think of himself as defending the establishment because the establishment hardly exists any more in any real sense.' But LeWitt did not believe that the artist should therefore make an art of political or social protest: 'as an artist he can do nothing except be an artist. He is asocial, not only anti-social, not pro-social. The sculptor, the painter, in today's world only implies by his reaction his protest.'

111
Police charging demonstrators sheltering under the arcades of St Mark's Square during the Venice Biennale, June 1968

Although it was not often ostensibly political, in its emphasis on truth- and lie-telling, and in its discomfort with the consumer society, Conceptual art was very much a reaction to and against this time. 'There is a tremendous dissatisfaction', the San Francisco artist Tom Marioni wrote in 1969, 'with the destructive forces of modern culture: war, pollution, and its generally widespread ignorance of nature. Another influence is the popularity of drug use and the religious importance that it places on an awareness of our environment and the reality of natural processes.'

Art belonged to the people, but had become the plaything of the decadent rich – or such was the popular belief. At the 1968 Venice Biennale students demonstrated, carrying banners saying 'Down with the art of the "padrone"', '1964: Pop Art, 1968: Police art.' The exhibition was ruined by the protests, both against the corrupt organization of the Biennale itself and the American involvement in Vietnam. Some 600 police officers beat back the protesters (111) and guarded the exhibitions. Twenty out of the twenty-three exhibiting Italian artists withdrew. Michelangelo Pistoletto put up a poster saying that anyone could come and work in his space. In the Argentinian pavilion, David Lamelas exhibited a telex machine that relayed the latest news reports from Vietnam.

Student activism inflamed the campuses of European universities, most flamboyantly in France, where a right-wing government under General de Gaulle was in power. Student numbers had been expanding rapidly, prompting the arts and social science faculties in Paris to move facilities and accommodation to the former shanty town of Nanterre. The student body in Nanterre alone had grown by nearly 11,000 between 1964 and 1967, and discontent was growing due to the lack of student representation, the formality of relations between teachers and students, and discontent at the bourgeois mentality of the Gaullist state which the university was geared to feeding. When the anarchist Danny Cohn-Bendit, fresh from an international student demonstration against the Vietnam War, found that militant colleagues had been arrested, he and his comrades took over the administrative block in Nanterre on 22 March 1968. Some of the Situationists became involved, organizing the students and fomenting wider unrest. The student union and the lecturers' union began to mobilize and teaching was suspended.

On 2 May the entire campus was closed, and the focus of agitation moved to the Sorbonne in Paris. Demonstrations turned into out-and-out riots on 3 May, more arrests were made and even school students, stirred up by police repression, became involved. On the night of 10–11 May, barricades went up in the streets of Paris. ('I am too old to meddle, even to have an opinion about all this nonsense,'

Duchamp, that least politically engaged figure, wrote to a friend before he fled to Switzerland.) The Sorbonne became a student commune. The workers went on strike, calling for De Gaulle to be consigned to the history books. But, of course, no such revolution occurred. The atmosphere of this brief period before normality returned is now looked upon as one of heady, Utopian euphoria, but there was also an element of foot-stamping on the part of the students, who were fed up with being treated like children.

Images were crucial. The year before, the Situationist Guy Debord's influential book *The Society of the Spectacle* had been published. As the quote that introduced this chapter shows, it was concerned with Marxist notions of alienation, but within a society of conspicuous consumption, where 'all that once was directly lived has become mere representation'. This transformation of objects and lives into images meant that 'the spectacle is a social relationship between people that is mediated by images.' Many of the posters created by art students during the riots of 1968 combined 'agit-prop' (agitational propaganda) with an awareness of advertising and a sort of proto-Conceptual art. Many of the paradoxical slogans, seen either in the posters, or in graffiti, retain the acerbic flavour of the Situationist theory: 'Let us be realistic and demand the impossible.' 'If I do not want to think, I am a coward.' 'Art does not exist, art is you.' 'Are you consumers or participants?' 'Revolution must happen inside us before it is achieved in reality.' 'Live your dreams!' The poster reproduced here (112), which translates as 'Propaganda comes into your home', shows a Situationist awareness of the extent to which spectacle controlled the populace, the mass media being what the Marxist philosopher Louis Althusser called an 'ideological state apparatus'. Television, controlled by the state and big business, allowed for a new type of colonialism, an inner colonialism whereby the population was duped and controlled, not with weapons but with a glossy, false picture of the world.

When Grace Slick, lead singer of the band Jefferson Airplane, screeched out her parody of Lewis Carroll, quoted at the beginning of this chapter, she was not just intimating that hallucinogenic drugs

112
L'Intox vient a domicile (Propaganda comes into your home), Situationist poster, 1968. Private collection

were disorientating – and fun – she was calling for a rebellion against authority and a willingness to expand one's consciousness. Some saw the political sloganizing of such bands as loudmouthed, specious and dishonest. Frank Zappa's attitude to all this 'revolutionizing' was cynical and dismissive. 'Revolution is just this year's flower-power', he said in 1969 at the London School of Economics, a famous hotbed of student dissidence. 'I'm not big on demonstrations,' he replied when asked about the recent riots at the University of California in Berkeley. 'Infiltrate the establishment,' he continued to a mounting chorus of boos and hisses from the audience of students, 'that's the way it happens. Infiltrate until there's another generation of lawyers, doctors, judges – I don't think you should harm people.' At one of his concerts in 1969, when the audience began objecting to the presence of security guards he replied, to general disbelief, that 'everybody in this room is wearing a uniform, and don't kid yourselves.'

Artists too were involved in protests and alternative organizations. In New York many artists joined the Art Workers' Coalition, which protested against museum policies and society at large. Many of their demonstrations were of a decidedly Dadaistic nature, for example when they interrupted a meeting of the board of the Metropolitan Museum of Art and hurled cockroaches on the table; many of its members were believed to make their money through renting out slum property.

What the artists were doing, above all, was talking incessantly. This moment of Conceptual art was one of fervent argument and discussion, whether at the soirées held each week in New York by Robert Smithson, in bars late into the night, in galleries like Antwerp's Wide White Space or, most especially, in large group exhibitions, which effectively functioned as conferences for the artists. International travel was just becoming readily available, and even in large cities the art communities were still small and easy to find and enter. It was possible for a British artist like Terry Atkinson to go to New York and meet all the Minimalists and Conceptualists, or for a New Yorker to go to London and find his confrères there. As some artists recall, however, this was not so much a social scene as an arguing scene.

113
Joseph Beuys teaching, 1965.
l to r: Hasenauer, Brömmelkamp, Beuys, Thadeus, Palermo

The art schools were the other crucial forum for discussion. Many of those associated with Conceptual art taught for a living and saw this as an integral part of their creative work. 'It [teaching] is my most important function,' said Joseph Beuys. 'To be a teacher is my greatest work of art.' Teaching for Beuys was always about discussing and arguing (113), not about explaining craft skills. Education for him should never be an elitist activity; he was sacked from the Düsseldorf academy in 1972 because he let anyone join his course who applied for it.

Coventry School of Art in the Midlands was the original venue for Art & Language, where its members taught an art theory course from 1969 until 1971 (when most of them were sacked by a new and conservative dean). For them, teaching or conversation was as self-evident a way of making art as it would be for a philosopher to make philosophy.

In 1971 John Baldessari was asked to put on an exhibition at the Nova Scotia College of Art and Design, but there wasn't enough money in the budget for him to travel there. He therefore proposed that the

students should write 'I will not make any more boring art' on the walls of the gallery. In the event, they went one step further and repeated the line again and again, covering the walls entirely (114). This was a wonderful parody both of school punishments and of the way that students of academic art had traditionally copied their masters. Now one could learn or teach by making challenging proposals, or by asking questions.

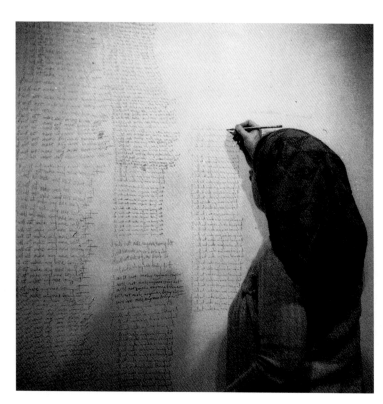

114
Students of
John Baldessari,
*I will not make
any more
boring art,*
1971
Left
Student writing
on a wall of the
gallery, Nova
Scotia College
of Art and
Design, Halifax
Right
Lithograph
after the
original work;
57 × 76.4 cm,
22½ × 30⅛ in

Amid all this ferment hardly anyone noticed when the most polite and diffident of revolutionaries, Marcel Duchamp, died in 1968. 'The silence of Marcel Duchamp is overrated,' Joseph Beuys had claimed in 1964, and by the late 1960s this silence seemed reprehensible. Later, it transpired that Duchamp had not, in fact, stopped working but rather had spent twenty years making an illusionist tableau entitled *Given: 1° The Waterfall; 2° The Illuminating Gas (Etant donnés).* It consisted of a naked woman lying in a landscape, holding a lamp, which one peeped at through holes in an old wooden

I will not make any more boring art.
I will not make any more boring art.
I will not make any more boring art.
I will not make any more boring art.
I will not make any more boring art.
I will not make any more boring art.
I will not make any more boring art.
I will not make any more boring art.
I will not make any more boring art.
I will not make any more boring art.
I will not make any more boring art.
I will not make any more boring art.
I will not make any more boring art.
I will not make any more boring art.
I will not make any more boring art.
I will not make any more boring art.

door. In a world where voyeurism was about to be declared offensive by Feminists and the puritanical Left, this seemed inappropriate and irrelevant.

Despite the seriousness of the time, the meetings and events of Conceptual art could also be fun. During the *Third International Exhibition of Figurative Art* at Amalfi in Italy in 1968, Alighiero Boetti sat outside the entrance to the exhibition like some itinerant peddler, with a few gadgets and samples of materials on a white cloth beside him. Michelangelo Pistoletto draped an old coffin with cheap and gaudy fabrics. Mario Merz placed a large wicker cone over a steaming pan of beans. 'Long,' as artist and agitator Piero Gilardi recounts,

'climbed the hill behind the town and erected a white pole at the top, then, in a second action, he put on his St Martin's School sweater, came into the square and shook hands with twenty people or so' (115). The key event was when the Italian artists played the English and Dutch at football in the exhibition hall. For Gilardi, who had demanded the end of the gallery system in an article the previous year, this was a new sort of carnival that would embody pleasure, communication and political upheaval.

If there is a history of Conceptual art in this period, it is not a history of individual geniuses and their 'breakthroughs', but of such exhibitions. Crucially, in the ensuing search for change and

alternatives, the role of the exhibition organizer went from that of the impresario or dealer to that of the exhibition maker, creatively involved with the artist in the production of the exhibition as an art form in itself. The development of this phenomenon would transform and inform exhibitions generally in the years to come. It also signalled the opening up of the museum to an art that explored self-consciously both the way that it had been created and the way that it embodied society's values and structures (an approach later to be termed 'an art of institutional critique'). Pre-eminent innovators in the area of exhibition-making were Seth Siegelaub and Harald Szeemann, who curated the two most famous of Conceptual exhibitions, which epitomized respectively the narrow and wide definitions of Conceptual art.

In the United States, the seminal Conceptual art exhibition is commonly regarded as the New York dealer Seth Siegelaub's *January 5–31 1969*. It was not the first time that Siegelaub had experimented with alternative forms of 'exhibiting'; he had already on occasion dispensed with the actual show, instead producing a catalogue that would function as an exhibition in itself. Having taken art out of the conventional gallery context and enclosed it within the pages of a book, Siegelaub now brought his 'January Show' back into real space, but into a space very different from the one that art had previously inhabited. Renting vacant office space in the nondescript McLendon Building at 44 East 52nd Street, Siegelaub set out to create a show which 'consisted' of ideas in much the same way that the work by his artists (including Robert Barry, Douglas Huebler, Joseph Kosuth and Lawrence Weiner) emphasized the process of ideation over realization.

The most important component was still the catalogue, where the ideas were predominant, and presented directly and in their essence. On an accompanying sheet Siegelaub maintained that 'the exhibition consists of [the ideas communicated in] the catalogue; the physical presence [of the work] is supplementary to the catalogue.' Visitors entered a reception area where Adrian Piper (then a young and unknown artist) was available to answer questions, and where they

115
Richard Long
shaking hands
with passers-by
at Amalfi,
1968

could sit and read the catalogue. This was a small ring-bound folder, listing eight works by each artist, including two photographs, and a statement. In the McLendon Building, Weiner removed a 92 × 92 cm (36 × 36 in) square from the wall, showing also *An amount of bleach poured upon a rug and allowed to bleach*. Kosuth mounted a series of pages from newspapers and magazines in which he had had thesaurus entries printed as part of his *Art as Idea as Idea* series.

Douglas Huebler had begun his career as an action painter, but by the 1960s he was making Minimal-like sculpture. When he met Siegelaub in 1965, he was in the process of rethinking the whole process of making objects. He was attempting to convey geometric and minimal shapes so large that they could be indicated only by such conceptual forms of illustration as maps and charts. In the catalogue, he stated that, 'The world is full of objects, more or less interesting; I do not wish to add any more. I prefer, simply, to state the existence of things in terms of time and/or place. More specifically, the work concerns itself with things whose interrelationship is beyond direct perceptual experience. Because the work is beyond direct perceptual experience, awareness of the work depends on a system of documentation. This documentation takes the form of photographs, maps, drawings and descriptive language.' The first sentence, with its implications of dematerialization, was eagerly quoted, but the second, with its attention on the everyday – emphasized by the banal photograph opposite of a street corner on which Huebler had placed a small sticker marking the apex of a vast, but otherwise undelineated triangle – was often forgotten.

Huebler's *Duration Piece #6, 1969* was the first work with which one came into contact upon entering the exhibition space: it consisted of a series of photographs of what had begun as a large square of sawdust (about 2 m or 7 ft on each side) on the opening Saturday, but which, as people walked in and out, changed constantly. Adrian Piper (not the artist himself, since Huebler was keen to remove himself as much as possible from the act of making) had been instructed to take Polaroid photographs every thirty minutes over a six-hour period, and to tape them to the wall, but not in tem-

116
**Douglas
Huebler**,
Installation of
*Haverhill-
Windham-New
York Marker
Piece, 1968* at
the exhibition
*January 5–31
1969*, New York,
1969

poral order. At the end of the first day, the sawdust was swept up,
and the piece finished. On a windowsill Huebler placed a notebook
documenting the *Haverhill-Windham-New York Marker Piece, 1968*
(116). In it were photographs of thirteen locations, taken at 80 km
(50 mile) intervals along the 1045 km (650 mile) route connecting the
three cities named in the title. The work had a poetic suggestiveness
and humility very much in contrast to the tautological certainties
characteristic of Joseph Kosuth.

Robert Barry, in one of the pieces in the catalogue, *Outdoor nylon
monofilament installation*, stretched transparent nylon strings
between trees and took a photograph of the area he had thus
modified. The photograph shows nothing more than a suburban
house and garden as, of course, the strings were invisible. In the
gallery he created two (unhearable) sound pieces, both of which
consisted of a single radio wave, one 88 megacycles (FM), the other
1600 kilocycles (AM). The transmitters were concealed, so that the
only visible aspects of the works were the labels on the gallery
wall, informing the public of their presence. He also buried half a
microcurie of barium-133 in Central Park: the art, as with his inert
gas series (117) – where he released small amounts of various gases
into the atmosphere – was there, but could not be seen.

Harald Szeemann, curator of the Kunsthalle in Berne, mounted the
influential exhibition *When Attitudes Become Form: Works – Concepts*

117
Robert Barry,
*Inert Gas:
Helium*,
1969.
2 cubic feet of
helium released
into the
atmosphere in
the Mojave
Desert,
California

– Processes – Situations – Information between 22 March and 27 April
1969. On top of the title page of the catalogue he wrote the motto
'Live in Your Head', and in his introductory notes described how 'the
artists represented in this exhibition are in no way object-makers.
On the contrary they aspire to freedom from the object, and in this
way, deepen the levels of meaning of the object, reveal the meaning
of those levels beyond the object. They want the artistic process itself
to remain visible.' Szeemann had been following events in New York
and elsewhere with interest, and wanted to bring together these art
forms, variously labelled Conceptual art, Earth art, Anti-form and
Arte Povera. He realized that in order to exhibit such work success-
fully, it was vital to ignore categories and to give way to the spirit of
informality in which the works themselves had been conceived. If the
object was incidental, then the attitude was everything, or as he put
it, 'works, concepts, processes, situations, information (we conscious-
ly avoided the expressions object and experiment) are the "forms"
through which these artistic positions are expressed.'

Szeemann's attitude towards curating was analogous to that of
the artists. He revealed his curatorial processes in the catalogue by
including such ephemera as the letters from the artists responding
to his invitation to show in the exhibition, and the address he had

118
Walter de Maria,
Art by Telephone,
Installation work for the exhibition
When Attitudes Become Form,
1969.
Kunsthalle, Bern

If this telephone rings, you may answer it. Walter De Maria is on the line and would like to talk to you.

Wenn dieses Telephon klingelt, dann nehmen Sie den Hörer ab.

Walter De Maria wird am Apparat sein und möchte zu Ihnen sprechen.

used on his trip to New York: thus entering into the preparation of the exhibition as a collaborator. This show was, typically, also a social occasion: twenty-eight of the sixty-nine artists involved came from outside Switzerland to install their work for the exhibition. Outside the Berne museum, Michael Heizer created the *Berne Depression* by using a wrecking ball to smash part of the pavement near the Kunsthalle, and Richard Long went on a hike in the Swiss mountains, documenting this with a statement inside the gallery itself. Every free bit of space was used, with Jannis Kounellis placing bags of grain along the stairway. Walter de Maria placed a telephone on the floor; beside it he put a sign saying 'If this telephone rings, you may answer it. Walter de Maria is on the line and would like to talk to you' (118). Joseph Beuys smeared fat along the wall and added a bed of felt, placing a cassette recorder alongside which constantly repeated 'ja-ja-ja-ja-ja-nee-nee-nee-nee-nee'.

When the exhibition moved to London, Victor Burgin joined the list of exhibitors and installed his *Photopath* (119), the materialization of one of the index cards on which he was writing 'concepts': 'a path along a floor, of proportions 1 × 20 units, photographed. Photographs printed to actual size of objects and prints stapled to floor so that the images are perfectly congruent with their objects.' This may seem

119
Victor Burgin,
Photopath,
1967.
As installed in
the exhibition
*When Attitudes
Become Form* at
the Institute of
Contemporary
Arts, London,
1969.
Private
collection

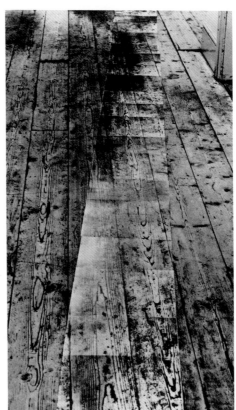

like a dematerialized version of Carl Andre's *Lever* (see 68), but it had a rather different genesis. It came out of Burgin's reflections on those passages in the *Philosophical Investigations* where Wittgenstein explores how we can simultaneously look at something and think about it.

Lucy Lippard organized a show entitled *557,087* in Seattle, in September 1969, likewise seeking to break the restrictions of the museum exhibition. The title was the population of the city and the work of sixty-two exhibiting artists was spread about it, often in obscure or unexpected places. Much of the work seemed self-consciously provisional: Robert Smithson told Lippard to make '400 square snapshots of Seattle horizons – should be empty, plain, vacant, surd, common, ordinary, blank, dull, level. Beaches, unoccupied, uninhabited, deserted fields, scanty lots. Houseless, typical, average, void, roads, sand bars, remote lakes, distant timeless sites – use Kodak instamatic 804.' She was then to pin them to the wall in eight rows. Every day, Vito Acconci sent a postcard from New York, which was pinned to a calendar. Keith Arnatt's proposal was for a hole in the ground to have mirrors put in it, while the plug of earth removed should also be covered in mirrors. The catalogue consisted of ninety-five catalogue cards bearing the artists' proposals (120) and Lippard's enthusiastic introduction.

Konzeption/Conception at the Stadtisches Museum, Leverkusen, in October 1969, was the first museum show to include a variant of the word 'Conceptual' in its title. It was appropriate that it should be held in Germany, as this country (and Europe as a whole) provided institutional support for Conceptual art, both in terms of exhibitions and purchases. By the end of the 1970s, for example, most European museums that collected contemporary art owned a work by the American Robert Barry, but not a single museum in his native country had a piece in their collection. A high proportion of the work at Leverkusen was photographic: Robert Smithson showed particularly atmospheric images of industrial landscapes in the Ruhr, Bernd and Hilla Becher showed photographs of electricity pylons, Ed Ruscha showed pictures of old girlfriends from his teenage

seth siegelaub has cooperated in the development of the show from its inception; anne gerber was a most sympathetic liaison between us and the contemporary art council. friends from seattle and vancouver, as well as some of the artists, helped with the installation.

i should also like to thank mrs. arthur krauss, mrs. peter rawn and mrs. sheffield phelps for assisting mrs. gerber; neil meitzler and thomas maytham of the seattle art museum; the fischbach and castelli galleries, raymond l. dirks, new york; and above all the artists – for their patience and their works.

the catalog consists of 95 4" x 6" index cards in random order including 64 cards compiled by the artists themselves, 20 text cards by l.r.l., 1 title page, 1 acknowledgements, 2 lists of the council members and officers, 1 forward by the council president, 1 list of artists, 3 selective bibliography, 1 list of films shown, 1 addenda to artists' cards.

l.r.l.

a) Daniel Buren d) Nothing
b) March 25 -I938 e) Nothing
c) Paris f) I°- I do not show anything pere
sonally in this exhibition.
2°- You can see during both exhi
bitions, in Seattle and Vancouver, sheets of paper
with white and coloured vertical stripes glued on
walls, palisades, shop-windows etc... as well as insi-
de the museum.
3°- This proposition is the work
of several people, artists or not, whose names you
will find in this catalog as well as the other invited
"artists".
The thing is to see alternate white and co-
loured vertical stripes,
Which are mere alternate white and coloured
vertical stripes,
Which take back to alternate white and co-
loured vertical stripes......whatsoever may be their
place, colour, number, author........

Jeffrey Wall
b. 29/9/1946 Vancouver, B. C. Residence: Vancouver

Project (Seattle): Area Analysis 1968-1969
Materials: Turf/Sod
Size (Dimensions): Unlimited
Procedure: 1.Predetermined number of markers (75) are dis-
tributed over area the size and shape of which is indeterminate &
which is established in accordance with conditions of practical
availability. 2.At each marker a 10-inch square of turf is removed.
3.All squares are collected, then all are replaced.
Note: Step 3 is entirely indeterminate.

JOHN BALDESSARI
GEORGE NICOLAIDIS

June 17, 1931
September 6, 1939

National City, California
Jersey City, New Jersey

Title: Ghetto Boundary Project

Date: First Version April 6, 1969

■ ■ ■ ■BOUNDARY■ ■ ■ ■
A SECTION OF A CITY, ESPECIALLY A THICKLY POPU-
LATED AREA INHABITED BY MINORITY GROUPS OFTEN
AS A RESULT OF SOCIAL OR ECONOMIC RESTRICTIONS.

Description: Two thousand ghetto boundary stickers were affixed
to telephone poles, street signs, etc. along the fifteen mile
boundary on the ghetto in southeast San Diego. Boundary location
was supplied by the San Diego Planning Commission. Project can
be done wherever there is a ghetto. Number of stickers used
varies with size of ghetto.

RE: SEATTLE SHOW, SEPTEMBER 1969/

TERRITORIAL RESERVE #4 (1968)

FOR THE DURATION OF AN EX-
HIBITION A BOUNDARIED, UN-
MARKED, PRE-ALLOCATED, SPACE
OF 46,656 CUBIC INCHES IS TO
REMAIN UNOCCUPIED.

MEL BOCHNER

B.D : 23 AUG.'40 R.: NEW YORK CITY

" A word is worth 1,000th of a picture." Iain Baxter

The visual artist uses words to convey information about sen-
sorial or potentially perceptible phenomena; his current pre-
occupation with linguistics, semantics, and social structures
as exposed by anthropology is not surprising. The fact that it
is indeed structural patterns that are the basis of these fields
brings them into visual range.
"People deny that words have anything to do with pictures. I
don't accept that. They do. Art is a source of information....
the work concerns itself with things whose inter–relationship is
beyond perceptual experience. Because the work is beyond per-
ceptual experience, awareness of the work depends on a sys-
tem of documentation...photographs, maps, drawings and de-
scriptive language."
Douglas Huebler
"All art originates in the human mind, in our reaction to the
world rather than in the visible world in itself."
Ernst Gombrich

years in Oklahoma, Hamish Fulton showed photographs of the
landscapes he had walked through. Artists using words included
Lawrence Weiner, Joseph Kosuth and Pier Paolo Calzolari, whose
piece *Iomemecomepunticardinali* (*Imemelikecardinalpoints*) showed
those words cast in bronze and tin. Bochner, Kawara, LeWitt and
Piper all showed work concerned with measurement or time. Huebler
showed *Location Piece #14*:

Once every week during the exhibition 'Conceptual Art – No Objects'
at the Stadtisches Museum Leverkusen, Schloss Morsbroich an
editorial concerning a 'typical' domestic issue originally printed in the
Haverhill [Huebler's home town] *Gazette* newspaper will be reprinted
in German in the Leverkusen newspaper and a similar 'typical'
editorial printed in that newspaper will be reprinted in the *Haverhill
Gazette*. In this manner an exchange of the location will occur with
the location of the artist during the period of the exhibition.

120
Catalogue cards
from 557,087,
Seattle, 1969.
10·2 × 15·2 cm,
4 × 6 in

```
KEITH ARNATT
Tintern, Chepstow (England)

Mirror Plug: positive mirror
case; negative mirror chamber.

(it can be considered as a
disappearing act in two senses:
optically and physically).

(LL card from KA information)        photo:G.M. Moore
```

The exhibition *Conceptual Art and Conceptual Aspects*, held at the
New York Cultural Center in April 1970, was an early statement of
what can be referred to as 'hardcore' Conceptual art – that is, almost
exclusively language-based works. It was an austere exhibition.
Having been allocated 4·5 m (15 ft) of wall space, Mel Bochner marked
his boundaries with two strips of masking tape, drew a line between
them and wrote "15´" on it; Hans Haacke (a German who had moved
to New York) displayed recordings of the climate in the main room
of the exhibition; Kosuth created an information room in which, on

long library tables, were placed stacks of books relating to his works including *The Fifth Investigation (Proposition One) and The Sixth Investigation (Proposition Two)*. Newspapers and journals were added as the exhibition proceeded. Some of Bruce Nauman's videos and Ed Ruscha's books were shown, but most of the seventy-five works were unadorned text on paper. A statement by Donald Karshan, the organizer, sought to claim that this was the true Conceptual art: 'the most "conceptual aspect" of work often categorized as "anti-form", "earthworks", "arte povera", and so on.' Sol LeWitt's version of Conceptual art was historically important, he claimed, but no more. 'We know that quality exists in the thinking of the artist, not in the object he employs – if he employs an object at all. We begin to under-stand that painting and sculpture are simply unreal in the coming age of computers and instant travel. Post-Object Art is based on the premise that the idea of art has expanded beyond the object or visual experience to an area of serious art "investigations". That is, to a philosophical-like inquiry into the nature of the concept "art" so that the working procedure of the artist not only encompasses the formulation of works, but also annexes the traditional one of the critic.' Karshan is echoing Joseph Kosuth here, whom he claimed was the earliest American artist to begin such work – a claim that Bochner, Graham and Smithson disputed. Kosuth's 'Art after Philosophy', first printed in *Studio International* the year before, and quoted in the previous chapter, was the main catalogue text. There were further theoretical texts by exhibitors, in particular Art & Language and another theoretical think-tank, the Society for Theoretical Art & Analyses, one of whose members, the Australian Ian Burn, had also been involved in the show's organization. Perhaps the most intriguing part of the catalogue, however, was a medley of ninety-one quotes on art by a wide range of artists including Duchamp, Malevich and those artists involved in the exhibition:

Art should raise questions.
Bruce Nauman

The working premise is to think in terms of systems, the interference with and the exposure of existing systems. Such an approach is

concerned with the operational structure of organizations, in which the transfer of information, energy and/or material occurs. Systems can be physical, biological or social, they can be man-made, naturally existing or a combination of any of the above. In all cases verifiable processes are referred to.

Hans Haacke

I present oral communication as an object, all art is information and communication. I've chosen to speak rather than sculpt. I've freed art from a specific place. It's possible for everyone. I'm diametrically opposed to the precious object. My art is not visual, but visualized.

Ian Wilson

Every act is political and, whether one is conscious of it or not, the presentation of one's work is no exception. Any production, any work of art is social, has a political significance. We are obliged to pass over the sociological aspect of the proposition before us due to lack of space and considerations of priority among the question to be analysed.

Daniel Buren

Although the editor of this collection of quotes remained anonymous in the catalogue, it has subsequently been published (in his collected writings) as a work by Joseph Kosuth.

In June 1970, an exhibition organized by Germano Celant, *Conceptual Art, Arte Povera, Land Art*, opened in Turin: the selection again showed that the European notion of Conceptual art was wider than that held in New York: word-oriented artists such as Joseph Kosuth and Lawrence Weiner were hung next to Land artists such as Walter de Maria and Robert Smithson, and Arte Povera artists like Michelangelo Pistoletto and Jannis Kounellis. The three tendencies were seen as overlapping, rather than mutually exclusive. The inclusion of pieces by Piero Manzoni and Yves Klein also indicated a specifically European genealogy for the later works. During the show, Piero Gilardi led protests against the inclusion of American artists: like others in Europe, he believed that there should be an embargo on all American culture until the United States army left Vietnam.

In July 1970 the Museum of Modern Art in New York mounted

Question:

Would the fact that Governor Rockefeller has not denounced President Nixon's Indochina policy be a reason for you not to vote for him in November?

Answer:

If 'yes'
please cast your ballot into the left box
if 'no'
into the right box.

121
Hans Haacke,
Ballot box
installed for the
exhibition
Information at
the Museum of
Modern Art, New
York, 1970

122
John Baldessari,
*Cremation
Project*,
1970.
Bronze plaque
and urn, box of
ashes, six colour
photographs
mounted on
board.
Sonnabend
Gallery, New York

the exhibition *Information*, a reluctant acknowledgment of Conceptualism by the bastion of Modernism in which seventy artists participated. As so often, Stanley Brouwn exhibited most discreetly: an index card gave his address (he felt that 'this project is the potential bearer of millions of other projects: they can write me or phone me; or they might think of writing or phoning me; or they might note my address and send me something, etc.'). Rafael Ferrer put eight tons of ice in the garden; three photographs of it on the day of the opening were installed in the gallery. The Brazilian Cildo Meireles showed two Coca-Cola bottles and two one-dollar bills. (This was one of the very few Conceptual exhibitions that included artists from the Communist countries and from Latin America.) Walter de Maria affixed to the wall an enlarged page from *Time* magazine which featured a review of his work.

JOHN ANTHONY BALDESSARI

MAY 1953 MARCH 1966

Some critics worried that *Information* castrated the work: that it appeared as just 'information', not in any way a challenge or threat to the institution in which it was displayed. For most of the 299,057 people who visited the exhibition during its twelve-week run, it was probably an entertainment, albeit a confusing one, rather than an experience of consciousness raising. Some 12·4 per cent of those visitors put their ballots as requested in the piece situated by Hans Haacke at the entrance (121). Nelson Rockefeller was then running for re-election as governor of New York and he was also a member of the museum's board of trustees. The ballot asked visitors to indicate whether they thought his support for the Vietnam War was a reason not to vote for him. Most of those who completed the ballot said it was.

In September 1970 John Baldessari showed his *Cremation Project* (122) as part of the exhibition *Software* at the Jewish Museum in New York. Weary of the way that old paintings were clogging up his studio, he had all the unsold works of art that he had made between 1953 and 1966 officially cremated. It was a typically witty and coherently acted out play: where was the art? In the six caskets (five adult size, one child size) containing the ashes? Or in the set of photographs that documented the action? Or in the bronze plaque that recorded the act?

Some exhibitions or projects became known only after the event, through documentation. One such was *Pier 18*, initiated by the artist Willoughby Sharp and the photographer Harry Shunk, in which twenty-seven artists were each invited to define an idea in a performance on a disused pier on the west side of Manhattan. The performance would be photographed by Shunk. Allen Ruppersberg performed *Homage to Houdini*: a brick from Houdini's home was put in a suitcase, which was securely bound with chains and thrown into the sea. Unsurprisingly the brick did not manage to escape. In an ecological gesture Gordon Matta-Clark built a mound of junk and earth on the pier in which he planted some discarded Christmas trees: then he had himself suspended upside down over the mound so as just to touch the top of a tree. Subsequently the photographs were pinned to the wall of the Museum of Modern Art: a photograph of each handwritten project was followed by a long sequence of

black-and-white images. In effect, the exhibition could be seen only after the event.

On 15 April 1969, German television broadcast a 'television exhibition' entitled *Land Art*. The director, Gerry Schum, had asked several artists to conceptualize or direct a short sequence while he filmed it. With Richard Long, he went on a ten-mile walk and every half mile switched on the camera and zoomed in on the landscape at that point. With Smithson, he showed mirrors placed in the landscape. But Schum was only allowed to broadcast one such exhibition, for he refused to overlay the works with the inane commentary that normally accompanied art programmes. On two other occasions he was able to insert an art piece into the daily flow of televisual trivia and entertainment: between 11 and 18 October 1969 a series of nine

123
Jan Dibbetts,
TV as a
Fireplace,
1969.
Still from a
24-minute
television film
transmitted on
West German
television

photographs were shown of Keith Arnatt slowly disappearing into a hole in the ground, one image each night repeated twice (at 8·15 and 9·15) for two seconds. Arnatt noted wryly that, 'it was originally made as a comment upon the notion of the "disappearance of the art object". It seemed a logical corollary that the artist should also disappear.' Through seven days in December, at the end of the night's viewing, Jan Dibbets showed a fireplace (123): over the period, the fire was seen being lit, blazing and dying down. Both of these pieces dealt with duration and sequence in ways that were radically different from normal television; they were neither voiced-over nor explained – bemused viewers had to make a meaning for themselves.

IT IS PURPOSEFUL.

IT IS VARIED.

IT IS DIRECT.

IT IS AMORPHOUS.

IT IS INFLUENCED.

IT IS REMOTE.

IT IS DEFINED.

IT IS INCONSISTENT.

Schum had a messianic zeal for the new media. He believed that in future artists would survive, like authors, on publication fees or television repeat fees, not on the sale of objects. He also believed that, as we know the world primarily through television, it was the role of artists to explore and expose the medium. This was a way towards political understanding and change. 'The criterion for the selection of artists and art tendencies for presentation in the Television gallery,' which he proposed opening in Berlin, 'is based on whether the underlying concepts may be expected to contribute to the advancement of cultural and social change.' Video, in particular, might allow art to escape from the restrictive triangle of studio-gallery-collector. However, the artists often did not share such Utopian beliefs. Though they liked the idea of reaching a wide public, generally they were more interested in how a time-based medium allowed them to formulate a concept or act.

124
Robert Barry,
Eight slides
from *It is ...
Inconsistent*,
1971.
Slide projection
installation at
Prospect 71
exhibition,
Düsseldorf

The role of Conceptual artists in developing these new media has been too little realized. In the late 1980s a new generation would reinvestigate the technology of video and projection, but at the show *Prospect 71* in Düsseldorf, for example, seventy-five different artists showed films, videos, slide projections or photo-texts. Bas Jan Ader showed two short films (thirty-four and thirteen seconds long): in *Fall I (Los Angeles)* he fell off a roof, in *Fall II (Amsterdam)* he fell into a canal. His terse statement in the catalogue was: 'The artist's body as gravity makes itself its master.' Robert Barry showed several of his slide projection pieces including *It is ... Inconsistent* (124) in which twenty-one slides of words were flashed up in sequence.

Commercial galleries could be almost as entrenched and stuffy as museums. For a new type of art and a new type of artist, a new type of gallery owner, or gallerist, was needed. Turned off by the stolidity and chauvinism of the Cologne Art Fair, which began in 1967, Konrad Fischer initiated the alternative art fair or exhibition *Prospect 68* in Düsseldorf the next year, inviting only the most adventurous galleries to bring artists.

The Düsseldorf exhibition was not so much about the marketing of commodities as about the presentation of artists, and the viewing

of each other's work: more a seminar than a saleroom. It was crucial for Fischer that such events were meeting places for an international community of artists. For exhibitions at his own gallery, he would pay for artists to travel to Düsseldorf to make their work rather than transport it. He would even have them stay in his own home, both to save money and because he saw them as colleagues rather than employees. He correctly assumed that if an artist created a reputation among his or her peers their work would eventually sell. The gallery could also generate publications as information: Fischer got each artist to design the private-view card for his or her exhibition, thus making it part of the exhibition.

The publicity that the Amsterdam gallery Art & Project put out soon became as important as the exhibitions themselves. Starting in 1968, each exhibition would be announced by a four-page bulletin, but this, and the works made for it, soon took on a status all of their own. *Bulletin 11* was ostensibly an advert for Stanley Brouwn's participation at *Prospect 69*, but it was very much a work in its own right: the exhibition information was given on the first page, but the second and third were covered by the words:

walk during a few moments very consciously
in a certain direction;
simultaniously an infinite number
of living creatures in the universe
are moving in an infinite number of directions.

The fourth page shifted from vast type to minuscule. Below a circle were the words:

walk during a few moments very consciously
in a certain direction;
simultaniously a vast number
of microbes within the circle
are moving in a vast number of directions.

In *Bulletin 15* Jan Dibbets asked each recipient to return the right-hand page. For each page returned a straight line would then be drawn on a map of the world from that person's home to Amsterdam. (Again,

duration and communication were subjects – the map was ultimately reproduced in *Studio International*.) *Bulletin 17* had the 'advert' for Barry's famous exhibition: its pages were empty but for the statement 'during the exhibition the gallery will be closed' (see 97). In *Bulletin 23* Keith Arnatt gave readers the opportunity to buy units of time from his exhibition. The price was $1 per second and one had to buy at least sixty seconds. The purchaser was promised that they would receive photographic evidence of the time they had bought – in his installation, Arnatt was counting down to the end of the exhibition with a digital display. Ian Wilson chose to show nothing but three blank pages in *Bulletin 30*. Barry's second piece in *Bulletin 37* was more verbose than his first:

some places to which we can come, and for a while, 'be free to think about what we are going to do.' (Marcuse)

galleria sperone, turin
I.galleria san fedele, milan
II.art and project, amsterdam
III.

The attitude of Anny De Decker and Bernd Lohaus at the Wide White Space gallery was that they too were participants, that it was not merely a matter of getting stuff to put up on the wall to sell, but of getting the artists to come to the space and make something appropriate for it. Inevitably, many of the exhibitions were of ephemeral or apparently unsellable pieces: in 1974 Lothar Baumgarten exhibited a slide projected over some real objects. All of Buren's five exhibitions included work *in situ*, both inside and outside the gallery. In 1969, in lieu of a summer show, the Wide White Space posted out an envelope bearing the name of the gallery and that of James Lee Byars (one of the more eccentric artists of the period, much given to wearing gold suits and big hats); inside was a crumpled slip of paper which when straightened out read:

The epitaph of con. art is which questions have disappeared?

Many of these gallerists were opposed to the capitalist system, while paradoxically living by it. They believed, like at least some of their

artists, that art could change the world. The Cologne gallerist Paul Maenz took a motto from Seth Siegelaub: 'Art is to change what you expect from it'. Generally the European galleries were much more adventurous than the American. 'In America all the galleries are basically general stores,' remarked Konrad Fischer. 'Anything new is just a drop in the ocean.' However, apart from Siegelaub who had no real gallery, John Gibson was showing Conceptual artists, especially those using photography. In 1971 John Weber opened a gallery in New York, representing Smithson, Buren, Haacke, LeWitt and others. He was selling not to new clients, but to the same people who had always been interested in avant-garde art; he had previously worked for the Dwan Gallery in Los Angeles, which represented Klein and the Nouveaux Réalistes and then, when it moved to New York, sponsored the Land artists. It was difficult, however, to sell certain works: Weber held eight exhibitions of work by Hans Haacke before he sold anything at all. In 1971 Leo Castelli, doyen of New York gallerists, began to represent artists such as Kosuth, Barry, Huebler and Weiner.

The whole context of the commercial gallery was paradoxical for those Conceptual artists whose work presented a critique of capitalism and the art world. This was most clearly shown by Michael Asher's 1974 exhibition at the Claire Copley Gallery in Los Angeles, where he showed nothing, but removed the partition that normally separated the gallery's office from the public viewing area (125). It was the gallerist, her desk and stock that were on exhibition and anyone who came in to discuss business also became part of it. By implication, the gallerist also became a performer – indeed only one with a keen sense of the ambiguity of her position would have accepted the proposal.

As with the gallerists, there was also a new type of collector who behaved like a participant. Having bought a piece by Marcel Broodthaers, Isi Fiszman smashed it at an exhibition opening at the Wide White Space. Anny De Decker was horrified, but Fiszman had Broodthaer's approval for this action. Typically, the artist reused the fragments in another work. Fiszman remarked that the Conceptual collector was one who asked questions and did not just hoard.

Count Panza de Biumo, who acquired one of the largest collections of Minimal and Conceptual art, believed that collecting a person's work was equivalent to studying him: just as, if one was studying Wittgenstein, one would read all that was available, so it was necessary to collect an artist in equivalent depth. Alan Charlton, the painter of grey monochromes (see 103), on one occasion found that Panza had bought a complete exhibition before it even opened. He eventually bought over forty of Charlton's paintings; between 1971 and 1974 he also bought twenty-one works by Kosuth. Although he was often buying just proposals or concepts, Panza had the space in his home at Varese in Italy to realize them, earning the wrath of Donald Judd when he fabricated some of his proposals without approval.

He also gave a permanent place to the immaterial works of Robert Irwin and Maria Nordman. Their light-based pieces bear a curious relation to Conceptual art: these were artists who literally dematerialized the work. Irwin was making works that consisted of nothing but windows, their frames so sharply honed as to make the world outside seem palpable, just as the light which spread across the frame and room began to seem palpable (126). But their emphasis is on the purely perceptual, and they reject the linguistic as a basis for understanding. The first monograph on Robert Irwin took as its title Paul Valéry's statement that 'seeing is when you forget the name of what you are looking at.'

Herbert and Dorothy Vogel in New York did not have the financial resources of Count Panza, but they both worked: he at the post office, she as a librarian. They had some money to spend on art, though often the only way they could afford works was on 'hire purchase'. At this time such work was very cheap; these were artists who did not expect to sell anything. Within twenty years, the Vogels had managed to acquire fifty-five works by LeWitt and seventy-five by Barry. As they did not have the space to display large works, they concentrated on drawings and proposals. When they bought an early 2·5 m (8 ft) vertical Sol LeWitt sculpture, they had to get permission from him to install it horizontally so that it would fit into their modestly scaled home. Herbert Vogel had met Sol LeWitt in the 1950s

126
Robert Irwin,
Varese Portal Room,
1973. As installed at Varese, Italy

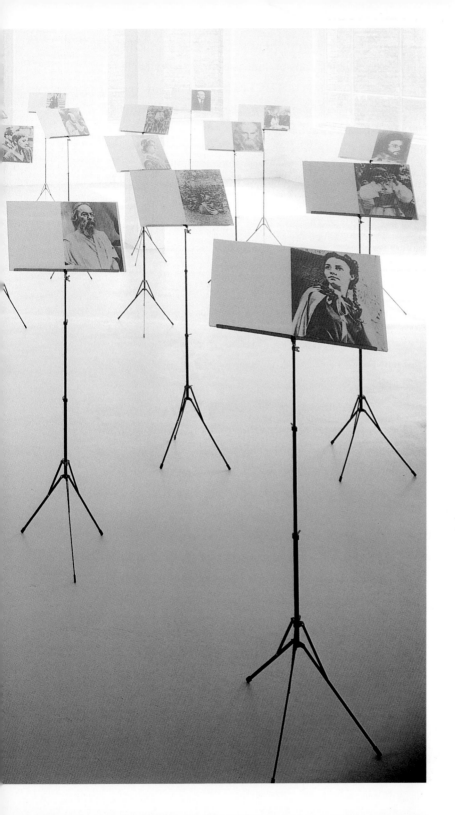

127
Giulio Paolini,
*Apotheosis of
Homer*,
1970–1.
Music stands,
photographs,
text and glass.
Private
collection

and this friendship had led him to meet many other artists, including Dan Graham. A friendship with the artists and an engagement with their thinking was a necessary prelude to buying a work. For the Vogels, Minimal and Conceptual art 'was challenging. But it wasn't revolutionary. It evolved from what was before. It was rejecting the abstract expressionist, but it made sense.'

Collecting Conceptual art raised interesting questions. How could you purchase Robert Barry's 'Closed Gallery'? Until the Vogels bought it, Barry himself had thought it was unsellable. What they got to own were the announcements for the three different exhibitions where the gallery was closed, framed with a piece of paper signed by Robert Barry stating that they owned it. As Dorothy Vogel said, 'even the ownership is conceptual because anybody having those three announcements could frame them and say there's the Closed Gallery piece.'

Private collectors were prepared and able to stage works permanently and sympathetically. Few museums have been willing, for example, to give a home, as Anton and Annik Herbert in Ghent have, to such difficult works as Paolini's *Apotheosis of Homer* of 1970–1 (127). These assembled music stands support no musical scores, but only photographs of historical figures as played by famous actors: Jack Palance as Attila the Hun, Richard Harris as Oliver Cromwell, Jean Sylver as Socrates, Flora Robson as Queen Elizabeth I. 'Each spectator', Paolini said, 'can feel himself reflected in each of the actors, and thus in each of the historical characters and this completes the scene. This, however, has no narrative intention whatsoever: there is no link between the characters, save their shared symbolic function.' It is an opportunity to choose, however vicariously, a new identity.

One of the impulses of Conceptual art was to fuse the role of artist and critic, so inevitably the magazines of this period are full of articles and reviews written by artists. The substantial body of theory found in them is a key element in Conceptual art's self-analysis. Those most sympathetic, other than *Art–Language* and later its New York equivalent *The Fox*, were *Studio International* (where Charles Harrison, later a member of Art & Language, was an assistant editor), *Artforum* in New York, and the eclectic magazine

128
Daniel Buren,
Work in Situ,
1969.
As installed at
the Wide White
Space, Antwerp

Avalanche, edited by the artist Willoughby Sharp. From the start, the magazines realized that they were not necessarily just about art, but were art itself. Typical of such self-consciousness was the way that *Avalanche* organized exhibitions in 1973 about its own history, showing its audio tapes, layout sheets and unpaid bills.

Studio International reserved forty-eight pages of its July/August issue in 1970 for Seth Siegelaub, who in turn requested that six international curators should each take eight pages in which to 'exhibit' work by their chosen artists. Although the idea of an exhibition in a magazine was novel, the issue as a whole took on the look of countless other 'catalogue exhibitions', with endless pages of black-and-white photographs (many artists just sent photographs of physical objects on display elsewhere), diagrams and typewritten statements. The French curator Michel Claura decided to break with what was rapidly becoming a mannered format, however, and breathed new life into the enterprise: his entire section consists of nothing but Daniel Buren's alternating yellow and white vertical stripes. Flicking through the magazine, these jump out of the monochrome, introducing an unexpectedly bright freshness, which suggests a keener and more imaginative approach to the possibilities of a 'curated magazine'.

Books were an attractive format to artists of this time: they were reasonably cheap, accessible and transportable. 'Books are a neutral source. Books are "containers" of information,' as Siegelaub remarked. On the other hand, there were conventions and expecta-

tions to play with and subvert (as Ed Ruscha had already shown) just as there were with art. Most Conceptual artists produced books and, together with exhibition catalogues and magazines, they still give today an extraordinary sense of the art and its period. They were normally small and allusive objects, such as Richard Long's *From Along a River Bank* (produced by Art & Project in an edition of 300), a slim 10 x 20 cm (4 x 8 in) pamphlet with nineteen black-and-white photographs of reeds and grasses, plus a couple of clover leaves that Long, one presumes, had picked along a riverbank. The image that the book creates, with its echoes of the pressed flower in the keepsake book, is of the 'readyfound' as memento. Such books had, from the start, the feel of a small press production in their inevitable

129
Tom Marioni,
The act of drinking beer with one's friends is the highest form of art,
1970

130
Paul Kos,
Sound of Ice Melting,
1970.
Installation with ice and microphones.
As installed at the Museum of Conceptual Art, San Francisco

sense of rarity and preciousness. As a student I did not find them cheap: why should I pay so much for Lawrence Weiner's *Statements*, a book of only twenty-six pages, each with nothing but a terse sentence on, when I could buy two much-needed textbooks for the same amount? Only later did I realize that they were cheap as art. But, even if one did not buy them, there were galleries where one could go and see them.

Douglas Huebler's desire to make an everyday art was echoed by others. 'What I'm trying to do is make art that's as close to real life as I can without its being real life,' said Tom Marioni. If art was made art by being in a museum or gallery, did it cease to be art when it came

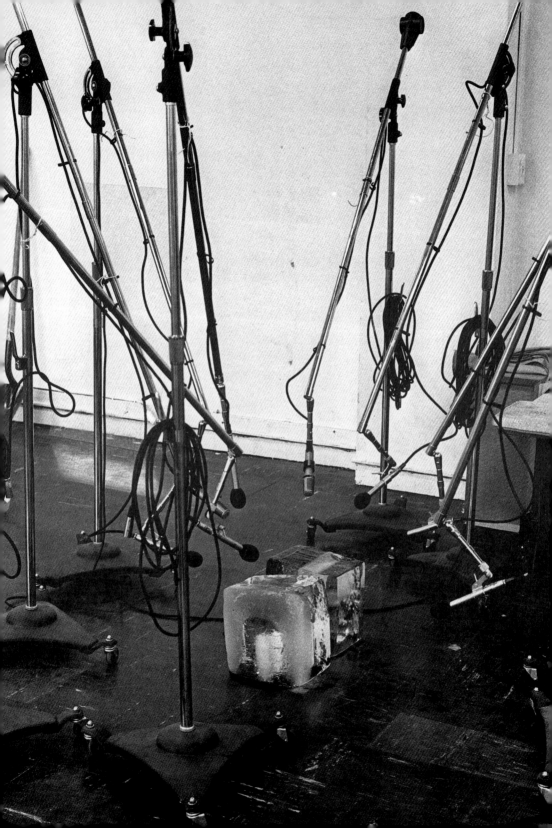

outside? This uncertainty was crucial to the growth of 'alternative spaces', run normally by artists, which acted both as public experimental laboratories and as intermediary places between the museum and the street. The division between the art and non-art context was made especially clear in a series of works by Buren, which were placed both inside and outside the museum or gallery. In his installation at John Weber's gallery, the ubiquitous stripes were displayed on fabric that was strung on a line like flags out of the window and across the street; in his 1969 installation at the Wide White Space, the stripes were pasted on the interior and exterior walls (128). If inside they were preserved as art objects, outside they were subject to wind, rain, snow and the unwelcome attention of passing dogs.

Having worked as a curator at the Richmond Art Center in California, Tom Marioni was aware of the social nature of the museum. Some of his early performances were called *The act of drinking beer with one's friends is the highest form of art* (129), and involved him or Allan Fish, the name he assumed for these and other works, getting drunk. But the key element was that of drinking 'with one's friends' – it was all about communication, of which the shared beer was an emblem. The residue of the event, empty bottles and all, were left as an exhibition. So when he created his own 'museum' or 'alternative space', it was the social function that concerned him especially. This was where you could come to have a drink and to talk. It was a site for performances and installations, not a repository of objects. In 1970, at the opening of an alternative space that Marioni grandly

131
Reiner Ruthenbeck,
Apartment Object II,
1971

132
Lothar Baumgarten,
A voyage or 'With the Ms Remscheid on the Amazon': The account of a voyage under the stars of the refrigerator,
1968–71.
Details from a series of 81 slides
Top left
Äskulap,
1971
Top right
Fauna-Flora,
1970
Bottom left
Pigment Stacked,
1968
Bottom right
Norddeutscher Lloyd,
1970

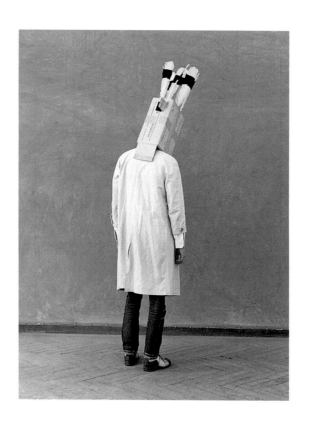

called the Museum of Conceptual Art in San Francisco, Paul Kos exhibited a piece called *Sound of Ice Melting* (130) in which two 11 kg (25 lb) blocks of ice were surrounded by eight microphones which amplified and recorded that sound. (In a 1969 exhibition Kos had blocked the entrance to the Richmond Art Center with 3,080 kg (7,000 lb) of ice and given visitors axes to hack their way into the museum.) Kos's 1970 piece asked an imponderable question – what sound does ice make when it melts? – but in some respects it was a somewhat Fluxus event, as was the accompanying piece by Tom Marioni: he climbed up a ladder and urinated into a bucket below, much to the consternation of the audience.

If art was everyday, then art could be made in everyday situations. Why not store it where one stored other things – such as in the freezer? Out of necessity, this was where Reiner Ruthenbeck's *Apartment Object II* (131), a large block of frozen Chinese ink, had to be kept. He had written in an early text that he was 'interested in stillness, in the silence that emanates from objects. I see this stillness as a form of energy that these objects radiate.' (Ruthenbeck was later to become involved in transcendental meditation.) The photograph was also a good medium to preserve that stillness. 'I try to make it [the art object] function as an obstruction, so that people are irritated. It bothers me that people always put the art on the wall – the wall has become the ghetto for the art. Another aspect of my work, one that interests me especially is that I'd rather affix art to a window or put it in a refrigerator, so as to make the viewer more aware of it. I want to confront the viewer or the collector with my art. When the art is suddenly in his washing machine, he's got to think about it.' The block of black ice is unexpected, paradoxical (we expect ice to be translucent) and not consumable. Ruthenbeck was acutely aware that what an art object means depends on where it is placed. His objects are deliberately difficult to define: existing somewhere between 'useful' and 'poetic'.

Between 1968 and 1971 Lothar Baumgarten made various ephemeral actions or objects in his studio or in the street (132). Sometimes these would be simple: a pyramid of pigment placed in a forest. Sometimes

they were more complex: a photograph of jaguar skin set on a music stand in the woods, as though it were a score for the animals to sing; the red feather of a South American bird seemingly discovered beneath the floorboards; tropical butterflies in his fridge; the artist standing with a box on his head (133). These are all ephemeral or transient: 'the street was my gallery,' he said. The objects were left there to disintegrate: anyone could see them – if they noticed them. Much of his work showed a fascination with native cultures of South America; he would eventually go and live with the Yanomami Indians in Venezuela in 1978 for eighteen months. This was a time when artists wished to see other cultures not as merely exotic, as tourist entertainment, or as tokens of the 'primitive', but as alternative social structures. The works would have been most likely seen at the time in the form of a slide projection entitled *A voyage or 'With the Ms Remscheid on the Amazon': The account of a voyage under the stars of the refrigerator*, in which images and quotes from anthropological books of the early twentieth century were often interleaved, so that different languages and positions were set in dialectic.

134
Adrian Piper,
Catalysis III,
1970

Adrian Piper took to the street. 'All around me I see galleries and museums faltering or closing as the capitalist structure on which they are based crumbles. This makes me realize that art as a commodity really isn't such a good idea after all.' So she wrote in 1970. Following the bombing of Cambodia by the United States, the shooting of four protesting students at Kent State University and the growth of the women's movement and of black consciousness, Piper had become radically aware of her own blackness and womanhood. She turned against dealers who expected her to be nothing more than 'an outstandingly creative gallery receptionist'. Her expectation that the capitalist art world was on the edge of collapse was commonly held. She resented its elitism: 'There must be some way of making high-quality, exciting art that doesn't presuppose an intensive education in Art Since 1917 in order to appreciate it.'

In response, she gave up making austere Conceptual works, documented by text on paper, and began making what she called

'Catalysis' actions. She believed that the art object – material or
conceptual – in its assumption of separateness and stability,
could no longer relate to a society in turmoil. She set out to make
performances which made strange people's perception of the
everyday: each act being a 'catalytic agent between myself and the
viewer' (a catalytic agent is one that causes change, but does not
change itself). She did not want to make Happenings, so she behaved
coolly, as if nothing untoward was going on. She wanted to preserve

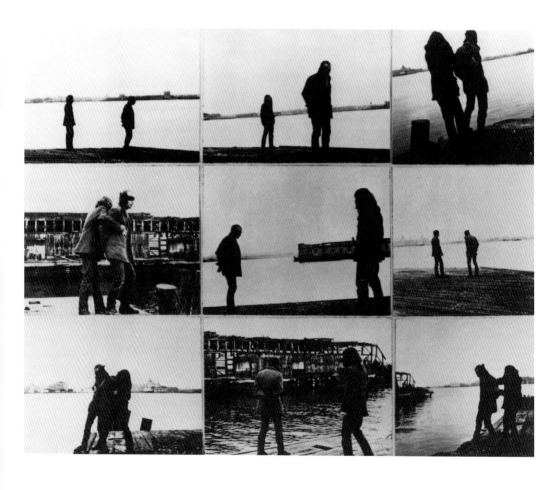

135
Vito Acconci,
Security Zone,
1971

136
Robert
Smithson,
Spiral Jetty,
1970.
Rock, salt
crystals, earth
and water;
diam. c.457 m,
1500 ft.
Great Salt Lake,
Utah

PURE DIRT PURE EARTH PURE LAND

WALTER DE MARIA
THE LANDSHOW

NO OBJECT ON IT
NO OBJECT IN IT

GALERIE HEINER FRIEDRICH*
MÜNCHEN, MAXIMILIANSTRASSE 15
28. SEPTEMBER BIS 12. OKTOBER
DIENSTAG BIS SAMSTAG 10 BIS 19 UHR

NO MARKING ON IT
NO MARKING IN IT
GROWING ON IT
GROWING IN IT

CARL ANDRE, DAN FLAVIN, HEERICH, SOL LEWITT, LUEG, WALTER DE MARIA, CLAES OLDENBURG, GERHARD RICHTER, BOB RYMAN, PALERMO, POLKE, RUTHENBECK, FRED SANDBACK, CY TWOMBLY, FRANZ ERHARD WATHER, ANDY WARHOL, GALERIE HEINER FRIEDRICH, MÜNCHEN, MAXIMILIANSTRASSE 15, TELEFON 08 11 29 50 21

the impact and the uncategorized nature of the confrontation. In *Catalysis III* (134) she painted her clothes with white paint, put on a sign saying 'Wet Paint', and went shopping at Macy's for some gloves and sunglasses.

Vito Acconci had begun life as a poet, but by 1969 he was also doing performances which addressed the relationship between artist and audience: which invaded personal spaces, or exposed his own. He performed *Security Zone* (135) with fellow artist Lee Jaffe for the exhibition *Pier 18*. His proposal had been as follows:

1. A person is chosen as my guard and/or opposition party. He is specifically chosen: someone about whom my feelings are ambiguous, someone whose moves I don't fully trust. 2. We are together on the pier: I am blindfolded, my ears are plugged, my hands are tied behind my back – I spin around a few times to lose ground orientation. 3. I walk around the pier – I attempt to gain assurance in walking around the pier (putting myself in the other person's control ((I am a non-swimmer)) – learning to trust in that control – trying out whether I should trust in that control). The other person determines how he wants to use the trust I am forced to have in him. 4. The piece is designed for our particular relationship: it tests that relationship, works on it, can possibly improve it.

If the street could be a venue for Conceptual art, why not nature? When Walter de Maria filled a room in a Munich gallery with 50 cubic m (1766 cubic ft) of earth, it seemed a highly material act, yet the plan for it (137) is just as much a concept piece as any by Lawrence Weiner. One could argue that work like Smithson's monumental *Spiral Jetty* (136), which curves 457 m (1,500 ft) out into the Great Salt Lake in Utah, with its uncounted tons of rubble, is also to some extent Conceptual – the idea is what matters most. There has been a tendency to interpret Land art as not truly Conceptual, both because it created such large objects and because it is thought to have a somewhat uncritical, sentimental or nostalgic philosophy. But the distinction between Conceptual and Land art is unclear, even more so than between Conceptual art and Arte Povera, or Conceptual art and Performance art.

Nature for these artists was where ideas could be embodied, made evident and tested. If Smithson was obsessed with entropy, Peter Hutchinson was obsessed with the viral persistence of life. Having received funding from *Time* magazine and the gallerist Virginia Dwan, he climbed to the top of Paricutín volcano in Mexico and placed 204 kg (450 lb) of white bread around the rim (138). This was a place where life should not exist, but in the sulphurous fumes of the volcano and covered with plastic, mould grew in profusion on the bread, changing it from white to red to orange and black within six days. Just as Baldessari had given up his 'authorship' to a sign painter and Haacke his to museum visitors, so Hutchinson, in this process work, gave up authorship to the forces of nature.

This is the end, intimate friend.
This is the end, my only friend, the end.
The Doors, 'The End', 1967

We must cease once and for all to describe the effects of power in negative terms: it 'excludes', it 'represses', it 'censors', it 'abstracts', it 'masks', it 'conceals'. In fact, power produces; it produces reality; it produces domains of objects and rituals of truth. The individual and the knowledge that may be gained of him belong to this production.
Michel Foucault, *Discipline and Punish*, 1975

139
Art Workers
Coalition
(Ronald
Haeberle and
Peter Brandt),
*Q. And babies?
A. And babies*,
1970.
Colour
lithograph;
63.5 × 96.5 cm,
25 × 38 in.
Museum of
Modern Art,
New York

Did Conceptual art end in the early 1970s? Did it, as the Vietnam War drew to its climax and conclusion, become more or less political? Was there a Conceptual art being made outside the Western democracies? These are the questions that will be addressed in this chapter.

On 24 November 1969, as millions of American households were sitting in front of their televisions, awaiting news of the triumphal return from the moon of the Apollo 12 mission, CBS ran an interview with an unknown discharged soldier, Paul Meadlo. 'How do you shoot babies?', he was asked. 'I don't know,' he said. 'It's just one of those things.' 'How many people would you imagine were killed that day?' 'I would say 370.'

Meadlo had been at My Lai, a small village in South Vietnam, when on 16 March the previous year, C Charley Company was sent in to 'neutralize' it. Although they were not fired on by the inhabitants, the American soldiers had gone on a spree of destruction, killing the livestock, burning the village, raping the women (sometimes mutilating them), shooting the old people and the children. Over one hundred villagers had been rounded up and driven into a ditch, where Meadlo and his platoon commander Lieutenant William Calley had shot them all.

Four days before Meadlo appeared on television, eight photographs of the massacre (women and children crying, waiting to be shot, wounded children crawling on the ground, the pile of bodies in the ditch) had appeared in a newspaper, the *Cleveland Plain Dealer*, and then on Walter Cronkite's much-watched news programme. Meadlo's mother was interviewed after his televised confession: 'I raised him to be a good boy. He fought for his country and look what they've done to him – made a murderer out of him.' Calley had already been charged with killing 109 'oriental human beings'.

The photograph of the bodies in the ditch was made into a poster by the Art Workers Coalition (whose members included Carl Andre, Robert Morris and Mel Bochner), overprinted with the laconic slogan 'Q. And babies? A. And babies' (139). It was distributed around the world. Some members of the Coalition led a protest, carrying the poster to the Museum of Modern Art, where they posed before *Guernica*, Pablo Picasso's protest against bombing in the Spanish Civil War. It was the place to protest, because the men who sat on the museum board of trustees were the very same men who owned those huge American companies that were were providing the machinery of war – and benefiting financially from it. Critic Gregory Battcock claimed at a conference that it was these 'art-loving, culturally committed trustees ... who are waging the war in Vietnam'. The museums and universities, Carl Andre asserted in 1970, were intended to be quiet, apolitical institutions in order to suppress political discussion and protest, while 'the war in Vietnam is a war of punitive oppression, we are killing people ostensibly to maintain the rationale of artistic freedom.'

This seemed like the moment of awful truth, when crusading democracy was seen to be not just euphoric, but psychopathic. But the case would not stick. Other than Calley, twenty-nine soldiers were believed on good evidence to be guilty of major war crimes, but only two were actually court-martialled. The rest were acquitted. Three days after his conviction and the commencement of a life sentence with hard labour, President Nixon released Calley from prison into house arrest, pending an appeal. Three years later he was released.

It is a final telling irony in this sequence of massacre, cover-up, exposure and whitewash that the village was not even called My Lai. For convenience, American intelligence had renamed all the adjoining villages in this area and numbered them. Tu Cung was the real name of the place that they called My Lai 4. A contempt for names, it appears, precedes a contempt for human lives.

The war had made artists more consciously political. In March 1970 the Art Workers Coalition had demanded that museums should be free, have artists as trustees, do more to encourage women and blacks, and accept that artists always maintained control of their work. On 22 May they organized the New York Art Strike (140), attempting to empty the studios and close the museums. They

Decline or Diaspora of Conceptual Art?

140
Sit-in at the Metropolitan Museum of Art as part of the New York Art Strike, 1970. The crowd includes Carl Andre (left of centre, with big beard), Robert Morris (centre, with small beard) and Mel Bochner (right foreground, with long hair)

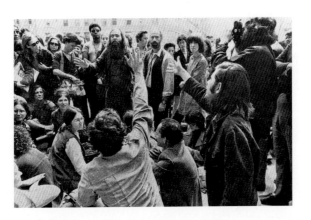

sat on the steps of the Metropolitan Museum of Art with placards saying 'Art Strike Against Racism War Repression'. It was Mel Bochner's last involvement with the Coalition as he felt that it was being hijacked by radical groups. Like Lawrence Weiner, another working-class boy, he was more interested in practical issues such as health insurance for artists, but the executive of the Coalition, most of whom came from reasonably wealthy backgrounds, were uninterested in such practicalities.

Some art interventions certainly had an effect in raising consciousness about specific issues. In 1971 Hans Haacke's proposed exhibition at the Soloman R Guggenheim Museum in New York was cancelled. This was meant to be a retrospective of Haacke's work with natural

141

Hans Haacke,
Manet-PROJEKT 74,
1974
Left
Édouard Manet,
Bunch of
Asparagus,
1880.
Oil on canvas;
44 × 54 cm,
17³⁄8 × 21¹⁄4 in.
Wallraf-Richartz-
Museum, Cologne
Right
Tenth panel.
52 × 80 cm,
32³⁄4 × 37 in.
Private collection

Das Spargel-Stilleben
erworben durch die Initiative des
Vorsitzenden des Wallraf-Richartz-Kuratoriums

Hermann J. Abs

Geboren 1901 in Bonn. – Entstammt wohlhabender katholischer Familie. Vater Dr. Josef Abs, Rechtsanwalt und Justizrat, Mitinhaber der Hubertus Braunkohlen AG, Brüggen, Erft. Mutter Katharina Lückerath.

Abitur 1919 Realgymnasium Bonn. – Ein Sem. Jurastudium Universität Bonn. – Banklehre im Kölner Bankhaus Delbrück von der Heydt & Co. Erwirbt internationale Bankerfahrung in Amsterdam, London, Paris, USA.

Heiratet 1928 Inez Schnitzler. Ihr Vater mit Georg von Schnitzler vom Vorstand des IG. Farben-Konzerns verwandt. Tante verheiratet mit Baron Alfred Neven du Mont. Schwester verheiratet mit Georg Graf von der Goltz. – Geburt der Kinder Thomas und Marion Abs.

Mitglied der Zentrumspartei. – 1929 Prokura im Bankhaus Delbrück, Schickler & Co., Berlin. 1935-37 einer der 5 Teilhaber der Bank.

1937 im Vorstand und Aufsichtsrat der Deutschen Bank, Berlin. Leiter der Auslandsabteilung. – 1939 von Reichswirtschaftsminister Funk in den Beirat der Deutschen Reichsbank berufen. – Mitglied in Ausschüssen der Reichsbank, Reichsgruppe Industrie, Reichsgruppe Banken, Reichswirtschafts-kammer und einem Arbeitskreis im Reichswirtschaftsministerium. – 1944 in über 50 Aufsichts- und Verwaltungsräten großer Unternehmen. Mitgliedschaft in Gesellschaften zur Wahrnehmung deutscher Wirtschaftsinteressen im Ausland.

1946 für 6 Wochen in britischer Haft. – Von der Alliierten Entnazifizierungsbehörde als entlastet (5) eingestuft.

1948 bei der Gründung der Kreditanstalt für Wiederaufbau. Maßgeblich an der Wirtschafts-planung der Bundesregierung beteiligt. Wirtschaftsberater Konrad Adenauers. – Leiter der deutschen Delegation bei der Londoner Schuldenkonferenz 1951-53. Berater bei den Wiedergutmachungsver-handlungen mit Israel in Den Haag. 1954 Mitglied der CDU.

1952 im Aufsichtsrat der Süddeutschen Bank AG. – 1957-67 Vorstandssprecher der Deutschen Bank AG. Seit 1967 Vorsitzender des Aufsichtsrats.

Ehrenvorsitzender des Aufsichtsrats:
Deutsche Übersee ische Bank, Hamburg – Pittler Maschinenfabrik AG, Langen (Hessen)
Vorsitzender des Aufsichtsrats:
Dahlbusch Verwaltungs-AG, Gelsenkirchen – Daimler Benz AG, Stuttgart-Unterturkheim –
Deutsche Bank AG, Frankfurt – Deutsche Lufthansa AG, Köln – Philipp Holzmann AG, Frankfurt –
Phoenix Gummiwerke AG, Hamburg-Harburg – RWE Elektrizitätswerk AG, Essen –
Vereinigte Glanzstoff AG, Wuppertal-Elberfeld – Zellstoff-Fabrik Waldhof AG, Mannheim

Ehrenvorsitzender:
Salamander AG, Kornwestheim – Gebr. Stumm GmbH, Brambauer (Westf.) –
Süddeutsche Zucker-AG, Mannheim
Stellvertr. Vors. des Aufsichtsrats:
Badische Anilin- und Sodafabrik AG, Ludwigshafen – Siemens AG, Berlin-München
Mitglied des Aufsichtsrats:
Metallgesellschaft AG, Frankfurt
Präsident des Verwaltungsrats:
Kreditanstalt für Wiederaufbau – Deutsche Bundesbahn

Großes Bundesverdienstkreuz mit Stern, Päpstl. Stern zum Komturkreuz, Großkreuz Isabella die Katholische von Spanien, Cruzeiro do Sul von Brasilien. – Ritter des Ordens vom Heiligen Grabe. – Dr. h.c. der Univ. Göttingen, Sofia, Tokio und der Wirtschaftshochschule Mannheim.

Lebt in Kronberg (Taunus) und auf dem Bentgerhof bei Remagen.

Photo aus Current Biography Yearbook 1970 New York

or social systems such as chicken hatching and ant colonies, but he had recently turned his attention instead to systems of property. Two new projects (documented with photographs and publicly available information) looked at the ownership of slum property in New York by two real estate firms. *Shapolsky et al. Manhattan Real Estate Holdings* consisted of two maps and 142 photographs of buildings (each accompanied by details of how the property was acquired) while six charts showed the complex web of holding companies and mortgagees. Believing that this was not art and that it might also be libellous, the Director of the museum cancelled the show. When the curator Edward Fry complained publicly, he was fired. Fry said that he 'felt the museum must think about how it should face up to the changing character of art and play a larger role in the social community because this is in many ways what younger artists were doing.' Ironically, the show got more publicity for being cancelled than it would have done if it had actually taken place.

The Director had also been worried about Haacke's questionnaire: since 1969 Haacke had given visitors to his exhibitions a list of questions asking whether they believed marijuana should be legalized, whether capitalism was compatible with the common good, whether they would support Saigon if they were Vietnamese, and so on. Ostensibly this was to make a sociological profile of the visitors, but it served primarily to make the visitor self-conscious, aware that this art, at least, was not just entertainment.

This was a way of working that Haacke was to persist with. In 1974, on being invited to show at *PROJEKT 74*, an exhibition of international art at the Wallraf-Richartz Museum in Cologne, he submitted the following proposal: '*Manet's Bunch of Asparagus* of 1880, collection Wallraf-Richartz museum, is on a studio easel in an approx. 6 x 8 metres room of *PROJEKT 74*. Panels on the walls present the social and economic positions of the persons who have owned the painting over the years and the prices paid for it.' This was clearly an examination of the art trade as a system, and did not differ much from the provenances that traditional art historians compile for a painting's history. However, Haacke did not just name the nine consecutive

owners of this seemingly innocuous painting, but also gave full
details of their activities, both in business and politics. The organiz-
ers rejected the proposal, the problem being that the last panel gave
details about the chairman of the Friends of the Museum, Hermann
Abs, who had helped to acquire the painting for the museum. He had
been an adviser to the Deutsche Bank during the Third Reich and had
served on fifty different boards of directors under that regime. He
had spent six weeks in a British prison after the war before being
exonerated, as so many Nazi businessmen were. Neither he nor the
museum wanted this to be remembered. 'It would mean giving an
absolutely inadequate evaluation of the spiritual initiative of a man
if one were to relate in any way the host of offices he holds in totally
different walks of life with such an idealistic engagement,' the
museum director told Haacke. 'A museum knows nothing about
economic power; it does indeed, however, know something about
spiritual power.' To Haacke this statement stank of mystification
and hypocrisy. In protest, the work (141) was shown at the Cologne
gallery of Paul Maenz with a colour reproduction of Manet's *Bunch of
Asparagus* rather than the real painting. Buren pasted a scaled-down
version of Haacke's piece over his own work at *PROJEKT 74*. 'Art
remains Politics', read a poster that he added, as a parody of what he
saw as the exhibition's 'slimy' official slogan: 'Art remains Art'.
Immediately after the opening, the museum papered over Buren's
installation. LeWitt and Andre had already withdrawn from the
exhibition; now others did.

As the 1970s progressed, the art community tended to polarize
between those whose work was becoming more politicized, like
Haacke, and those whose work was not. Artists with political agendas
became more doctrinaire and judgemental: Susan Hiller recalls
one meeting in London where Victor Burgin and Jeff Wall were
acting like cultural commissars, telling others what was and was
not acceptable. Differing positions became more entrenched:
Feminist, Marxist, Workers Revolutionary Party, Socialist Workers
Party, etc. But generally the shift was away from such 'political'
involvement: even Conceptual artists became more concerned with

making their works well, even elegantly. Refinement, not revolution, was what they sought.

For example, if the viewer had gone to the Rowan Gallery in London in 1974 to see an exhibition of work by Michael Craig-Martin, they would have entered the room to discover nothing but a glass shelf (such as one might find in any bathroom) with a glass of water on it, placed almost 3 m (9 ft) high on the wall (142). A label nearby explained that this work was called *An Oak Tree*. There was only one other thing in the gallery: a sheet of paper with a series of anonymous questions and answers on it:

Q: To begin with could you describe this work?
A: Yes, of course. What I've done is change a glass of water into a full-grown oak tree without altering the accidents of the glass of water.
Q: The accidents?
A: Yes. The colour, feel, weight, size.
Q: Haven't you simply called this glass of water an oak tree?
A: Absolutely not. It is not a glass of water anymore. I have changed its actual substance. It would no longer be accurate to call it a glass of water. One could call it anything one wished but that would not alter the fact that it is an oak tree ...
Q: Do you consider that changing the glass of water into an oak tree constitutes an artwork?
A: Yes.

This was a clean, simple and elegant installation. The work assumed that the viewer knew something of previous Conceptual art: that such art had now, in fact, developed a history – a tradition even. The work also assumed, or at least hoped, that the viewer was sophisticated enough to recognize the rather po-faced tone of scholastic philosophy. One not untypical reviewer, Caryn Faure Walker, was obviously beginning to tire of such Conceptual archness, complaining in *Studio International* that 'Craig-Martin has spent all bravado of invention on his sparsely decorated stage set. Similar originality in the dialogue is all but missing. None but the philosophically illiterate will find his mode of argument fresh.' The point was no longer to say something new, however, but rather to say it precisely.

142
Michael Craig-Martin,
An Oak Tree,
1973.
Glass shelf,
glass tumbler,
two chrome
shelf brackets;
15 × 46 × 14 cm,
5⁷⁸ × 18¹⁸ × 5¹² in.
Australian
National
Gallery,
Canberra

Mel Bochner had always poured scorn on the notion of demateri_
ization ('even this piece of paper is a support', he reiterated) and his
work, though still based on abstract thinking, became increasingly
physical. A piece such as *Triangular and Square Numbers* (143) –
one of a series of works based on mathematics – used stones in a way
not unlike Arte Povera, with its 'poetic' use of things from the real
world. The art was still 'in' the concept, one could remake it with
different stones, but this was his last set of works to be so. In 1973 he

began painting geometric figures on the wall and eventually
returned, at the end of the 1970s, to painting on canvas.

Although the Arte Povera artists refined their position, they too
moved increasingly away from a strategy of surprise to one in which
they treated their objects and materials as if they were autographic.
The most important thing about the piles of coffee made by Kounellis
(see 107) had become not their everydayness, but their mystique as
a symbol of the artist's early life. Like Beuys, Kounellis and other Arte

Povera artists had effectively created myths around themselves and the first step in understanding their works was necessarily a reference to their own personal histories. It was no surprise, therefore, that Kounellis and others should be aligned with the self-consciously personal and expressionist form of painting that became dominant at the start of the 1980s with such artists as Georg Baselitz and Francesco Clemente.

The major exhibition of 1972, *Documenta V* in Kassel, was billed as an 'Inquiry into Reality – Today's Imagery' and may be seen as both the high-water mark and the end of Conceptualism as an apparently distinct movement. In the catalogue, reality was defined as 'the sum of all images – artistic and non-artistic'. In order to realize this ambitious project, Harald Szeemann and his co-curators devised an 'official statement of categories' around which sub-themes were explored. These included Trivial Realism, Emblematic Trivialism, Socialistic Realism, Paintings of the Mentally Disturbed, The Realm of Pictures and Piety, Individual Mythologies I and II, and Processes, Conceptual art being blended into these categories. This program-matic approach was attacked both by the artists involved and by critics. Whereas, in 1969, Szeemann had enthused that 'never before has the inner being of the artist been turned so directly into a work of art', in 1972 he was declaring that the activity of the artist came from 'another world, a world of beautiful illusions, a dream world, a between world'. If that was the case, contemporary art was a realm apart, rather than an integral and decisive factor in the contemporary world. Art's revolutionary or subversive character was minimized and absorbed, to the extent that it now seemed little more than another tool in the arsenal of the establishment (hardly surprising, when one considers that 95% of the total budget had been provided by the German government, the province of Hesse and the city of Kassel).

On a more practical level, a number of artists objected to being forced into categories in order to conform to the overweening curatorial vision. In a joint letter, a group including Andre, Morris, Judd, LeWitt and Smithson expressed dismay at the organization of

143
Mel Bochner,
*Triangular and
Square Numbers*,
1971.
Collection of the
artist

the show, and several withdrew, while Smithson's condition for appearing in the catalogue was that he could include a text criticizing museums. Many felt that the spirit of collaboration that had existed in *When Attitudes Become Form*, when artists had been given the freedom to make work on the spot, and to decide how it was shown, was now sacrificed in favour of an 'exhibition as spectacle'. Even Lawrence Alloway, one of the more even-handed critics, concluded that 'the result' of the undertaking was 'something between a supermarket and a *wunderkammer* [wonder chamber]'. He damned the entire venture with the faintest of praise.

Nevertheless, some historically significant pieces of Conceptual art were shown at *Documenta V*. Art & Language's installation *Index 01* was first shown on this occasion. It was composed of eight metal filing cabinets, each with six drawers, on four grey stands. The drawers contained texts published in *Art–Language*, together with other unpublished texts by members of Art & Language, arranged in alphabetical and sub-alphabetical order, depending on their date and degree of completion. The surrounding walls were covered with the results of their cross-referential index system, which included around 350 textual citations, arranged according to compatibility, incompatibility and lack of relational value (denoted by the symbols '+', '-', and 'T'). Thus the nature of the textual analysis undertaken by the group members, as a communal endeavour, was made explicit. The work raised questions typical of the Art & Language project as a whole, centring on the nature of the public for this kind of art. Above all else it was like a model of human thought processes and reflexivity.

Two years later Atkinson, and others, left the group. 'A good degree of the thrust and energy of conceptualism had been directed towards making art practice a homeless one,' he recalled in 1992, 'pulling and dredging the practice out of its clamped philosophical homelands. In 1974, regardless of how successful it had been, Conceptualism was itself beginning to feel like a philosophical homeland. Its style was instantly recognizable, and the Indexing seemed to me to bear the imprint of a conceptual career publishing house.' The rationale behind Art & Language, like other groups, was that it would act as a

democratic think-tank, where theory was kept open, but Atkinson believed that Baldwin's domination of the index made this impossible. He believed that he could sustain the theoretical impetus of Conceptual art only outside Conceptualism, in his case, in painting.

The protests and grumbling around *Documenta V* could not conceal the fact that Conceptual art had become a sort of new establishment, a new formalism. There was a growing consensus that it had either ended, lost direction or become the very thing it was meant not to be: a new academy. Another 1972 exhibition, at the Hayward Gallery in London, *The New Art*, similarly demonstrated the institutional acceptance of Conceptual practices. But the title seemed ironic; by becoming accepted, this art was no longer 'new'. Moreover, many of the artists had reached the point where their work was moving in ever tighter circles of self reference. It was time to develop or move on. That is how Keith Arnatt saw it. Instead of such self-referential pieces as the digital counter he had shown at Art & Project or the proposal 'Is it possible for me to do nothing as my contribution to this exhibition?', he showed instead large photographs of each of the museum attendants – a work he called *An Institutional Fact*. After that he stopped exhibiting work for seven years and committed himself fully to photography.

Around 1973 many artists previously committed to linguistic philosophy turned their attention to political issues (linguistic philosophy looked academic and hence institutional), or else to the critical theorizing of French writers such as Michel Foucault and Jacques Lacan, who were then being translated into English. An exception was Adrian Piper, who was studying for a PhD on Immanuel Kant. She claimed rather harshly that the others gave up language-based work because it was too demanding – and because their efforts had been mockingly dismissed by academic philosophers.

Perhaps the most eloquent and extended lament for the supposed end of Conceptual art was that by Lucy Lippard in the conclusion to her book *Six Years: the dematerialization of the art object*, published in 1973: 'It seemed in 1969 that no one, not even a public greedy for

novelty, would actually pay money, or much of it, for a xerox sheet referring to an event passed or never directly perceived. Three years later, the major conceptualists are selling work for substantial sums here and in Europe; they are represented (and still more unexpected – showing in) the world's most prestigious galleries.' She lamented that Conceptual art had not broken down the barriers to other disciplines, social and academic. Because the artists were so ignorant of theory, because of their ghetto mentality, because they accepted the power structure of the art world, because they had given up trying to reach the 'masses' with advanced art, they would have no more effect on the world than any other art form – maybe even less. But the lament seems strangely sentimental. It was the critics rather than the artists who had proclaimed such hopes.

In 1982 Douglas Huebler wrote that:

conceptual art had never been really bent on collapsing the very institutions – the art galleries, museums, collectors – through which their nature must be communicated. There are those who wrongly perceive Conceptualism as having had such an ambition, and who declare the entire enterprise to have been co-opted because it (necessarily) remained thoroughly within the art system. The conduct of ideological activities in the 'real' world can always be virtuous, always be politically 'correct', simply by being exercised through head-on confrontation with an opposing ideology. In the 1960s Conceptual Activity assumed a dialectical stance towards various art-world ideologies because head-on confrontation would have failed to produce any affective discourse, thereby rendering it a non-issue.

The more sophisticated analyses of power and the production of truth then available in the writings of Foucault, quoted at the beginning of this chapter, argued for such a dialectical approach. For Huebler, Conceptual art was seen as finished, because it had been interpreted mistakenly as just another style (one in which object was replaced by idea). In fact, Huebler claimed, 'the form of Conceptualist practice that associated its dialectic with phenomena and events in the world not only *does* manifest works: moreover, its potential to engender a view of the world has hardly been tapped.' Huebler

emphasized the word 'dialectical': a word that some artists might have preferred in the first place to 'conceptual'.

By 1973 Victor Burgin had come to see 'pure' Conceptual art as the last gasp of formalism. 'The discourse', he wrote, 'of the art community, work and commentary, became self-absorbed as it became anomalous within its historical context, encouraging the attitude of "Art for Art's sake" whose most recent manifestation is the desultory meanderings of theoretical art.' Art should be concerned with how things and representations relate to one another in the world today (that is to say, ideology). Artists must be involved in the world at large: '"Theoretical" artists', he wrote, 'who produce no art are in the positions of craftsmen who perpetually shape their tools but never actually get down to any work.' To Burgin, Conceptual art had, however, 'opened onto that other history', a history of representations rather than of art. How did images and the words which invariably accompanied them (whether written, spoken or implied) create society? How could artists intervene effectively in this unceasing flow of ideology?

Not even the most naïve person could now believe that revolution was just around the corner. The wide-eyed, ever-smiling euphoria that had characterized the 1967 Summer of Love had dissolved. The oedipal struggle enunciated by Jim Morrison in the song 'The End' – 'Father I want to kill you!' – quoted at the beginning of this chapter, was not a revolutionary call for the younger generation to seize power after all but only a sign of psychological dysfunction. 'Fuck you, let's boogie!' shouted the audience at the Celebration of Life rock festival in 1971 when the spiritual leader Yogi Bharjan stood on the stage and asked for a minute's silent meditation. In 1970 John Lennon complained that 'The people who are in control and in power and the class system and the whole bullshit bourgeois scene is exactly the same, except that there are a lot of middle-class kids with long hair walking around London in trendy clothes. Nothing happened except that we dressed up. The same bastards are in control, the same people are running everything, it's exactly the same.'

The late 1960s and early 1970s saw a boom in the art world. Many artists, without even trying or expecting to, had made money: in 1969 Kosuth had been dumbfounded when an Italian dealer had offered him a wad of cash for his work – an experience which became common to many of these artists. The market had been buoyant enough to support even an anti-market art. But the boom collapsed by the mid-1970s and people had to work harder to survive: they could no longer assume a living. Some compromised with the market, many relied more on teaching for their living. Generally they arrived at more pessimistic notions of how things were. Ian Burn, a member of the Society for Theoretical Art and Analyses who, with Mel Ramsden, had also become a New York member of Art & Language, wrote in 1975: 'Art sales are declining and there is an air of pessimism. The sense of opulence of the 1960s has gone to dust. As artists, we have tended to understand the art market only in its reward capacity, preferring to ignore the "dismal science" of economics. But no longer, it seems.' A simple understanding of economics would show that art did not just end up as commodity but always started off as such. Artists had been blind in thinking that they held an anti-market position, for art and the market were intertwined. Burn continued: 'Wanting to abolish elitism in art is tantamount to wanting to abolish modern art itself. I'm revolted by the torpidity of the status quo on the one hand – and on the other, any desperate reactions to escape that status are celebrated as part of the "innovative logic" of the system!'

At the theoretical level, Conceptual art was often chronically entangled in its own inconsistencies: in the third and final issue of *The Fox*, the artist Kathryn Bigelow pointed out the inherent paradox of the magazine: 'theory pertaining to class issues is packaged for market acceptance ... The magazine as a *commodity* is not analysed in relation to its ideology, its methodology and its societal demands ... Is opposition to capitalist culture just the *theme* of the criticism or is the magazine itself a methodology for opposition? *Where* is the opposition?' Perhaps most importantly, she criticized the assumption that the class conditions in the art world were a paradigm for '*the* class struggle'. At the other end of the spectrum the more wacky or

whimsical artists had run out of ideas (or jokes) and had little left to say. The easygoing tolerance of the late 1960s had come to an end: reviewing an oral communication piece by Ian Wilson at John Weber's gallery in 1975 for *The Fox*, the art historian Michael Corris dismissed it summarily: 'I don't like Ian Wilson and I thought his discussion was boring. As well as unimportant to anybody's idea of discourse.' The days when people were willing to hang around listening to self-indulgent rambles were over.

Many of those involved in the art world gave it up in favour of more practical political activities. As early as 1971, Seth Siegelaub had stopped organizing exhibitions and concentrated first on working out a legal contract that would give all artists fifteen per cent of the resale value of their work and, second, on working for the United States Serviceman's Fund, a body dedicated to ensuring free speech for soldiers. Isi Fiszman devoted his energy to publishing political magazines, selling his art collection to subsidize this. Piero Gilardi had given up making art in 1968, attempting instead to live out what he saw as the philosophy of Arte Povera for real: as a political militant opposing American imperialism and working as a volunteer in a mental hospital.

After 1972 the once radical galleries became more like businesses: those such as Konrad Fischer or Art & Project acquired bigger premises and took on extra staff. They tried to poach each other's artists. There were more collectors about, but they were less adventurous. To many it just was not exciting any more. Anny De Decker lamented that by 1972 she was 'seeing fewer and fewer artists and more and more dealers'. Not only the business, but the art had got dull: 'artists were having more and more shows, and I was forever seeing the same things all over again. I couldn't stand it. I found it futile. I'd pretty much had enough of Conceptual Art. Because of the uselessness of those repetitive works. I was starting to find it all a bit dry, a bit boring.' To the dismay of her artists, she effectively closed the Wide White Space in 1975.

Conceptual art may have spent itself as a radical force, but there were many, like Huebler, who had not made over-grandiose claims and who continued to develop their work. If we see Conceptual art as

a coherent movement dedicated to the destruction of the gallery system, then it had undeniably failed and fizzled out. If not, then we can see it being sustained, perhaps less visibly, in various places and various ways – not all of them recognizably 'Conceptual'.

Gordon Matta-Clark, who had been an architecture student, had a strong sense of how the political was revealed in urban geography. By way of showing the strangeness of existing property demarcation lines, he bought up micro-parcels of land, leftovers from architects' drawings: a strip of land by a driveway, a kerbstone, a small area of pavement. This was absurd: he could do nothing with them but point at them and hence show how 'property is all pervasive'.

144
Gordon Matta-Clark,
Splitting,
1974

145
Marcel Broodthaers,
*Musée d'Art Moderne,
Département des Aigles,
Section des Figures*,
1972.
Kunsthalle,
Dusseldorf

In 1974 a building owned by the gallerist Holly Solomon was due for demolition. Matta-Clark cut it in half and dug away some of the foundations, so that it started splitting (144). This was obviously exposing the inside of a building – he often spoke of the box we live in as a prison, and of architecture as the janitor to civilization. He saw his processing of cutting buildings, which were normally in urban areas, as similar to the actions of the Situationists – as 'cuts' into the social fabric. The 'social' architecture of capitalism was 'an industry that proliferates suburban and urban boxes as a context for

insuring a passive, isolated consumer – a virtually captive audience.'
Matta-Clark noted that in suburban Englewood, the location of
Solomon's building, many of the neighbours felt there was a sexual
allusion in what he was doing, that it was somewhat improper.
But his main aim was to make the building self-evidently a building:
'what the cutting's done is to make the space more articulated,
but the identity of the building as a place, as an object, is strongly
preserved, enhanced.'

Marcel Broodthaers was also expanding his art of institutional
critique, but his was a complex, double-edged art, in which that
critique was itself made strange by his evident delight in making

objects and the vagaries of his imagination. 'The invention of the
Musée d'Art Moderne, Département des Aigles (Department of
Eagles), which took the immediate form of an arrangement of crates,
postcards and inscriptions – this invention, a jumble of nothing,
shared a character connected to the events of 1968, that is, to a type
of political event experienced by every country.' This was his descrip-
tion of the exhibition that he had in his home for a year and that he
would show in several European museums over the next four years
(145). Fragments of antique vases, wine labels, paintings, comic strips

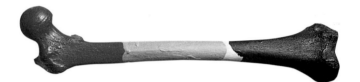

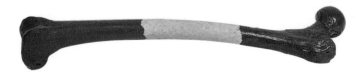

– whatever had an eagle on it – could be included, in glass cases, on plinths or on the walls. Each of the two hundred or more exhibits was labelled with a catalogue number and the inscription, 'This is not a work of art.' Here was a conscious reversal of Duchamp, of whom he wrote in the avowedly scholarly catalogue: 'Whether a urinal signed "R Mutt" (1917) or an objet trouvé, any object can be elevated to the status of art. The artist defines this object in such a way that its future can lie only in the museum. Since Duchamp, the artist is author of a definition.' The exhibition was a proposition and obviously, despite the po-faced catalogue, a comic one. But no exhibition can be more than that. An exhibition or a museum seems to proffer truth and history, but in fact only offers objects that have been given meaning by a certain display, a certain taxonomy. Whoever determines the display, determines the meaning. The museum was a site of power, a site of misconception, where, or so Guy Debord believed (see chapters 3 and 6), the history of things was enshrined in place of the history of lives lived.

It is surely correct to see Broodthaers as the one artist who, while being involved in Conceptual art, also made a farce of it. As Benjamin Buchloh said, he 'constructed objects in which the radical achievements of Conceptual Art turned into immediate travesty.' His role had often seemed like that of the court fool: referring to the Brussels high-society circles in which he moved, De Decker remarked that 'people looked on him as an entertainer, a society artist who was invited because he would always tell a few jokes. People didn't buy his work, but they invited him because he made everyone laugh.' Critique it may have been, but his work was always poetic: the eagle was not just a device to debunk the museum, but one of a number of images that Broodthaers, like any traditional poet, used to create a personal universe.

Several of his works mock the absurdity of nationalism, such as the two bones labelled as the femurs of a Belgian man and a French woman (146), and therefore – with apparent logic – painted in the colours of these nations. The arbitrariness of maps and representation is mocked in *The Conquest of Space: Atlas for the Use*

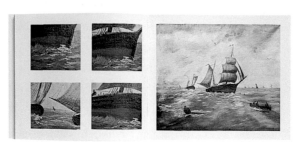

A VOYAGE ON THE NORTH SEA

MARCEL BROODTHAERS

of Artists and the Military of 1975 (148): a tiny book in which maps of eight countries are reproduced to the exact same size in silhouette. It could hardly be more useless, but it plays on our delight in the miniature, something akin perhaps to our enjoyment in collecting. If this is about 'reading', his *A Voyage on the North Sea* (147) plays with how we define a thing and how we see a picture. It exists both as a four-minute film and a thirty-eight page book. The book shows details of a Victorian amateur painting of a fishing boat in a choppy sea interspersed with black-and-white photographs of a yacht. Most pages have four details, often repeated, as though in the montage of film editing with the camera going in and out of the scene. This is, of course, not unlike the way we actually look at a painting, focusing on one detail, coming back, returning, remembering something else. The film is organized, paradoxically, by page numbers. (Just to con- fuse the issue Broodthaers also made two other films based on this painting: systems and representations proliferate in his work like viruses.) Seeing and organizing (and they are intimately connected: they are how we know and how we make that knowledge into language) are the key themes of Broodthaer's philosophical farce. His own image became an element in that farce: he would place photographs of himself in jars and bottles in works that may look like Pop Art, but are in fact parodies of it (see cover).

147
Marcel
Broodthaers,
*A Voyage on
the North Sea*,
1973.
Each page
15 × 17.5 cm,
5⅞ × 6⅞ in.
Estate of the
artist

148
Marcel
Broodthaers,
*The Conquest of
Space: Atlas for
the Use of
Artists and the
Military*,
1975.
Each page
3.8 × 2.5 cm,
1½ × 1 in. Private
collection

Perhaps the final jeering retort to the 1970s and the triumph of conservatism (Pope John Paul II came into office in 1978, Margaret Thatcher was elected in 1979 and Ronald Reagan would be elected in 1980) came in 1980 from Art & Language (after years of internecine arguing and back-stabbing it now had only two members, Baldwin and Ramsden). They exhibited a series of paintings collectively entitled *A Portrait of V I Lenin in the Style of Jackson Pollock* (149). The idea, according to Charles Harrison, was to produce a number of small pictures of widely varying subjects, styles and cultural associations. Since 1977 Art & Language had been concentrating on the issue of exactly what pictures represent and how, stressing the material properties of pictures as things produced within a specific historical context, rather than as manifestations of transcendentally induced inspiration. Their purpose was to put aside the iconic

reading of these images (the kind of reading which focuses on what the pictures appear to represent), and emphasize their 'genetic character', the material circumstances that had brought about their creation. After making pastiches of various styles and subjects, they photocopied them three times and cut them up, then recomposed them: the first was reassembled to produce the original, but the other two were scrambled and reordered to make one large, semi-abstract work, similar to Jackson Pollock's gestural paintings, but supposedly depicting Lenin. They were thus bringing together two antithetical cultural icons: Pollock, the paradigmatic Modernist painter (championed for the formal purity of his works), and Lenin, the quintessential revolutionary hero.

In 1988 when asked to explain this seemingly heretical return to painting, Ramsden replied: 'We started to hear our work described as classical conceptual art and what we did was we arranged an accident for the work. The idea of a conceptual art being a kind of classical style is a joke. You see conceptual art doesn't have to do with words on walls. It's about finding alternatives for critical inquiry and it's about a sense of corrosive irony.'

Our attention so far has been focused almost exclusively on art made by men working in the Western democracies. Was Conceptual art peculiar to the West? What was happening in Communist Eastern Europe, in Latin America, or Fascist Spain? If there was a Conceptual art in these other countries, in what ways was it different? And did it too come to an end?

In Czechoslovakia, following the end of the liberal regime of Alexander Dubček in 1968, Milan Knizak's work had become more introspective. Living outside Prague in a commune, he composed rock music and set up simple ceremonies that were less Dadaistic and more understated than his earlier Happenings-influenced work. In 1971 he organized *Instant Cathedrals*, in which, in his own words, 'circles are constructed of stones in the bottom of an abandoned quarry. Each person works on his own. Then everyone stands silently in his circle, sits down and draws his own magic sign in the ground inside his own circle. Then with a quiet monotonous humming, he

149
Art & Language, *Portrait of V I Lenin with Cap, in the Style of Jackson Pollock III*, 1980. Enamel on canvas; 239 × 210 cm, 92⅛ × 82¾ in. Galerie de Paris, Paris

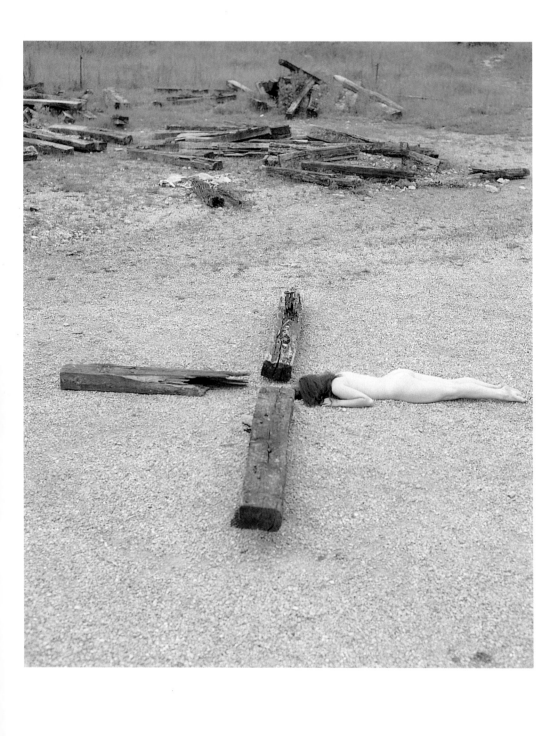

goes with the others to the rocks above the quarry, where he observes the stone circles left on the quarry floor.' The participants were not professional artists but a stoker, a charwoman, a warehouse-hand, an engineer's assistant, a plumber, a factory worker and a chauffeur. If we compare this with the circles that Lawrence Weiner had blasted in the landscape or those that Richard Long made on obscure hillsides, we realize that there is a social dimension here that is missing in most Western art – it is also non-heroic and gentle.

150
Milan Knizak,
Instant Temples,
1970–1

151
Gyula Konkoly,
Monument of
1956,
1969.
Ice and
colouring

As in his earlier outside event, *Instant Temples* (150), there was a candour, indeed innocence, no longer possible in the West. Like the *samizdat* literature that it paralleled (typewritten manuscripts passed hand to hand), this type of Conceptual art was both secret and concerned with communication.

The influence of Fluxus was more positive here: play had a transgressive quality that it could not have in the West. Many of the objects made in Eastern Europe may seem crude or illustrative, such as the Hungarian Gyula Konkoly's *Monument of 1956* (the year of the failed anti-Communist uprising), in which red colouring was mixed in a large block of ice so that what looked like a pool of blood would gather beneath as it slowly melted (151). There was no need for undue finesse: Lucy Lippard was never going to come and assess this in

comparison to New York 'dematerialization'. What was important was to express or to problematize something as clearly and as expediently as possible. The echo of Christ's bleeding heart was not unintended: much Conceptual art in Eastern Europe revolved around ceremonies, quasi-religious or not. '*It was necessary*,' claimed Knizak of these events and ceremonies. 'There was no purpose in making art. (There was no one to sell it to, and no museum that would show such work.) It was just a way of communicating. A way to learn and teach – how to push people to listen, to think, to exist.'

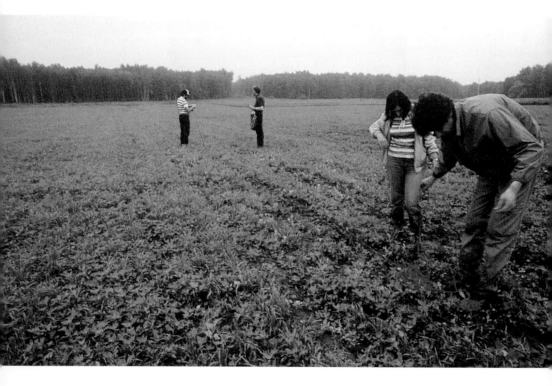

In the Soviet Union during the 1970s those artists who did not fit the officially approved forms of art, who had been content previously to show their work in each other's homes, began to work with Conceptual projects and performances. Andrei Monastrysky, the theorist of the group Collective Actions, points out, 'In Russia, where there is no market to promote artistic objects, it is not worth creating them. That is why many artists who work with objects leave Russia for the West. Only artists like us can survive here because we do not

make "things", but rather perceive art as one form of existence. Since travelling is restricted in Russia we decided to initiate it by going outside and constructing imaginary "cities", that is our performances.' Collective Actions had been founded in 1975 by seven artists and poets much influenced by John Cage and his notion of letting silence be heard. Participants would be invited to meet far out in the countryside, where they might see a rope 7 km (4 miles) long pulled across a field (152), or be instructed to walk away from a snowy field and return along the same route. It was left to each participant to interpret their experience. Stalin had called artists 'engineers of the human soul', but these artists wanted to hand this responsibility back to the viewer.

Just as Conceptual art in the West was made in opposition to formalism, and often produced paradoxically in formalist terms, so that made in the East was made in opposition to Socialist Realism and often made in the guise of that 'anabolic steroid' version of realism. So when Vitaly Komar and Aleksander Melamid, two young artists working in collaboration, made their first essay in what they called 'Sots Art', in 1972, it was a portrait of Melamid's father in the most bombastic parody of an art form already bombastic. In the East, Conceptual art was not necessarily opposed to painting. Artists in the Communist countries were reacting against a particular kind of painting, rather than an idealist theory of it. This is borne out by the paintings of Eric Bulatov which appear superficially somewhat like Pop Art but were in fact *détournements* of Socialist Realism. In a painting from 1971–2, *Red Horizon* (153), a band of red and gold blocks our route to the horizon, destroying the vista. Although it is in the patriotic colours of the Soviet Union, it obliterates the satisfying marine view that the people had expected. Another language has been dropped, interruptively, into that of Soviet promises. The tradition of painting was, as Bulatov claimed in an interview, very different from that in the West: 'even from the nineteenth century a distinction is recognizable. In the West a painting is basically a correctly fashioned object (disregarding questions of quality) whereas in Russia it is a challenge.' His interviewer, the artist Ilya Kabakov, agreed: 'what counts with

152
Collective
Actions group,
*Viewers
Movements,*
1989

153
Erik Bulatov,
Red Horizon,
1971–2.
Oil on canvas;
140 × 180 cm,
55⅛ × 70⅞ in.
Private
collection

us above all is the way the painting is understood. Its value is not in the thing itself but in its interpretation, its message. We do not judge the object, but what it tells us.' Kabakov, who had been periodically involved in Collective Actions, was concerned with the everyday nature of Soviet life, the rituals of apartment living: the true subject of 'realism' should be such things as the schedule for slop pail dumping (154). Typically, Kabakov treats such a schedule with some aesthetic seriousness.

As always, context changes meaning: the Nest group's *Half-hour attempt to materialize Komar and Melamid*, in which the three members of that group stared at chairs containing the portraits of the two artists they used to work with, would seem mere Fluxus whimsy in the West, but in the East it had a certain poignancy. Komar and Melamid had left for New York and the action was performed on the day in 1978 when these two opened their first exhibition in the capitalist emporium. A Nest project in 1981, *Let's come one metre closer*, involved each of them, in a different part of the world, digging a metre-deep hole so that they would become literally closer to one another, even if that closeness was effectively only symbolic.

1.

```
What is it?
Qu'est que c'est?
Was ist das?
Co to jest?

It is a room.
C'est une chambre.
Das ist ein Zimmer.
To jest pokój.

Is it a room?
Est-ce une chambre?
Ist das ein Zimmer?
Czy to jest pokój?
```

It would also be quite wrong to assume that artists in Eastern Europe were naïve or ill-informed: *Mythologies* by Roland Barthes was translated into Polish before it was translated into English. In Poland, Jarosław Kozłowski was producing work that was as sophisticated as any in its analysis of how we understand reality. In *Metaphysics* (155), an exhibition at the influential Foksal Gallery in Warsaw, he projected an image of an ordinary interior on to a wall. Each object was hand numbered on the wall. A tape recorder enunciated in English, French, German and Polish: 'Number 1. What is it? It is a room. Is it a room? Number 2. What is it? It is a floor. Is it a floor? Number 3. What is it? It is a chair. Is it a chair?' The exhibition card added another element to this catechism: 'What is it? It is a metaphysics. Is it a metaphysics?' 'Reality authenticates art, art in turn introduces order and gives metaphysical dimension to reality,' Kozłowski remarked. The next year, in a show called *Physics*, he hung a photograph identical to that in the projection and of the same size on the same wall. The year after that, in an exhibition called *ICSs*, only the numbers were to be seen while words came from a tape recorder describing the absent objects: poor, attractive, crumbling, printed, hairy, damaged, cheap, pale, blue. For Kozłowski, attitudes were not just form but ethical

1/10 Brossa

behaviour: 'In art, though not only there, attitude actualizes itself in action, through conscious acts of choice, taken in confrontation with events or situations which demand the defining of one's stance.' Eventually, like the artists in the West, Kozłowski abandoned his linguistic explorations. 'I noticed I was feeling more and more comfortable with them. I enjoyed arranging various conceptual configurations, combinations of more and more ingenious games and logical paradoxes. Again I felt the necessity to abandon that, get away from "stupefaction with form".'

Perhaps the artists of Eastern Europe were more disillusioned by the 'failure' of Conceptual art than those in the West. 'In the beginning Conceptual Art was considered to be against the corruption of consciousness and the bourgeois ethic of the artist. That this has been proved otherwise by their counterparts in the West,' wrote the Yugoslavs Zoran Popović and Jasna Tijadović, 'that Conceptual Art was just a perpetuation of the Western Bourgeois tradition, has been felt deeply by certain Yugoslav artists.' The OHO group had begun in 1966 to make Fluxus works, moved on to Land art and then in 1970 created linguistic forms, but gave it all up in 1971. Another group, ⟨EKÔD, having helped to translate and publish texts by Burgin, Kosuth, and Art & Language, were apparently so horrified to find that Western Conceptual works were selling for around $10,000 each that they too gave up. But generally, the artists in Eastern Europe just carried on, and indeed more Conceptual art seems to have been made there after the 'failure' than before.

Artists working under the Fascist or military regimes in Spain and the Latin Americas adopted Conceptual strategies for similar reasons. In Catalonia the poet Joan Brossa, who had once made a living importing illegal books into Spain, made 'poem objects' (156) that were a rebuke to the common-sense assumptions of a dull and repressive regime. He was an inspiration to a whole range of younger Catalan artists, such as Ferran Garcia Sevilla or the Grup de Treball, one of whose actions in 1974 was to make a map of the routes to prison taken variously by the 113 delegates to the regional assembly arrested by the Fascists in the preceding year.

156
Joan Brossa,
Burocracia,
1967.
Poem object;
30 × 23 × 1·5 cm,
11⁷⁸ × 9 × ½ in.
Galeria Joan
Prats, Barcelona

In a public square in Buenos Aires, in 1972, Victor Grippo built an oven (157). For two days he and some colleagues baked bread and handed it out to passers by. Then the police came and destroyed it. The notion of an art based on sharing and communality, rather than individuality and control, was unacceptable. The oven was a specifically rural one and its placement within the capital city drew attention to the dramatic division between town and country in Argentina. Grippo's 'concept' for the oven was as follows:

Construction of a Traditional Rural Oven for Making Bread.

Intention: to translate an object known in a particular environment, by particular people, to another environment, frequented by other kinds of people.
Purpose: to rediscover the value of an everyday object which, over and above its constructional and sculptural qualities, represents an attitude [ie a way of life]
Action:
a) Construction of the Oven
b) Making of the Bread
c) Breaking of the Bread
Educational result: To describe the process of building the oven and baking the bread. The distribution of a leaflet. The public shall be able to participate through the exchange of information.

In other works from 1970 onwards Grippo used potatoes, the archetypal food of the poor in the Americas. Often the potatoes

157
Victor Grippo,
*Construction
of a Traditional
Rural Oven for
Making Bread*,
1972

158
Cildo Meireles,
Southern Cross,
1969–70.
Pine and oak cube;
h.0·9 cm, ³⁄₈ in.
Collection of
the artist

would be wired up to electronic meters, which showed how these tubers generated energy. Displayed on long tables they also evoked communal suppers and the dignity of ordinary life.

The Brazilian Cildo Meireles was less interested in conventional scientific processes than Grippo, turning rather to processes which had an element of the alchemical about them. Early in his career he contemplated space, evoking it in paradoxical and poetic ways. His *Southern Cross* (158) is a tiny cube made of equal parts of pine and oak, trees which in Tupi – one of the main Amazonian languages – represent mythical beings. When rubbed together, these woods produce fire, and Meireles specifies that this cube, small though it may be, must be placed on its own in an area of at least two hundred square metres. He too draws our attention to the potential energy contained within matter, in spite of its apparent insignificance.

Meanwhile Hélio Oiticica was living in New York, having lost that communal purpose which so distinguished his earlier career. In retrospect, the works that he made there using cocaine (159) perhaps best represent the becalmed self-indulgence of a period when the sense of the communal seemed to be giving way to the 'Me generation', and when fantasy replaced action.

159
Hélio Oiticica,
*Quasi-Cinema,
Block
Experiments in
Cosmococa, CC3
MAILERYN,*
1973

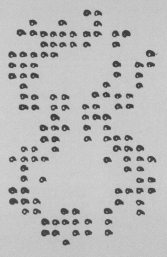

You seem not to be listening.

Nico, 'You Forget to Answer', 1974

Woman, then, stands in patriarchal culture as a signifier for the male
other, bound by a symbolic order in which man can live out his
fantasies and obsessions through linguistic command by imposing
them on the silent image of a woman still tied to her place as a bearer
of meaning, not maker of meaning.

Laura Mulvey, 'Visual Pleasure and Narrative Cinema',
***Screen*, Autumn 1975**

**As well as being the moment of Conceptual art, the late 1960s
has also been seen as the time when Feminism began as a mass
movement. Yet very few women apparently made Conceptual art.
In many ways, Feminism functioned like a separatist movement,
so it is perhaps not surprising that Feminist artists tried to establish
a milieu for themselves outside the patriarchal art world. Given the
anti-establishment and liberal bias of Conceptual art, however, the
rejection of it by so many women artists, or their rejection by
Conceptual artists, still remains puzzling.**

**One answer may be that there were women Conceptual artists, but
that they were ignored by the sexist art press. In response to those
who claimed there were no female Conceptual artists, Lucy Lippard
organized a touring exhibition, entitled *7,500*, of twenty-seven
female Conceptual artists, including Hanne Darboven, Christine
Kozlov and Adrian Piper, in 1973. To ensure that the show would be
able to travel, each artist's work had to fit into one large envelope,
so that the entire exhibition would fit in one packing case. Much of
the work addressed issues of female identity or female experience.
Laurie Anderson took photographs of all the men who made
unsolicited remarks towards her. Mierle Ukeles declared that the
cleaning staff of each museum, normally women, were artists. Most**

160
Ana Mendieta,
*Facial Hair
Transplant*,
1972

reviews were written by men and were dismissive, the few female reviewers were, however, positive and the exhibition became the locus for many discussions about identity, discrimination in the art world and the varying stereotypes of 'woman' and 'artist'. These discussions were perhaps more important than the work itself.

A second answer may be that the female artists making equivalently critical pieces were not classified as Conceptual because their work was in some respects, especially in its refusal to deny emotiveness, different. Given their disprivileged status, a critical art made by women, Feminist or not, was frequently made not just in response to 'male' art, but in parody of it. When Ana Mendieta, an American artist of Cuban extraction, paid an ironic homage to Duchamp in 1972, it was avowedly political – she stuck hairs from a man friend's beard on her upper lip, in the manner of *LHOOQ* (160, 161). It was also fetishistic, as she remarked: 'What I did was transfer his beard to my face. By transfer I mean to take an object from one place and to put it in another. I like the idea of transferring hair from one person to another because I think it gives me that person's strength.' This is also a reversal of Duchamp's readymade, for it is no longer the face that is the readymade but the hair itself: in short, the token or fetish of male power becomes the readymade. As we now know from Calvin Tompkins's biography that Duchamp had a total aversion to female body hair, this was more ironic than she probably realized.

161
Ana Mendieta,
Facial Hair
Transplant,
1972

Much of Mendieta's early work involved the use of blood. 'I think', she said, 'it's a very powerful magic thing. I don't see it as a negative force. I really would get it because I was working with blood and with my body. The men were into conceptual art and doing things that were very clean.' Mendieta did not see her work as Conceptual art, but in some respects it runs in parallel to it. In one 1973 piece she used blood very much as Buren or Toroni used 'painting': blood was spilled on the pavement outside her apartment and she photo-graphed people who stopped to look at it. As readymade she was using not indifferent stripes or objects, but a material to which everyone reacts subjectively.

As her work progressed, such symbolism became more heavy-handed – a development that is typical of many women artists of the period. The playful aspect that was so crucial to much Conceptual art was replaced by an overt preachiness. Her most confrontational piece was *Rape Scenes* (162). Following the rape and murder of a fellow student at her college, friends and colleagues were invited to visit her apart-ment, where they found her bound to a table, naked from the waist down and covered with blood; broken plates and more blood were strewn and spattered across the floor. The woman – the victim – had become the art object: the readymade. This could be seen as an attempt to reclaim her own body, and other women's bodies, from the power of men to turn them into sex, or art, objects – as exem-plified by the deluge of photographic pornography that was currently pouring into the bookshops.

Sexism was certainly latent among Conceptual artists, if not so endemic as in other areas. For example, in their earlier photographic work both Baldessari and Huebler displayed naked female bodies apparently without a thought for the politics of gender represen-tations. But perhaps the archetypal image of woman in Conceptual art of the 1960s was in the photographs of Duchamp playing chess with a naked woman in his 1963 retrospective exhibition (163). Many people have assumed that Duchamp set this up and that the woman, whose hair covered her face, was, in true Surrealist fashion, actually a mannequin – a truly nameless and voiceless other, a bearer of

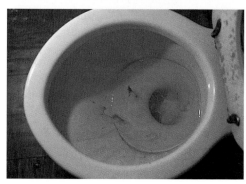

meaning, but definitely not a maker of meaning. In fact it was a girl named Eve Babitz, a friend of Walter Hopps, the museum's director. But Wasser's choice of images that left her faceless, and Duchamp's acquiescence in it, is symptomatic of the period.

Women were beginning increasingly to reject such faceless, voiceless positions, and also to reject the individualistic, macho, heroic posing of men. According to one story from 1967 Jim Morrison, when tripping out on acid in the Castle, a guest house in Los Angeles, went with his then girlfriend Nico to the top of the tower and climbed naked out on to the narrow parapet. He asked Nico to follow, but she refused. It is often recounted as an act of crazy rock heroism, like Jimi

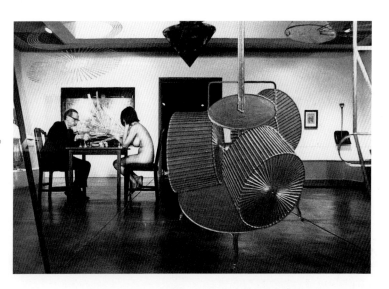

162
Ana Mendieta,
Rape Scenes,
1973

163
Julian Wasser,
Marcel Duchamp
at chessboard
with Eve Babitz
seen through a
reconstruction
of the *Large
Glass* at the
Pasadena Art
Museum, 1963

Hendrix burning his guitar, but Nico's view was different: 'I said to him "Why?" and he couldn't answer. It was not a positive act, and not a destructive act; it didn't change anything. So why should I do something that is so vain, just to follow him? It was not spiritual or philosophical. It was a drunk man displaying himself.'

Hannah Wilke's work, like Mendieta's, was about reclaiming women's right to represent their own bodies. Famous for being beautiful, she often appeared naked in her performance work, ironically and knowingly appropriating the forms and poses that a growing Feminist consciousness had come to identify as sympto-

matic of the patriarchal objectification of women, both socially and culturally. Because of this, Wilke has often been criticized for narcissism and exhibitionism, but she maintained that she was celebrating female sexuality. In this ambivalence, her work has gained a more responsive audience in a post-Feminist generation.

Her performances and the resulting photographs were often aggressively confrontational, as in *What Does This Represent? What Do You Represent? (Reinhart)*, where she sits naked in high-heeled shoes, her legs apart, surrounded by toy pistols, machine guns and other toys (164). The fetishistic high heels, the hard phallic forms of the guns, all of these objects are typically associated with men or boys, the suggestion being that the naked woman and the toys are equivalent in their status as the objects of male gratification and amusement. Paradoxically, she is also in a position to control those desires. Far from remaining potentially the victim of male objectifi-

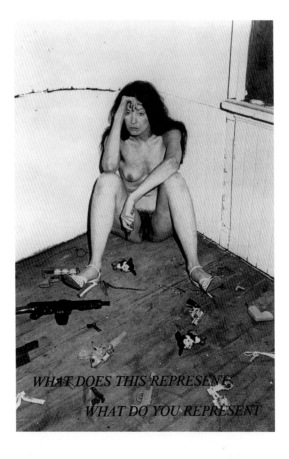

WHAT DOES THIS REPRESENT
WHAT DO YOU REPRESENT

164
Hannah Wilke,
*What Does This
Represent?
What Do You
Represent?
(Reinhart)*,
1978–84

165 Overleaf
Martha Rosler,
*Semiotics of the
Kitchen*,
1975.
Stills from
a black-and-
white video;
l to r:
T (tenderizer),
W, X, K (knife)

cation, it could be argued that Wilke's choice to do this reverses the balance of power, teasing the viewer and playing on the ambiguity of the objectifying gaze, a project she developed throughout her life. The piece redirects Reinhardt's slogan (see 37) specifically to the politics of gender representation.

Feminist rejection of Modernism was based on gender-political, as well as aesthetic, objections: sculpture and painting on canvas seemed inseparable from the heroic, masculine rhetoric that Feminist discourse was attempting to break open. Collaboration was another frequently used strategy to escape this, along with the use of 'low-art, feminine' craft techniques like needlework. If the work of these artists appears emotive and declamatory in many cases, it is because they were consciously reclaiming a whole area for discussion: their lives and bodies, and the representation of them.

The work of Martha Rosler is more detached and clinical in its proce-dures, and therefore more readily recognizable as Conceptual in tone. Picking up on the fact that television was often looked upon as a provider of answers, and had the spurious air of impartiality, Rosler made videos that exposed culturally encoded assumptions, thus pointing out their very tenuousness, and their pernicious implica-tions. In *Semiotics of the Kitchen* (165), Rosler is shown standing in front of a kitchen counter. She begins to recite the alphabet, lifting one piece of kitchen equipment for each letter ('Apron, Bowl, Chopper...') and mechanically illustrating how each item is used, stabbing with the fork, scooping the air with a spoon, noisily plung-ing an eggbeater into a metal bowl. When she reaches the last six letters, she stops displaying items and slices the air with a knife. It is at once a parody of the stereotype of the woman as an extension of the kitchen and of semiotics (the study of signs and symbols which was conducted by Roland Barthes, Umberto Eco and others.)

The work of Adrian Piper, although clearly influenced at the begin-ning by her involvement with Seth Siegelaub, became increasingly politicized, focusing on her position as a female artist of mixed race. In April 1970 she created *Untitled Performance for Max's Kansas City* (166), which she described in 1981 in the following way: 'Max's was

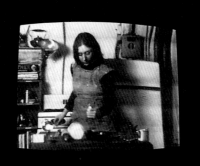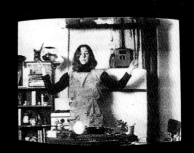

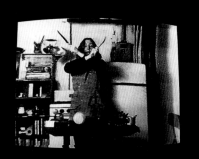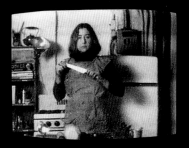

an Art Environment, replete with Art Consciousness and about Art Consciousness. To even walk in Max's was to be absorbed into the collective Art Self-Conscious Consciousness, either as object or as collaborator. I didn't want to be absorbed as a collaborator, because that would mean having my own consciousness co-opted and modified by that of others. It would mean allowing my consciousness to be influenced by their perceptions of art, and exposing my perceptions of art to their consciousness, and I didn't want that. I have always had a very strong individualistic streak. My solution was to privatize my own consciousness as much as possible, by depriving it of sensory input from that environment; to isolate it from all tactile, aural, and visual feedback. In doing so I presented myself as a silent, secret, passive object, seemingly ready to be absorbed into their consciousness as an object. But I learned that complete absorption was impossible, because my *voluntary* objectlike passivity implied aggressive activity and choice, an independent presence confronting the Art-Conscious environment with its autonomy. My objecthood became my subjecthood.' The problem, as always, was to change the way that women saw themselves and were seen by others. Given the way that identities

166
Adrian Piper,
Untitled Performance for Max's Kansas City,
1970

were thrust upon them, self-consciousness was an even more problematic issue for women than it was for men. If the male gaze determined how women acted, then a critique of that gaze and of the ensuing representations was essential.

Susan Hiller had worked as an anthropologist before moving from the United States to London in 1970, where she has been based ever since. Like many female artists working at the time, Hiller eschewed the idea of Conceptual art as primarily language-based, describing her artistic lineage as an amalgamation of Fluxus and Minimalism. Much of her work has been a meditation upon forgotten or unexplored aspects of popular culture. One of the earliest manifestations of this is her project (begun in 1972) entitled *Dedicated to the Unknown Artists* (167). By bringing together over 300 postcards collected from British seaside resorts, each with the title 'Rough Sea', Hiller sets up a forum for debate, for these postcards are curious in many ways. For each question that arises, numerous answers present themselves. Are the postcards works of art, and if so, is Susan Hiller's role in bringing them together that of a curator, or that of an artist? Perhaps the answer to the first question can be found in a statement by literary theorist Susan Stewart, which Hiller herself has quoted in relation to her collection-based works: 'the Collection is not constructed by its elements: rather, it comes to exist by means of its principle of organization.' *Dedicated to the Unknown Artists* has been shown, since 1976, as an installation comprising fourteen large wall panels on which the postcards are mounted along with related charts and maps. There is also a set of notes in which Hiller records the reactions and musings which the creation of this work has prompted in her. Writing about them, Hiller has said, 'we love these pictures because they freeze a movement which otherwise we never realize we see'. But why do we love to see these rough seas? Because of their windswept, wuthering Romanticism? Their elemental destructiveness? Are the waves meant to elicit the delightful terror of the sublime, or should their thrusting eruptions prompt more animal metaphors?

It is important to bear in mind that not all women making art in this period wished to be identified exclusively with the women's

167 Overleaf
Susan Hiller,
Dedicated to the Unknown Artists,
1972–6.
1 of 14 panels.
Each panel
66 × 104.8 cm,
26 × 41¼ in.
Collection of the artist

Rough Sea, Filey Briggs

132

5

Rough Sea.

8

ROUGH SEA ABERYSTWYTH

I suppose the guinea pigs are all right.

10

4

ROUGH SEA ON THE EAST COAST

131

ROUGH SEA ON HILLSBORO' BEACH, ILFRACOMBE

179

ROUGH SEA AT THE GIANT'S CAUSEWAY

me stay please send my black underskirt down
With love from 6 Mo. L

194

Rough Sea, Cornwall

230

THE NEEDLES, ISLE OF WIGHT

B 5

"THE HOMELESS OCEAN'S HEAVING FIELD"

C 12

A Rough Sea at Teignmouth

229

Storm scene at Santa Catalina Island,
California

D 13

California Breaks in a Storm

D 9

THE BOW-FIDDLE ROCK, CULLEN

Hope you had a fine Easter. We did.
enjoyed ourselves great. Best

C 2

HIGH WAVES

D 19

A September Sea

D 51

D 26

198

2

229

211

3

135

57

167

170

217

C 1

C10

020

D27

C13

029

D30

D3?

movement, and Susan Hiller is a case in point. The project could be read systematically, as if they were pottery shards collated by an archaeologist, or, more intimately, as if it were a dream diary. Crucial to her work from 1972 was her involvement with automatic writing – where subconscious images and ideas are brought to the surface – and the way it revealed the insubstantiality of the individual's autonomous identity.

Annette Messager, a French artist, takes a similarly oblique approach to gender politics. *My Voluntary Punishments* (168) is a collection of photographs of the countless treatments and manipulations that women undergo in the quest for beauty and youth. They catalogue a truly hair-raising array of contraptions to which the female body submits: to be pressed, pummelled, electrocuted, peeled, strapped and pinned down. These beautician's machines from the 1970s do very often look like instruments of torture. There are other photographs, however, which seem curiously out of place; how many people – men or women – would describe healthy exercise, a jacuzzi, or even a face mask as a punishment? Messager's works have an intimate feel to them, she uses materials which can be found in the home, and much of the intrigue in her work comes from the displacement of these materials from the domestic setting to the public space. The echoes of their intimate and domestic associations collide with their modified form and setting. So when a viewer encounters her *Proverbs* of 1974, handkerchiefs on which she has embroidered proverbs about women ('You can trust your dog, never your wife', 'Women are taught by nature, men by books', 'Where there is a woman there is no silence'), it is likely that the first reaction will be recognition of an everyday object, swiftly followed either by agreement or dissent as to the content of the embroidered message.

It would be too simple, however, to say that her work directly condemns the attitudes or behaviour of either sex. As she herself says, 'when, as an artist, I transcribe a recipe, I am aping a gesture, the activity of a real practical woman, of a real model woman, but within this parody there is an element of admiration.' In contrast to women working in America, Hiller and Messager feel happier to

168
Annette Messager, *My Voluntary Punishments*, 1972. Overall dimensions 188 × 300 cm, 74 × 118¼ in. Private collection

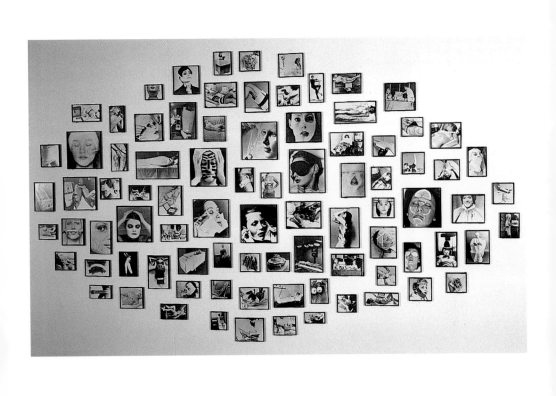

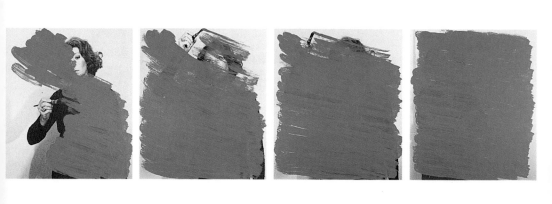

169
Helena Almeida, *Inhabited Painting*, 1976. Acrylic on photographs; each panel 46 × 40 cm, 18½ × 15¾ in. Módulo-Centro Difusor de Arte, Lisbon

explore the realm of ambiguity which divides art from politics, rather than trying to tie the two together. Much the same is true of the elliptical and enigmatic work of the Portuguese artist Helena Almeida. Like others, her photographed actions look like rituals, but they derive from the process of making art, rather than any attempt to invoke myth. Normally she will herself appear in the midst of some action, for example painting herself out of the image (169).

Though perhaps marginalized and undervalued at the time, artists such as these were to be an important model for a later generation of both male and female artists, because of their multivalent approach and for their concentration on issues of subjectivity and identity as well as meaning. Equally crucial was the parallel search in theoretical writings, such as those of Laura Mulvey (quoted at the beginning of this chapter), to deconstruct patriarchal ways of seeing and locate ways in which women artists could work. Such writers were especially important in the shift from linguistic philosophy to psychoanalytic and post-structuralist theory (as explored by Julia Kristeva and Luce Irigary) as models for art.

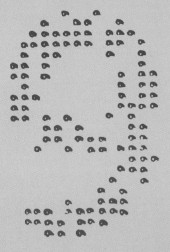

What does possession mean to you?

7% of our population own 84% of our wealth

The Economist, 15 January, 1966

We don't need another hero,

We don't wanna know the way home.

Tina Turner, 'We don't need another hero (Thunderdome)', 1985

I want a History of Looking. For the Photograph is the advent of myself
as other: a cunning dissociation of consciousness from identity.

Roland Barthes, *Camera Lucida*, 1980

In 1970 Mel Bochner published his *Misunderstandings (A Theory
of Photography)* (171): an envelope containing one reproduction
photograph and nine index cards, each with a quote from a famous
author handwritten on it. But the photograph was paradoxical:
entitled *Actual size (Hand)*, it was a reproduction of an earlier work
by Bochner: a photograph of the artist's arm and hand printed to
the exact size of his real arm and hand, relating to his measurement
series. Here, reduced to the index-card size, it was no longer the
actual size, and, moreover, it was in negative. It was a 'misunder-
standing', if not a lie. The same was true of the quotes on the cards,
for three of the nine had been made up by Bochner himself. Twenty-
five years later, to Bochner's great amusement, nobody has worked
out which ones are fake, and he is not telling. What mattered, as far
as he was concerned, was not photography *per se*, but thinking about
photography and how we use it. This was to be true of most
Conceptual artists who used photography.

Conceptual art has had the widest possible effect on how photo-
graphy is used in art, because it does not take the medium as a
given, but as something whose mechanisms and use have to be
analysed. Photography is never innocent, but framed by ways of
representing that are always ideologically loaded. If Conceptual art
in its linguistic mode investigates how we think and make others
think, then a Conceptual art of photography has to be about how
photographs are used to make meanings. It could be argued that the

170
Victor Burgin,
Possession,
1976.
Poster;
109·2 × 83·8 cm,
43 × 33 in

heart of Conceptual art in the late 1960s was not, as is often stated, the notion of the artwork being essentially linguistic, but rather the notion that it was simultaneously linguistic and visual. It is certainly true that the combination of text and photograph became increasingly its archetypal form.

However, it is too little recognized that this critical revision of the use of photography in art began with a thorough resistance to it. 'Photographs steal away the spirit of the work,' Robert Smithson

remarked in a discussion on Land art in 1969. Carl Andre said in 1973 that, 'The photograph is a lie. I'm afraid we get a great deal of our exposure to art through magazines and through slides and I think this is dreadful, this is anti-art because art is a direct experience with something in the world and photography is just a rumour, a kind of pornography of art.' The widespread fear that photography was an alienating device was epitomized by the question asked of press photographers in Vietnam, 'Do you photograph a man when

he has just been shot and in danger of dying, or do you get a Band-Aid?' Reiner Ruthenbeck had been a professional photographer before going to Düsseldorf to study with Joseph Beuys: in 1976 he remarked that 'I really liked to photograph. But after a while, I found that photography corrupts you. After a while, one can no longer stand firmly in the middle of the world. One always stands beside it and looks at it, and even then only at a rectangular segment of it.' And, moreover, as Roland Barthes was to point out, the photograph was never an image of oneself, always an image of oneself as an other.

Yet, at the same time, there was a widespread acceptance both that a photographically affected perception of the world was endemic, and that art was and would primarily be known through photographic reproduction. The artist Dennis Oppenheim's response to Smithson in 1969 was that photography was bound to get more important. 'Let's assume', he added, 'that art has moved away from its manual phase and that now it's more concerned with the location of material and with speculation. So the work of art has now to be visited or abstracted from a photograph, rather than made.'

171
Mel Bochner,
Misunderstandings (A Theory of Photography), 1967–70. Notecards and a Manila envelope; each card 12·7 × 20·3 cm, 5 × 8 in

The initial role of photography in Conceptual art was to document actions or phenomena. This is true of the work of Bruce Nauman. There is a laconic quality to his photographs that owes much to Ed Ruscha's books. In a curious act of homage in 1967 Nauman made a fold-out book entitled *Burning Small Fires*, which consisted of a sequence of photographs of him burning a copy of Ruscha's *Various Small Fires and Milk* (see 59). More commonly, he used film to document his acts, taking its limitations as a structuring device: his camera shot in spools of 122 m (400 ft), therefore his films are all nine minutes long. For nine minutes, he would make himself black with make-up, or bounce two balls between floor and ceiling, or play a note on the violin while he walked around his studio (see 80).

Douglas Huebler had likewise begun using the camera as a 'dumb' recording instrument. The naïve view that underlies much early photography by Conceptual artists was that the camera was an 'opinion-less copying device', as the curator Donald Karshan put it in

Variable Piece #34

Bradford, Massachusetts

During November, 1970 forty people were photographed at
the instant exactly after the photographer said, "You
have a beautiful face."

The forty photographs and this statement join together
to constitute the form of this piece.

December, 1970 Douglas Huebler

172
Douglas
Huebler,
Details from
Variable Piece
#34,
1970

1970. It was a way of pointing at or indexing something in the world. This view became unsustainable as the artists began to see its ideological implications. For example, Huebler became aware that people grew self-conscious when faced by the camera. In leaving the studio he had not only entered real space, he had entered 'social space'. His work began to reflect this: each photograph was a social transaction. For example, he would photograph strangers as he told them 'you have a beautiful face' (172). This echoes and to some extent pastiches the techniques of sociologists and behavioural psychologists. The way in which such scientists built up archives of such data was frequently mimicked by Conceptual artists.

In the most grandiose of these archive projects, *Variable Piece #70*, Huebler set out to document everyone alive. One element of this inevitably unfinished project, *100E/ Variable Piece #70*, involved Huebler playing on the arbitrary relationship between words and images by giving people one of eighty randomly chosen signs to hold as they were photographed, each with a cliché written on it, such as 'One person who is pretty as a picture' or 'One person who always has the last word'. Scientist rituals were not only being gently parodied here, but were being used to give significance to everyday experience. As the critic Jack Burnham said in 1972, 'Huebler isolates the mundane into a series of tiny aesthetic acts. The function of art is

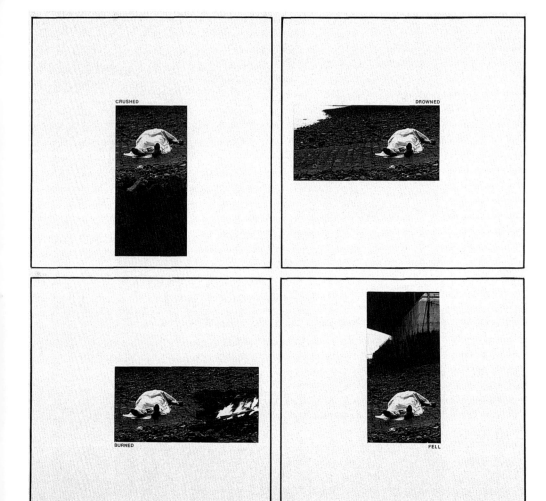

that sense of orientation that accompanies the constant repetition of the art act in the here and now.'

A concern with the everyday can also be seen in the *Landscape Manual* of the Canadian artist Jeff Wall (173). Self-consciously scruffy like much 1960s Conceptual art, remorselessly anti-romantic, the works view the world through a windscreen and a mirror referring both to road movies and the sense of being but not belonging in the landscape. The crossings out and the handwritten corrections attempt to both represent a mode of thinking aloud and mark its difference from the normally slick travelogue. Yet, whereas Huebler has continued to use the camera as 'a duplicating device whose operator makes no "aesthetic" decisions', Wall was to re-embrace, for considered reasons, the 'aesthetic'.

175
John Hilliard,
*Cause of Death?
(3)*,
1974.
Photographs
on card;
4 panels, each
50 × 50 cm,
19¾ × 19¾ in.
Private
collection

The Englishman John Hilliard had begun as a sculptor and, as many of his sculptures were ephemeral or specific to a place, it was essential to document them with his camera. Eventually it dawned on him that, in effect, he was only making sculptures so as to photograph them. He then asked himself 'Why not concentrate on the actual photograph?' In the following year, Hilliard took the logical step of shifting entirely to photography and began a systematic analysis of how the camera created meaning. All the mechanisms of the camera were explored: cropping, focusing, exposing, developing. The title of *Camera recording its own condition* (174) ironically suggests that the camera is doing this for itself, though we can see the long hair of Hilliard behind it, his finger on the release button. The grid contains seventy different images of the camera itself, graduated according to seven apertures and ten different exposure times. Obviously photography here was not giving a picture of 'reality', but different versions of reality, which were more or less 'true'.

Hilliard's *Cause of Death? (3)* (175) is one of a number of works that investigate how the cropping of an image can effect meaning. A photograph of a body with a sheet draped across it is cropped in four different ways; where it is shown by water we have the caption 'Drowned', where we have the caption 'Fell' there is a bridge above.

The 'real' photograph would, of course, have all four options. But we know that newspapers edit photographs to tell a particular story. The work is also an investigation into the suggestive power of the caption. As Roland Barthes had pointed out in his 1964 article, 'Rhetoric of the Image', photographic images in fact do not have clear and specific meanings, they are 'polysemous'; it is the title, text or caption that anchors the image to a particular reading, and this reading, by denying other meanings, is repressive.

176
Hans Peter Feldman,
Books hung on strings.
As installed at the Galerie Paul Maenz, Brussels, 1973

Artists like Hilliard whose work appeared increasingly in the guise of photographs were, however, wary of calling themselves 'photographers'. This was firstly because the thinking that led to taking the photograph and exhibiting it was always more crucial than the final object; secondly, because they did not want to be associated with 'Art Photography'. The notion of Art Photography, dominant at that time, clung to an old idealist notion of creativity and truth. Great photographs were taken by great geniuses. Photographers such as Edward Weston or Ansel Adams were

paradigms of this. The recurrent phrase was that of the French photographer Henri Cartier-Bresson, 'the decisive moment' – that split second when the pure and perfect picture, some 'inner, deeper truth' was revealed to the genius-photographer who 'captured' it. (Generally speaking, photographers who saw themselves as artists took photographs, artists who used photographs made or constructed them.) Art Photography, moreover, was associated with voyeurism. Was not the archetypal subject of Art Photography a naked woman (photographed by a man)? But in the hands of Hilliard and others, photography was not used as though it was transparent, but rather as reflexive, always turning back on itself, questioning what it was doing.

There was a growing sense that, at a theoretical level, there was something intrinsically wrong with the camera and the way it showed the world. Its fixed, monocular viewpoint was seen to be ultimately about control and domination. It was no coincidence that photography was such an ideal medium for pornography and surveillance. This had to be questioned. There had to be not just a critique of representation, but a critique of vision.

An alternative to Hilliard's structural approach, of finding out how the photograph and the act of seeing worked, was to examine how it was used – understanding it in its human, social context. It was necessary, therefore, not so much to take photographs as to collect and examine them – just as Hiller and Messager had done.

The Düsseldorf artist Hans Peter Feldman began to make small books containing a few banal photographs that he had either found or taken himself. Often he exhibited these books hanging on string (176), as if they were as insignificant and mundane as washing left out to dry. To take one of these tethered little books and look at grainy photographs of women's knees, or mountains, or shoes, gave only vestigial voyeuristic pleasure – more importantly, the viewer was made self-conscious of the act of looking. In 1972, in one of the wittiest interviews that *Avalanche* ever published, he responded to questions with photographs. Q: 'Are you attracted by the idea of working on a vast scale?', A: A picture of a magazine stand covered

177 Overleaf
Dan Graham,
Homes for America,
1966–7.
Written and printed texts and photographs mounted on board; each panel 101·6 × 76·2 cm, 40 × 30 in. Daled Collection, Brussels

Homes for America

D. GRAHAM

"The Serenade"- Cape Coral unit, Fla.

Each house in a development is a lightly constructed 'shell' although this fact is often concealed by fake (half-stone) brick walls. Shells can be added or subtracted easily. The standard unit is a box or a series of boxes, sometimes contemptuously called 'pillboxes.' When the box has a sharply oblique roof it is called a Cape Cod. When it is longer than wide it is a 'ranch.' A

Set-back, Jersey City, New Jersey

Large-scale 'tract' housing 'developments' constitute the new city. They are located everywhere. They are not particularly bound to existing communities; they fail to develop either regional characteristics or separate identity. These 'projects' date from the end of World War II when in southern California speculators or 'operative' builders adapted mass production techniques to quickly build many houses for the defense workers over-concentrated there. This 'California Method' consisted simply of determining in advance the exact amount and lengths of pieces of lumber and multiplying them by the number of standardized houses to be built. A cutting yard was set up near the site of the project to saw rough lumber into those sizes. By mass buying, greater use of machines and factory produced parts, assembly line standardization, multiple units were easily fabricated.

Two Entrance Doorways, "Two HomeHomes", Jersey City, N.J.

The logic relating each sectioned part to the entire plan follows a systematic plan. A development contains a limited, set number of house models. For instance, Cape Coral, a Florida project, advertises eight different models:

A The Sonata
B The Concerto
C The Overture
D The Ballet
E The Prelude
F The Serenade
G The Nocturne
H The Rhapsody

Center Court, Baluasen, Development, Jersey City, N.J.

two-story house is usually called 'colonial.' If it consists of contiguous boxes with one slightly higher elevation it is a 'split level.' Such stylistic differentiation is advantageous to the basic structure (with the possible exception of the split level whose plan simplifies construction on discontinuous ground levels).

There is a recent trend toward 'two home homes' which are two boxes split by adjoining walls and having separate entrances. The left and right hand units are mirror reproductions of each other. Often sold as private units are strings of apartment-like, quasi-discrete cells formed by subdividing laterally an extended rectangular parallelopiped into as many as ten or twelve separate dwellings.

Developers usually build large groups of individual homes sharing similar floor plans and whose overall grouping possesses a discrete flow plan. Regional shopping centers and industrial parks are sometimes integrated as well into the general scheme. Each development is sectioned into blocked-out areas containing a series of identical or sequentially related types of houses all of which have uniform or staggered set-backs and land plots.

In addition, there is a choice of eight 'exterior colors:
1 White
2 Moonstone Grey
3 Nickle

LAWN GREEN

4 Seafoam Green
5 Lawn Green
6 Bamboo
7 Coral Pink
8 Colonial Red

As the color series usually varies independently of the model series, a block of eight houses utilizing four models and four colors might have forty-eight times forty-eight or 2,304 possible arrangements.

Housing Development, rear view, Bayonne, New Jersey

Housing Development, front view, Bayonne, New Jersey

Dan Graham

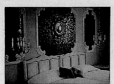

Interior of Model Home, Staten Island, N.Y.

Each block of houses is a self-contained sequence — there is no development — selected from the possible acceptable arrangements. As an example, if a section was to contain eight houses of which four model types were to be used, any of these permutational possibilities could be used:

Bedroom of model Home, S.I., N.Y.

AABBCCDD	ABCDABCD
AABBDDCC	ABDCABDC
AACCBBDD	ACBDACBD
AACCDDBB	ACDBACDB
AADDCCBB	ADBCADBC
AADDBBCC	ADCBADCB
BBAADDCC	BACDBACD
BBCCAADD	BCADBCAD
BBCCDDAA	BCDABCDA
BBDDAACC	BDACBDAC
BBDDCCAA	BDCABDCA
CCAABBDD	CABDCABD
CCAADDBB	CADBCADB
CCBBDDAA	CBADCBAD
CCBBAADD	CBDACBDA
CCDDAABB	CDACBDAB
CCDDBBAA	CDBACDBA
DDAABBCC	DACBDACB
DDAACCBB	DABCDABC
DDBBAACC	DBACDBAC
DDBBCCAA	DBCADBCA
DDCCAABB	DCABDCAB
DDCCBBAA	DCBADCBA

Basement Area, Home, New Jersey

'Discount Store', Sweater on Racks, New Jersey

The 8 color variables were equally distributed among the house exteriors. The first buyers were more likely to have obtained their first choice in color. Family units had to make a choice based on the available colors which also took account of both husband and wife's likes and dislikes. Adult male and female color likes and dislikes were compared in a survey of the homeowners:

'Like'

Male	Female
Skyway	Skyway Blue
Colonial Red	Lawn Green
Patio White	Nickle
Yellow Chiffon	Colonial Red
Lawn Green	Yellow Chiffon
Nickle	Patio White
Fawn	Moonstone Grey
Moonstone Grey	Fawn

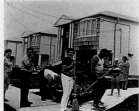

Two Family Units, Staten Island, N.Y.

'Dislike'

Male	Female
Lawn Green	Patio White
Colonial Red	Fawn
Patio White	Colonial Red
Moonstone Grey	Moonstone Grey
Fawn	Yellow Chiffon
Yellow Chiffon	Lawn Green
Nickle	Skyway blue
Skyway Blue	Nickle

Car Hop, Jersey City, N.J.

A given development might use, perhaps, *four* of these possibilities as an arbitrary scheme for different sectors; then select four from another scheme which utilizes the remaining four unused models and colors; then select four from another scheme which utilizes all eight models and eight colors; then four from another scheme which utilizes a single model and all eight colors (or four or two colors); and finally utilize that single scheme for one model and one color. This serial logic might follow consistently until, at the edges, it is abruptly terminated by pre-existent highways, bowling alleys, shopping plazas, car hops, discount houses, lumber yards or factories.

'Split-Level', 'Two Home Home', Jersey City, N.J.

'Ground-Level', 'Two Home Home', Jersey City, N.J.

Although there is perhaps some aesthetic precedence in the row houses which are indigenous to many older cities along the east coast, and built with uniform facades and set-backs early this century, housing developments as an architectural phenomenon seem peculiarly gratuitous. They exist apart from prior standards of 'good' architecture. They were not built to satisfy individual needs or tastes. The owner is completely tangential to the product's completion. His home isn't really possessable in the old sense; it wasn't designed to 'last for generations'; and outside of its immediate 'here and now' context it is useless, designed to be thrown away. Both architecture and craftsmanship as values are subverted by the dependence on simplified and easily duplicated techniques of fabrication and standardized modular plans. Contingencies such as mass production technology and land use economics make the final decisions, denying the architect his former 'unique' role. Developments stand in an altered relationship to their environment. Designed to fill in 'dead' land areas, the houses needn't adapt to or attempt to withstand Nature. There is no organic unity connecting the land site and the home. Both are without roots — separate parts in a larger, predetermined, synthetic order.

Kitchen Trays, 'Discount House', New Jersey

ARTS MAGAZINE/December 1966–January 1967

Dan Graham

with glossy monthlies. Q: 'Could you be more specific about the relationship of your work to language?', A: A picture of a mini-skirted girl in a telephone box. Q: 'Do you ever consider the political implications of your work?', A: A picture of Hitler Youth at an art exhibition. Q: 'How do you define sculpture now?', A: A picture of a chair.

There is often the sensation with Feldman that his images, although banal and endlessly proliferated, somehow hold or stand in for memories. In the 1963 movie *Les Carabiniers*, directed by Jean-Luc Godard (who had a profound influence on artists with his brutal inter-cutting of images with text), the two heroes return from their adventures, but the only things they have to show their girlfriends are a motley selection of old postcards. The pathos of photographs as emblems of lives once lived was important to Feldman and this is what his subsequent work has concentrated upon. As Barthes points out, a photograph – like any document – is always of the past.

There is pathos, too, in the colour snaps of Dan Graham's *Homes for America*, but the work is riddled with irony. Colour was associated with holiday snaps and the glossy images in *National Geographic*, whereas 'art photography' was almost exclusively in black and white: the distance that it gave from reality accentuated a purely 'aesthetic' quality. This is one reason for Dan Graham's use of colour in *Homes for America*. He had wanted initially to publish the work in a magazine such as *Esquire*, so that it would function as a surprising insert, much as his earlier *Figurative* had appeared in *Harper's Bazaar* (see 98). But he could get it published only in *Arts Magazine* and, failing to grasp what the work was about, they cut all but one of the photographs. Now, we normally see it in the form of lithographs after his original artwork (177). The work also exists as a collage of thirteen photographs rather than the original seven. There is no one canonical state. The photographs are un-arty documents, the original text is self-consciously flat. Is it art, reportage or ironic criticism? At this point, Graham would have been known as a poet and occasional writer of criticism – not as an artist. Is it a critique or a celebration of suburban housing? It is crucial to see it as neither, to see it instead as provocatively ambiguous, existing in an in-between state.

178
Bernd and Hilla Becher,
Winding Towers,
1997.
Black-and-white photographs;
173.4 × 191.1 cm,
68¼ × 75¼ in

Jeff Wall has recently claimed that this piece is the key to establishing a way from the self-referentiality of Conceptual art through to a constructive but critical use of photography:

Like much conceptualism, it attempts to breach the dominance of the established art forms and to articulate a critique of them. But unlike the more academic types of conceptual art, such as practised by Art & Language, which could arrive only at a paradoxical state of establishing themselves as works of art negatively, by enunciating conditions for art which they had no interest in actually fulfilling, Graham's photo-journalistic format demands that his work have a separable distinguishable subject matter. Instead of making artistic gestures which were little more than rehearsals of first principles, as Kosuth or Art–Language were to do, Graham brings his analysis of the institutional status of art into being though the dynamics of a journalistic subject.

In other words, the work analyses the status of the art and the state of the world.

The two artists included in the early exhibitions of Conceptual art who did have a definite commitment to photography as a discipline were Bernd and Hilla Becher (178). They saw themselves in the German tradition of *Neue Sachlichkeit*, or new objectivity, which dated back to the 1920s. The anonymity of their work and the logic of its archival organization appealed to the Conceptualists. Their aesthetic seemed Minimalist, their subject was everyday structures. As early as 1957 Bernd Becher had begun to document monuments of nineteenth-century industry: winding towers, water towers, peasant housing – initially with drawings. Many of these buildings were being destroyed at that time and were regarded as eyesores. The Bechers saw an aesthetic coherence in them, a humanity, that should be preserved. Influenced by nineteenth-century photography and that archetypal recorder of early twentieth-century German society, August Sander, they adopted a way of photographing that let each building reveal itself. The Bechers were not trying to express themselves. Just as, in their publications, they often used a grid to

179
Christian
Boltanski,
*10 Portraits
Photographiques
de Christian
Boltanski
1946–1964,*
1972

display the photos in groups of nine or more, to allow for comparisons, in galleries they exhibited them in grid formations.

In 1970 they published *Anonymous Sculptures: A Typology of Technical Constructions*, in which laconic descriptions of the functions of lime-kilns, cooling towers, blast furnaces, winding towers, water towers, gas-holders and silos were followed by full-page photographs of examples, always photographed formally, with no sign of humanity. In a brief afterword they wrote, 'in this book we show objects predominantly instrumental in character, whose shapes are the results of calculation and whose processes of development are

optically evident. They are generally buildings where anonymity is accepted to be the style. Their peculiarities originate not in spite of, but because of the lack of design.'

Another book which they published the next year, *The Architecture of Winding Towers and Cooling Towers*, though still organized by typologies, contained both innumerable details of the structures and panoramic shots of collieries, which give the context, both geographical and social. This book was more clearly aimed at the industrial archaeologist, but its images, though not replicating so

clearly the grids of Minimalism, were prescient of later photographic work that sought similarly to disclose complex situations.

Huebler may, in his *Variable Pieces*, have played with imposture, the Bechers may have sought clarity and candour, but the Frenchman Christian Boltanski lied outright. Pathos, deceit and uncertainty proliferate in his early photo-books. In the photographs that form *10 Portraits Photographiques de Christian Boltanski 1946–1964*, we see ten images of the artist at different stages in his growth to maturity (179). How sweet a child he was! But then, with the farce that typifies Boltanski's work, we suffer an awful doubt: how could he be such a slight child at the age of three, but so chubby at the age of five?

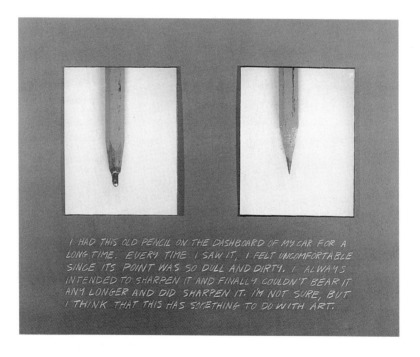

I HAD THIS OLD PENCIL ON THE DASHBOARD OF MY CAR FOR A LONG TIME. EVERY TIME I SAW IT, I FELT UNCOMFORTABLE SINCE ITS POINT WAS SO DULL AND DIRTY. I ALWAYS INTENDED TO SHARPEN IT AND FINALLY COULDN'T BEAR IT ANY LONGER AND DID SHARPEN IT. I'M NOT SURE, BUT I THINK THAT THIS HAS SOMETHING TO DO WITH ART.

Though each picture is listed as taken in a different month, the vegetation and light are always similar. How can that be? And how is it that he has blond hair, not brown, when he is fourteen? They are, of course, all images of children whom Boltanski had photographed in a park in 1972. The last of the ten images is of him as claimed, but aged twenty-eight, not twenty. Furthermore, the photographer was not himself, but Annette Messager.

From 1973 onwards, after the gallerist John Gibson had mounted an exhibition called *Story*, there was a short-lived 'movement' normally called 'Narrative art' – or rather, we should say, there was an attempt by dealers and curators to gather together all those artists who were making art using text and image in a more or less narrative way. Among these were John Baldessari, Peter Hutchinson and Bill Beckley. The narratives tended to be quizzical or anecdotal, with text and images often not matching up 'naturally'. If John Baldessari's *Pencil Story* is a good work of art, it is not because of its beautiful form, nor because it expresses his emotions, nor because it is witty, but because it sets us thinking (180). Its success is in being dissatisfying, not in being satisfying. Narrative had, of course, been specifically excluded from art by the formalists, which was one good reason to bring it back; another reason was the interest in the everyday; another was the desire, given the academicization of much Conceptual art, to be more accessible. Bill Beckley's work (181), with its large-format photographs, allusive texts and apparent disconnections, is typical of the play on the techniques of advertising and photo-romance. Much Narrative art was merely fey or whimsical, but the mode recurs, albeit in a more confessional or autobiographical way, in the work of artists like Sophie Calle, whose *Suite Vénitienne* of 1983 documents in furtive snaps and diary entries how, having met a man, she followed him to Venice and shadowed him, imagining what his life was like.

Another prefiguration of such work is the sequence of eighteen photographs, each inscribed with a line from the Coasters' song 'Searchin', entitled *In Search of the Miraculous (One Night in Los Angeles)* by Bas Jan Ader (182). He showed himself wandering around the city with everyday urban life forming the backdrop for this romantic search for the poetic or the elusive. Yet again, the images do not illustrate the text – we struggle to link them. An intended sequel to this work was never completed: having left an exhibition in Los Angeles, where a choir sang sea shanties, he set sail from Cape Cod for Holland, where he was to exhibit. But he never arrived. His boat was washed up the next year on the Irish coast.

180
John Baldessari,
Pencil Story,
1972–3.
Photographs
and pencil on
board.
Private
collection

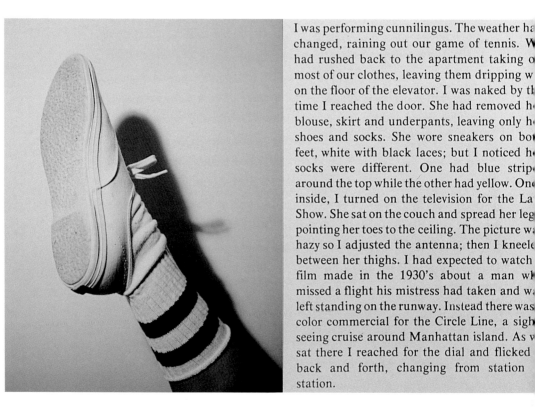

I was performing cunnilingus. The weather ha
changed, raining out our game of tennis. W
had rushed back to the apartment taking o
most of our clothes, leaving them dripping w
on the floor of the elevator. I was naked by th
time I reached the door. She had removed h
blouse, skirt and underpants, leaving only h
shoes and socks. She wore sneakers on bo
feet, white with black laces; but I noticed h
socks were different. One had blue strip
around the top while the other had yellow. On
inside, I turned on the television for the La
Show. She sat on the couch and spread her leg
pointing her toes to the ceiling. The picture w
hazy so I adjusted the antenna; then I kneele
between her thighs. I had expected to watch
film made in the 1930's about a man wh
missed a flight his mistress had taken and w
left standing on the runway. Instead there was
color commercial for the Circle Line, a sigh
seeing cruise around Manhattan island. As v
sat there I reached for the dial and flicked
back and forth, changing from station
station.

181
Bill Beckley,
The Circle Line,
1974.
Cibachrome
photographs;
101·6 × 304·8 cm,
40 × 120 in

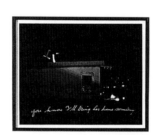

182
Bas Jan Ader,
*In Search of the
Miraculous
(One Night in
Los Angeles),*
1973.
18 black-and-
white
photographs,
text

For many, it was not scientific documentation or the photo-story that
acted as an ironic model, but advertising. There, the ideology, or
myths, which structure our society and the way we act, were flagrant-
ly displayed. An advert such as that for a bra titled 'Lovable' (183) –
understandably detested by feminists – is transparent in seeking
to sell a bra by associating it with a certain lifestyle, a certain way of
thinking: that a woman would always be 'just' a woman – feminine,
soft, sexy, loveable – even if they were a lawyer or a businesswoman.
In his 1957 book *Mythologies*, Barthes had shown how the ideology
of a society works like myth, underpinning representations so
that we understand them in a certain way: so that when he looked
at a copy of *Paris Match* and saw on the cover a young black soldier
saluting (184), he in fact saw the French Empire. His eyes were up-
lifted, presumably on the tricolour. 'I see very well what it signifies

PARIS
MATCH

N° 326 25 JUIN - 2 JUIL. 1955 50 Fr.

LE NAUFRAGE
DE RIVA·BELLA

•

Les enquêteurs recherchent
les responsabilités et
revivent par la photo les
dix minutes d'horreur de

LA TRAGÉDIE
DU MANS

LES NUITS DE L'ARMÉE
Le petit Diouf est venu de Ouagadougou
avec ses camarades, enfants de troupes
d'A.O.F., pour ouvrir le fantastique
spectacle que l'Armée française présente
au Palais des Sports cette semaine.

to me: that France is a great empire, that all her sons, without any colour discrimination, faithfully serve under her flag, and that there is no better answer to the detractors of an alleged colonialism than the zeal shown by this Negro in serving his so-called oppressors.'

As we have already seen, by 1973 Victor Burgin was looking for ways to convert theory into practice and to make some impact on the consciousness of the public at large. When in 1976 he was asked to make a poster for a group exhibition in Newcastle upon Tyne, he seized the chance (170 and 185). His poster was meant to be formally indistinguishable from all the other hundreds of posters pasted on the walls and billboards of the city (Burgin had actually got his image from a picture library used by advertising companies), but the message was different. Instead of trying to sell a commodity, it asked a question: 'What does possession mean to you?' Underneath was a colour photograph of an attractive young woman embracing a man. That this was firstly about economic, rather than sexual, possession was emphasized by an appended quote from the *Economist* magazine on how much was in fact owned by so few.

This was the only time that he confronted mass media directly. He came to see it as based on a crass notion of ideology: 'the exercise was one of getting a certain message onto the street – again, a pretty vulgar notion of how we can confront false consciousness with the naked truth.' Ideology, he had come to understand, through a reading of latter-day Marxists such as Louis Althusser and Antonio Gramsci, was more subtle than this, permeating society, reinforced by institutions such as education and art. One had to work through these institutions, not against them. One could not persuade people suddenly to see the 'naked truth', but you could try to make them think about it. The paradigm for his ensuing works became the seminar or reading-room, not the slogan.

In Berlin the next year, he made a set of eight photo-text diptychs entitled *Zoo 78* (186). In the old West Berlin, the zoo was at the centre of the city and was an emblem for a town permanently under surveillance. It was also around the nearby railway station that one found the porn shops and the peep shows. In the left-hand panel of

The plan is circular: at the periphery, an annular building; at the centre, a tower pierced with many windows. The building consists of cells; each has two windows: one in the outer wall of the cell allows daylight to pass into it; another in the inner wall looks onto the tower, or rather is looked upon by the tower, for the windows of the tower are dark, and the occupants of the cells cannot know who watches, or if anyone watches.

186
Victor Burgin,
Zoo 78,
1978–9.
1 of 8 diptychs,
each panel
81·3 × 91·4 cm,
32 × 36 in.
Private
collection

one diptych we peer, like voyeurs, at a naked girl on all fours, like an animal. A text from Michel Foucault's study of institutional control, *Discipline and Punish*, is overlaid on the image. It describes how the panopticon prison works: a warder can see all the prisoners from his central tower, but they cannot see him. Such constant surveillance, from school to the workplace or the prison, ensures our behaviour in modern society. On the right, we see some floral wallpaper and a sentimental painting of the Brandenburg Gate.

We can approach these pictures on different levels: scan them and get some glimmer of uncertainty or cross-reference all the images and texts, and even go and read Burgin's extensive theoretical writings, in which we find a thorough critique of the politics of representation. What connects the three elements? The gate was the symbol of a German reunification that then seemed far distant – like the woman, it was an object of desire. Desire is always desire for the past, for the lost infantile sense of completeness. Desire is always about our sense of lack. But voyeurism, as Freud tells us, is linked to sadism: this is a mastering gaze and, as we engage with the work, we realize our complicity in these mechanisms of control and repression.

By the 1990s Burgin was using video, and his work was less austere, allowing more for the eye to enjoy. But the themes remained the same: appearance and reality, urban life and sexuality, the space we create around ourselves with our consciousness. In *Love Stories* #2 (187), three video monitors show three people walking around. A man wanders down a hotel corridor, cleaning as he goes. A woman wanders around a park. Disconnected voices ruminate: 'Why can't you like me as I am?' 'I could have posed for this painting.' One is the voice of Ava Gardner. 'It's not me as I am at all, it's me as I'd like to be. Why am I not like that?' The tapes rotate by chance, they are out of sync and, as each ends, it finishes with an extended flash of solid colour – red, green or blue. Behind on the wall are the words 'driving fast on empty freeways'. As in his earlier work, a variety of elements are brought together for us to dismantle and reconstruct. Again, as in *Zoo*, this work functions as an invitation to readers to form their own thoughts and associations around the work.

187
Victor Burgin,
Love Stories #2,
1996.
Video
installation.
As installed at
the Lisson
Gallery, London

Boris Mikhailov, working in the Ukraine, had a different but surprisingly parallel agenda. Images of sexuality and nudity were, for him – given the puritanical repressiveness of the Soviet regime – liberating. At the age of twenty-eight he lost his job as an engineer because the police found 'pornographic' photographs that he had taken. He became a full-time photographer, subverting the banal images approved by the government: for example, the kitschy tourist photograph reproduced here, of three young people in front of one of the gigantic, heroic Soviet Socialist monuments (188), from the series *Luriki*, a word derived from the Russian for 'blink'. In his commercial work, Mikhailov was often asked to hand-colour photographs of dead people for their relatives, painting their eyes so they seemed to be blinking. Here, as in his *Sots Art* series (189), Mikhailov has hand-coloured the image, 'making it strange', leaving us uncertain whether we should affirm or deny the sentimentality.

In the years of the Russian Revolution, the theorist Viktor Shlovsky had proposed '*ostranenie*' (making strange) as a necessary tactic. 'Art exists to help us recover the sensation of life, to make the stone stony. The end of art is to make things unfamiliar.' 'Only the creation of new forms of art can restore to man the sensation of the world,' he wrote in 1914. In photography, this supposedly revolutionary approach was exemplified by Alexander Rodchenko, whose photographs, taken from unusual angles and perspectives, contradict our habitual ways of seeing things. Mikhailov's is a very different kind of 'making strange' from that proposed by Shlovsky or Rodchenko. For Mikhailov, aware that we can know the world only as representation, it is at the level of representation that this making strange must happen. Here, he adds colour to a black and white image, elsewhere, he adds text. 'By adding text I was able to apply to photography a method which Kabakov had developed [in his installations]: the introduction of "idiopathic" subjectivity into an objective environment with the aim of revealing it. The text contributes towards focusing on painful intellectual vulnerability, which was and still is unusual for our society with its positive heroes, and at the same time distorting it grotesquely. The text in the image has the prime task of declaring it unreal. The subjective text makes this image even more unreal, a tautology.'

**188
Boris
Mikhailov**,
Image from
Luriki,
1975–85.
Painted
photograph;
60 × 40 cm,
23⅝ × 15¾ in.
Collection of
the artist

**189
Boris
Mikhailov**,
Image from
Sots Art,
1975–85.
Painted
photograph;
50 × 60 cm,
19¾ × 23⅝ in.
Collection of
the artist

A very different type of appropriation was exercised by the American artist Sherrie Levine in 1981, when she showed twenty-two photographs of photographs taken by Walker Evans in the 1930s (190). These were, however, 'Levines' not 'Evanses': it was her act and her thinking. 'I take photographs of photographs. I choose pictures that manifest the desire that nature and culture provide us with a sense of order and meaning. I appropriate these images to express my own simultaneous longing for the passion of engagement and the sublimity of aloofness.' As she remarked, because of their strangeness, their *ostrananie*, these works can have paradoxically more aura than the originals. But, at the time, they were taken very much to be empty simulacra of art. It is important to realize that Levine could work

190
Sherrie Levine,
*After Walker
Evans (After
Walker Evans's
portrait of Allie
May Burroughs)*,
1981.
Metropolitan
Museum of Art,
New York

191
Jeff Wall,
*Picture for
Women*,
1979.
Transparency in
light box;
163 × 229 cm,
64¼ × 90¼ in.
Musée Nationale
d'Art Moderne,
Centre Georges
Pompidou, Paris

with a far greater awareness of semiotics and photographic history than artists ten years earlier: like most recent photography, it is far more 'knowing', more consciously a strategic move within art history.

Other differences between the use of photography by Conceptual artists in the late 1960s and the 1980s can be seen by comparing Jeff Wall's *Landscape Manual* (see 173) with his more recent works (191). Obviously the technical standard of the recent work is far higher, which is true of many artists, including Burgin and Long. Wall's *Picture for Women* of 1979 signals a shift away from collage or text–image contrasts. The photograph has the same integrity as a

nineteenth-century painting and is on a monumental scale. Indeed, it clearly echoes Édouard Manet's *Bar at the Folies-Bergère* (see 10). But whereas, in Manet's painting, we see a customer gazing at a barmaid, in the photograph, we see Wall himself staring at the reflection of a girl who stares at the camera, which itself is reflected in the mirror; and it is from the viewpoint of the camera that we see everything.

By being made so explicit, the male gaze, with its assumptions of control, is thwarted in Wall's image – or, at least, we can interpret it

that way. Unanchored by any text, the conflicts and complexity of the subject had to be in the image itself: art-historical reference and allegory being two key ways of facilitating this. By making the photograph so large and exhibiting it as a transparency on a light-box, it has quite literally a presence and an aura. The intention, though, has not changed: 'in general, my primary objective is to create a sort of identity crisis within the viewer in some form, maybe even a subliminal one.'

We can see a similar difference if we compare a work made in 1973 by the Catalan artist, Ferran Garcia Sevilla, of people looking at Diego Velázquez's *Las Meninas* (itself an allegory of seeing), with the photographs by Thomas Struth, a student of the Bechers, of people in art galleries. Sevilla's photographs are unspectacular, inept almost, whereas Struth's are of great beauty: looking at his viewers, we too can participate in their visual pleasure. Is it an attack of 1960s puritanism to suggest that Struth's work is, because it is so beautiful, complicit with the museum spectacle? That an approach that began as a critique has become the new establishment aesthetic?

A similar trajectory from puritanical critique to the re-instatement of both pleasure and the aesthetic may be charted in the writings of Roland Barthes: his early work analysed press and advertising photographs purely in terms of semiotics: 'in photography,' he wrote in 1961, 'contrary to the intentions of exhibition photographers, there is never *art* but always *meaning*.' But by 1980, when he wrote *Camera Lucida*, a book centred on his emotional reaction to photographs of his mother after her death, his responses were more coloured by pleasure and longing. 'The photograph', he wrote in continuation of the quotation that opened this chapter, 'represents that very subtle moment when, to tell the truth, I am neither subject nor object but a subject who feels he is becoming an object: I then experience a micro-version of death (of parenthesis): I am truly becoming a spectre.' 'Ultimately, Photography is subversive,' Barthes claims, 'not when it frightens, repels, or even stigmatizes, but when it is pensive, when it thinks.' One imagines that both Wall and Struth believe they are making 'thinking photographs', but one could argue that they also reintroduce the old photographer genius and also privilege the visual in isolation from language. Is this acceptable for a critical practice, given that most of the photographic images we digest everyday still come anchored and labelled with words?

Barbara Kruger would disagree with Wall's severance of text from image, much as she would disagree with Burgin's retreat from the street. She describes her use of text and image as an attempt to couple 'the ingratiation of wishful thinking with the criticality of

192
Barbara Kruger,
Untitled (We don't need another hero),
1987.
Photographic silkscreen on vinyl;
276.9 × 533.4 cm,
109 × 210 in.
Mary Boone Gallery, New York

knowing better. To use the device to get people to look at the picture, and then to displace the conventional meaning that that image usually carries with perhaps a number of different readings.' In other words, to destroy the apparent seamlessness of the text–image union in advertising and editorial. She is quite clear about the need to work against the popular ideology of advertisements and lifestyle magazines: 'it is not surprising that most people are comforted by popular depictions. Sometimes these images emerge as "semblances of beauty", as confluences of desirous points. They seem to locate themselves in a kind of free zone, offering dispensations from the mundane particularities of everyday life; tickets to a sort of unre-

lenting terrain of gorgeousness and glamour expenditure. If you and I think that we are not susceptible to these images and stereotypes then we are sadly deluded.' Photography, she emphasizes, relates not to the rhetoric of realism, but of the unreal. A work such as *Untitled (We don't need another hero)* (192) is perhaps a bit obvious and takes a rather hectoring tone, but if we imagine it seen, as it was intended, as a billboard in the peripheral vision of someone driving to work, perhaps there is sufficient complexity.

Context can open up the potential meanings of a photograph, as well as text. In 1995 the Swiss artist Christian Marclay installed six snap-

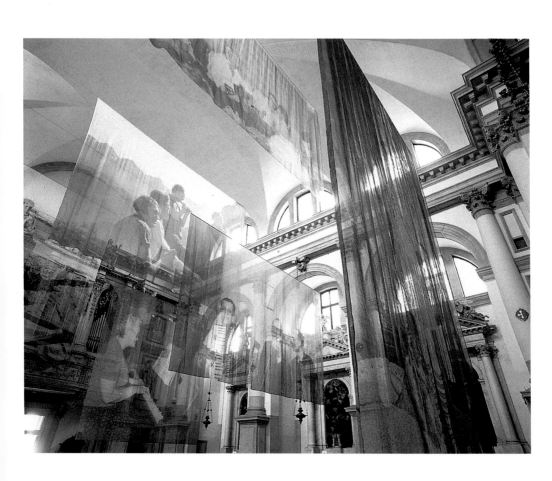

shots in San Stae, a Baroque church in Venice (193). Found in junk shops and flea markets, the photographs were framed and placed on each of the six side altars. He also had them enlarged, mounted on translucent material and hung across the church. These were very ordinary photographs, relics of unexceptional lives: a red-faced man playing a guitar at a party, an old lady at a piano, a child with a serious face playing a recorder. This is perhaps a monumental version of that everyday-ness which Huebler and Feldman aspired to. All the images were of music-making, something vision can never duplicate. Their happy mundanity was in counterpoint to the grandiloquent decoration of the church and the paintings of violent martyrdoms that surround the altar. The photographs were readymade, but by amplification and a change of context they are made new.

Much of what we have said about photography is also true of video works. Placement is key here too: to see a television pushed into a corner, showing an image of a girl crying, saying nothing, giving no reason for her crying, as in Georgina Starr's *Crying* (194), makes one acutely self-aware. We are embarrassed, as if the television were a surrogate person. Video is, as Bruce Nauman has said, a private medium in a public place.

A major premise underlying the photography affected by Conceptual art, as we have noted, has been the destruction of the mystique of the photographer as author and genius. However, this has not precluded the artist himself or herself being the subject: as in the work of Arnatt, Acconci, Nauman, Piper and Mendieta. They could become the artistic equivalent of a laboratory rat or a sociological or anthropological subject, as a way of both telling us something about themselves and exposing the mechanisms of the so-called social sciences.

In the end the greatest effect of Conceptual art on the use of photography has been to make the photograph function like a question and not like a self-evident statement. Of course, Conceptual art cannot change the photograph, but it has changed how we think about the photograph. It has made the viewer more aware of their own act of looking. In one image (195) Ken Lum, a one-time student of Jeff Wall, shows us a distressed young girl in a sleazy dressing-

193
Christian
Marclay,
Amplification,
Ink jet prints on
cotton scrim,
found
photographs,
frames.
As installed at
San Stae
Church as part
of the 1995
Venice Biennale

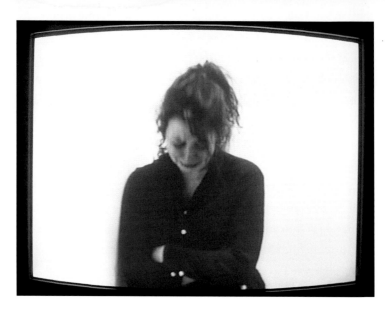

room. The words on the accompanying panel seem to be the words
running through her head: 'What am I doing here?' Have financial
circumstances or some foolish act forced her to become a stripper?
Or is she just an actress in a provincial repertory company with stage
fright? We speak the words to ourselves and so also ask ourselves
what we are doing here. It is the same catch as Reinhardt's 'What
do you represent?'

The shift from the abstract to the particular, from the generic to the
autobiographical, is common to much work made under the sign of
Conceptual art in the last ten years. The issue is frequently one of
identity, the question increasingly being 'Who am I?', rather than
'What is it?' Since the 1970s, art made by women, especially, has
brought the confessional and the autobiographical narrative into
the realms of a critical, non-expressionistic art. From Martha Rosler
to Georgina Starr, it has been women above all who have turned the
camera on themselves, and the image back on the viewer.

In 1992 the English artist Gillian Wearing began a series of
photographs entitled *Signs that say what you want them to say and
not signs that say what someone else wants you to say* (196). She
would go up to people on the street, give them a clipboard and a

195
Ken Lum,
*What am I
doing here?*
1994.
Laminated C-
print on sintra,
lacquer, enamel
and aluminium;
182·9 × 243·8
× 5·1 cm,
72 × 96 × 2 in.
Private
collection

What am I
doing here?
What am I
doing?
How'd I get
into this?
What am I
doing here?

pen, ask them to write down what they were thinking and then photograph them with these signs. 'I wanted to find out what made people tick. A great deal of my work is about questioning handed-down truths without being force-fed in front of the television.' She made four hundred of these, eventually giving up when people started to recognize her and when the idea was used for an advertising campaign. These images show cries from the heart, complaints, jokes or statements of allegiance. A homeless girl: 'Give people houses, there is plenty of empty ones, OK!' A tattooed man: 'I have been certified mildly insane'.

How do we compare this with Huebler's coincidentally similar work? Huebler is more concerned with guying the idea of the artist as maker and the notion of the archive. It has an element of satire that Wearing's does not. Whereas hers is more direct, streetwise, populist even, his is double-edged. It is less certain what he is getting at. His work adopts the pose of the social scientist, whereas hers is that of the investigative journalist. In both, photography speaks not with one voice, but with a myriad of voices: black, white, brown; male, female, transsexual; sane, demented, mildly insane. The gaze of the camera is one of mastery, in which a dominant ideology tells, hints and insinuates what we should do and how we should think; but

occasionally there are ways, like these, for an artist with the camera not to dominate their subjects, to escape the horror of always speaking for others, to let that other have a voice.

Conceptual Art

196
Gillian Wearing,
Signs that say what you want them to say and not signs that say what someone else wants you to say,
1992–5.
C-prints mounted on aluminium

MURDERER

... and her name is

G, L, O, R, I, A, G, L, O, R, I, A, Gloria!

G, L, O, R, I, A, Gloria!

I'm goin' to shout it all the night! Gloria!

I'm goin' to shout it every day! Gloria!

Them, 'Gloria', 1965

When within *consciousness,* the name *is called* proper, it is already classified and is obliterated in *being named.* It is already no more than a *so-called* proper name ... The battle of proper names follows the arrival of the foreigner and that is not surprising.

Jacques Derrida, *Of Grammatology,* 1967

197
Willie Doherty,
Same Difference
(detail of 218)

It is 1994 and a young woman is walking down the road. She is wearing a white T-shirt, devoid of any decoration save in green letters, on the back below the collar, the words 'Nobody owns me' (198). What is odd about this? Visually it is not immediately striking, but an inquisitive mind will soon start to find it irritating or thought-provoking. Normally what we see on the back of a T-shirt, if anything, is the name of the manufacturer, but instead we see this elliptical message. Is it not a truism? Of course, nobody owns us: we are all, supposedly, free people. But then, could we not argue that by buying any commercial product displaying the brand name we have been named, captured and even possessed by the advertising and marketing of that product: we have become a Mitsubishi man or a Gucci girl. This particular T-shirt is a refusal of that type of surreptitious ownership. In an age of greater and greater state surveillance and control, it is an affirmation by that person that their body belongs to them and no one else.

The T-shirt was commissioned by the French clothes company Agnes B and designed by the American artist Felix Gonzalez-Torres. We may ask why this T-shirt is art and another is not. What about a T-shirt

inscribed 'Megadeath' or 'Rolling Stones' or 'Madonna'? Could that not be art? Is Gonzalez-Torres's T-shirt art because he was an artist? Or because it is done with a greater awareness of what it means? Or because the possible interpretations are greater and more complex? There is no straight answer: there is no definite line that divides the art T-shirt from the non-art T-shirt. Perhaps, for Gonzalez-Torres's generation, the point is not to play on definitions of art but, as with the Situationists, to adjust or intervene in the flow of things.

What of the T-shirt by the English designer Katherine Hamnett with the words '58% Don't Want Pershing' on it (199)? This is again allegiance (albeit to a cause rather than a rock band, Pershing being an American missile with a nuclear warhead which was then

198
Felix Gonzalez-Torres,
Untitled,
1994.
Cotton T-shirt

199
Katherine Hamnett and Margaret Thatcher at a reception at 10 Downing Street for British Fashion Week designers, 1984

controversially being deployed, with the approval of Margaret Thatcher, in the United Kingdom), but it too is an intervention. Not only designers, but rock bands such as the Sex Pistols in the late 1970s, had begun using such Situationist ploys.

Wherever we see words presented visually in public, we are seeing political or ideological struggle. Whether it be placards held aloft in a demonstration (200), or graffiti scrawled upon a wall. Very often graffiti will involve defacing some previous inscription – and that word 'defacing' is indicative. To wipe words out or to cross them out is to take the face off, to subvert or steal someone's identity or position. In 1990, the singer k d lang, the only famous person ever to be born in the small Canadian beef town of Consort, announced her

200
Demonstration
against the
Vietnam War at
the American
Embassy,
London,
1968

201
Supporters
of k d lang
cleaning a
defaced sign
at the edge
of Consort,
Alberta,
1990

opposition to meat-eating in adverts made on behalf of the organization People for Ethical Treatment of Animals. In response, the sign outside the town, which read 'Consort, home of k d lang' was defaced by locals with 'I love Alberta beef' stickers and the spray-painted advice 'Eat Beef, Dyke'. (k d lang's homosexuality was well known, but the good folk of Consort were never bothered by it until she also came out as a vegetarian.) Counter-demonstrators, bearing placards, cleaned up the sign (201). Words, especially those written in public, are where we announce our identities and beliefs.

Naming is crucial. It is the act of naming which gives meaning and significance to the things of the world. The scene in Genesis where Adam names the animals is a key one: in a sense he is taking ownership of them. Naming is an almost magical act, hence the persistence of such rituals as christening, or the conjuring of names in rock music, as in the song quoted at the beginning of the chapter: as if to say 'Gloria' enough times would make her manifest. Our entry into language as children is marked by our naming of people and things: 'Mother', 'milk', and by requests: 'more!', 'now!' It is when we ask questions that we begin to achieve some degree of self-awareness: 'Why must I do that?' 'Why am I myself, and not another?'

Annette Lemieux's painting (see 7) asks these questions for us: 'Where am I? Where are you? Where is she? Where is he? Where are they? Where are we?' 'Who? What? Why?' Her list also parodies the way that we learn verbs in a foreign language, but presented as a painting we become aware of other things: does the 'I' refer to the reader or the author? Who speaks? Who reads? We may even ask whether, after Conceptual art, the status of painting has changed too, so that to make a painting is now more like asking a question than making a statement.

Neither Gonzalez-Torres nor Lemieux see words as separate from their presentation and context. In this, they are different from artists working in the late 1960s, who treated words as effectively disembodied, at least initially: for example Lawrence Weiner's early indifference to how his words were shown (see Chapter 5). But the problem was soon realized. Words are not *ipso facto* concepts.

202
Robert
Smithson,
*A Heap of
Language,*
1966.
Pencil;
16·5 × 55·9 cm,
6¹₂ × 22 in.
John Weber
Gallery,
New York

They cannot exist apart from their visual or aural presentation. After John Baldessari had told his students to make no more boring art and they had responded with veritable logorrhea (see 114), he stopped making word-based art completely. 'Unless you can prove me wrong,' he said some years later, 'any artist who has ever used language has had to get more and more visual to say the same thing, to the point where it becomes all visual spectacle and the meaning is lost. They have to keep upping the ante. That's why I stopped using words in the work. I realized that's where it had to go, and I did not want to do that.' There was a considerable transition from the time when Victor Burgin or Lawrence Weiner were content to type a few words on an index card to that when Jenny Holzer could fill the entire atrium of the Guggenheim Museum in New York with words (see 221), although in fact it took just twenty years. It is not language *per se* but language rammed up against visual appearances, including its own, that ultimately characterizes Conceptual art.

From the start, word-based art was as much a critique of language as it was of the 'visual'. In a 1970 exhibition Mel Bochner wrote in white chalk on black walls in enormous letters the words 'Language is not transparent.' Robert Smithson was also acutely aware of language as material, as his drawing *A Heap of Language* shows (202). If one wanted to make an art of pure information, then words might initially have seemed an appropriate means, but as we have seen, such a project was doomed to failure. Words cannot exist without matter: paper, ink, a computer screen, the air through which we speak. They cannot exist save in a context: a billboard on the street,

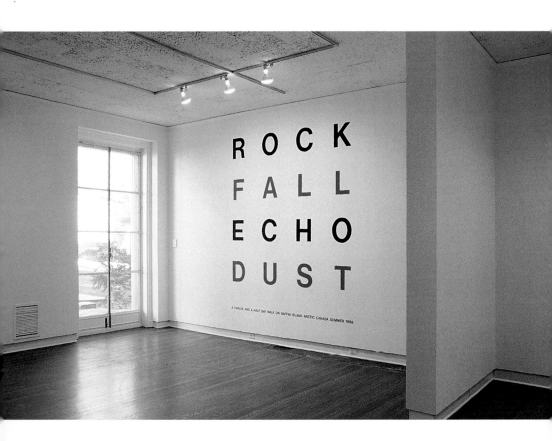

203
Hamish Fulton,
Rock Fall Echo
Dust (A Twelve
and a Half Day
Walk on Baffin
Island Arctic
Canada
Summer 1988),
1988.
Wall painting.
As installed at
the Tyler Gallery,
Philadelphia

204
**Jessica
Diamond**,
*Yes Bruce
Nauman*,
1989.
Acrylic and
flash paint
on wall.
Museum van
Hedendaagse
Kunst, Antwerp

an instruction manual, a conversation between friends. Artists who have used words since the 1970s have generally shown an increasingly sophisticated awareness of this context, and have become more attentive to the way that words are displayed visually: through typeface, size, colour and other means. Paradoxically, given the nominal attention paid to display and typeface by Conceptual artists at first, their austere typewritten pages and index cards now look like a mannerism – even a style.

Hamish Fulton's *Rock Fall Echo Dust* (203) is a very clear example of the care taken over the form and presentation of words, subsequent to the late 1960s. It has a simple visual appeal: sixteen letters in a grid. The variation between the colours, and the way that the sixteen letters are anchored to a longer line of smaller type, give it both visual and literary cohesion and poignancy. There is a surprising progression, counterpointing the stasis of the visual form: in a journey across Baffin Island, Fulton saw a rock fall, heard the noise echoing and saw the dust rising. This movement or progression is easily deduced by reading the words from top to bottom. There is also a tension between the abstract or general nature (the top four lines): something we could all see, and the particular of the bottom line: very few of us have made a twelve-and-a-half day walk across Baffin Island.

Jessica Diamond's *Yes Bruce Nauman* (204), like Gonzalez-Torres's T-shirt or Fulton's grid, is again indicative of a growing sophistication in artists' use of language – and an expectation of sophistication in their viewers. By the late 1980s, Bruce Nauman seemed, for many, to be the most important living artist – and Diamond assumes that her audience is aware of this. So initially we read her work as an affirmation of his. Or perhaps we could read it as an agreement with what he is saying. But what exactly is Bruce Nauman saying? What does he represent? Then, perhaps, we begin more consciously to take note of the visual presentation: the magic-marker style of writing, as though on a memo pad; the scale – this is a wall drawing that will normally cover most of a wall. It begins to be not just a three-word statement, but a complex and uncertain image or message, where affirmation soon peters out, turning into an ironic question.

An installation by Rosemarie Trockel (205) shows clearly both how words and context interact, and how artists can use that to their advantage, just as Christian Marclay had used San Stae in Venice (see 193). In St Peter's Church in Cologne, a church restored after heavy bomb damage and now also used as an art space, Trockel had placed the words 'Ich Habe Angst' ('I am scared', or quite literally, 'I have fear') above the altar. Was this a simple statement of fear? First one had to ask who was speaking: Trockel, God, Christ or oneself – the reader? Trockel had shrouded the windows so that the church was unusually dark and gloomy. Who was the reader? An art groupie who had wandered in from the nearby Cologne Art Fair or a parishioner who had come in for peace and prayer? How can the particular reader respond to the implicit injunction to internalize this statement: to be fearful, and think on the cause for fear? The altar is the site of the word, both written and spoken: are these words then to be spoken in the sombre silence?

**205
Rosemarie
Trockel**,
Ich Habe Angst,
Installation at
St Peter's
Church,
Cologne, 1993

An earlier work by Trockel reveals again how words and presentation interweave to produce meaning. On a piece of machine-knitted wool are written the famous words of the French philosopher René Descartes: 'Cogito ergo sum' ('I think therefore I am'; 206). But to knit rather than write it, raises odd thoughts: we consider writing as being tantamount to thought, but we do not think the same thing of knitting. It is normally seen more as a way of filling time than a way of being an 'author', and it is moreover often seen as a female occupation. Trockel gives this an ironic twist by machine knitting the words and adding at the bottom a black square by way of ironic reference to Malevich and Reinhardt.

206
Rosemarie Trockel,
Cogito, ergo sum,
1988.
Wool;
220 × 150 cm,
86⅝ × 59⅛ in.
Monika Sprüth Galerie,
Cologne

207
Lawrence Weiner,
Fire and Brimstone Set in a Hollow Formed by Hand,
installation,
1988

Those artists from the 1960s who still concentrate on a word-based art often bear out Baldessari's claim that it tends inevitably towards visual spectacle. Although Lawrence Weiner's apothegms are as pithy as ever, they have become far larger, more elegant and visually orientated. In 1988, at an exhibition of public art beside a canal in an industrial area of Manchester, Weiner wrapped the words 'Fire and Brimstone Set in a Hollow Formed by Hand' around a pillar of a disused railway bridge (207). There is a real sense in which his works have become sculpture, as he himself claims; they hold the space as well as any three-dimensional object. Many of Kosuth's recent installations have been almost megalomaniacal in scale: he once

filled a Polish castle with a hundred chairs and tables and, for *Documenta IX* in 1992, he draped all the statues along two corridors with motto-printed cloths.

Kosuth also organized a series of five exhibitions entitled *Zero and Not* (208), culminating at the Freud Museum in Vienna in 1989. In each instance, he took a different paragraph from Freud's writings, enlarged it onto huge sheets of paper and covered the walls with it. As though in an act of repression, Kosuth crossed the words out but then, as Freud points out, the repressed always returns. We can still read the words, though our reading is slower and perhaps more careful. It could be argued that this is, as Kosuth says, a Conceptual 'architecture', where the type acts like a structure. Language becomes explicit as a physical object here, just as the site-specific installation makes the 'architecture' of the building explicit. Critics would argue that the work is so baroque in design that one hardly thinks of reading, let alone critically engaging with the language.

208
Joseph Kosuth,
Zero and Not,
1986.
Silkscreen
on paper.
As installed at
the Chambre
d'Amis, Ghent

In the late 1980s Robert Barry began painting entire rooms in a single colour (209). Over this he would write words such as 'Hope', 'Anxious', 'Remind', 'Explain'. They seem to be floating, some upside down, others on the diagonal. Anchored neither by gravity or noun, they inhabit both real space and a kind of mental limbo. Many of the words are even cut off by the ceiling or dado. In an interview for the magazine *Flash Art* Barry said: 'I use words in a sense that makes them meaningless, and of course the only way you can make something meaningless is to present it in all of its possible meanings.'

Susan Hiller's *Monument* of 1981 (210) demonstrates a more multi-layered approach to language, in which private and public, rational and irrational, spoken and written modes of language are combined and contrasted. In a darkened room we find a park bench and behind it, on the wall, photographs of forty-one Victorian memorial plaques dedicated to people who sacrificed their lives for others. They are public commemorations and moral exhortations. But on the bench we also find headphones: if we sit down and put them on we become part of this memorial too. If the plaques are objective, the voice coming over the headphones is communicating in a private, personal

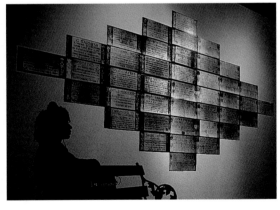

way. It is a fragmented monologue: 'Do the dead speak through us? I'm insisting on the reality of your first-hand experience. I'm insisting on the evidence of eyes (Is). I'm insisting the word is not primary ... Her voice is winding past your ear; a line, a text, an inscription ... She treated words like objects, objects like subjects, and subjects like herself.' Ideas and identities float up as in a dream: darkness suggests sleep and death. We have at least three voices intersecting here: the lament of the plaques, the confidential musings of Hiller (who seems to speak for more than one) and, of course, that of our own questioning consciousness. One of Hiller's points is that consciousness is a communal thing and that therefore a monument must be subjective as well as objective.

Lothar Baumgarten's *Monument for the Native Nations of South America* (211) seems initially more straightforward. Exhibited at *Documenta VII*, it looks like those lists of famous men that are engraved on public buildings. Monuments are about shared or communal memory, so what Baumgarten exhibited was paradoxical. In the West these words do not evoke communal memories: 'Namba', 'Bororo', 'Xavante', 'Toba', 'Arekuna'. These are the names of the Indian peoples of South America. The monument must in some way be ironic, for a monument is normally permanent, as this was not, and dedicated to the conquerors, not as here, to the conquered. The first act of conquerors is to rename, a subject central to Derrida's book *Of Grammatology*, a quote from which opened this chapter. A monument is about memory, and here the memory of what has been neglected is in some way pushed back into culture's consciousness.

Tania Mouraud's project for a nursery school is another monument to the potency of naming (212). In a conscious gesture of anti-racism,

211
**Lothar
Baumgarten**,
*Monument for
the Native
Nations of
South America,*
1976–82.
As shown at
Documenta VII,
1982

212
Tania Mouraud,
*Groupe scolaire,
St Quentin en
Yvelines,*
1979–81

she had 450 forenames of children from around the world inscribed upon the walls. Like Baumgarten, though on a more personal level, she is asserting the right of people to their own names.

Places too must be named or renamed, and many artists have reworked maps in an attempt to subvert dominant readings. We may recall Situationist maps and that by the Grup de Treball which is mentioned in Chapter 7. Maps give a (purely conceptual) sense of one's place in the world. When one travels on a ship one has to get orientated: Where is my cabin? How do I get to the lifeboats? Where is the dining room? Placed around the ship are schematic drawings

213
**Simon
Patterson**,
*Monkey
Business*, 1993.
Lisson Gallery,
London

that show what is on each deck. Simon Patterson has drawn just such a schematic ship (213), but the directions seem curious. The decks are labelled 'Quaternary, Tertiary, Cretaceous', as if they were geological ages, and then 'Weasel, Raccoon, Archaeopteryx', as if they were the stages in a rather eccentric ascent of animal species. Another time line extends diagonally down through the decks, interrupted by lines for 1400, 1500, 1600 – a chronology of Venetian painters: Jacopo Bellini, Antonio Vivarini, Bartolomeo Vivarini, but the sequence ends incongruously in the bilge of the ship with the word 'slime'. A reference to

primordial slime, from which our very distant ancestors supposedly emerged? This is a comedy of languages and schema.

The original map of the underground railway system in London over-laid the routes on a street map. It was difficult to read and, as more and more lines opened, it became hopelessly unclear. Harry Beck designed a new one that has been used ever since, with separate colours for each line and clear points of intersection. He was neither a graphic designer nor a cartographer, but an electrician who had been temporarily laid off, and his map was based on the type that he knew best: electrical circuit plans – in effect an energy map. When Simon Patterson détourned it in 1992, retitling it with the astro-nomical term 'the Great Bear', he renamed the different lines after philosophers, comedians, footballers, saints (214). He has remarked that this is a 'neurological map' and, given that our thoughts and impulses are transmitted electrically, this both explains how it was made and how we should read it. The fun begins when two lines, or systems, collide. Where the line of saints meets the footballers' line we have a station named 'Gary Lineker', an English player renowned for fair play. Other junctures are less explicable: why does Kierkegaard appear when the philosophers' line joins that of the Hollywood actors? Some of the lines read chronologically or alphabetically while others seem to follow word association or stream of consciousness.

In the fourth volume of her ongoing book *To Place*, Roni Horn includes a map of Iceland. On it are superimposed all the titles of the various essays she has written there in the past few years, the map becoming one of lived experience. Both writing and geography are systems and the individual is a point, a place in both: 'I' is both the first person linguistically and the place where I am. But this fascination with the first person is coupled with a distaste for the way that such pronouns define experience, especially 'he' and 'she': 'I've been built into a sixties suburban style ranch home like a dishwasher and it's been mistaken for my life. I want a language without pronouns. I want to come, direct and complete, without pronoun. Yes I do. I want to come before gender. Yes, yes I do.' The book forms the support for many of

her works, which include word pieces such as *Kafka's Palindrome* (215). In this the words 'It would be enough to consider the spot where I am as some other spot' encircle a block – many of her objects are like Minimal sculptures turned uncanny. We have to circle the entire sculpture to read the sentence, so that reading a text becomes tantamount to how we experience a place by walking in time.

As with so many of the works we have discussed, this would be better described as a reading piece than a word piece. Likewise, Horn's works based on the poems of Emily Dickinson (216) include the whole of a poem, but the words are inscribed on aluminium columns with plastic letters, installed askew, so that one cannot read it immediately but must move around to reconstitute the lines. Walking and looking become obvious components of reading. Reading is avowedly a physical process, though the words remain immaculate, certain, unlike the uncertain body that moves around them.

214
Simon Patterson,
The Great Bear,
1992.
Lithograph
and anodized
aluminium frame
with glass;
109 × 134·8 × 5 cm,
43 × 53⅛ × 2 in.
Lisson Gallery,
London
Below
Detail

Gonzalez-Torres wryly suggests that we literally transfer a photographic portrait into language: 'he has a happy smile, sparkling eyes', 'she looks cross and mean'. In his own portrait pieces he reverses this: making us with words instead (217). 'I start a portrait by asking the person to give me a list of important events in his or her life – intensively personal moments which outsiders have very little knowledge of or insight into. Then I add some relevant historical events that, in more ways than one, have probably altered the course of and the possibility for those supposedly private or personal events.' 'These portraits are always changing, and whoever owns them can alter, add, or take out information.' Such a portrait can, at least in theory, reflect the present image or self-image like a mirror, and in this it differs from the photograph, which is always a thing from the past.

As with a lot of photographic-based work, much word-based work revolves around the issue of identity. Who is who, and who determines who will be what? When you entered the gallery to see Willie Doherty's *Same Difference* in 1990 (197 and 218), you were confronted by a black-and-white photograph taken from a newspaper of a young woman's head projected onto the wall. A series of words were project-

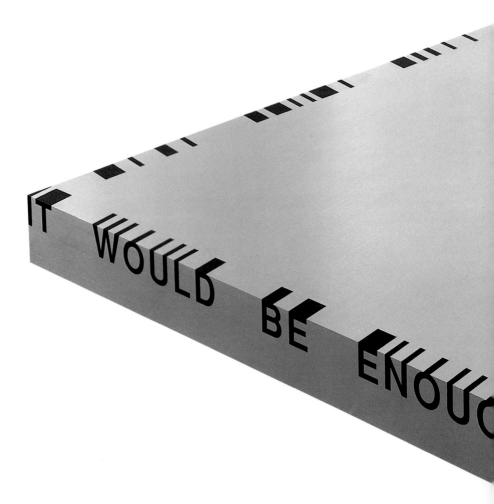

215
Roni Horn,
Kafka's Palindrome,
1991–4.
Solid aluminium
and plastic;
10·8 × 124·5
× 106·7 cm,
4¼ × 49 × 42 in.
Baltimore Museum
of Art

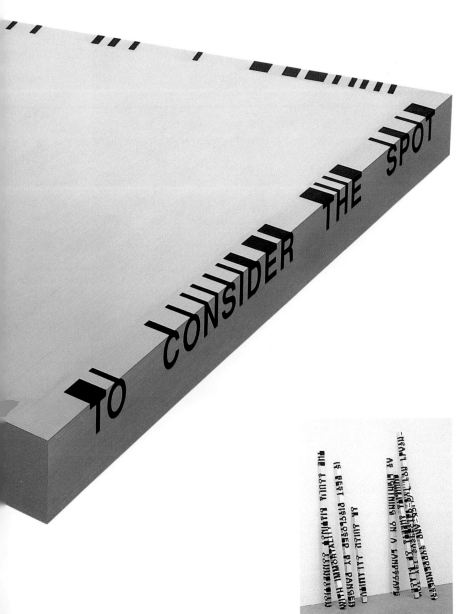

TO CONSIDER THE SPOT

216
Roni Horn,
*When Dickinson
Shut Her Eyes,
No.974*,
1994.
Solid aluminium
and plastic;
max. h.182·9 cm,
72 in.
Matthew Marks
Gallery, New York

217
Felix Gonzalez-Torres,
Untitled (Portrait of the Stillpasses),
1991

218
Willie Doherty,
Same Difference,
1990.
Slide installation with text.
As installed at Matt's Gallery, London

ed onto this face in turn: 'odious', 'murderer', 'callous', 'ruthless'.
There were eighty words in total, half of them were 'murderer' and
the other half were adjectives, most of which one would have expect-
ed in the normal newspaper stereotyping of terrorists or gangsters.
Some, however, were more contradictory: 'loyal', 'delirious',
'impulsive', 'perfect'. Initially one's reading of the portrait photo-
graph was coloured in a rather obvious way by the overlaid words,
but as the sequence continued one became unsure as to whether
they were parts of a cumulative characterization, or alternatives.

Across the room the same face appeared once more, but a different
sequence of words flashed across it: 'meticulous', 'volunteer', 'loyal'.
Now the adjectives seemed to belong to a laudatory obituary: 'noble',

'defiant', but once again unexpected adjectives started to appear:
'melancholic', 'mythical', 'sentimental'. One was confused by the
contradictions between and within the two sequences: the face
became more and more uncharacterizable, more unknowable.
The initial sense that one was watching a slide lecture was replaced
by the sense, with the repetitive click of the changing slide, of being
at an interrogation. This was very different from Robert Barry's uses
of the slide-projection format (see 124): this was a highly charged
discussion about identity rather than a calm, albeit paradoxical,
debate on abstract categories. The question of identity, of who you
are – is it who I say you are, or who you say you are? – became more
poignant if one knew that the face did in fact belong to a woman,
Donna Maguire, who had just been arrested, on dubious evidence, as

a terrorist, and if one knew that Doherty came from a town with two names: Derry if you are Catholic, Londonderry if you are Protestant. If politics were implicit in Conceptual art of the late 1960s, they have become more frequently explicit now.

'Having to learn to express oneself in someone else's language' is, as the American Glenn Ligon remarks, not only a problem for women, but one for any artist from a minority: Ligon is in a minority twice over, through his blackness and his gayness. The work reproduced here (220) is painted, or written, on a door – something which is by size, shape and function related to the human body. The door is a found object and, he points out, the words too are 'found language'. The text is a quote from the black American author Zora Neale Hurston's 'How it Feels to be Colored Me'. As he works, the stencil gets more covered with the wet oilstick and starts to smear the words: 'I spent a lot of time trying to figure out how to keep this smearing from happening, until I realized that it was interesting. It seemed to coincide with my way of reading the text, my way of obsessively rereading. The idea of saying something over and over and not being heard. The idea of being heard and not being heard.' Again the work is about identity and how language determines identity (a false one). For all the use of a stencil and the found object and language, the

219
**Kathy
Prendergast**,
*Two Hundred
Words For Lonely*,
1994.
Pillow and ink;
32 × 46 × 4 cm,
12⅝ × 18⅛ × 1½ in.
Collection of the
artist

220
Glenn Ligon,
*Untitled (I feel
most colored
when I am
thrown against a
sharp white
background)*,
1990.
Oil stick and
gesso on wood;
203·2 × 76·2 cm,
80 × 30 in.
Max Protetch
Gallery, New York

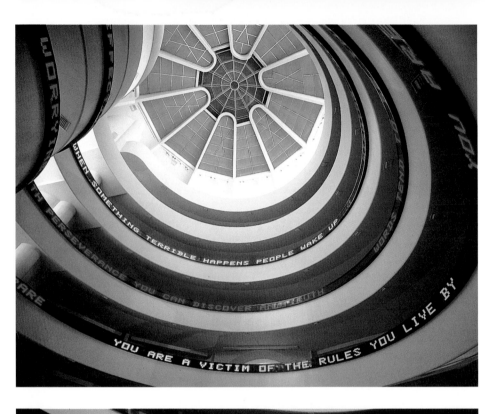

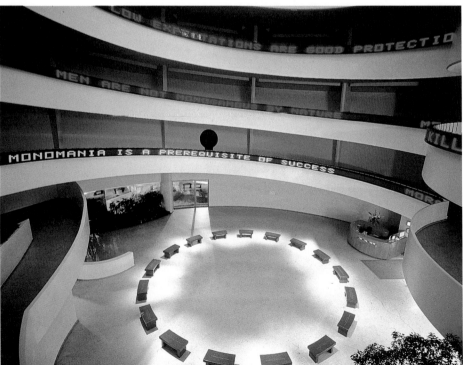

handmade element, as in so much word-based art now, is crucial – for it is in this that we traditionally see the person, sense the identity. In its handmade quality, *Two Hundred Words For Lonely* (219) by the Irish artist Kathy Prendergast likewise seems to be a refusal of austerity or abstraction in favour of the personal. The object is inscribed with its own history.

Looking for news of a postponed train, a message flashes unexpectedly on a public information display: 'Murder has its sexual side'. Travelling on a Venice waterbus, one sees a poster bearing the words 'Protect me from what I want'. A woman jogs down the street, on her T-shirt are the words 'Abuse of power comes as no surprise'. Perhaps no word-based artist has become so well known as Jenny Holzer. She seems to be the acceptable face of language-based Conceptual art. The pithiness of her work from the early 1980s, *The Truisms*, is in part a response to the overlong theoretical texts she was made to read as a student, such as those in *The Fox*.

221
Jenny Holzer,
Selections from
*Truisms,
Inflammatory
Essays, The Living
Series, The Survival
Series, Under a
Rock, Laments* and
new writing,
1989.
Extended helical
LED electronic
signboard. As
installed at
Soloman R
Guggenheim
Museum, New
York, 1990

Soon her work became longer: the *Inflammatory Essays* that she began in 1979 were a hundred words each. 'They are too long for an electronic signboard that people glance at for thirty seconds. They're meant for the streets, maybe deep in the alleys, where people might be sympathetic to the anger; or in art galleries where people have lots of time on their hands, and should think about getting angry.' But the more grandiose and hi-tech her work becomes, the more we notice the display rather than the words. The flashing lights in the 1990 Venice Biennale, when she was given an exceptionally large budget, made her work appear like a discotheque; the pulsing of the lights was more evident than the words. One may be impressed by her large-scale displays such as that at the Soloman R Guggenheim Museum in New York (221), but not surprised. The interest becomes aesthetic and structural: how words cross-reference, not how they inveigle themselves into the subconscious.

A more discrete intervention into public space is that by the Swiss artist Rémy Zaugg who inscribed words on the bridges over the Rhine at Arnhem. On the Nelson Mandela bridge (222) were the words 'Huizen', 'Wind', 'De Stroom', 'De Verte', 'De Utopie', 'Indonesie',

'Boten', 'De Zee', 'Blauwe Lucht' (house, wind, the river, the distance, Utopia, Indonesia, boats, the sea, blue sky). Zaugg's intention was 'to inscribe on the sides of the two bridges words which describe the real, visible landscapes now present above and below them, but also the imaginary landscapes of yesterday's and today's Holland, the places the river comes from and those it leads to, the places it has stirred people to go, and toward which it still stirs them today.' The plan to put words on the second bridge, so framing and enlivening the dull quay area of the town, was not fulfilled, but this half-finished project creates a thinking space between the facts and the dreams. It makes explicit the history of its context, a place. Whereas much earlier work used words indexically, as a way of pointing, this is far more reflexive. The words turn back on themselves, drawing attention to their form and site. We cannot look at them without wondering why they are there, what intentions underlie their instal-lation and what language displayed in public actually does. How far formal elegance diffuses, or even defuses, the work, so that like much other work done today it becomes decorative, merely radical chic design, we shall consider in the next and last chapter.

222
Rémy Zaugg,
The Bridges of
Arnhem,
1993.
View of
the Nelson
Mandela Bridge

Then there's always the cash
Selling your soul for some trash
Smiling at people you cannot stand
You're in demand
Your fifteen minutes start now.
Kirsty McColl, 'Fifteen Minutes', 1989

As experience is increasingly mediated and abstracted, the lived
relation of the body to the phenomenological world is replaced by
a nostalgic myth of contact and presence. 'Authentic' experience
becomes both elusive and allusive as it is placed beyond the horizon
of present lived experience, the beyond in which the antique, the
pastoral, the exotic, and other fictive domains are articulated.
In this process of distancing, the memory of the body is replaced
by the memory of the object, a memory standing outside the self
and thus presenting both a surplus and a lack of significance.
Susan Stewart, *On Looking*, 1993

**In the 1990s the term 'Conceptual' has become a synonym for the
far-out or crazy; not for the intellectual or difficult, but for a show-
manship that seems a flagrant bid for that fifteen minutes of fame
which an earlier generation of Conceptual artists had so ostensibly
decried. One is unsure at times whether outrage is being used as
an artistic strategy or as a way of getting media attention – or even
whether the two can be differentiated any longer. Of no one is this
more true than Damien Hirst, the most ferociously hyped artist of
the 1990s, much given to cutting up animals and displaying them in
formaldehyde (223): an ingenious conflation of the readymade with
the *memento mori*.**

**In 1992, in a gesture that was reminiscent of the empty rooms of
Manzoni and Robert Barry (see chapters 2 and 5), a student in the
sculpture department of the Royal College of Art, Gavin Turk, left**

**223
Damien Hirst**,
*Away from the
Flock* (third
version),
1994.
As installed in
the exhibition
Private View at
the Bowes
Museum,
Barnard Castle,
County.
Durham, 1996.
The case in the
background
contains a late
19th-century
calf that was
born with
2 heads, 7 legs
and 2 tails

224
Gavin Turk,
Cave,
1991
Left
Ceramic plaque
as installed at
the Royal
College of Art,
London
Above
Plastic version
of ceramic
heritage plaque

nothing in his studio for his final degree assessment, save a plaque like those on buildings in London where famous people have lived. On it were embossed the words, 'Gavin Turk, Sculptor, worked here, 1989–1991' (224). What is noteworthy, however, is not the anti-establishment joke, but that there was an object, and an elegantly made one at that. Nevertheless, his reactionary tutors promptly failed him. With equal promptitude he was signed up by a leading London gallery, and soon the plaque was available in plastic in a limited edition of one hundred. The cynical would say that a work which depended solely on context to have a meaning and signi-ficance, had, once confirmed by the market, become a mere token of radical chic. Alternatively, one might say that this was a wry play on the status that readymades and Conceptual documentation had achieved in the art market by the 1990s.

The art world in the 1990s was awash with works that looked remarkably like those made thirty years earlier. What is the differ-ence? We have already remarked, at the end of Chapter 9, that the photographic work of Gillian Wearing, though more striking than the apparently similar earlier work of Douglas Huebler, is far less problematic; and likewise in Chapter 10 that the word pieces of Rémy Zaugg are more elegant, but less discomforting, than the equivalent early pieces of Lawrence Weiner. The same can be said for much recent work in those other two modes we identified in the Introduction: the readymade and the intervention. Arguably, such work is now done better than in the 1960s, but normally to less point, in so far as the ideological context and medium are not questioned to the same degree. A counter argument might be that Conceptual art of the 1960s was a failure in that it did not attain its Utopian goals, but that the new generation of artists are setting themselves feasible objectives : 'I don't think about conceptual art,' remarked Barbara Kruger in 1988. 'I prefer effectivity to sadly deluded romanticism.'

Has what was once a critique of spectacle become merely spectacle? In 1996 the English artist Anya Gallaccio displayed thirty-four tons of ice in an old disused pumping station in east London (225) – a solid

rectangular mass, about 4 m (12 ft) high. Below the ice were some electric lights, while embedded in the top of the ice and slowly working its way down through it was a vast lump of rock salt. Does this merely imitate the earlier ice works by Ferrer, Kos (see 130) or Konkoly (see 151)? Whereas Kos was asking the viewer to imagine the sound of ice melting, an impossibly metaphysical concept, and Konkoly asking the viewer to see the object as an allegory, Gallaccio was just presenting a massive object, albeit one that would actually dematerialize. In a cold winter this took eight weeks, changing slowly, melting and refreezing at night in runnels and ridges, in places opaque, elsewhere bubbled or glistening. It was, unlike Kos's piece, essential to see the work: the sensory experience was far more important and interesting than the concept *per se*.

In another controversial work, Rachel Whiteread's *Untitled (House)* (226), a whole house was filled with concrete, and the walls were then peeled away. This could be seen as nothing less than the material-ization of Ed Kienholz's concept tableau of 1967, *The Cement Store No. 1*, which consisted of the plan to remove the roof of a shop and fill it with concrete. Was this plagiarism or brilliant realization? Certainly, the two works by Gallaccio and Whiteread are visually memorable, whereas those by Kienholz and Kos are intriguing. Again, a counter argument might be that 1960s Conceptual art depended on a false dichotomy between form and content, which artists no longer accept.

We can only resolve these arguments by looking at the variety of work made in recent years that has developed from the readymade and the intervention. This is the primary subject of this chapter. We shall also look at other areas in which the legacy of Conceptualism has developed: project-directed work and an ongoing concern with the everyday and interpersonal communications. However, we must look first at some of the controversies that have centred in the last ten years around not just the status of 'neo-Conceptualism', but around Conceptual art of the 1960s. And what of the artists from the 1960s? Does their recent work, too, tend towards spectacle or farce?

Many of those older Conceptual artists see their successors as lightweight imitators, making up-market novelties, knowing and

225
Anya Gallaccio,
Intensities and
Surfaces,
1996.
34 tons of ice
and ¹₂ ton
boulder of
rock salt;
300 × 400 ×
400 cm, 118¹₈ ×
157¹₂ × 157¹₂ in.
As installed at
the Wapping
Pumping
Station, London

226
**Rachel
Whiteread**,
*Untitled
(House)*,
1993.
Concrete and
plaster;
h.c.10 m, 32½ ft
(now destroyed)

professional, where they were committed and amateur. 'The original conceptual art', Victor Burgin remarked in 1988 vis-à-vis neo-Conceptualism, 'is a failed avant-garde. Historians will not be surprised to find, amongst the ruins of its Utopian program, the desire to resist commodification and assimilation to a history of styles. The "new" conceptualism is the mirror image of the old – *nothing but commodity, nothing but style.* We once again have occasion to observe, "What history plays the first time around as tragedy, it repeats as farce."' This is a sweeping condemnation. Others, too, sneer at the apparent lack of originality and connivance with the market. The critic Mary Anne Staniszewski commented in 1988 that 'Much of the new work has the cool and intellectual look associated with conceptualism, but it functions primarily, if not completely, as luxury goods.'

The relationship of this 'neo' or 'post' Conceptualism to previous Conceptualisms has worried art historians and art critics. In his book, *Return of the Real*, Hal Foster makes the often overlooked point that Conceptual art of the 1960s was itself a return to the earlier Conceptualism of Duchamp and Dada. Perhaps the most coherently worked-out schema for this relationship is that proposed in a particularly cogent essay by Michael Newman, 'Conceptual Art from the 1960s to the 1990s: An unfinished project?':

1. Conceptual Art initially coincides with radical student movements and calls for real changes in social relations of art production and use;
2. Conceptual Art takes a turn to both subjectivity and psychoanalytic theory during a period of recession and the failure of radical student movements to achieve their goals;
3. Conceptual Art is marginalized during the hyperinflation of the art market which only acknowledged commodifiable art and ended up treating Conceptual art documentation as any other commodity;
4. neo-Conceptual Art emerges in the 1980s on the one hand allied with popular culture, and on the other hand as a reinvigoration of Conceptual Art as reflection on the status of the object, site and social relations. Such work continues to embody contradictory possibilities and its fate is by no means undecided.

Point 1 is relatively uncontroversial, but it is far from certain how radical the Conceptual artists of the 1960s actually were. Point 2 is even more of a generalization: certainly many early Conceptual artists looked more at psychoanalytic theory than linguistic philosophy as the 1970s developed, but, in fact, much 1960s Conceptual art was, as we have seen, deeply subjective. Point 3 is likewise a sweeping generalization: there were other reasons for the 'marginalization' of Conceptual art in the late 1970s. As much as the market, there was the desire of the entertainment industry for a glamorous, spectacular art. Point 4 is complex: certainly the new Conceptual art is more streetwise and populist, but it is at its most fruitful when conscious of its own contradictions. We should remain wary. There is a tendency in creating such 'meta-histories' to simplify or purify Conceptual art, beginning with theoretical assumptions rather than the variety of works made under its banner. Given the attack that Conceptualists launched on historicism – the idea of progress in art – this is, of course, highly ironic.

The most rancorous controversy followed the first museum retrospective of Conceptual art in Paris in 1989. One essay in the catalogue, 'From the Aesthetic of Administration to Institutional Critique', by Benjamin Buchloh, tried to explain Conceptual art of the 1960s very much in terms of the reception of Duchamp, denied the Utopianism of the artists and denigrated Kosuth for his covert formalism. Having treated Conceptual art purely as a New York phenomenon, Buchloh seized on Broodthaers, Buren and Haacke as artists who had avoided formalism for an art that critiqued the institutional framework in which it inevitably appeared. Understandably, this infuriated Kosuth, who was showing in the exhibition, and he demanded the right of reply within the catalogue. He accused Buchloh of lying and twisting history to the advantage of his friends. In a second edition Seth Siegelaub appended a more measured rebuttal, asserting that 'Buchloh's text is a formalistic and idealistic one, a sort of "art history as art history as art history"', which lacked any reference to the larger historical period. For Siegelaub the failure of Buchloh even to mention the Vietnam War, together with his 'Duchamp fixation', discredited his claims. The controversy rolled on through the pages

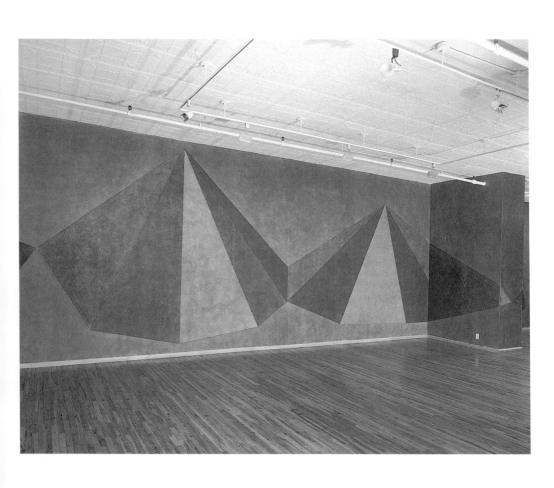

of *October*, the magazine co-edited by Buchloh, and its repercussions still continue. Many artists of the 1960s not only defend their position ferociously, but demand that their intentions be given precedence over other interpretations. Their rage has not only been at art critics and art historians pontificating after the event, but at each other: in 1997, weary of being lambasted by the remaining body of Art & Language, Kosuth and Atkinson started Art & Language 2.

In 1996 Atkinson also expressed his disquiet at the way Conceptualism had been subsumed under the category of the visual, especially in the Paris and the later Los Angeles retrospective. Had not Conceptual art been posited on a critique of 'the visual'? Perhaps making an exhibition inevitably portrays it as a movement of things rather than a time of debate – a criticism which could also be directed at this book with its plethora of illustrations. But a more sophisticated understanding of visual and material culture, influenced especially by Barthes, Foucault and a re-reading of Freud, has led in recent years to a far less censorious attitude to the making of actual objects and representations. Today, therefore, we no longer find such a rigid dichotomy between the conceptualization and making of art.

The work of some of the older artists has also become increasingly well made and elegant. By 1975 LeWitt had introduced colour into his wall drawings and in the 1980s he overlaid colour on colour. The results were often ravishingly beautiful. The procedures are still the same: a concept is established and then draughtsmen and women execute it. So, for example, in *Multiple Pyramids* (227), first executed at the John Weber Gallery in 1986, the instructions are accompanied by simple diagrams with the sequence of colour marked on it. There are still simple systemic variations being worked out: in the three drawings of this series the backgrounds and the sides of the pyramids are created by overlaying combinations of the primary colours plus grey in different orders. The logic of the choices is less easy to fathom, though the visual results are at once succulent and clear. With drawings like these, Conceptual art has finally arrived at a form which sits happily, much to the horror of some people, in corporate offices.

227
Sol LeWitt,
Multiple Pyramids,
1986.
Coloured ink wash on wall;
381 x 1196 cm,
150 x 471 in.
As installed at the John Weber Gallery, New York

Even when earlier work is remade, as it necessarily must be for retro-
spective exhibitions, it often becomes cleaner and more elegant.
When remaking his measurement pieces, which had always been site
specific, for the retrospective of his early work at Yale University Art
Gallery, Mel Bochner used not architectural features as before (see
Chapter 6), but artworks, specifically four that once belonged to the
Société Anonyme, Inc (228), a New York organization that promoted
Modernist art and whose one time president and adviser on acquisi-

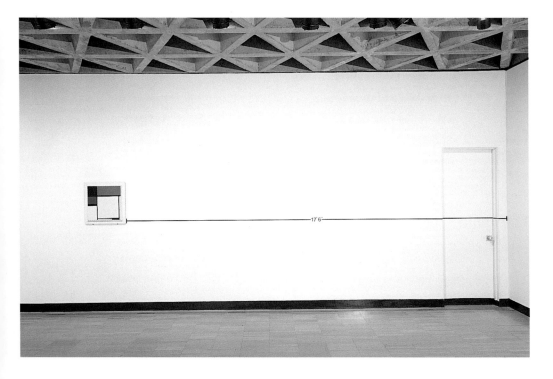

tions was Marcel Duchamp. That there should now be a reference to
the earlier history of Conceptual art was also typical of this period.

Another particularly good example of how the old art has become
more stylish is offered by the way that English artist John Murphy
reinstalled works from 1973 twenty years later. Originally, these
empty music manuscript books had been displayed on plain tables,
but in the new installation a glass museum case, heavy in brass, was
employed (229) – the associations with that institution are embraced
rather than pastiched. A concern with beauty and the ineffable, with

the use of music (rather than language) as a paradigm, as discussed previously in the work of LeWitt, has been too little noticed. Such a concern for the staging of artistic contexts as mysteries and the religious possibilities of a strategy of surprise have become more evident in recent years. As k d lang sings,

It takes you by surprise
There before your eyes
A place you've always been ...
Infinite and unforeseen.

It almost seems as if God had slipped back in by the back door. Such an anti-materialistic reading of Conceptual art has been evident since Harald Szeemann organized an exhibition in Berlin in

1988, featuring thirty-two Minimal and Conceptual artists (including Buren, Broodthaers, LeWitt and Long) entitled *Zeitlos* – timeless – this was an art, for him, of contemplation, rather than critique.

The Berlin exhibition illustrated the revival of interest during the last ten years in the 'classic' Conceptual art of the 1960s. The German economic magazine *Capital* makes a list each year of the hundred artists who have been exhibited and written about the most, thereby supposedly giving a guide for sound investment. By 1992 Bruce Nauman had made it to Number One in this Hit List. Other 'Conceptualists' also featured in this chart, including LeWitt (no.16), Buren (no.25), Long (no.30), Paolini (no.37), Kosuth (no.46), Haacke (no.59), Weiner (no.62), Graham (no.76), Baldessari (no.85) and Kawara (no.87). The one-time rebels and critics of the art world

230
Jeff Koons,
*New Hoover
Convertible*,
1980.
Vacuum
cleaner,
plexiglas,
fluorescent
lights;
142·2 × 57·2 ×
57·2 cm, 56 ×
22½ × 22½ in.
Private
collection

231
Haim
Steinbach,
Shelf with
Snoopy,
1982.
Mixed media;
77.5 × 47 ×
47 cm, 30$\frac{1}{2}$ ×
18$\frac{1}{2}$ × 18$\frac{1}{2}$ in.
Sonnabend
Gallery,
New York

had apparently become not just acceptable, but desirable. In the same year Nauman's *One Hundred Live and Die* (see 6) sold at auction for $1,750,000, and a work by Broodthaers sold for £360,000. Works by hardline Conceptualists made reasonable prices at auction too: one by Kosuth selling for $75,000 in 1989 and one by Buren for $23,000 in 1991.

Some critics and first-generation Conceptual artists were especially appalled by the seeming cynicism of the object-orientated neo-Conceptualism of artists like Jeff Koons or Haim Steinbach, whom they saw as epitomizing the shallowness and mendacity of the Thatcher–Reagan era. But could one not claim that such work extended the readymade tradition?

The 1980s was supposedly the yuppie decade: Jeff Koons made packaging as art while Madonna sang 'We are living in a material world and I am a material girl'. Seeing that packaging was erotic too, they both combined it with self-promotion and sexuality: Madonna releasing her book *Erotica* and Koons making a home-movie with his then wife – the porn star and politician La Cicciolina. The works with which he began his career glistened as if they were still on display in the shop window (230). These readymades had an aura of desirable consumer objects. They were super-clean, like Space equipment or hi-tech medical gear. Around the same time Haim Steinbach began putting consumer knick-knacks on shelves, as if display was all. Early on in his career, the shelves themselves were quaint and quirky objects (231), but as the 1980s developed they became simple geometric shapes, ironically reminiscent of Minimalism.

Perhaps Koons's great originality was in turning himself – the artist – into the object of his art. His body, airbrushed and gleaming, seemed the ultimate readymade. 'It's now a very narrow line between Hollywood and the art world,' remarked Steinbach, 'or, between the movie star and the art star. The operation of the entertainment industry encourages the "star" to become an object of desire of its own making, conditioning the subject to take on a false sense of self. Nonetheless, some of the best artists incorporate a critical process in their work reflecting on the myth-making operations of their

culture.' Although this was an art of objects, it was primarily about the person, for it was about the use of, and attitudes to, things in the world. As Susan Stewart suggests in the quotation at the beginning of this chapter, the object was increasingly a projection or memory of the person or the body. Art was supposedly the home of the 'authentic'. As Steinbach reflected, 'the ideology of individuality which corresponds with the "star" goes hand in hand with the ideology of authorship and originality ... everybody would like to believe he or she is not a tourist.'

Steinbach emphasized that he was not interested in the objects *per se,* but in their exchange, how buying and owning are taken to be part of the 'natural order of things' – as Barbara Kruger mocked in her photo-text work, 'I shop therefore I am.' In this reference to shopping, these artists broke finally with Duchamp (who, until nearly the end of his life, had given away his readymades, not sold them) and with the neo-Dadaists (who had always worked with used, humanized things). Given their gender stereotype, women made this type of art with an added, sardonic edge. In the 1990s, the Swiss artist Sylvie Fleury went shopping for shoes or clothes, fashionable and expensive, and then displayed them, some unwrapped, some half wrapped, as if she were still in the midst of trying them on. Just as Barbie exists to be dressed, so a woman becomes a woman by dressing as a woman. Fantasy precedes masquerade and there is nothing here but surface. The Brazilian Jac Leirner gathered together plastic carrier bags on her travels and then stitched them together into vast 'paintings' – the sign has truly replaced the signifier here. We do not even need to shop, just display the signifier of shopping – the bag bearing name Hermès, Armani, Versace.

Profoundly ironic, too, were the piles of sweets made by Gonzalez-Torres in the early 1990s (232). These works were intended to be completed by the viewer picking up a sweet, unwrapping and eating it. Sometimes they are titled after issues – *Untitled (Welcome back Heroes)* of 1991, a 200-pound pile of bazooka bubble-gums, was his response to the Gulf War. Sometimes they are titled after people – *Untitled (Portrait of Marcel Brient)* is a portrait of a French collector:

232 Overleaf
Felix Gonzalez-Torres,
Untitled (Lover Boys),
1991.
Individually cellophane-wrapped sweets, endless supply; ideal weight 159 kg (350 lb). Dimensions variable. Collection Sammlung Goetz, Munich

the artist instructed that the pile of sweets should be maintained at Brient's weight. Gonzalez-Torres also exhibited stacks of large posters or photographic reproductions, and invited the viewer to participate and take one home with them. When these are shown in museums, the staff top up the stack each morning. This is both an anti-market statement and an act of generosity: art is a sharing of experience, not just viewing another's experience.

It may be an anti-art market gesture, but it is a knowing and complicit one. Gonzalez-Torres had no desire to be ghettoized in alternative spaces: 'For me, it makes a lot of sense to be part of the market ... it's more threatening that people like me are operating as part of the market – selling the work, especially when you consider that yes, this is just a stack of paper that I didn't even touch. These contradictions have a lot of meaning ... I love the idea of being an infiltrator. I always said that I wanted to be a spy. I want my artwork to look like something else, nonartistic yet beautifully simple. I don't want to be the opposition because the opposition always serves a purpose.' In other words he did not want to be placed as an Other (gay, Hispanic or avant-garde) where he could be demonized, ignored or, still worse, patronized as being merely exotic. As an insider he could be subversive.

Given this new emphasis on the readymade object, or sculptures derived from it, Duchamp inevitably became a constant reference, as he had not been for the 1960s Conceptual artists. The year before she died of lymphoma, Hannah Wilke made her version of Duchamp's *Why not sneeze Rose Selavy?* (233). Hers is not a witty and allusive joke for a collector, but evidence of her body's suffering: the cage is filled with the syringes and containers of medicines that she was taking, and a thermometer replaces a cuttlefish. The New Yorker Maureen Connor also played with a Duchampian readymade, making several versions of *Bottlerack* from 1988 (234). She had, as she said, 'become involved with and much influenced by theory and my work became much more critical of female experience rather than celebratory. In fact the bottle-rack pieces are about clothing in that I dressed up Duchamp's readymades in order to reveal its corporeal and gendered

233
Hannah Wilke,
*Why not
sneeze?*,
1992.
17·8 × 22·9 ×
17·8 cm,
7 × 9 × 7 in.
Ronald Feldman
Gallery,
New York

234
**Maureen
Connor**,
Untitled,
1989.
Steel rack,
G-strings;
h.261·6 cm,
103 in.
Collection of
the artist

235
Sherrie Levine,
Fountain,
1991.
Cast bronze;
38·1 × 63·5 ×
36·2 cm,
15 × 25 × 14½ in.
Walker Art
Center,
Minneapolis

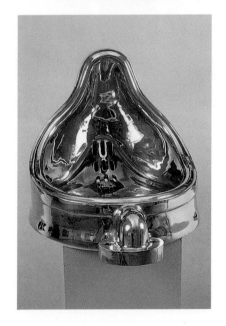

aspects ... with these Bottle-rack pieces I was questioning and attempting to transform and make fluid the identity of an already existing object.' These pieces are, of course, made, not found: the phallic form of the rack may be cross-dressed with veils of pink lace, its prongs stuck with glass casts of lungs or turned inwards. With G-strings stretched over it, the rack becomes like a ribcage or a corset. Duchamp's own *Bottlerack* might have been chosen out of an aesthetic indifference, but, given status by art history, it has accrued many meanings. One reading of Connor's work as illustrated here is that she is playing with the notion of striptease, hence the G-strings. Or the bottlerack with its prongs is a father figure (what is Duchamp if not the father of work like this?) diverted into femininity. Wilke and Connor's *détournements* of Duchampian readymades into areas of autobiography and gender politics are not untypical of the way female artists, especially, have developed and subverted a Conceptual tradition. In 1991 Sherrie Levine made her version of Duchamp's *Fountain* (235): casting it in gleaming bronze – at last that 'wretched urinal' existed in 'real' art materials.

236
Annette
Lemieux,
Black Mass,
1991.
Mixed media;
243.8 × 266.7 cm,
96 × 105 in.
Fisher Landau
Center, Long
Island City

Annette Lemieux's *Black Mass* of 1991 (236) likewise uses Conceptual and Minimal art as a tradition to refer back to. The black squares refer to the *Surrogates* then being made by Allan McCollum, as well as to Ad Reinhardt. McCollum's *Surrogates* were plaster imitations of paintings, frame and all, painted black, without subject or gesture. Mass produced by a team of assistants, they were meant to be bought and hung in bulk. They were intended as simulacra of paintings, rather than the real thing – totally devoid of aura. Lemieux's work is both more humorous, and wry, than most made earlier, and double-edged. The ironic way in which the tradition (of male artists) is invoked by Connor or Lemieux is also important, especially their contrariness and refusal of affirmation. James Joyce assumed that 'Yes' was the feminine word and hence used it as the concluding word of *Ulysses*. What we get from so many women artists is in fact a 'No'. Sometimes this is both the critical and creative statement. If it is assumed that one will do what is expected, to say 'No' is to emphasize one's freedom and identity.

In much recent object-based work the object's status as residue or substitute of the body is stressed. The sheer fetishism of a work like Janine Antoni's *Tender Buttons* (237) is intentional: the artist often plays on her youth and beauty. Nurture, nature and culture have always been her subjects: an earlier piece consisted of indentations in the wall corresponding to a baby's bottle, a teat, a nipple and her breasts. Again, her piece is made as a working out of a project, based on her body and issues of femininity. In comparison, Rosemarie Trockel's *Untitled (Mouth Sculpture)* (238), cast in silver from a piece of chewing gum, is disgusting rather than sexy. The material is a synonym of value, whereas used chewing gum is a synonym of the worthless. The notion of sculpting with the mouth is a ploy typical of Trockel, who concentrates on how different working methods can create meaning.

237
Janine Antoni,
Tender Buttons,
1994.
Two 18-carat
gold brooches
cast from the
artist's nipples;
diam. 3.4 cm,
1³⁄₈ in

238
**Rosemarie
Trockel**,
*Untitled (Mouth
Sculpture)*,
1989.
Silver-plated
chewing gum;
4 × 6 × 2 cm,
1¹⁄₂ × 2³⁄₈ × ⁷⁄₈ in.
Monika Sprüth
Galerie, Cologne

From Turk to Trockel, all these objects depended on being seen in an art context. But when placed in a museum or gallery, any object – though marked as special – is effectively stripped of its memories, of the original histories and contexts which gave it meaning. Artists have striven to bring such memories back, reawakening the everyday by interventions in the museum. As the visitor entered Rotterdam's Boymans-van Beuningen Museum in 1994, they were given a personal stereo, such as one hires in a museum for a guided tour. But the tape did not tell them the dates and names of artists or their histories. Instead, it directed them to twenty-one objects which Sophie Calle had placed in the collection of decorative arts. For each

object Calle had reminiscences to tell, about her mother or her employment as life model or stripper, and especially about her relationship with her ex-husband Greg Shephard. As Calle spoke, in the background one could hear the disconcertingly haunting music of the composer Laurie Anderson. In a cabinet of ancient chamber pots, she had placed a red plastic bucket (239). As Anderson played her violin eerily, Calle spoke, 'In my fantasies, I am a man. Greg was quick to notice this. Perhaps that's why one day he invited me to piss for him. It became a ritual: I would come up behind him, blindly undo his pants, take out his penis and do my best to aim well. Then, after the customary shake, I would nonchalantly put it back and close his fly. Shortly after our separation I asked Greg for a photo souvenir of this ritual. He accepted. So, in a Brooklyn studio, I had him pee into a plastic bucket, in front of the camera. This photograph was an excuse to put my hand on his sex one last time. That evening, I agreed to the divorce.' As the visitor looked at these banal objects she realized that all the objects in the museum once had similar associations, a personal, social history, a patina of use. The museum became, however briefly, a museum of lives lived, not just of things.

An earlier generation of artists, from Henry Flynt to Robert Smithson, had hated the museum to the point of waging war on it: they saw it as dead – as corrupt as the commercial gallery system. But now artists use the museum. It has become not a site of unspecified evil, but a place to research and negotiate new meanings. If the museum was where things were made special, where meanings and values were discovered and preserved, then it had to be an ideal forum for the critical artist. By the mid-1990s the curating of shows in museums by the artists themselves had become almost a genre in its own right. One critic, Lisa Corrin, mocked that 'museumism' would be the next category in the chronological survey of art movements. 'The context in which a work of art is exhibited for the first time is a material for me like canvas and paint,' remarked Hans Haacke, who had of course been working with museums since 1970. The world of the gallery and museum has changed in a direction foreshadowed in much Conceptual art, the roles of artists and curator becoming more interchangeable. The critic Brandon Taylor is surely right to claim

239
Sophie Calle,
*La Visite Guidée
(The Bucket)*
from the
exhibition
Absent at the
Museum
Boymans-van
Beuningen,
Rotterdam,
1994

that just as recent art 'has converted the anti-establishment gesture of 1960s art into a more measured, more philosophical critique. In the process, the art museum has become a space, not of contestation, but of speculation about representation and reality itself.'

Have such interventions lost their radicality? Daniel Buren complains that it is impossible for him to work in an interventionist way, for installations or the site specific are now the norm. Both he and Toroni have been asked to do larger and larger installations. Inevitably they have become less surprising, more decorative: we have developed a 'taste' for them. They are at their most effective, most teasing, when they are most discreet, as in Buren's 1993 intervention in the cloisters of the monastery on the island of San Lazzaro degli Armeni, Venice (240), or Toroni's work at London's Serpentine Gallery in 1994 (241). On that occasion Toroni had made a beautiful installation of his brushmarks in one of the galleries, but he wandered off and also painted them on the back doors of the gallery. Whereas inside his brushmarks were obviously art, and were inevitably looked at as art, outside on the doors they retained something subversive: a genuine surprise, that is, if one recognized them.

When invited to create a work in the grand foyer of the Brooklyn Museum in 1990, Joseph Kosuth brought together over a hundred different objects owned by the museum in what he called 'the play of

240
Daniel Buren, Installation in the cloisters of the monastery on the island of San Lazzaro degli Armeni, Venice, 1993

241
Niele Toroni, *Imprints of Brush No. 50 repeated at regular intervals (30 cm).* As installed at the *Wall to Wall Exhibition*, Serpentine Gallery, London, 1994

the unmentionable' (242). Unmentionable could be anything sexual or political that was liable to censorship – though it was also once a quaint term for women's underwear. This took place on the eve of the trial in Cincinatti of a museum curator who had exhibited seven supposedly 'obscene' photographs by Robert Mapplethorpe. To Senator Jesse Helms, who was demanding more censorship and less money for the National Endowment for the Arts that had funded such 'filth', the corrupting of art meant the corrupting of society. Some of the images that Kosuth found in this august institution would have horrified Helms, including a Persian miniature of one man urinating in the mouth of another – the Mapplethorpe photo which Helms loved to hate most was of a similar scene! Asked how he could describe himself as a creator here, rather than a curator, Kosuth replied, 'If art is to be more than an expensive decoration, you have to see it as expressing other kinds of philosophical and political meaning. And that varies according to the context in which you experience it. This particular exhibit tries to show that artworks, in that sense, are like words: while each individual word has its own integrity, you can put them together to create very different paragraphs. And it's the paragraph I claim authorship of.'

'A museum,' Fred Wilson, a black American artist, remarked, 'is more a state of mind than a piece of real estate.' This is something he was

One should add that the natives' response to the first Europeans, insofar as it is recorded, provides evidence of a comparable reaction: one Amerindian, astonished at the French custom of collecting and carrying about mucus in handkerchiefs, wryly declared: "If thou likest that filth, give me thy handkerchief and I will soon fill it."

242
Joseph Kosuth,
*The Play of the
Unmentionable*,
1990.
As installed at
the Brooklyn
Museum,
New York

METALWORK
1793-1880

able to elaborate when he became artist in residence at the Maryland
Historical Museum in Baltimore – a museum of decorative arts, histor-
ical curios and records. He tried to evoke those people that a museum
founded by the upper-class males of nineteenth-century Baltimore
would tend to ignore or patronize: native Americans, blacks, women.
The museum's exhibits were altered in order to tell the story of the
slaves as well as their masters. In one room the names of slaves
'Harriet Tubman', 'William Parker', 'Mary Fortune' were flashed across
a painting of John Brown's 1859 raid on Harpers Ferry (as part of his
anti-slavery campaign) and the spears used in that attack. Elegant
chairs, fine examples of nineteenth-century furniture-making, were
set on plinths facing a whipping post. Shackles were placed in a
cabinet of decorative silverware (243). Wilson added nothing to what
was already in the museum: his work was the research and the
rearrangement of what he found. 'Some artists use powdered pig-
ments, empty canvases, clay, or just a pile of stuff,' Wilson remarked,
'but this museum was raw material to me. It had everything.'

As has already been indicated, one effect of Conceptual art's critique
of the museum is that it has encouraged a similar critique by those
that run them. When Suzanne Pagé took control of the Musée d'Art
Moderne de la Ville de Paris in 1989, one of her first acts was to invite
artists to make work that related specifically to the museum.
Christian Boltanski opened up a storage basement and filled it with
second-hand clothes, Annette Messager placed small cuddly animals
among tribal sculpture that the museum had placed near the Cubist
paintings for stylistic comparison (244). Such acts break the monopo-
listic grip of art history on the museum, bringing in issues of the
everyday, personal memory and the childlike.

If Kosuth re-curates the museum collection and Messager intervenes
in it, Ilya Kabakov makes a full-blown burlesque of it. Off the main
galleries of the Museum Ludwig in Cologne is a rather dingy room; it
seems as though some workmen who were supposed to hang a large
oil painting have gone off for lunch, leaving the painting propped

against the wall (245). Beside it is a stepladder, and scattered around on the floor are hammers and nails. But the workmen's junk is as much part of the art as the painting. Soon one realizes that this is a replica of a Soviet communal area, lit by a single naked light bulb, and the painting is of Abramtsevo, the country house where nineteenth-century avant-gardists met, and which is now a museum. The unfinished, provisional appearance is important, for, as Kabakov says, 'between the beginning of the work and its "unfinishedness" a free space appears, a duration which is filled with questions, conjectures and reflections.' Many of these questions are raised by the comments of supposed visitors that are stuck to the wall: 'This artist is bad: he takes a beautiful subject and does it in such a vulgar banal way' – I Medvedev; 'This is the museum after the building work. The restoration has been badly done: the original is ruined.' – L Tourezki. Others reminisce or gripe. These texts are a necessary element in what Kabakov calls the 'Total Installation', a theatrical version of the everyday, a simulacra of reality, in which the work includes a chorus of dissonant, critical voices.

But the new generation of artists generally work with a lighter touch than Kabakov. Beside a window in the Louisiana Museum in Denmark, some flowers are set in a jam jar, tape marks a box on the floor (246). In a glass case nearby are books from the museum, piles of slides with a label 'A Theory of Sculpture' – all the ancillary things that a museum produces and keeps, but never, except here, displays as art. This is the work of Belgian artist Joelle Toerlincx. On other occasions she has placed small redundant objects: a pile of flour, some sticky labels on the wall, a length of string that visitors walk over, or kick away. 'When I am offered an exhibition space it is as though I received a kind of parcel, a packet of air,' she writes. These little objects and marks can seem like Lawrence Weiner proposals made for real, or they can remind one of the chaotic elements of the exhibition *When Attitudes Become Form* (see 118). Like Daniel Buren, she wants to make people aware of their environment. It is important that her discrete marks and objects are derived from and appropriate to that place: hence the boxes of slides or the objects from the museum shop. She is concerned with the ephemerality of experience, its particularity, the ineffability of its moments.

245
Ilya Kabakov,
The Unhung Painting,
1982–92.
Museum Ludwig,
Cologne

246
Joelle Toerlincx,
One Day – a Proposition for Louisiana, May 15 – September 8, 1996 – a theory of walking.
Installation at
Now Here,
1996.
Louisiana Museum,
Humlebaek

Likewise, the Mexican artist Gabriel Orozco creates an art of the mundane that seems suffused with a delicate beauty, an attentiveness to things and actions in the world. When he showed at the Museum of Modern Art in New York in 1993, he asked people with windows facing the museum to put an orange on their windowsill. 'The museum will provide fresh oranges each week, but participants living or working in these buildings, who are free to eat the fruits, may replace eaten ones with new ones themselves, should they wish. Anyone can join in this project simply by placing an orange in a clear tumbler on their windowsill, the curatorial staff told people, adding, presumably to their relief, that 'professional supervision is not required.' To make a typographic simile, if the Duchampian ready-made functions like a full stop, arresting one's progress, breaking

247
Gabriel Orozco,
Crazy Tourist,
1991.
Colour print;
31·8 × 47·3 cm,
12¹₂ × 18⁵₈ in

248
Gabriel Orozco,
Breath on Piano,
1993.
Colour print;
31·8 × 47·3 cm,
12¹₂ × 18⁵₈ in

the flow, these little objects, so cunningly placed, function like accents, pointing and enlivening the sentence. What is key is the act of placement, just like the act of taking a sweet from one of Gonzalez-Torres's piles. Orozco uses photography to document the poetry of those placements: in 1991, at the end of market day, he saw a pile of oranges left beside the empty stalls. Putting one on each deserted stall he photographed them (247). 'Crazy tourist!' muttered the few remaining people in the market. The most momentary of these gestures was the cloud of moisture left when he breathed on a piano (248). This recalls Manzoni's *Breath of the Artist*, but whereas that shrivelled balloon is a little fetish of the artist as creator, mocking the Catholic Church's cult of relics, this is ephemeral and everyday. Every viewer recognizes that moment when their breath momentarily appears on the piano or mirror, and then disappears.

Artists nowadays often also appropriate the archival approach of the museum curator or cataloguer. Art historian Frances Colpitt argues that, 'recent Conceptual Art takes the form of projects rather than documents. The new work takes the structures, the codes and the institutions of the world as its system. Whatever system is at hand to be analysed, the artist permutes it completely, so that the perceiver is drawn into its orbit, and must work through the system to arrive at a concept.' This seems a perfect description of, for example, Patterson's or Kabakov's work. Colpitt goes on to point out that the model for such an approach is not Kosuth – whose work 'now looks closer to the formalism it intended to displace' – but Huebler. Art is not about ideas in isolation, but about being in the world. If the paradigm for the Conceptual artist in the 1960s was the philosopher, that for the artist in the 1990s has been the researcher.

One artist who has taken the notion of such project-based work to an extreme is Stephen Prina. He began his *Exquisite Corpse: The Complete Paintings of Manet* series (249) in 1989. Each of Manet's paintings is repainted the same size, but with a monochrome wash; a lithograph accompanies each painting showing the relative sizes of the 556 paintings. 'Exquisite corpse' was a Surrealist parlour game in which each person, unseen by the others, drew part of a figure. Does Prina also mean by corpse the 'corpus' of Manet's career? Is it exquisite because it has been refined down to a wash? Does his version preserve any of the original's aura? Certainly this wash drawing has a beauty to it, but it is an empty beauty compared to that of Manet's complex, problematic pictures. Here the complexity lies in the system involved. Prina is both obsessed with systems and making a critique of those scientific, linguistic or sociological systems that purport to explain the world. And the system here is not only arbitrary but a little crazy: he is using an unreliable guide to Manet's works, which has incorrect dates, measurements and even inconsistent numbering! Prina himself talks of this as an 'attempt to allegorize time'.

'But no!', some artists would interject, 'the real Conceptual art of today is not to be found in such arcane projects, nor is it to be found in the work relating to object or installation/context that you have

249
Stephen Prina,
*Exquisite Corpse:
The Complete
Paintings of
Manet. 132 of 556:
L'Execution de
Maximilien de
Mexique
(The Execution of
Maximilian of
Mexico), 1867,
1990.*
Ink wash on rag
barrier paper;
left panel
193 × 259 cm,
76 × 102 in.
Lithograph on
paper;
right panel 63.5 ×
81.3 cm, 25 × 32 in.
Museum of Fine
Arts, Boston

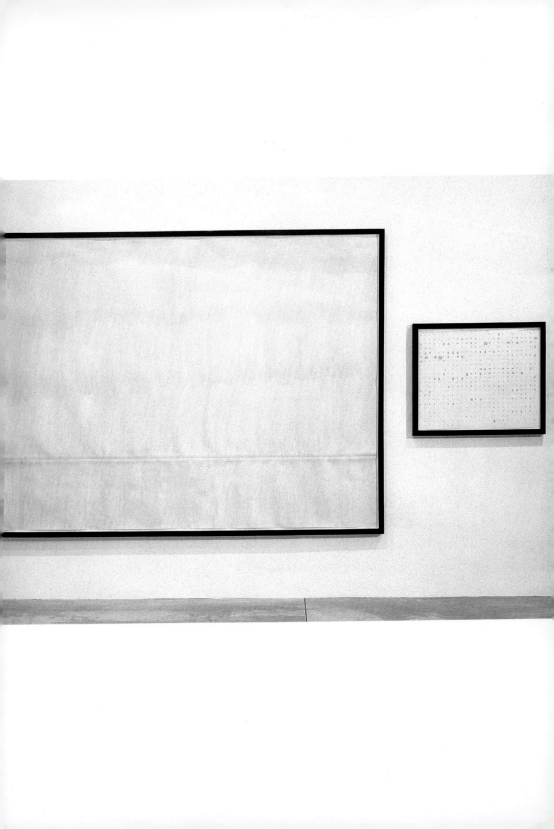

been discussing above – that is all gallery art.' Artists might well argue that what is key, in fact, is the plethora of small alternative spaces, small magazines and, above all else, the notion of artists working together. The key aspect of a Conceptual art today, would, thus, lie not in objects or spaces, but in communality, and an emphasis on communication and on how people behave.

Rikrit Tiravanija, an artist of Thai descent now based in New York, is an exemplar of this. When he showed at the 303 Gallery in 1992, he put all of the things he found in the storeroom and office into the gallery itself – including the director, who was thus forced to work in public. Meanwhile, in the storeroom, he cooked curries for the visitor to the gallery. The leftovers, kitchen utensils and used food packets became the art whenever he was not there (250). In a group show soon afterwards, he sat beside a tape recorder and invited people to ask him to dance. Whenever someone did, he switched on a recording of *The King and I* and asked them questions about the exhibition. When he showed at the Centro d'Arte Reina Sofia in Madrid, he arrived at the airport with a bicycle, a backpack filled with food and a portable gas cooker. It took him five days to get to the museum, for every lunch and dinner time he would stop and cook for the people that he met along the way. It is always important for him to talk to people and to listen to them. How else can you respond to a situation? He also asks people to drive him around: 'It's a very important part of my work to get driven around and feel things out and listen to what people say ... my work is less about things in the gallery and more about the people I've met, had a conversation with, talked about things with, and looked at things with.' Of course, this is not as novel as most people think. As we have seen, Tom Marioni was sharing beers with friends and talking – as art – in 1970, while in the same year in Los Angeles, Allen Ruppersberg was running 'Al's Café'. But there are subtle differences: the food Tiravanija makes is Thai, authentic or fake, a reference to cultural hybridization. Like a Buddhist monk, the itinerant nature of his life is important. He cites as key influences Andre's sculpture, which you can walk on, the way that Buren and Asher deconstructed the gallery system, and the attitude of Gonzalez-Torres to the object.

250
Rikrit Tiravanija,
Untitled (Free),
1992.
As installed at
the 303 Gallery,
New York

Perhaps more than its impact on the museum it is in the impetus that Conceptual art has given to interventions outside the museum, in social space, that matters – the reformulation of public sculpture as something that interacts with the life around it. In the 1997 exhibition *Sculpture.Projects* at Münster, Tiravanija had built a stage and organized puppet shows with local volunteers (251). Michael Asher repeated his action of the 1977 and 1987 *Sculpture.Projects* of having a nondescript caravan re-parked every week in a different place – an artwork that was nothing but context (252). Buren mimicked the carnival bunting on the main street with his 8·7 cm wide stripes that fluttered in joyous interrogation (253). The young Welsh artist Bethan Huws, like Richard Long so many years before, went for a walk in the nearby woods, leaving only some notes in the museum. Maria Eichhorn, a young German artist, bought a plot of land from the City council, much as Gordon Matta-Clark had in the 1970s, to point out the absurdity of property arrangements. But again, typically for her generation, the accompanying documen-tation was a far more thoroughly researched and documented

251
Rikrit Tiravanija,
Untitled, 1997.
(The Zoo Society),
1997

252
Michael Asher,
Installation
Münster
(Caravan),
1977/97

253
Daniel Buren,
Work in situ,
Münster,
1997

254
Maria Eichhorn,
(Acquisition of a
plot)
Tibusstrasse,
corner of Breul,
Münster,
1997

analysis of the City's land administration and its entanglement with private property speculation (254).

If Conceptual art is an unfinished project, as Michael Newman claims and I believe, then it is inappropriate at this time – indeed impossible – to 'sum up'. Far better, and more in keeping with the philosophy of this book, is to end as we began, with an extended account of a particular artwork.

In March 1996 a group of critics, artists and collectors met at the Henry Moore Institute in Leeds for a James Lee Byars performance. He himself was too ill to be there. There was nothing but a vast gold sphere, three metres in diameter, standing in the galleries. From it issued periodically gnomic statements, among them: 'The world itself maybe only a flaming word.' 'I made it out of a mouthful of air.' 'He tells of the Perfect Beauty.' Someone was hidden in this sculpture, which was entitled *The Monument to Language*, speaking these phrases from the work of the Irish poet William Butler Yeats. When it had been shown earlier in Paris, the person hidden inside had been given a hundred quotes from the writings of Roland Barthes to declaim.

A coach then took the guests on to Castle Howard, one of the great country houses of England. It was a bitterly cold day: people huddled in coats and hats as they walked through the grounds to the Temple of the Four Winds, a Baroque folly designed by Sir John Vanbrugh. Four philosophers had preceded them. On each side of the temple one of them waited, each with an answer to a question that Byars

had posed them: 'What is Question?' (255) First we heard the
Englishman William Charlton speak, at the West side, on the hetero-
geneity of questions, of how every question is a way of speaking
about things, which implicitly includes assertions. To say, 'What
colour are your socks?' could be restated, 'there is a colour your socks
exemplify; say they exemplify it?' Facing to the North, the Jesuit
Friedhelm Mennekes talked of how 'questions are the breath of life
to the human spirit.' Doubt and questioning is how we become self-
conscious, it is how we approach God. 'New questions break old
answers open again.' Answers are our Utopia, and 'our questioning is
forever restless, until at last it rests in God.' Facing to the East, Jean-
Michel Ribettes spoke of art's self-questioning. '*What is it to create?*'
'Does art have any other crucial question to ask its century than the
reflexive ontology: *what is art?*' If psychoanalysis seeks to explain the
past to construct the present, then art is an attempt to re-evaluate
life as it is lived in the present. He spoke at length, so one was able to
turn away and hear his words spreading out across the expansive
landscape, dispersing in the wind, one saw a hawk spiral and fall,
dogs running, and behind still bare trees the gaunt mausoleum
designed by Nicholas Hawksmoor. 'What is Question?' he asked
again: 'altogether, turned towards this transfiguration of time that
has been lived, James Lee Byars has become the heroic interpreter of
his own adventure. The speech of the artist, aphoristic, enigmatic,
oracular, will not have ceased to question, to interrogate, to put in
doubt, in the manner of metaphysical "koans", the ordinary
language of mankind.' Facing the South, the German Heinrich Heil
quoted René Daumal, 'The gateway to the invisible must be visible.'

'Over and over again, the artist has put the question into question. "Q. is point" – James Lee Byars has brought the question to the point.'

Byars – like all Conceptual artists – leads us to question, and he leads us to question in the real, everyday world. The legacy of Conceptual art is not a historical style, but an ingrained habit of interrogation. It is in the act of questioning that the subject, reader or viewer becomes himself or herself. Then, perhaps, we can determine whether our answer is 'yes' or 'no'. Or perhaps, as in Tania Mouraud's 1978 project, when she stuck fifty-four identical posters on Paris billboards (256), it is 'NI' – neither.

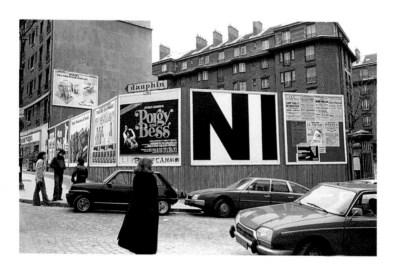

256
Tania Mouraud,
City
Performance
no.1 (Paris),
1978.
54 silkscreened
billboard
posters;
each poster
300 × 400 cm,
118¹⁄₄ × 157⁵⁄₈ in

Glossary

Appropriation A term, especially prevalent in the 1980s, used to describe the act of one artist assuming the work of another artist and claiming it as their own. This act defies assumptions about the authenticity of artistic creation and traditional notions of copyright.

Arte Povera (literally 'poor' or 'impoverished' art) A term coined by the critic Germano Celant in 1967 to describe a group of Italian artists (including Luciano Fabro, **Jannis Kounellis**, Mario Merz and **Giulio Paolini**) who brought together objects and materials in surprising but poetic conjunctions. Despite their connection to the radicalism of the period, many of these artists showed a taste for things historical, some incorporating casts of classical sculptures into their work.

Aura A term that originates from the German critic and theorist Walter Benjamin's article 'The Work of Art in the Age of Mechanical Reproduction', first published in 1936. It refers to the uniqueness or specialness that surrounds original, handmade works of art.

Cobra A group of artists founded in 1948 in Paris, which had dissipated by 1951. The name is derived from the initial letters of Copenhagen, Brussels and Amsterdam, where the artists came from. Asger Jorn, Christian Dotremont and Constant were the most dynamic spokesmen for the movement. They rejected Western culture in favour of an art of spontaneity and experimentation. Folk art and art made by children and the insane was a particular influence. Despite their revolutionary intentions and their desire to create a new art for the people, they are now best remembered for their bright and gleeful paintings.

Détournement A concept invented by the Situationists. Roughly translated it means 're-routing' or 'diversion'. It represents an attempt to extend the notions of parody, plagiarism and collage by replacing old meanings with new and often subversive ones.

Fluxus International group of avant-garde artists active in the early 1960s. Their name was conceived by the American writer, composer and performance artist George Maciunas (1931–78) and is taken from the Latin for 'flow'. The membership of the group was always fluid and included (though often only briefly) such people as **Joseph Beuys**, **Robert Morris**, George Brecht, Nam June Paik and Yoko Ono. The first Fluxus festival was held in Wiesbaden in 1962 and the first Flux yearbox was brought out in 1964. The festivals were sequences of humorous or inconsequential performances and compositions, the yearboxes were collections of cheaply made multiples. The movement's 1963 manifesto proclaimed its opposition to 'bourgeois sickness' and proposed a revolutionary new art characterized by individual eccentricity and collective amusement. Considered by some to have faded away by the mid-1960s, to others it ended with the death of Maciunas, to others Fluxus still continues today.

Formalism An approach to art that emphasizes form to the exclusion of content. The German idealist philosopher Immanuel Kant discussed the conception of a 'pure' beauty which can function as a symbol of the good, and proposed that an aesthetic experience could have moral effects. In the early twentieth century critics such as Roger Fry and Clive Bell formulated theories of significant form to justify **Modernism** and especially abstraction. The American critic Clement Greenberg's later justification for post-painterly abstraction (as exemplified by the work of Kenneth Noland and Anthony Caro) was generally seen as the acme of formalist explanation. This Western Formalism is not to be confused with Formalism as practised by Soviet writers such as Viktor Shlovsky who saw form and content as indivisible.

Gutai (Gutai Bijutsu Kyōkai – Concrete Art Association) Japanese avant-garde group founded in 1954 in Osaka by Jirō Yoshihara. Their early exhibitions, often held outdoors, emphasized the use of natural materials and performance. The group became known outside Japan through the periodical *Gutai* which was sent to many artists and critics around the world. By the late 1950s the group mainly produced derivative Parisian *art informel*. The group disbanded in 1972 after the death of Yoshihara.

Happenings A term coined by the American artist Allan Kaprow in 1959 to describe a seemingly anarchic, but in fact structured, performance. These were events inspired by the example of Jackson Pollock's action painting and influenced by the collaborative performances at Black Mountain College in North Carolina by **John Cage**, Merce Cunningham and **Robert Rauschenberg** (arguably the first Happenings) and by the outdoor events of **Gutai**.

Intervention A term used for when objects, images or information are placed in a certain context (such as a museum, a newspaper or magazine, or the street) in order to interrupt the viewer's normal perception of

art and draw attention to the ideological or institutional underpinning of that context.

Lettrisme A movement founded in France in 1945 by Isidore Isou to revivify art and poetry. The aim of the movement was to expose the way that film, painting and poetry worked. Isou and his followers had a taste for outrages and sensation. A politically more radical splinter group, the Lettriste International, was set up by Guy Debord in 1952.

Modernism A movement in art that is often seen to have begun with Gustave Courbet and Édouard Manet. They responded to the changing nature of urban, industrialized life rather than following immutable academic values. The drive to find novel forms of expression, to communicate 'the shock of the new', meant that a premium was placed on formal innovation, on progress for its own sake. To many, by the late 1960s, Modernism had become synonymous with **Formalism**, Abstract Expressionism and the critical writings of Clement Greenberg.

Monochrome A painting of a single colour or tone. The Russian painters Alexander Rodchenko and Kasimir Malevich are normally seen as the first monochromists though a monochrome painting was exhibited as an anarchic gesture in Paris as early as 1883. Intentions for such work vary: either to debunk painting or to demonstrate its 'end'; to intensify the experience of colour or texture; to intimate the void, the spiritual or the undefinable.

Neo-Dada A loose term applied to artists mainly working between 1958 and 1962, including the Nouveaux Réalistes in Paris, Jasper Johns and **Robert Rauschenberg** in New York, and artists associated with **Happenings** and **Fluxus**. It lacked the political venom of the original Dada movement and the highly critical attitude to making objects that was expressed by **Marcel Duchamp**.

Post-Modernism A term that emerged in the 1960s, initially to describe the increasingly eclectic work of architects such as Robert Venturi and Aldo Rossi. Theoreticians such as Frederick Jameson and Jean-François Lyotard gave it a wider reference: to describe the state of the world after such master-discourses as Modernism, with its narrative of progress, had collapsed. In the fine arts it is associated with arguments around the death of the author, the notion of the original and the authentic. The favoured techniques of post-Modernism are irony, **simulacra** and **appropriation**. There are increasing arguments over whether post-Modernism is in fact merely late Modernism rather than anti-Modernism.

Readymade A term invented by **Marcel Duchamp** in 1915 to describe a pre-existent and often commonplace object which is chosen by an artist and then put forward as 'art'. Variants include the assisted readymade: where the artist makes a slight change or addition to the object; the reciprocal readymade: an art object which is placed in a certain context so that it becomes an everyday object, and the mademade (an invention of **Art & Language**) where the artists made something not as art and then characterized it as art.

Simulacra The making of an object so that it is indistinguishable from its model.

Situationism The Situationist International was founded in 1957 by Guy Debord, Asger Jorn and Giuseppe Pinot-Gallizio, among others. An offshoot of the Lettriste International, it was influenced by anarchist ideas. In disdain of the capitalist world, which Debord typified as the 'Society of the Spectacle', they sought to undermine it through such means as **détournements**, *dérives* and rabid theorizing. Despite their concern with issues of representation they soon expelled all members who were artists. They had an unexpected moment of political effectiveness when they became involved in the 1968 student riots in Paris. The group disbanded in 1972.

Brief Biographies

Bas Jan Ader (1942–75) Dutch artist who moved to California in 1963 and began producing photographic and performance-based work. His work explored the vulnerability and fallibility of life. His last project, *In Search of the Miraculous*, resulted in his disappearance and death.

Keith Arnatt (b.1930) British artist. In 1967, on hearing how Claes Oldenburg had dug a hole as art in Central Park and then filled it in, he began to make 'Earthworks' which explored what such holes could mean and how they could be documented. The work that followed on from these was witty and paradoxical. Most famous was his own 'burial' in which not the art but the artist was apparently dematerialized. In 1972 he stopped making such Conceptual works and made only photographs, either portraits or landscapes, although these continue to be informed by a refined irony and a concern with ecological despoilation.

Art & Language Group of English Conceptual artists founded in Coventry in 1968 by **Terry Atkinson**, David Bainbridge (b.1941), Michael Baldwin (b.1945) and Harold Hurrell (b.1940). A discussion group that turned the process of theorizing about art into the act of art itself. Their main target was **Modernism** and the connections between art, society and the art market. Their main outlet was the magazine *Art–Language* which was launched in 1969. Many other people had become involved by the early 1970s, including **Joseph Kosuth,** who became the American editor of *Art–Language*. By the late 1970s Art & Language had effectively disbanded. However, Baldwin, along with Mel Ramsden (b.1944), continued to use the name, with Charles Harrison acting as explicator and apologist. In opposition to this in 1997, Atkinson and Kosuth founded Art & Language II.

Michael Asher (b.1943) Californian artist. Since 1966 he has made site specific interventions or alterations which draw attention to the economic and ideological context of the work. In 1979 he removed the sculpture of George Washington from outside the Art Institute of Chicago and placed it in a room of late eighteenth-century works contemporaneous with its creation. By transforming it from monument to art-historicized sculpture he drew attention to the varying statuses of such objects and their contexts.

Terry Atkinson (b.1939) British artist who studied in a Pop Art environment but found it ultimately naïve. Collaborated with Bainbridge, Baldwin and Hurrell as **Art & Language** from 1968. Had effectively left the group by 1975. Took up painting again, but in an antagonistic, materialist mode.

John Baldessari (b.1931) Californian artist, born in National City, he later moved to Los Angeles. Although by his own description a provincial artist he was aware of international developments through magazines. In 1966 he gave up painting and began using text, video and photography. His early Conceptual work is notable for its wit and variety. Baldessari taught Post-Studio Art at the California Institute for the Arts where his critical and experimental approach influenced a subsequent generation. Since the late 1970s his work has mainly been in the form of large collaged photographs.

Robert Barry (b.1936) New York artist. His early work as a painter dealt with the demarcation of space: for example his *Painting in four parts* of 1967, in which four small canvases each established the corner of a much larger rectangle. He then began to produce work which drew attention to space in a manner which is imperceptible to sight: for example releasing small amounts of different gases into the atmosphere. His subsequent work has concentrated on the use of language.

Lothar Baumgarten (b.1944) Studied under **Joseph Beuys** at the Staatliche Kunstakademie in Düsseldorf. Began making ephemeral sculptures partly in reaction to the commercialism of the 1967 Cologne Art Fair. His interest in non-Western cultures led to him living with the Yanomami Indians in Venezuela from 1978 to 1980. Baumgarten's work often attacks the way that colonial powers subjugate cultures through the act of re-naming.

Joseph Beuys (1921–86) German sculptor and teacher. Serving in the Luftwaffe during World War II, he was shot down in the Crimea; injured and nearly frozen he was discovered by nomads who looked after him, treating his wounds with animal fat and keeping him warm by wrapping him in felt. This event, the veracity of which has been challenged, led to the continued use of felt and fat in his work. Believing that all could be artists he was a charismatic but controversial teacher. After being sacked by the Staatliche Kunstakademie in Düsseldorf in 1972 for refusing to reject any applicants to his course, he founded the 'Freie Internationale Universität' to teach and uphold his 'expanded concept of art'. His shaman-like role and voluminous production make his relationship to Conceptual art highly problematic.

Mel Bochner (b.1940) American artist, initially best known for his critical writings, sometimes in collaboration with **Robert Smithson**. In 1966 he curated the exhibition *Working Drawings and Other Visible Things on Paper Not Necessarily Meant to Be Viewed as Art*, which has been described as the first Conceptual art exhibition. Other Conceptual work by Bochner included measurement and counting pieces. By 1973 he began making wall-paintings and by 1983 was painting on canvas.

Marcel Broodthaers (1924–76) Belgian painter, sculptor, film-maker and poet. Born in Brussels he lived in poverty as a poet for twenty years before becoming an artist in 1964. His work includes films, objects, books and installations which frequently simulate the environment of the museum. His often puzzling and contradictory art has been variously interpreted as that of the imaginative poet, the intellectual joker and the Marxist intent on subverting institutions.

Stanley Brouwn (b. 1935) Artist from Surinam who lives and works in Amsterdam. By 1960 he was making dematerialized works, which described routes and options that the viewer could take. His work has remained consistently sparse and austere.

Daniel Buren (b.1938) French artist who set out to strip painting of its idealist pretensions and illusionistic qualities. Since 1965 he has worked solely in his signature format of vertical stripes 8·7 cm (3½ in) wide (originally painted, later prefabricated). From the beginning he worked only *in situ*, so that the viewer, having noticed the ubiquitous stripes, then becomes aware of the architectural, social or economic context in which they appear.

Victor Burgin (b.1941) British artist and writer. Although his first job on leaving art school was teaching life drawing, he soon began making monochrome paintings. By 1969 he was making Conceptual works, the instructions for which could be written on an index card. In the 1970s he began using photography and text together, juxtaposed so as to draw attention to the complex layers of apparent and implicit meaning. His theoretical writings – which use semiotic, feminist and psychoanalytical theory to examine our understanding and use of representation – have been highly influential.

James Lee Byars (1932–97) Born in Michigan, he lived in Japan from 1958 to 1963. He was concerned with the act of questioning and the notion of the perfect. His work often involved performance elements: in 1968 he had 500 people wear a continuous length of silk and walk through the streets of New York.

John Cage (1912–92) American composer, philosopher, painter and writer who was described by his teacher Arnold Schoenberg as an inventor, not a composer. From the 1940s he was influenced by Zen Buddhism and Indian philosophy. He claimed that all sounds should be considered as potential music. Collaborated with **Robert Rauschenberg** and the choreographer Merce Cunningham.

Jan Dibbets (b.1941) Dutch artist who began his career as an abstract painter. After studying at St Martin's School of Art in London in 1967, he began using photography to document the effects of changing light and perspective.

Marcel Duchamp (1887–1968) French artist whose brothers and sisters were also artists. Associated with the Paris avant-garde at the start of the twentieth century. In 1913 Duchamp gave up painting and turned instead to making **readymades**. He moved to New York in 1915 where he gained celebrity status. By 1923, having ostensibly given up art, he played chess, taught French and acted as an art dealer and consultant. Admired by the Surrealists for his intelligence and ironic stance, he was 'rediscovered' by the **neo-Dadaists** in the 1950s.

Felix Gonzalez-Torres (1957–96) Born in Cuba, he lived and worked in New York. Was initially involved in the collaborative venture Group Material. Worked with such varied materials as billboards, books, clocks, jigsaws, light-bulbs and sweets. His work, often related to his own gayness, was highly attentive to the way that context or use gives meaning to art.

Dan Graham (b.1942) American artist and writer. Ran the Daniels Gallery in New York from 1964 to 1965, through which he came into contact with many Minimal artists, including Dan Flavin and **Sol LeWitt**. Disillusioned with the commercial gallery system, he began producing his own art. In the late 1960s he produced works that were designed to appear interruptively in magazines. Subsequently he has worked mainly with performance, video and mirrored rooms.

Hans Haacke (b.1936) German artist whose early work was influenced by gestural painting and then by **Yves Klein**. By the time he moved to New York in 1965 his work was concerned with the analysis of ecological systems. This then developed into an analysis of social and ideological systems. Since the late 1960s his work has been highly critical of the establishment – something which has led to the cancellation of exhibitions of his work.

Susan Hiller (b.1942) British artist born in New York. Studied archaeology and anthropology but underwent a 'crisis of conscience' and turned to art as a way to participate in the culture in which she lived. Her art and writings explore issues of language, gender, desire and death.

John Hilliard (b.1945) British artist who studied sculpture at St Martin's School of Art in London. He turned his attention to photography and an analysis of photography when he realized that his sculptural work was primarily known through photographic documentation. Since the late 1970s

his work has become more concerned with issues such as gender, age and race.

Jenny Holzer (b.1950) Daughter of a car dealer, raised in the American Midwest, her work has always been that of a moralist, but one who has inverted advertising strategies. By 1975 her paintings were dominated by words; by 1978 her art consisted of textual statements pasted onto street walls. In subsequent years, her work (still entirely textual) has become more spectacular and more reflective.

Roni Horn (b.1955) American artist. Her installations often employ apparently identical objects, elucidating issues of identity, ideal form and placement. Her interest is not in objects themselves but how we experience them. Androgyny, desire and the nature of language are constant themes. Her work often employs texts by Emily Dickinson, a poet she has long been fascinated by. Her ongoing series of books, *To Place*, combines photographs, texts, drawings and maps to investigate both a place, the act of placing and the experience of being in a place (in her case Iceland, a place that she has visited every year since 1975).

Douglas Huebler (1924–97) Studied drawing in Paris after serving as a marine in World War II. He worked as a commercial artist but from 1955 taught art. By the mid-1960s he was making Minimal sculpture, and then he turned to an art concerned with experiences, not objects. He preferred to call his a 'dialectical' art, rather than 'Conceptual'.

Ilya Kabakov (b.1933) Ukranian artist. Initially made a living as an illustrator of children's books. From 1970 he began making albums and 'total installations' which comment on the nature of personal and communal life. Moved to New York in 1991.

On Kawara (b.1933) Japanese artist who settled in New York in 1965. His early paintings were of distorted human figures. In 1966 he began his series of *Date Paintings*. These form the major element of his *Today* series: others parts being his books which contain typewritten lists of years, and his telegrams containing simple messages such as 'I am still alive'. The series will finish on his death.

Yves Klein (1928–62) French artist, judo expert and Rosicrucian. In 1952–3 he travelled to Japan. Taught judo until 1959. May have exhibited monochrome paintings (which he saw as symbols of the infinite and the immaterial) as early as 1950 but his public success dates from 1956. Patented his trademark colour IKB (International Klein Blue) in 1960. Also made performances which sought to manifest the void.

Milan Knizak (b.1940) Czechoslovakian artist. Best-known exponent of **Happenings** and **Fluxus** in Eastern Europe. Carried out his first 'actions' in Prague in 1964. Founded the Aktual group to defy authority by holding performances and actions in the street. Often imprisoned for such so-called subversive behaviour. In 1990 became Rector of the Prague Academy of Fine Arts.

Joseph Kosuth (b. 1945) American artist. His early work was tautological, lacking any possible autographic meaning, such as objects shown with their photograph and dictionary definition. In 1965 he began producing works which employed language as their principal element. He was briefly associated with **Art & Language**. His early work analysed dictionary and thesaurus definitions but his interests later extended to meaning in literary, philosophical and psychoanalytic texts.

Jannis Kounellis (b.1936) Born in Greece, since 1956 he has lived in Rome. Began making paintings of numbers and alphabets in the late 1950s. Began to use objects and materials in the 1960s, becoming a leading light of the **Arte Povera** group. His materials, like those of **Joseph Beuys**, have autographic and cultural resonances.

Sol LeWitt (b.1938) American artist who originally worked as an architectural draughtsman. Began making serial works in 1965. Began drawing on the wall in 1968. Associated with the Minimalist sculptors. In 1967 he published 'Paragraphs on Conceptual Art' and in 1969 his 'Sentences on Conceptual Art'. A great collector, supporter and publisher of fellow artists.

Richard Long (b.1945) British artist who studied at St Martin's School of Art in London. His art since 1967, whether documented by photographs, text or sculptures, has existed in his walking. Unlike American Land artists, his interventions are gentle and ephemeral.

Man Ray (1890–1976) American painter, sculptor and photographer. Became friends with **Duchamp** in New York. Made **readymades**, published Dada magazines, but continued to paint. In 1921 he moved to Paris where he became involved with Surrealism. He made a living as a portrait and fashion photographer.

Piero Manzoni (1933–63) Italian artist. Before 1957 Manzoni was making paintings with household objects embedded in them. After seeing Yves Klein's 1957 exhibition in Milan he began producing his Achromes: 'paintings' made with kaolin or white materials such as cotton wool. Other Conceptual works included lines contained in sealed tubes and the signing of people as artworks.

Ana Mendieta (1948–85) American performance artist. Her work was always about her body, her womanhood and nature. Much of her later work involved imprinting the form of her own body or ritual marks of the feminine on the landscape. Her Hispanic heritage (she was sent away from her native Cuba to avoid the regime of Fidel Castro) also became an important issue. She died after falling from a window in the flat that she shared with Carl Andre.

Annette Messager (b.1943) French artist. After the radical upheavals in Paris in 1968 she decided to make no more 'great art' and

hence gave up painting, instead adopting the various roles of collector, trickster, artist and practical woman. Her work of the 1970s dealt with woman as collector, victim and artist. Her materials are everyday things such as toys, snapshots and needlework. Her work often subverts the traditional roles of men and women. In recent years her work has grown more expansive and more installation orientated.

Robert Morris. (b.1931) American artist. Spent the last half of the 1950s involved in experimental dance in San Francisco. In 1961 he moved to New York where he began to make objects influenced by **Duchamp**. He wrote articles on the phenomenology of what was to be termed Minimal sculpture. From then on much of his work was in ephemeral form: made from felt, dirt or steam. But by the 1980s Morris was making grandiose figurative drawings and installations.

Tania Mouraud (b.1942) French artist. By 1969 she had largely given up painting, working instead with space and light installations, often in collaboration with musicians such as La Monte Young. By the mid-1970s she was primarily using text as an artistic medium. Her work often seeks to counter notions of racial superiority. Recently she has worked with such forms as maps and military decorations.

Bruce Nauman (b.1941) American artist. Studied mathematics and music as well as art. He gave up painting in favour of using film, photography and drawing to document performances that seemed absurd but were systematic. His work is always emotional and visually powerful. He often employs wordplay, especially when working in the medium of neon light. In the 1970s he primarily made environmental sculpture, but in 1981 returned to the use of video.

Hélio Oiticica (1937–80) Brazilian artist. By the mid-1960s he was making environmental work with a social function. His art was often interactive and represented a celebration of the body. From 1970 to 1978 he lived in New York.

Giulio Paolini (b.1940) Italian artist. Since 1960 his work has been concerned with the ontology of art, with paradox and systems of perspective. Associated with the **Arte Povera** group.

Francis Picabia (1879–1953) French avant-garde artist. A contrary figure, Picabia was variously an Impressionist, Fauvist, Cubist and a Dadaist. Often denigrated as a playboy (in the course of his life he owned more than a hundred different cars), his dandyish attitude can also be seen as highly ironic. Apart from paintings in innumerable styles he also created readymades and published the key Dada magazine *391* (1917–24).

Adrian Piper (b.1948) American artist. Her earliest work was linguistic and self-referential, but by 1970 she was making her *Catalysis* works where she sought to interact with the outside world. In the 1970s she returned to college to study philosophy. Subsequently her work has become more concerned with her own identity as a woman of mixed race.

Robert Rauschenberg (b.1925) American artist. After studying in Paris after World War II he collaborated with his wife Susan Weil on photographic pieces. His work of the late 1950s was a transposition of the way that **Duchamp** and the Dadaists used objects. In this period he also worked closely with **John Cage**, Merce Cunningham and Jasper Johns. In 1962 he began making paintings using silk-screened images.

Ad Reinhardt (1913–67) American artist, often mistakenly seen as an Abstract Expressionist. His paintings were always geometric. In the 1940s he also made cartoons which were either political satires or lampoons of the art world. His writings insisted on 'Art-as-Art'. For the last seven years of his life he made nothing but square near-black paintings.

Reiner Ruthenbeck (b.1937) German sculptor and photographer. Worked as a professional photographer before studying under **Joseph Beuys** at the Staatliche Kunstakademie in Düsseldorf from 1962 to 1968. His objects and installations seek to disturb the equanimity of their context by introducing a note of tranquillity. For the *Sculpture.Projects Münster 1997* exhibition he arranged to have a black and a white horse going around the city's ring road in opposite directions.

Robert Smithson (1938–73) American artist. His early paintings combined mythological subjects with Abstract Expressionist handling. An avid reader and talker, he also wrote copiously. In the mid-1960s he was seen as a Minimal artist, but he became known from 1968 onwards for his Earthworks: simple shapes constructed often on a grand scale in reclaimed industrial wastelands or remote wildernesses. Killed in a plane crash while surveying his work *Amarillo Ramp* in Amarillo, Texas.

Niele Toroni (b.1937) Swiss artist. Since 1966 his work has consisted of 'the imprints of a no.50 paintbrush repeated at regular intervals of 30 cm.' The repetitious brushmarks draw attention to themselves by their tiny irregularities which betray them as the product of a human hand. His work invites the viewer to consider the space around them, by drawing attention to areas which are normally glanced at without being properly considered.

Rosemarie Trockel (b.1952) German artist whose early work was influenced by **Joseph Beuys**. In 1985 she showed her first 'knitting paintings' which commented on commercial imagery, mechanized manufacture and the expectations of female work. Recently she has worked more with photography and video.

Jeff Wall (b.1946) Canadian artist. After an initial involvement in Conceptual art he went to the Courtauld Institute of Art in

London to do doctoral research (1970–3), and subsequently taught art history. Since 1979 he has made large colour photographs which he exhibits as transparencies on light-boxes. Recently he has used computer technology to manipulate his images and in 1997 he began using black-and-white photography in his work.

Andy Warhol (1928–87) American artist and film-maker. Worked as a commercial artist in the 1950s. By 1960 he was determined to be a fine artist and began making paintings with the use of rubber stamps, stencils and silk-screens. The films that he started making in 1964 also lacked the human touch. He acted as manager of the rock band the Velvet Underground. He was a compulsive shopper, self-promoter and socialite.

Lawrence Weiner (b. 1942) American artist who realized that he was spending more time talking about his paintings than actually making them. Having described what the painting would be like, it did not seem necessary to make it – he therefore gave up painting in 1965. Since then his work has been primarily based around language, either written or sung. He defines his works as sculptures.

Hannah Wilke (1940–93) American artist whose performances and other related work explored and exploited her own beauty. In her *Starification Object Series* of the 1970s she evolved specifically female imagery such as vulva shaped bits of plasticine or chewing gum which she dotted over her half-naked body. Her last works consisted of the photographic documentation of her own slow but defiant death from lymphoma.

Frank Zappa (1940–93) American rock musician, song writer and producer. After hearing Bob Dylan's song 'Like a Rolling Stone' he came to believe that the world of pop music, ideologically anodyne and musically infantile, could be replaced by intelligent rock music. From 1965 to 1976 his main outlet was the band the Mothers (renamed the Mothers of Invention by their record company). Their music combined rock, pastiche, abuse and elaborate arrangements. Their album *Freak Out* was the first double album to be made by a rock band. Despite his notoriously freakish appearance and anarchic behaviour, he was reputedly the only rock star of the 1960s never to take drugs. In the last years of his life he acquired a reputation as a serious classical composer.

Key Dates

Numbers in square brackets refer to illustrations

Conceptual Art

1912	Marcel Duchamp withdraws *Nude Descending a Staircase (No. 2)* [13] from the Salon des Indépendents in Paris
1913	Marcel Duchamp exhibits *Nude Descending a Staircase (No. 2)* at the Armory Show in New York
1915	Marcel Duchamp arrives in New York
1916	Dada begins in Zurich
1917	Marcel Duchamp, *Fountain* [2, 14]
1921	Francis Picabia renounces Dadaism
1942	*First Papers of Surrealism* exhibition, New York [23]
1951	Publication of *Dada Poets and Painters* (ed. Robert Motherwell)
1952	First Happenings at Black Mountain College, North Carolina. John Cage, *4'33"*
1954	Gutai founded in Osaka
1955	Yves Klein's first exhibition held
1956	Death of Jackson Pollock
1957	Piero Manzoni's first Achromes. Situationist International founded
1958	Yves Klein's exhibition, *La Vide*. Robert Lebel, *Sur Marcel Duchamp*
1960	Yves Klein patents his colour International Klein Blue (IKB)

A Context of Events

1912	First issue of the Communist newspaper *Pravda* published in Russia
1914	World War I begins (to 1918)
1915	Zeppelins bomb London
1916	Battle of the Somme. 60,000 British casualties on first day
1917	Battle of Passchendaele. October Revolution in Russia
1921	*Chanel No.5* perfume launched
1922	James Joyce, *Ulysses*
1939	World War II begins (to 1945)
1942	First Nazi death camps open
1944	Jorge Luis Borges, *Ficciones*
1945	Nazi concentration camps liberated
1946	Beginning of liberation war in Vietnam
1950	First colour televisions become available in the United States
1953	Ludwig Wittgenstein, *Philosophical Investigations*
1954	French army defeated by the Vietnamese in the battle of Dien Bien Phu. Liberation struggle begins in Algeria
1955	Disneyland opens in California
1956	Suez Canal crisis. Warsaw Pact countries invade Hungary
1957	Roland Barthes, *Mythologies*
1958	Introduction of the Barbie doll. First passenger jets to fly between London and New York
1960	John F Kennedy elected president of the United States. The first Playboy Club opens in Chicago

Conceptual Art	A Context of Events
1961 Joseph Beuys starts teaching at Staatliche Kunstakademie, Düsseldorf. Clement Greenberg, *Art and Culture*	**1961** First manned space flights. Berlin Wall built
1962 Camilla Gray, *The Great Experiment: Russian Art 1863–1922.* La Monte Young, *An Anthology.* Fluxus begins at Wiesbaden. Death of Yves Klein	**1962** Jorge Luis Borges, *Labyrinths.* Satirical programme *That was The Week That Was* begins on British television
1963 Marcel Duchamp retrospective exhibition at the Pasadena Art Museum [163]. Death of Piero Manzoni	**1963** 200,000 march on Washington for civil rights. Assassination of John F Kennedy
1964 Marcel Broodthaers becomes an artist	**1964** First mini-skirts. Palestine Liberation Organization (PLO) founded
	1965 US planes bomb North Vietnam. US Marines arrive in South Vietnam. Race riots in Watts, Los Angeles. Allen Ginsberg coins the phrase 'Flower power'. Terry Riley, *In C.* Rolling Stones, *Satisfaction.* Jean-Luc Godard, *Alphaville.* Cultural Revolution begins in China (to 1968)
1966 *Primary Structures.* exhibition, New York (April) *Working Drawings and Other Visible Things on Paper Not Necessarily Meant To Be Viewed as Art* exhibition (December) [72–3]	**1966** National Organization for Women (NOW) founded in the United States. Stokely Carmichael calls for 'Black Power'. Beach Boys, 'Good Vibrations'. Cardinal Spellman says Vietnam is a war for civilization: US must win. John Lennon claims that the Beatles are more popular than Jesus. Mothers of Invention, *Freak Out*
1967 Germano Celant invents term 'Arte Povera'	**1967** Sit-in at London School of Economics. Execution of Che Guevara in Bolivia. Beatles, *Sergeant Pepper's Lonely Hearts Club Band.* Joseph Beuys founds German Student party
1968 *Prospect 68* exhibition, Düsseldorf. *Douglas Huebler* exhibition, New York. *Richard Long* exhibition, Düsseldorf. Death of Marcel Duchamp	**1968** Tet Offensive in Vietnam. Martin Luther King assassinated. Miss America competition disrupted by femi nist protesters. Richard Nixon elected president of the United States. Demonstration in London against US involvement in Vietnam. Warsaw Pact countries invade Czechoslovakia
1969 *Art–Language* No.1. *January 5–31 1969* exhibition, New York [116]. *Op Losse Schroeven: situaties en cryptostructuren (Square pegs in round holes)* exhibition, Amsterdam. *When Attitudes Become Form* exhibition, Berne [118–19]. *Land Art* exhibition, broadcast on German television. *July, August, September* exhibition, various locations around the world. *557,087* exhibition, Seattle *Prospect 69* exhibition, Düsseldorf *Konzeption–Conception* exhibition, Leverkusen	**1969** Catholics and Protestants fight in Londonderry (Derry). 'Monty Python's Flying Circus' launched on British television. Woodstock music festival, New York state. Details emerge of massacre by US Marines at My Lai in Vietnam. John Lennon and Yoko Ono carry out a 'bed in' for peace. First man on the moon

Conceptual Art	A Context of Events
1970 *Conceptual Art and Conceptual Aspects* exhibition, New York. *Conceptual Art, Arte Povera, Land Art* exhibition, Turin. *Idea Structures* exhibition, London. *Information* exhibition, New York	**1970** Four anti-Vietnam protesters shot dead by National Guardsmen at Kent State University, Ohio. Death of Jimi Hendrix
1971 *Pier 18* exhibition, New York. *Prospect 71* exhibition, Düsseldorf	**1971** Greenpeace founded. Princess Anne wears hot pants
1972 *Documenta V* exhibition, Kassel. *The New Art* exhibition, London. *Book as Artwork* exhibition, London	**1972** Video cassette recorders available
1973 *C.7,500* exhibition, Valencia, California. Lucy Lippard, *Six Years: The Dematerialization of the Art Object*. Death of Robert Smithson	**1973** Last US troops leave Vietnam
	1974 Richard Nixon resigns as president of the United States after the Watergate scandal
1975 Death of Bas Jan Ader	**1975** South Vietnam falls to the Communist North Vietnamese
1976 Death of Marcel Broodthaers	**1976** Death of Mao Tse-tung
1978 Death of Gordon Matta-Clark	**1978** Cardinal Karol Wojtyla becomes Pope John Paul II
	1979 Margaret Thatcher becomes prime minister of the United Kingdom
	1980 Ronald Reagan elected president of the United States. John Lennon shot dead in New York
	1981 Prince Charles marries Lady Diana Spencer
	1990 Resignation of Margaret Thatcher
	1994 Nelson Mandela becomes president of South Africa
1995 *Reconsidering the Object of Art: 1965–1975* exhibition, Los Angeles	
1996 Death of Felix Gonzalez-Torres	
1997 Death of James Lee Byars. *Sculpture.Projects Münster 1997* exhibition, Münster. Death of Douglas Huebler. Four female 'Conceptual artists' nominated for the Turner Prize in the United Kingdom. Gillian Wearing wins the Turner Prize	**1997** Liam Gallagher claims that Oasis are more popular than Jesus. Labour government elected in the United Kingdom. Death of Diana, Princess of Wales. Birth of the first cloned sheep

CANADA

UNITED STATES
OF AMERICA

NOVA
SCOTIA

● Salt Lake City

San Francisco ●

● New York

Los Angeles ●

● Oklahoma City

MEXICO

YUCATAN

BRAZ

| 0 | 1000 | 2000 | 3000 | 4000 miles |

| 0 | 1000 | 2000 | 3000 | 4000 | 5000 | 6000 kilometres |

Further Reading

A thorough and extensive bibliography is to be found in the exhibition catalogue *Reconsidering the Object of Art: 1965–1975*.

A major source is also, of course, the catalogues of the exhibitions cited in Chapter 6, plus others of the period. In addition magazines of the period, especially *Studio International* and *Avalanche*, are essential points of reference.

Introduction and General

Bruce Altshuler, *The Avant-garde in Exhibition* (New York, 1994)

L'art conceptual, une perspective (exh. cat., Musée d'Art Moderne de la Ville de Paris, 1989)

Rene Block (ed.), *The Readymade Boomerang* (exh. cat., Art Gallery of New South Wales, Sydney, 1990)

AA Bronson and Peggy Gale (eds), *Museums by Artists* (exh. cat., Art Metropole, Toronto, 1983)

Stewart Home, *The Assault on Culture: Utopian Currents from Lettrisme to Class War* (Stirling, 1991)

Greil Marcus, *Lipstick Traces* (Harvard, 1990)

Reconsidering the Object of Art: 1965–1975 (exh. cat., Museum of Contemporary Art, Los Angeles, 1995)

Early or Proto-Conceptualism

Gregory Battcock (ed.), *Minimal Art: A Critical Anthology* (New York, 1968)

'Bauhaus Situationist', *Lund Art Press*, vol.2, no.3, 1992

Pierre Cabane, *Dialogues with Marcel Duchamp* (London, 1971)

William Camfield, *Marcel Duchamp: Fountain* (Houston, 1989)

Thomas Crow, *The Rise of the Sixties* (London, 1997)

Thierry de Duve (ed.), *The Definitively Unfinished Marcel Duchamp* (Cambridge, MA, 1991)

Susan Hapgood, *Neo-Dada; Redefining Art, 1958–1960* (New York, 1994)

Walter Hopps, *Robert Rauschenberg: The Early 1950s* (Houston, 1991)

In the Spirit of Fluxus (exh. cat., Walker Art Center, Minneapolis, 1993)

Thomas Kellein, *Fluxus* (London, 1995)

Robert Lebel, *Sur Marcel Duchamp* (London, 1959)

Robert Motherwell (ed.), *The Dada Poets and Painters* (New York, 1951)

On the Passage of a Few People through a Rather Brief Moment in Time: The Situationist International, 1957–1972 (exh. cat., Musée National d'Art Moderne, Centre Georges Pompidou, Paris, 1989)

Piero Manzoni (exh. cat., Musée d'Art Moderne de la Ville de Paris, 1991)

Ad Reinhardt, *Art-as-Art, the selected writings of Ad Reinhardt* (New York, 1975)

James Roberts, 'Painting as Performance', *Art in America* (May 1992)

Michel Sanouillet & Elmer Peterson (eds), *The Writings of Marcel Duchamp* (New York, 1973)

Arturo Schwarz, *Man Ray* (London, 1977)

Edward Strickland, *Minimalism: Origins* (Bloomington, 1993)

Calvin Tomkins, *Duchamp: A Biography* (New York, 1996)

La Monte Young (ed.), *An Anthology* (New York, 1962)

Yves Klein (exh. cat., Hayward Gallery, London, 1995)

The Late 1960s

1965–1972 when attitudes became form (exh. cat., Kettle's Yard, Cambridge, 1984)

Alexander Alberro and Alice Zimmerman, *Lawrence Weiner* (London, 1998)

Ana Mendieta (exh. cat., Centro Galego de Arte Contemperánea, Santiago de Compostela, 1996)

Annette Messager: Comédie Tragédie 1971–1989 (exh. cat., Musée de Peinture et de Sculpture, Grenoble, 1989)

Art Conceptual Formes Conceptuelles (exh. cat., Galerie 1900–2000, Paris, 1990)

Arte Conceptual Revisado (exh. cat., Universidad Politechnica de Valencia, 1990)

Michael Asher, *Writings 1973–1983 on works 1969–1979* (Halifax, 1983)

Terry Atkinson, *The Indexing, the World War I Moves and the Ruins of Conceptualism* (Manchester, 1992)

Bas Jan Ader: Kunstenaar/Artist (exh. cat., Stedelijk Museum, Amsterdam, 1988)

Bernd and Hilla Becher, *Anonyme Skulpturen: A Typology of Technical Construction* (New York, 1970)

Andrea Bee, *Reiner Ruthenbeck* (Frankfurt, 1996)

Between Spring and Summer: Soviet Conceptual Art in the Era of Late Communism (exh. cat., Tacoma Art Museum, Washington, 1990)

Bruce Nauman (exh. cat., Walker Art Center, Minneapolis, 1994)

Coosje van Bruggen, *John Baldessari* (Los Angeles, 1990)

Benjamin H D Buchloh (ed.), *Broodthaers: Writings, Interviews, Photographs* (Cambridge, MA, 1988)

Daniel Buren, *Five texts* (London, 1973)

James Lee Byars, *The Monument to Language – The Diamond Floor* (Paris, 1995)

Germano Celant, *Arte Povera: conceptual, actual or impossible art* (London, 1969)

—, *Giulio Paolini* (New York, 1972)

Douglas Huebler: 'Variable' etc. (exh. cat., FRAC, Limoges, 1992)

Barbara Einzig (ed.), *Thinking about Art: Conversations with Susan Hiller* (Manchester, 1996)

Richard S Field (ed.), *Mel Bochner: Thought Made Visible 1966–1973* (exh. cat., Yale University Art Gallery, New Haven, 1995)

Richard Fleming and William Duckworth, *Sound and Light: La Monte Young, Marian Zazeela* (Lewisburg, 1996)

Suzanne Foley, *Space/Time/Sound – Conceptual Art in the San Francisco Bay Area: The 1970s* (Seattle and London, 1981)

Erich Franz (ed.), *Robert Barry* (Bielefeld, 1986)

Rudi Fuchs, *Richard Long* (London, 1986)

Gerry Schum (exh. cat., Stedelijk Museum, Amsterdam, 1979)

Gordon Matta-Clark (exh. cat., IVAM Centre Julio González, Valencia, 1992)

Dan Graham, *Rock my Religion: Writings and Projects 1965–90* (Cambridge, MA, 1993)

—, *For Publication* (Los Angeles, 1975)

Hannah Wilke (exh. cat., Museum of Art and Archaeology, University of Missouri, Columbia, 1989)

Charles Harrison, *Essays on Art and Language* (Oxford, 1991)

Harry Shunk Project: Pier 18 (exh. cat., Musée d'Art Moderne et d'Art Contemporain, Nice, 1992)

Hélio Oiticica (exh. cat., Witte de With Center for Contemporary Art, Rotterdam, 1992)

Peter Hutchinson, *Dissolving Clouds: Writings of Peter Hutchinson* (Provincetown, 1994)

Ian Burn: Minimal-Conceptual Work 1965–1970 (exh. cat., Art Gallery of Western Australia, Perth, 1992)

Ideas and Attitudes: Catalan Conceptual Art 1969–1981 (exh. cat., Cornerhouse, Manchester 1994)

Jan Dibbets (exh. cat., Walker Art Center, Minneapolis, 1987)

Jarosław Kozłowski, Things and Spaces (exh. cat., Muzeum Sztuki, Lódz, 1994)

Kate Linker, *Vito Acconci* (New York, 1994)

John Hilliard (exh. cat., Kölnischer Kunstverein, Cologne, 1983)

Keith Arnatt (exh. cat., Oriel Mostyn, Llandudno, 1989)

Joseph Kosuth, *Art after Philosophy and After: Collected Writings, 1966–1990* (Cambridge, MA, 1991)

—, *The Play of the Unmentionable* (Brooklyn, 1992)

Lucy Lippard, *Six Years: the Dematerialization of the Art Object* (New York, 1973)

Werner Lippert, *Hans-Peter Feldmann / Das Museum im Kopf* (Cologne, 1989)

Marcel Broodthaers (exh. cat., Walker Art Center, Minneapolis, 1989)

Ursula Meyer (ed.), *Conceptual Art* (New York, 1972)

Michael Craig-Martin: A Retrospective 1968–1989 (exh. cat., Whitechapel Art Gallery, London, 1989)

Robert C Morgan, *Art into Ideas: Essays on conceptual art* (New York, 1996)

—, *Conceptual Art: An American Perspective* (London, 1994)

—, *Commentaries on the New Media Arts: Fluxus & Conceptual, Artist's Books, Mail Art, Correspondence Art, Audio & Video Art* (Pasadena, 1992)

Robert Morris, *Continuous Project Altered Daily: The Writing of Robert Morris* (Cambridge, MA, 1993)

Gloria Moure, *Kounellis* (New York, 1990)

The Narrative Art of Peter Hutchinson: A Retrospective (exh. cat., Provincetown Art Association and Museum, Massachusetts, 1994)

Niele Toroni (exh. cat., Stedelijk Museum, Amsterdam, 1994)

On Kawara: Date paintings in 89 Cities (exh. cat., Museum Boymans-van Beuningen, Rotterdam, 1992)

Craig Owens, 'Improper names', *Art in America* (July 1986)

Peter Roehr (exh. cat., Kunsthalle, Tübingen, 1977)

Adrian Piper, *Out of Order, Out of Sight* (Cambridge, MA, 1996)

Robert Morris (exh. cat., Musée National d'Art Moderne, Paris, 1994) – in French

Robert Smithson: Photo Works (exh. cat., Los Angeles County Museum of Art, 1993)

Dieter Schwarz, *Lawrence Weiner – Books 1968–1989. Catalogue Raisonée* (Cologne, 1989)

Robert Smithson, *The Collected Writings* (Berkeley, 1996)

Susan Hiller (exh. cat., Tate Gallery, Liverpool, 1996)

Natalia Tamruchi, *Moscow Conceptualism 1970–1990* (Roseville East, NSW, 1995)

Victor Grippo (exh. cat., Ikon Gallery, Birmingham, 1995)

Jeff Wall, 'Dan Graham's Kammerspiel' in *Dan Graham* (exh. cat., Art Gallery of Western Australia, Perth, 1984)

Lawrence Weschler, *Seeing is Forgetting the Name of the Thing One Sees: A Life of Contemporary Artist Robert Irwin* (Berkeley, 1982)

Wide White Space (exh. cat., Palais des Beaux-Arts, Brussels, 1994)

The Work of Edward Ruscha (exh. cat., San Francisco Museum of Modern Art, 1982)

Adachiara Zevi (ed.), *Sol LeWitt Critical Texts* (Rome, 1994)

Nancy Spector (ed.), *Felix Gonzalez-Torres* (exh. cat., Soloman R Guggenheim Museum, New York, 1995)

Sandra Stich, *Rosemarie Trockel* (Cologne, 1991)

Tania Mouraud (exh. cat., Centre d'Art Contemporain Pablo Neruda, Corbeil-Essonnes, 1989)

Post-1973

Michael Auping, *Jenny Holzer* (New York, 1992)

Boris Mikhailov (exh. cat., Portikus Gallery, Frankfurt, 1995)

Victor Burgin, *Between* (Oxford, 1986)

Jimmie Durham, *A Certain Lack of Coherence: Writings on Art and Cultural Politics* (London, 1993)

Thierry de Duve *et al.*, *Jeff Wall* (London, 1996)

A Forest of Signs (exh. cat., Museum of Contemporary Art, Los Angeles, 1989)

Gabriel Orozco (exh. cat., Kunsthalle, Zürich, 1996)

Lynn Gumpert, *Christian Boltanski* (Paris, 1994)

Roni Horn, *To Place, Pooling Waters* (Cologne, 1994)

David Joselit, *Jenny Holzer* (London, 1998)

Mining the Museum: An Installation by Fred Wilson (exh. cat., Maryland Historical Society, Baltimore, 1993)

Michael Newman, 'Conceptual Art from the 1960s to the 1990s: An unfinished Project?', *Kunst and Museum Journal*, vol. 7, no.1/2, 1996

Public Information: Desire, Disaster, Document (exh. cat., Museum of Modern Art, San Francisco, 1994)

Rémy Zaugg: The Work's Unfolding (exh. cat., Kröller-Müller Museum, Otterlo, 1996)

John Roberts, *The Impossible Document: Photography and Conceptual art in Britain 1966–1976* (London, 1997)

Index

Numbers in **bold** refer to illustrations

Acknowledgements

A debt is owed to all those who have given generously of their time to talk or answer my queries, in particular John Baldessari, Barry Barker, Robert Barry, Lothar Baumgarten, Iwona Blazwick, Mel Bochner, Daniel Buren, Victor Burgin, Michael Corris, Jessica Diamond, Julia Fabényi, Henry Flynt, Anya Gallaccio, Gerlinde Gabriel, Liam Gillick, Nigel Greenwood, Susan Hiller, John Hilliard, Roni Horn, Douglas Huebler, Peter Hutchinson, Stephen Johnstone, Joseph Kosuth, Annette Lemieux, Tom Marioni, John Murphy, Simon Patterson and John Weber. In addition to all my students on the MA course in Contemporary art at Sotheby's Institute for past discussions, especially Natasha Lutovich, Patrick Mackie and Pamela Meredith, and most especially to my colleagues Mark Gisbourne and Anna Moszynska. To the libraries at Sotheby's Institute and the Tate Gallery and to Sotheby's Institute for a sabbatical without which the completion of this book would have been impossible. To my research assistant Margarida Vasconcellos who in the middle stages of this book's preparation should be more correctly termed a collaborator. To my editors Tim Ayers, Pat Barylski and Cleia Smith for more than usual patience. To my companion, as always, Peggy Prendeville for support and to my two daughters Heloïse and Isolde, who have frequently accompanied me to exhibitions, studios and post-studio situations, and to whom this book is dedicated.

One must also, perhaps unusually but importantly, include apologies in these acknowledgements. A book like this that covers a wide area normally degenerates periodically into lists of names. This I resolved not to do, but this has meant that many interesting and important artists have gone unmentioned. I can do nothing but apologize to them all.

Finally one must thank the reader for getting this far and beg of her or of him that they would use this book in the manner it was intended to be: not as the last word on the subject, but as an introduction and an irritation – an intellectual provocation that will raise as many questions as it, hopefully, answers.

T G

For Heloïse and Isolde

303 Gallery, New York: 250; Claudio Abate: 106; estate of Bas Jan Ader and Patrick Painter Editions, Vancouver: 182; Pierre Alechinsky, Paris: 45; Anders Tornberg Gallery, Lund: 237; Andrea Rosen Gallery, New York: photos Isaac Applebaum 195, Cal Kowal 217, Peter Muscato 4, 232; Annely Juda Gallery, London: photo John Riddy 69; Michael Asher: photo Gary Kruger 125; Ashiya City Museum of Art and History: 39; AP, London: 109, 111; Barbara Gladstone Gallery, New York: 135, 154, photo David Heald 221; Robert Barry: 97, 117, 124, 209; Bill Beckley: 181; Mel Bochner: 72, 73, 171; Pieter Boersma, Amsterdam: 222; Christian Boltanski: 179; Museum Boymans-van Beuningen, Rotterdam: 24, 92; Bridgeman Art Library, London: 10; estate of Marcel Broodthaers: 146, 148, photos Maria Gilissen 60, 145, Philippe De Gobert 147; Daniel Buren: 104, 105; Victor Burgin: photos Sean Hudson 119, 170, 185, 186, 187; Paola Colombo Collection, Geneva: photo Yukio Kobayashi 203; Maureen Connor: 234; Anny De Decker: 128; Walter de Maria: photo Andrew Wright 137; Jessica Diamond: 204; Henry Flynt: photo Tony Conrad 1; Galeria Joan Prats, Barcelona: 156; Galerie Beaubourg, Paris: 43; Galerie Christine et Isy Brachot, Brussels: cover, 31; Galerie Clara Maria Sels, Düsseldorf: 153; Galerie Stadler S A, Paris: 32; Giraudon, Paris: 8; Tony Godfrey: 38, 86, 103, 198, 207, 226, 240, 241, 246, 255; Soloman R Guggenheim Museum, New York: Panza Collection, gift Count Giuseppe Panza, 1992, copyright Solomon R Guggenheim Foundation, New York, photo Giorgio Colombo 126; Hans Haacke: 121, 141 right; Hayward Gallery, London: photo John Riddy 40; Heiner Bastien Fine Art, Berlin: 108; Hélio Oiticica Archive, Rio de Janeiro: 76; Collection Herbert, Ghent: 127; Herning Kunstmuseum, Denmark: 48, 49; Susan Hiller: 167, 210; John Hilliard: 175; estate of Douglas Huebler: 172; Peter Hutchinson: 138; Jay Gorney Gallery, New York: photo David Lubarsky 231; Jay Jopling, White Cube, London/The Henry Moore Sculpture Trust, Leeds: photos Jerry Hardman Jones 223, 224; John Weber Gallery, New York: 91, 93, 94, 95, 136, 202, 227; Kaiser Wilhelm Museum, Krefeld: 107; Yves Klein Archive, Paris: photo Shunk-Kender 42; James Klosty: 34; Milan Knizak: 150; Gyula Konkoly: 151; Jeff Koons: 230; Paul Kos: 130; Joseph Kosuth: 5, photos Jay Cantor 83, 87, 208, Ken Schles 242; Jarosław Kozłowski and Matt's Gallery, London: 155; L A Louver Gallery, Venice, California: 54; Lee Miller Archives, East Sussex: photo Antony Penrose 17; Annette Lemieux: 7, 236; Leo Castelli Gallery, New York: frontispiece, 6; copyright Manfred Leve, Nuremberg: 63; Lia Rumma Gallery, Naples: 115; Lisson Gallery, London: 101, photos John Riddy 229, Gareth Winters 149; Richard Long: 81; Luhring Augustine Gallery, New York: 249; Christian Marclay: photo P-A Grisoni and

J Staub 193; Margo Leavin Gallery, Los Angeles: 235; Marian Goodman Gallery, New York: 98, 132, 133, 177, 247, 248; Tom Marioni: 129; Mary Boone Gallery, New York: photo Zindman/ Fremont 192; Mary Evans/Serena Waldham: 200; Matt's Gallery, London: photos by the artist 197, 218; Matthew Marks Gallery, New York: 215, 216; Maureen Paley/Interim Art, London: 196; Max Protetch Gallery, New York: 220; Cildo Meireles: photo Wilton Montenegro 158; estate of Ana Mendieta and Galerie Lelong, New York: 160, 161, 162; Roman Mensing: 251, 252, 253, 254; Annette Messager: 168, 244; Metropolitan Museum of Art, New York: gift of the artist, 1995 copyright Walker Evans Archive 190; Boris Mikhailov: 188, 189; Modulo-Centro Difusor de Arte, Lisbon: 169; Monika Spruth Gallery, Cologne: 205, 206, 238; Mountain High Maps, copyright © 1995 Digital Wisdom Inc: pp.436–7; Tania Mouraud: 256; Musée Nationale d'Art Moderne, Centre Georges Pompidou, Paris: photos Philippe Migeat 18, 66; Museum für Moderne Kunste, Frankfurt am Main: photos Robert Hausser 70, 90; Museum Ludwig, Cologne: 50, 55, 58, 245; Museum of Modern Art, New York: gift of the Benefit for Attica Defence Fund, 1997 139; National Archives/Corbis: 110; National Gallery of Canada, Ottawa: 68; copyright the New Yorker magazine, Inc: 29; Claes Oldenburg and Coosje Van Bruggen: photo Robert McElroy 56; Giulio Paolini: 84; Simon Patterson: 213, 214; Philadelphia Museum of Art: Louise and Walter Arensberg Collection 3, 13, 14, 16, Duchamp Archives 23, Bequest of Katherine Dreier 28, lent by Mme Marcel Duchamp 163; Adrian Piper: 134, 166; Michelangelo Pistoletto: 71; Kathy Prendergast: 219; Press Association, London: 199; Jan Van Raay: 140; Redferns, London: photo Michael Ochs 89; RMN, Paris: photo Gerard Blot 12; Ronald Feldman Fine Art, New York: estate of Hannah Wilke 164, 233; Martha Rosler: 165; Ed Ruscha: 59; Reiner Ruthenbeck: 77, 113, 131; Arturo Schwarz Collection, Milan, SADE Archives: 15; Scoop, Paris: photo IZIS 184; Jean Sellem: 51; Gilbert and Lila Silverman Fluxus Collection Foundation, New York: 53, 64, 65; estate of Robert Smithson: 82; Sonnabend Gallery, New York: 85, 96, 114 right, 143, 178, 228; Sotheby's, London: 47; Staatliche Museen, Kassel: 9; Georgina Starr and Anthony Reynolds Gallery, London: 194; Stedelijk Museum, Amsterdam: 123; Stephen Freidman Gallery, London: photo Giorgio Sadotti 225; Tate Gallery, London: 36, 52, 174; Telimage, Paris: 26; The Edmonton Sun: 201; The Maryland Historical Society, Baltimore: photo Jeff D Goldman 243; The Vintage Magazine Co Archive, London: 183; Visual Arts Library, London: 30, 44; Waddington Galleries, London: 142; Jeff Wall: 173, 191; Wallraf-Richartz-Museum, Cologne: 141 left; Andrew Wright: 120; La Monte Young: 61

Phaidon Press Limited
Regent's Wharf
All Saints Street
London N1 9PA

Phaidon Press Inc.
180 Varick Street
New York, NY 10014

www.phaidon.com

First published 1998
Reprinted 1998, 1999, 2001, 2003, 2004
© 1998 Phaidon Press Limited

ISBN 0 7148 3388 6

A CIP catalogue record for this book is
available from the British Library.

Text typeset in FF Thesis, chapter numbers
based on patterns used in development work
on character recognition.

Printed in Singapore

Cover illustration Marcel Broodthaers,
Self Portrait in a Jar, 1966. Mixed media;
h.17.5 cm, 6⅞ in. Private collection